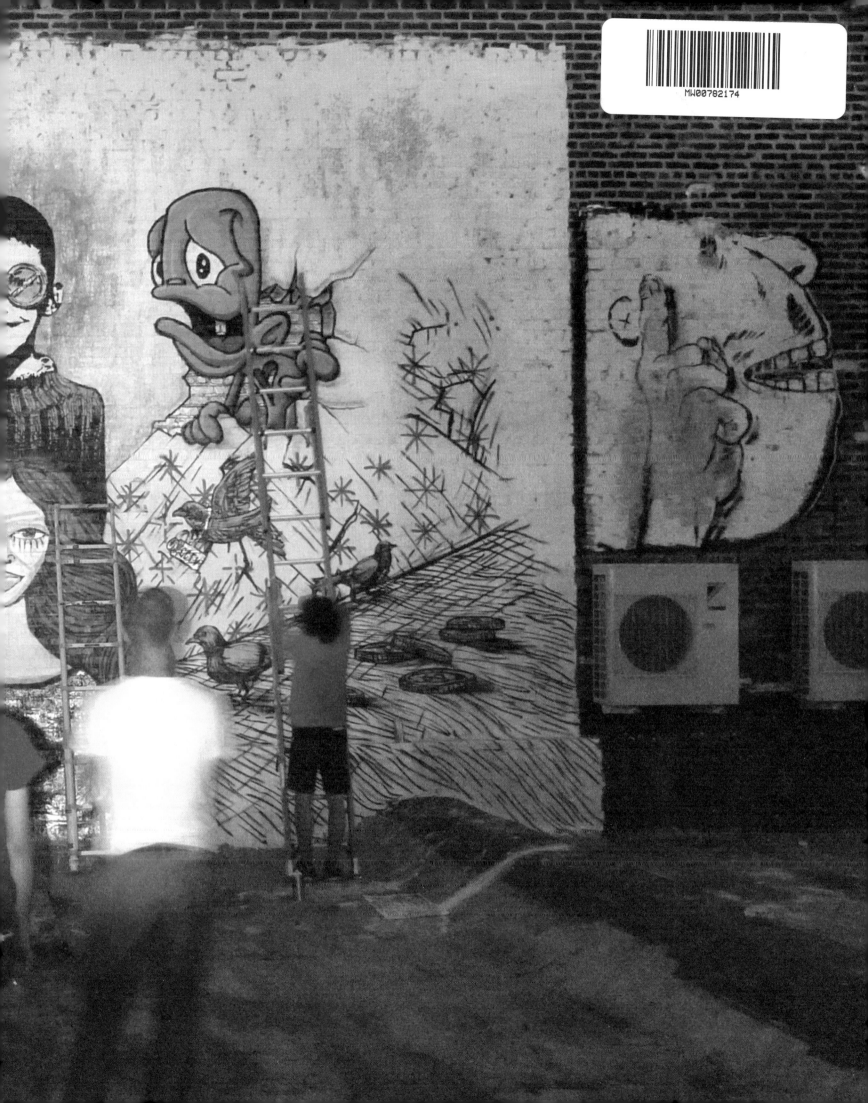

OUT-
DOOR
GAL-
LERY

NEW YORK CITY **YOAV LITVIN**

OUTDOOR GALLERY - NEW YORK CITY

FIRST PUBLISHED IN THE UNITED STATES OF AMERICA, 2014
FIRST EDITION

GINGKO PRESS, INC.
1321 FIFTH STREET
BERKELEY, CA 94710, USA
WWW.GINGKOPRESS.COM

ISBN: 978-1-58423-553-8

BOOK © YOAV LITVIN
DESIGN BY STEVEN MOSIER
ALL TEXTS EDITED BY YOAV LITVIN
ALL PHOTOGRAPHS (C) YOAV LITVIN UNLESS OTHERWISE STATED.
ALL ARTWORK (C) RESPECTIVE ARTISTS AND CONTRIBUTORS
ARTISTS FEATURED ON COVER MURAL ARE:
BISHOP203, LUNARNEWYEAR, ALICE MIZRACHI, QRST, GILF!, CERN AND ICY AND SOT.

PRINTED IN CHINA

DEDICATION
I DEDICATE THIS BOOK TO THE PEOPLE OF NYC AND TO ALL STREET ARTISTS AND THEIR FANS.

ACKNOWLEDGEMENTS
THANKS TO MY FAMILY AND FRIENDS FOR LOVE AND SUPPORT, GEORGE FOR FRIENDSHIP
AND EDITORIAL ASSISTANCE, STEVE FOR HIS WONDERFUL DESIGN OF THIS BOOK AND
GINGKO PRESS FOR BELIEVING IN THIS PROJECT.

MUCH RESPECT TO THE FINE PEOPLE WHO RUN PUBLIC ART PROJECTS THROUGHOUT NYC.
THESE PROJECTS INCLUDE 5 POINTZ (MERES ONE) AND WELLING COURT MURAL PROJECT (AD HOC ART)
IN QUEENS, THE BUSHWICK COLLECTIVE (JOE FICALORA) AND LOW BROW ARTIQUE (BISHOP203) IN BROOK-
LYN, THE BRONX MUSEUM (ESTEFANY CARMONA) AND BOONE AVENUE (COPE2 AND INDIE184) IN THE BRONX
AND
HIGH LINE ART (CECILIA ALEMANI), PUBLIC ART FUND, CRE8TIVE YOUTH*INK (JERRY OTERO), ARTUP, MANY
(KEITH SCHWEITZER), LMCC, PUBLIC AD CAMPAIGN (JORDAN SEILER), L.I.S.A. (WAYNE RADA), LOS MUROS
HABLAN AND CENTRE-FUGE ART PROJECT (PEBBLES RUSSELL AND JON NEVILLE) IN MANHATTAN.

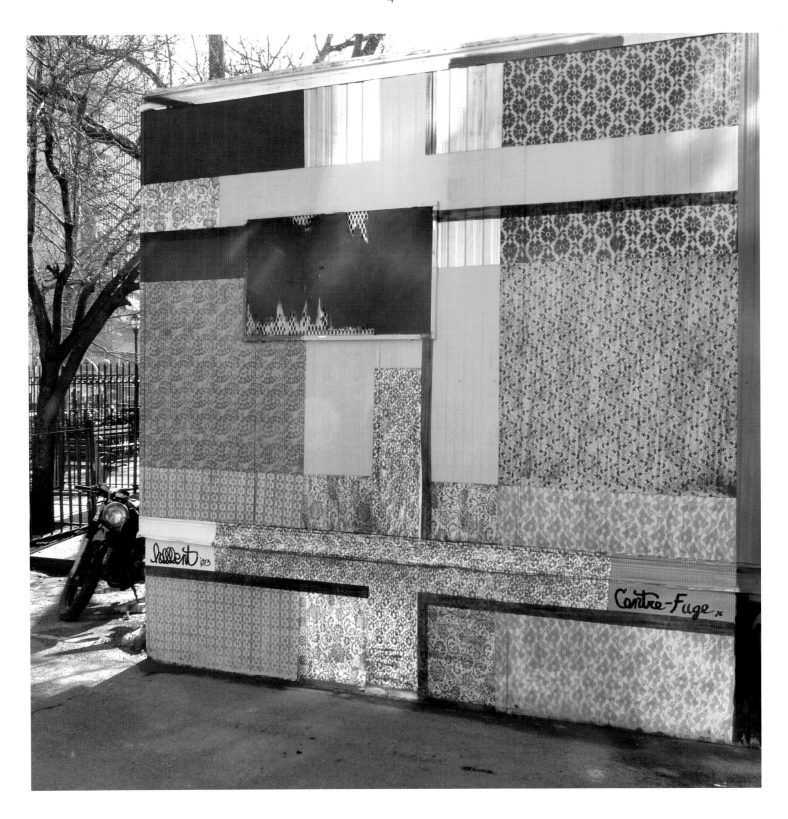

1ST ST., MANHATTAN

INTRODUCTION

YOAV LITVIN

New York City is in a league of its own. It is a metropolis that spans towering business quadrants, upscale neighborhoods, gentrified regions, quaint residential communities, trendy nouveau riche enclaves, bustling commercial sectors, artsy/hipsterish areas and finally, its ghettos.

I've strolled within these public spaces and discovered a trove of treasure that demands attention: a world of outdoor art. As I tread and my fascination grew, I learned a visual language spoken by a thriving community of artists that interact with each other, their physical environment and a diverse public. Driven by sparks of creativity, curiosity and productivity, a need for assertion, a sense of purpose, an urge for rebellion and/or fame, these artists invest money, time, effort and energy in art that will ultimately belong to not a single New York City inhabitant, but to all people. Collectively they contribute to the largest, most diverse and free outdoor gallery: New York City.

Outdoor art is posted: in subways, on walls, roads, rooftops, sidewalks, buildings, shop shutters, windows, doors, staircases, billboards, trucks, cars, traffic signs, traffic lights, traffic cones, parking meters, fire hydrants, phone booths, newspaper dispensaries, public bathrooms, gates, bridges, tunnels, toll booths, construction sites, schools, skateboard parks and playgrounds; to name a few locations. As weeds burst through concrete, so does outdoor art defy the sometimes cold, dirty, inorganic, alienating and ruthless urban reality. With its indiscernible boundaries and elusive definition, it embodies a non-violent and creative form of rebellion. It insistently pushes the boundaries of acceptable norms, constantly challenging conventions and setting new standards of public and private discourse, thought and action. It exposes the public to representations that remark on and accentuate the power of choice, rebellion, beauty, or simply the randomness of existence.

Outdoor artists use a variety of mediums to transmit their messages including: stickers, paint, spray paint, prints, stencils, three-dimensional installations and more. The life of an outdoor creation, a 'piece', does not end when it emerges in the public arena. A piece keeps changing, developing and finally: decaying. Outdoor art is continuously reshaped by forces of nature - winds, rain, snow, the sun, heat, cold, humidity – and, last but definitely not least, by human intervention. Sometimes police, but more commonly pedestrians, interact with a piece, at times destroying it, at times complementing it, but always maintaining its dynamic nature.

Today's world of instant accessibility and global interconnectivity complements and enhances the growing movement of 'street art'. This is art that reinforces the bond among people everywhere, questioning boundaries of class, nationality, race and sex. It emphasizes the continual need for growth, change, critique and humor. It is unapologetically shocking, exhilarating, witty and grotesque. The creation of outdoor art is a conscious act that forces people to confront certain personal as well as societal truths and issues of injustice, class, consumerism, sexuality, cultural norms and taboos, aggression and greed.

Outdoor Gallery: New York City grew organically to embody my process of exploration and discovery on the streets of New York City. It is a creation that was born out of love for New York City streets and their people, and focuses on artists as leaders with a unique and necessary role in a society that aspires for freedom and change. Cover to cover, visual representations are accompanied by interviews that convey the reflections of the artists on their own art, the movement called 'street art', New York City, the future and their techniques and influences. It is a snapshot of a delightful yet ephemeral world and represents an important process inherent within outdoor art, namely, discovery and sharing. This book is constructed as an inclusive, spacious progression through representations of: social commentary, empowerment, pride, beauty, truth, rebellion, humor, grief, dissent, the abstract, the wondrous, the absurd, the bizarre, the grotesque and finally, the imaginary surreal.

ART-
IST
PRO-
FILES

BRONX

MANHATTAN

QUEENS

BROOKLYN

STATEN
ISLAND

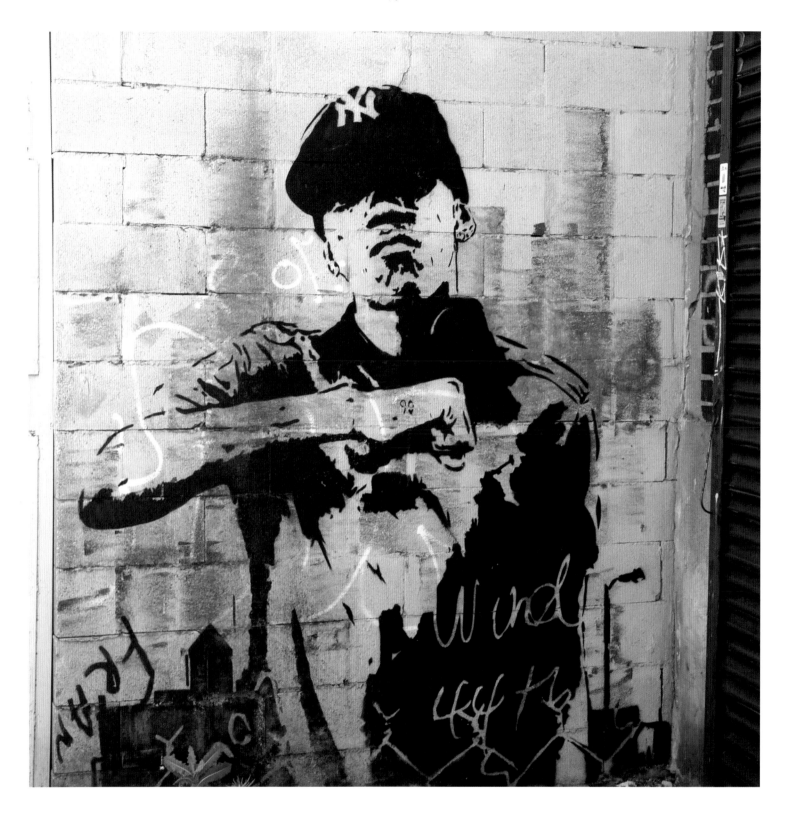

MAIN AVE., ASTORIA, QUEENS

CHRIS STAIN

CHRIS STAIN SPEAKS...

ON STREET ART

"I started out writing graffiti in 1984 so art for me started on the street. It seemed like the natural place for art to be. People have been painting illegally in public places far longer than the current influx of 'street art'. A little research into the history of stenciling and graffiti can provide some insight into that."

ON PERSONAL ART

"I went from the street to the studio. When I was 11-years-old I had no concept of studio space. You drew in your school notebook and then worked it out on an available wall somewhere. It wasn't until I was older that the studio concept came into play. Currently, I just work out of the basement where I live. The work I make now is more figurative and not letter-based. With my work I am interested in telling the story of the often-overlooked individual in society, the common folk."

ON NYC

"I live in New York City so it just makes sense that I work here. My wife and I moved back to her old neighborhood after living in Baltimore and Albany. I believe street art is an expression of how the artist is reacting to city life and his/her experience. Working in the streets I have been arrested, threatened, almost got into fights, but there is more drama on TV than what I have to offer."

ON THE FUTURE

"Honestly I don't even think about it. I just think about making new work and wait patiently for the creative spark to visit. I am currently studying for a BA in Art Education and plan to teach art as well as continue to make it."

ON YOUR PROCESS AND INFLUENCES

"When creating my images I work from photographs that I have found or taken that speak directly to me on a personal level. Then, I make very minor adjustments in Photoshop and cut the images out with an xacto knife using rubylith masking film or durlar film to create my stencil. From there I can either screen print or spray paint the image to create a print. When working on large mural pieces I have my image transferred to a piece of film. I then project the image on the wall and basically trace it using low-pressure spray paint to complete the piece.

One of my biggest influences outside the 1970-80's graffiti world of New York City is Kathe Kollwitz, the German Expressionist active circa World War I. The way she captured human emotion inspired me to follow a similar path. Also the work of Ezra Jack Keats, the children's book author and illustrator, certainly weighs in. Norman Rockwell should be mentioned as well for his illustrative storytelling abilities and use of a projector to speed up the production process. Jacob Lawrence also brought very emotive works to the table, which inspired me to tell the story of inner city life. For me the idea of the hand-cut stencil, which was sparked by Seth Tobocman and John Fekner from New York City, is attractive due to its simplicity."

"WITH MY WORK I AM INTERESTED IN TELLING THE STORY OF THE OFTEN-OVERLOOKED INDIVIDUAL IN SOCIETY, THE COMMON FOLK."

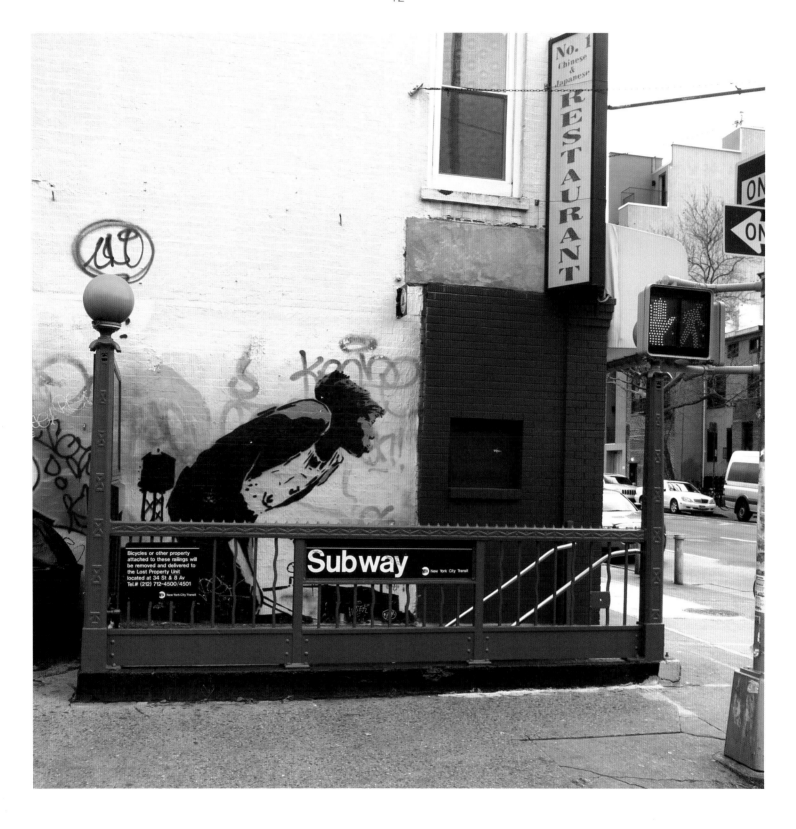

LAFAYETTE AVE., BEDFORD-STUYVESANT, BROOKLYN

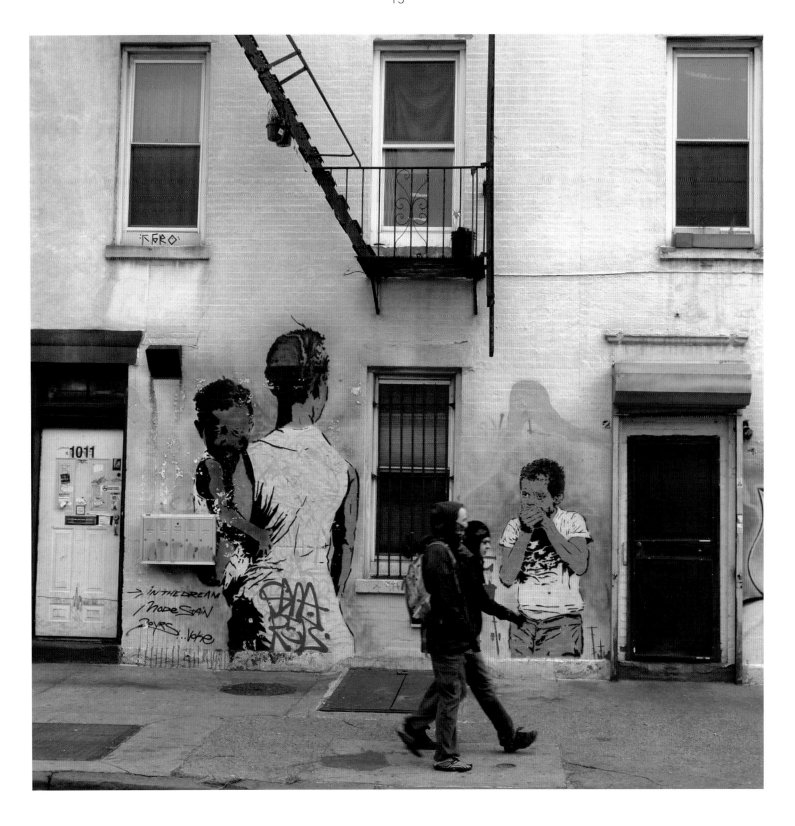

LAFAYETTE AVE., BEDFORD-STUYVESANT, BROOKLYN WITH BILLY MODE

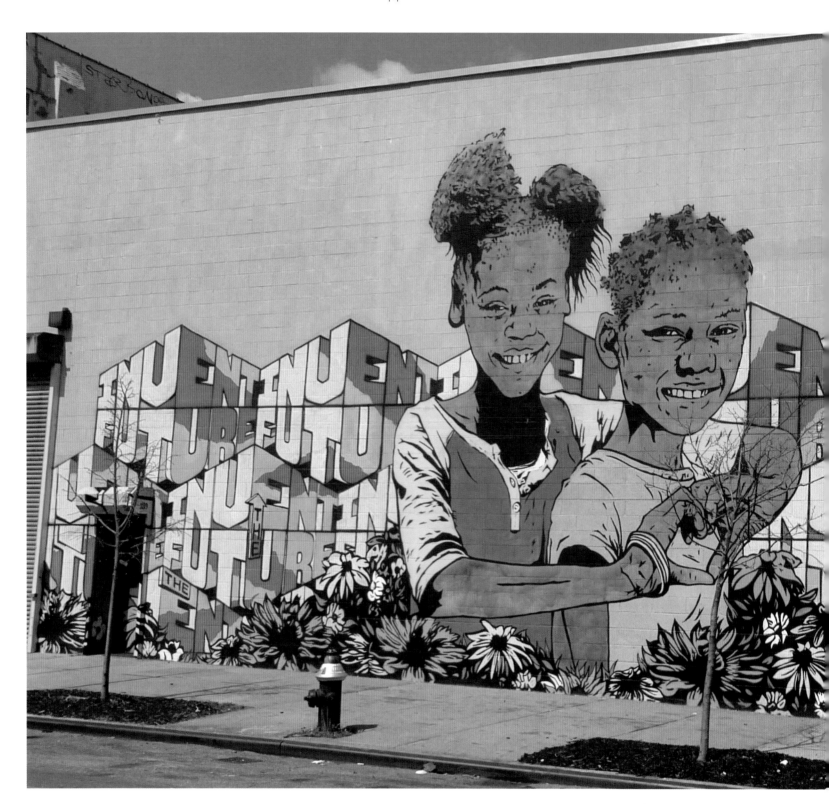

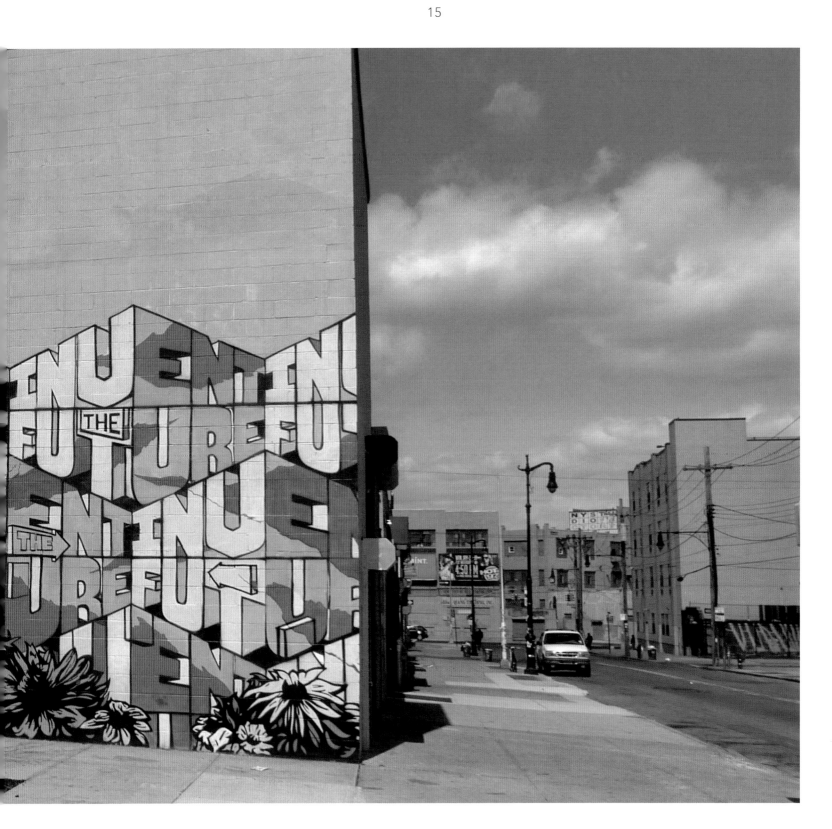

TROUTMAN ST., BUSHWICK, BROOKLYN WITH BILLY MODE

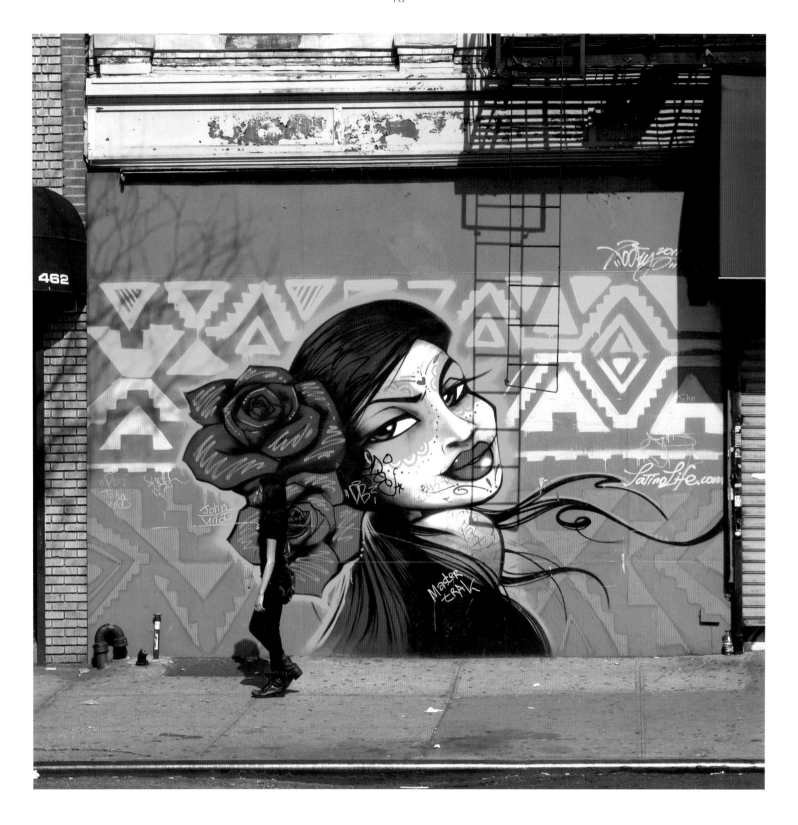

UNION AVE., WILLIAMSBURG, BROOKLYN

TOOFLY

TOOFLY SPEAKS…

ON STREET ART
"Art on the street is an opportunity to share our creative works publicly, either legally or illegally. Current street works show us that people are a lot more open minded these days and willing to allow all kinds of artists to paint, paste, and install personal ideas. It was not so easy back in the old days. We slowly showed people the beauty behind what we do and now they can't get enough of it."

ON PERSONAL ART
"I wanted to tag on the walls with the rest of the guys in my neighborhood back in the early 90's. When you're a teenager you are free and rebellious, which makes for the perfect time to focus in on the true expression of your spirit. I enjoyed graffiti, but preferred to paint figurative works. I've been focused for over 20 years on making paintings that allow me to express my personal feelings as well as the cultures of hip-hop and graffiti. I like to highlight strong women figures in my work. I enjoy painting women in various emotions, poses, and attitudes. I feel it is important for me to represent the feminine energy in order to bring balance, empowerment, and respect to women and girls.

I have had a studio of some sort since high school; a room dedicated to quiet mornings and evenings, drawing, and painting. The difference between working in my studio or on the street is the scale and accessibility. Outdoors I can instantaneously paint and communicate with the public."

ON NYC
"Street Art in NYC comes from a respected lineage of graffiti pioneers who took to the streets to express the ills of living in a raw, urban concrete jungle. These artists are mostly made up of young creative people who roamed the streets at night writing messages to proclaim their existence. We came from a time when we had 'less' and as a result we were able to originate and pioneer what many now enjoy. New York City set it off for the rest of the world. My favorite borough will always be Queens, because that is where I grew up. It's where I strolled the streets listening to mixed tapes of my favorite tunes, from Wu-tang to Mary J Blige.

I can recall one day when I was young, my mom agreed to drive me a few blocks away to Lefrak City in the middle of the night so I could catch a bunch of tags on the dark alleys. She was my lookout and the one who carried my paint as we snuck into Manhattan

buildings across from my high school. When Lee painted 'MOM' pieces on trains in the 80's I knew that there was a bigger reason why we did what we did; it was not just to 'get up'. As he quoted, we are the 'voice of the ghetto'. We have the power to spread our ideas throughout the city and keep the artistic spirit alive."

ON THE FUTURE
"Our goal has always been to keep what we did alive because it seemed at one point the city wanted to clean and buff it all. The corporate America take-over snuck into our neighborhoods and what was left to do was rebel in a much more creative, 'safe' way. So with little brush and stencil artists it was less likely the cops would bag you. The less 'graffiti' looking art on the streets made it easier for the common people to accept. So today, graffiti tags, letter pieces, characters, etc. live among pictures, shapes and installations - sharing space, surviving and evolving into the crazy street art world explosion everyone wants to have in their cities. I believe it will continue for years to come. It's a lot more interesting to look at than a blank wall!"

ON YOUR PROCESS AND INFLUENCES
"Pencil and paper is where it all starts for me. Once I get to a wall the cans and caps get me flowing; I start from sketching on a wall and filling it in with colors of my choice. Then I slice and cut into the line work and add blends and design elements as I move along the piece. It's like creating music, I suppose. If I am in my studio I can rock acrylic, collage and spray paint on canvas or wood. I like acrylic paint because it dries fast and I work fast. I like adding texture and ripped up elements in the work to build up layers. I use spray paint to accent and create markings that give the feel of my graffiti roots.

I grew up looking at comic books a lot. I enjoyed the graphic and slick line work of artists like Jim Lee and Scott Campbell. I was also drawn to the fine art of Franz Kline and Robert Rauschenberg during art history classes. I liked the large graphic mark paintings by Franz because they reminded me of abstract graffiti tag marks. I liked Robert Rauschenberg for his deconstructed use of found objects in his work. They reminded me of construction sites or garbage dumps I passed by on the street. Most of all, I liked the graffiti bombers from the 90's who inspired me to do hand-style marker letterings and street bombs. Fill-ins and tags covering various surfaces became layers on which to juxtapose my female characters, embedding them with everything I loved about city streets."

"I ENJOY PAINTING WOMEN IN VARIOUS EMOTIONS, POSES, AND ATTITUDES. I FEEL IT IS IMPORTANT FOR ME TO REPRESENT THE FEMININE ENERGY IN ORDER TO BRING BALANCE, EMPOWERMENT AND RESPECT TO WOMEN AND GIRLS."

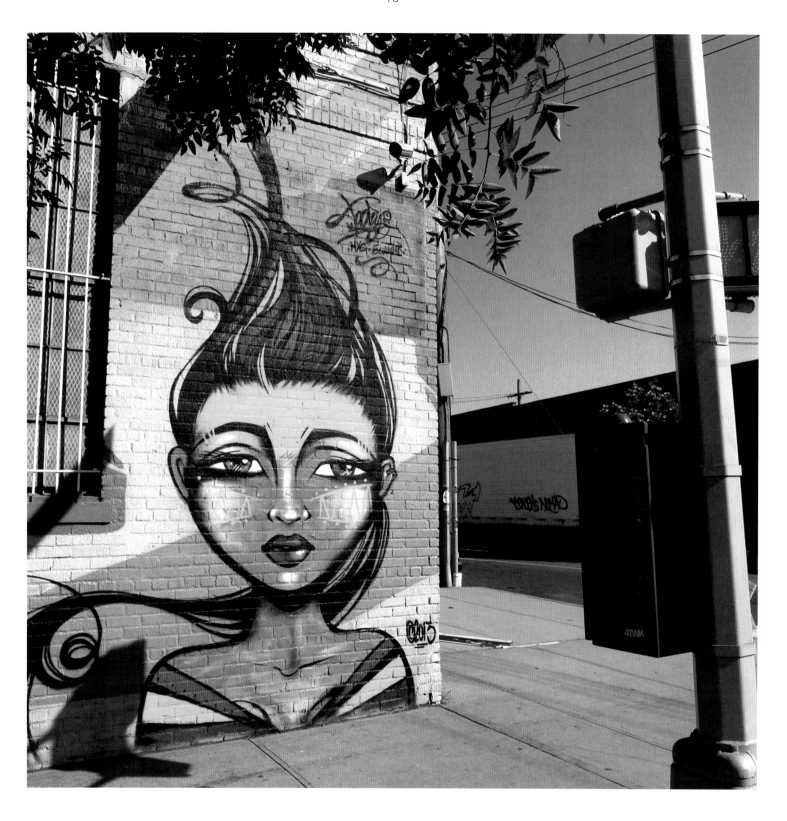

FLUSHING AVE., BUSHWICK, BROOKLYN

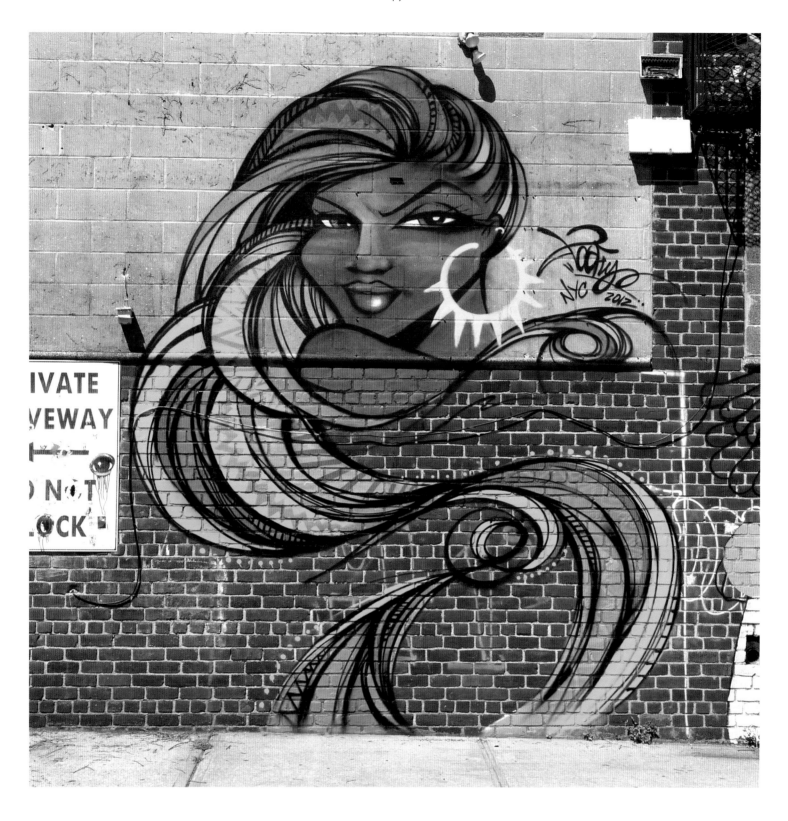

WELLING COURT, ASTORIA, QUEENS

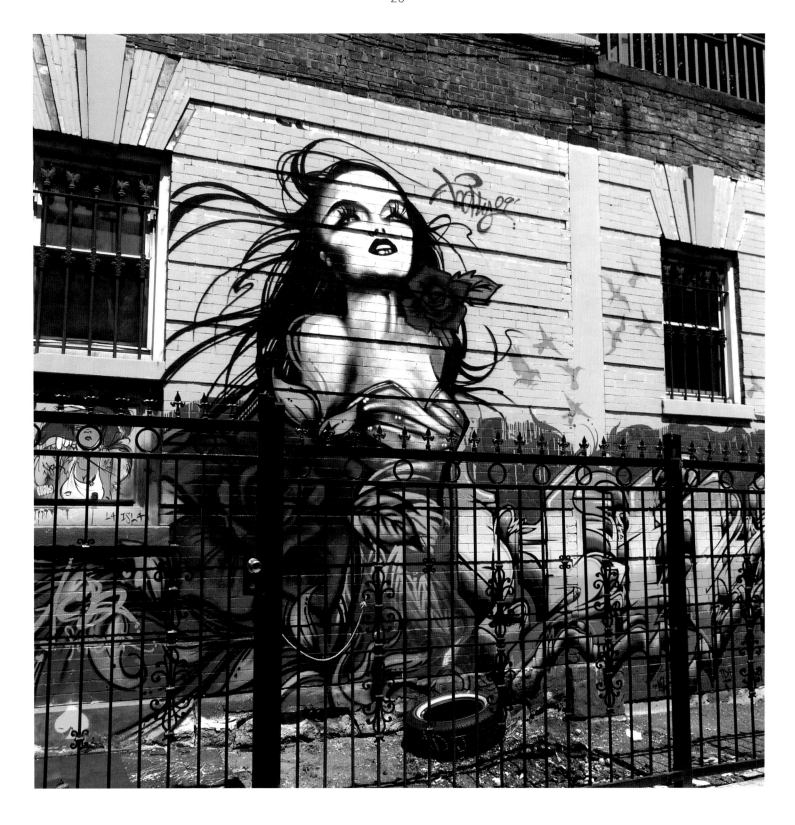

SOUTH 5TH ST., WILLIAMSBURG, BROOKLYN

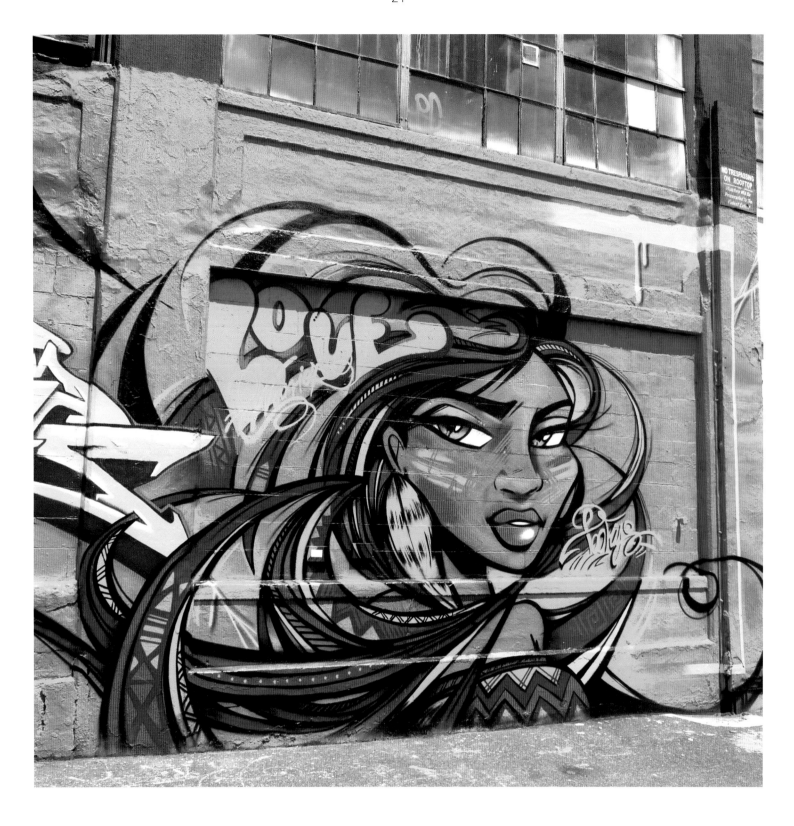

5 POINTZ, LONG ISLAND CITY, QUEENS

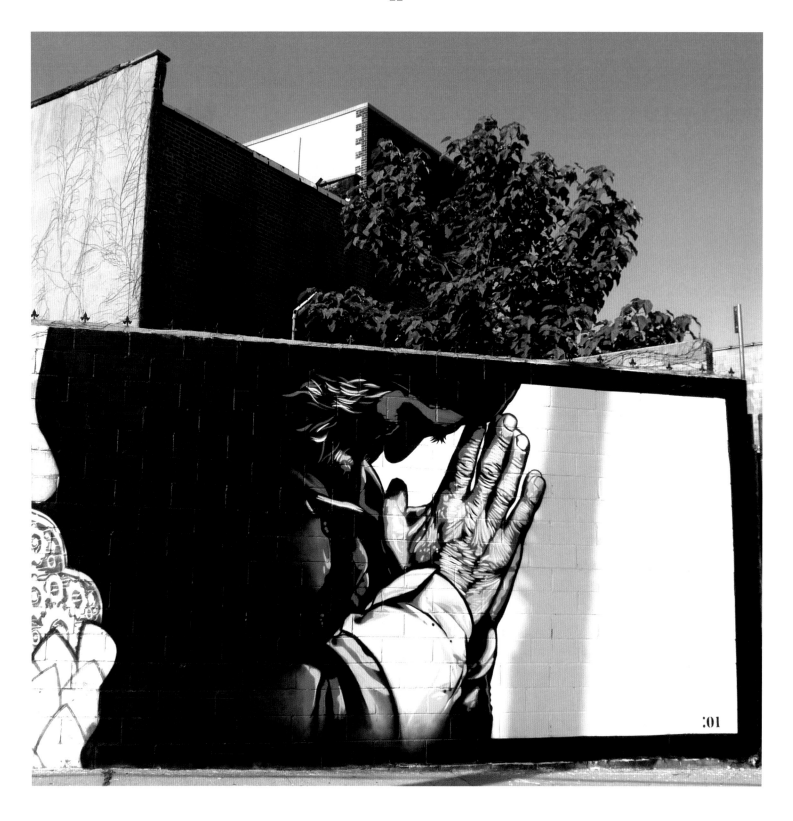

WELLING COURT, ASTORIA, QUEENS

JOE IURATO, :01

:01 represents one second. In times of adversity, it only takes a single second to decide you're going to pick yourself up and move forward in a positive direction, regardless of the circumstances involved. :01 means never give up. Stay the course. Believe in who you are. Embrace the next challenge and begin a new chapter.

JOE IURATO SPEAKS…

ON STREET ART

"People have different motives for creating public works and different ideas as to what they want people to take from it, so I guess significance varies. Collectively, art in any given time period almost always makes more sense when looked back on. It's a way to uncover and identify with the past. I feel this will prove true especially with public art. Regardless of the materials and methods being used, it's the honesty of the statements being made, the stories being told, and the issues being addressed that are creating some sort of time stamp for the world we currently live in. It's relevant now, but I believe even more so tomorrow. It's not so much about the application or technique as it is a bond with the environment and a voice for the times."

ON PERSONAL ART

"I prefer to address things that are important to me: the questions I have, sometimes the confusion or anger I feel, or even the morals I instill in my children. Then there are times when the work's just playful; where it's more about how a piece interacts with its surroundings than it is any particular message.

There was this piece I did on an underpass along the river in New Brunswick, New Jersey. It was a painting of a child praying. I went back a few months later to paint again. Within a few minutes of being there, a homeless man confronted me. He told me he didn't care where I painted or what I was doing there, but if I touched that piece, referring to my painting of the child praying, he'd kill me. He said it belonged to him. Of course, he didn't know I was the one who'd painted it and that I had no intentions of buffing it. He was protecting it and that gave me such an incredibly rewarding feeling. It was really the first time I witnessed the power a piece of my own art in the street can have."

ON NYC

"Probably the most realistic answer to why I work in New York City is because I live in Jersey, a stone's throw from the greatest city on the planet. So I spend a lot of time there. For me, the inspirations and possibilities to be found within New York City are limitless. Art in the streets is a defining part of the City's culture, a big piece of its fabric, and to be able to contribute to that in some small way, even if briefly, is really an honor."

ON YOUR PROCESS

"I've been getting into a few different methods and mediums lately. The process for each is quite different from the others, but the stencils almost always begin with a photograph. I try to shoot my own images, though there are times I'll work with a photographer. Once I have the image that I want to translate as a stencil, I turn it black and white and print it out a number of times, depending on how many layers I envision the stencil being. These days I've been sticking between 3 and 5 layers at the most – so I'll print it out maybe 5 times. Since I'm not using a computer program to separate the tones, I will often make markings and draw on the photos. In this way I give myself some kind of idea how I want to cut each layer, keeping in mind I usually build dark to light. It's probably not the most efficient way of doing things, but I enjoy figuring it out, the looseness of the finished cuts and the imperfections they bring. It's also meditative for me and I often describe it as drawing with a knife. When the layers are cut, they get sprayed in order- one at a time- until the image is built. For my smaller works, the process for the stencil ends there. For my larger works, I usually shoot a photo of the completed smaller piece, which now has basically become my study. I'll project the photo onto my studio wall to the desired size, tile a bunch of oil board to create the new large scale layers, tape them up, and redraw the piece. Then it's a matter of re-cutting and bringing it outside to be painted. The large pieces are very time consuming. I can spend an entire night just tiling the paper together, usually pull an all nighter redrawing, and then days of sitting on the floor and cutting away. I've also gone the route of having commissioned mural pieces cut by CNC machine, as opposed to projecting if my studio walls can't handle the size, or if time is of the essence. It's nice to get that monster all cut and ready to go, but it's costly and not something I can do very often. I'm happy either way, as long as I get it done."

"REGARDLESS OF THE MATERIALS AND METHODS BEING USED, IT'S THE HONESTY OF THE STATEMENTS BEING MADE, THE STORIES BEING TOLD, AND THE ISSUES BEING ADDRESSED THAT ARE CREATING SOME SORT OF TIME STAMP FOR THE WORLD WE CURRENTLY LIVE IN."

SCOTT AVE., BUSHWICK, BROOKLYN

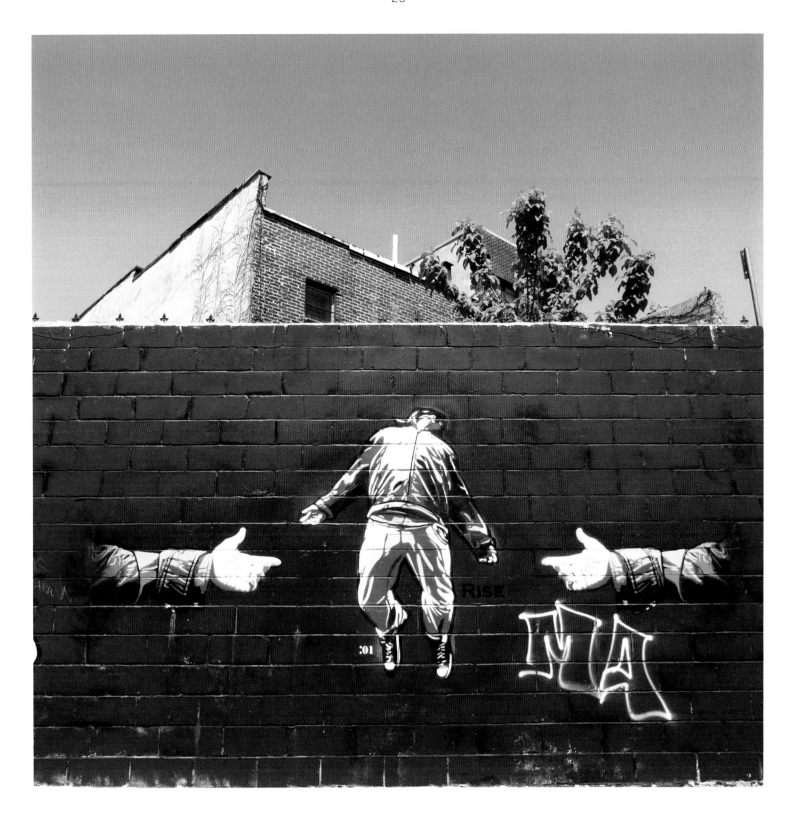

WELLING COURT, ASTORIA, QUEENS

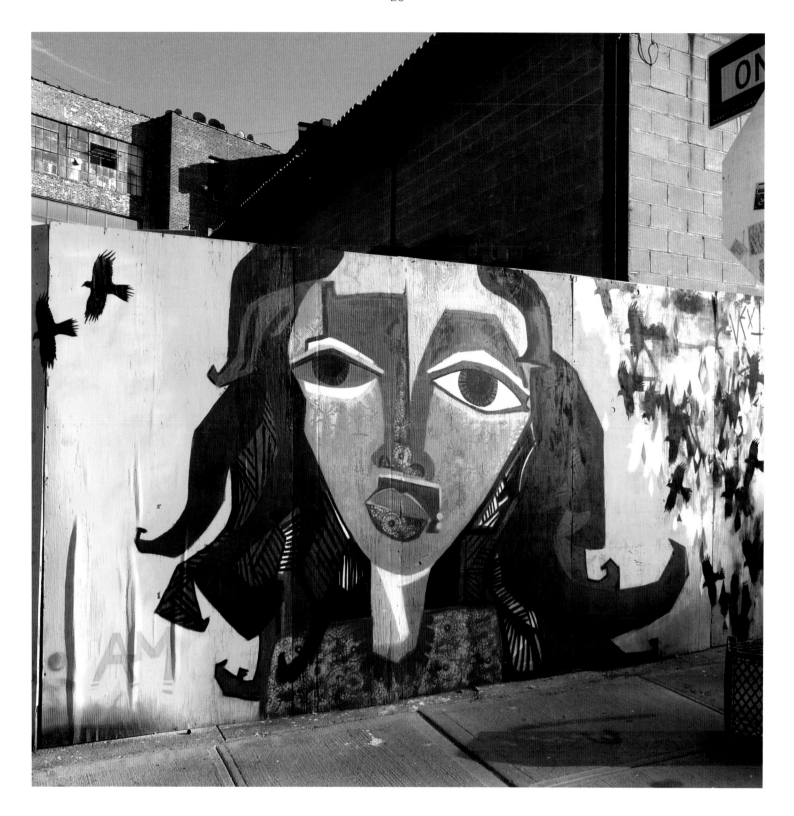

GRATTAN ST., BUSHWICK, BROOKLYN

ALICE MIZRACHI

Alice Mizrachi is a painter and teaching artist in New York. Through painting, murals, printmaking and installations, Alice creates figurative work that depicts characters whose relationships and emotions reflect her perspective of the social environment. Alice seeks to spread empathy and compassion through site-specific projects that are positive visual responses to social issues that affect neighboring residents.

In her roles as artist and teacher, Alice explores art as a path for communities and individuals to heal through creative expression. She works to empower and inspire women and girls by elevating females to sacred archetypes in her art. And as a teaching artist, Alice extends her personal commitment to art as a tool for healing through hands-on creative projects that help others express their ideas about topics such as environmentalism, identity and community.

Alice co-founded YOUNITY in 2006, a women's art collective that has provided a professional platform for hundreds of women in the arts through exhibitions, panel discussions, mural productions, and youth workshops. Alice's artwork has been exhibited at Washington DC's Museum of Contemporary Art and at The National Women's Museum.

ALICE MIZRACHI SPEAKS...

ON STREET ART

"Art on the streets is significant to me because it makes art accessible to everyone regardless of age, language, level of education, nationality or any other so-called category. I make art for public spaces so anyone can experience my message and images, not just those who actively pursue art by going to galleries and museums. Like many people whose families migrated to New York City, I felt somewhat disconnected from the culture at first, and certainly from institutions that exhibited art. But in Queens, where I grew up, I was exposed to art on the streets at a young age. I enjoyed the messages, symbols and images I saw around me and they made local streets and landmarks more meaningful. Today I love visiting museums and galleries, but I still look for the codes and symbols written and painted on the streets, even and especially when I travel. Art on the streets exists everywhere and excludes no one. Creating art

on the streets is most gratifying when I imagine a child who feels disconnected like I once did, seeing something I've made and then feeling a little more connected to the community."

ON PERSONAL ART

"My brother exposed me to hip-hop culture, graffiti, breaking and beat-making when I was 8-years-old. I'd always loved art, especially painting and sculpture, but as I became a teenager and studied the work of New York City artists who were active in the 1980s, such as Basquiat, I became more interested in what my brother and his friends were into. At some point my interests converged naturally. I reconnected with some childhood friends after college who were part of YMI crew and started spraying. After that, my studio art and public art merged into a unified aesthetic. But regardless of whether it's indoors or outdoors, I consider all of my art personal. It is my story, my commentary, my influences, my ideas, thoughts, desires and exploration of self."

ON NYC

"I was born and raised in Queens, so New York is home for me, and of course where and how you are raised influences your development. I tell my story with the images I paint, and the city has deeply inspired my process as an artist—the buildings, the hustle, the art, the ever-changing lifestyle and culture. It is part of my art. The mark I leave behind is emotional and expressive in nature. I like connecting to people emotionally so that my work becomes a personal experience, shared universally—something that can be felt no matter where you live. For instance, I often sit and watch people in NYC and witness the human exchanges that feel relevant to my story. Then I will paint figures against a backdrop of towering huge buildings that are strong and solid, yet textured and gritty; I place the strength of the surroundings in the people I paint. They are tall and proud and have something to say, a purpose greater than themselves, even if they are slumped or down in that moment.

Two years ago I was painting for The Welling Court Mural Project in Queens. I'd been invited for a third consecutive year, so many young girls in the community knew me. I spent time with them each year and they became inspired and looked forward to my return. One of the girls came up to me with a big drawing she created of my mural and asked me to sign it. I was so touched

"THE MARK THAT I LEAVE BEHIND IS OFTEN EMOTIONAL AND EXPRESSIVE IN NATURE. I LIKE TO CONNECT TO PEOPLE EMOTIONALLY SO MY WORK BECOMES UNIVERSAL; NO MATTER WHERE YOU ARE LOCATED YOU CAN FEEL IT."

by her ambition, confidence and curiosity. This is the kind of connection with community that continues to inspire me and push me forward. I like to inspire youth and give them a positive role model so they in turn can one day inspire others. One of my lifelong missions is to pass knowledge about the arts onto youth."

ON THE FUTURE

"Based on conversations I've had with friends who are older graffiti writers, I know that the beginning of the culture was a great struggle, and I respect my elders for paving the way for artists today. Street art and graffiti culture have come a long way during my lifetime, and I have great respect for the giants whose shoulders we stand on. I enjoy witnessing this culture and participating in its evolution by creating space for innovative ideas that will in turn influence future artists. For my part, I share my story in the hope that this will inspire others to tell theirs; these stories form links in a chain that connects us all."

ON YOUR PROCESS AND INFLUENCES

"I love printmaking, collage, spray paint, stencils, wheatpastes and stickers. I am an artist who likes to grow and evolve, so I stay busy with exploration of materials that will keep me curious and keep my artistic practice fresh. Currently I'm enjoying installation work with painting on found objects, often from city streets. In this way my paintings become part of a somewhat sculptural installation experience.

Some of my art influences are Hannah Hoch, Klimt, Basquiat, Picasso and Louise Bourgeois. And of course I am simply amazed by what my some of my friends and peers are doing today with their art."

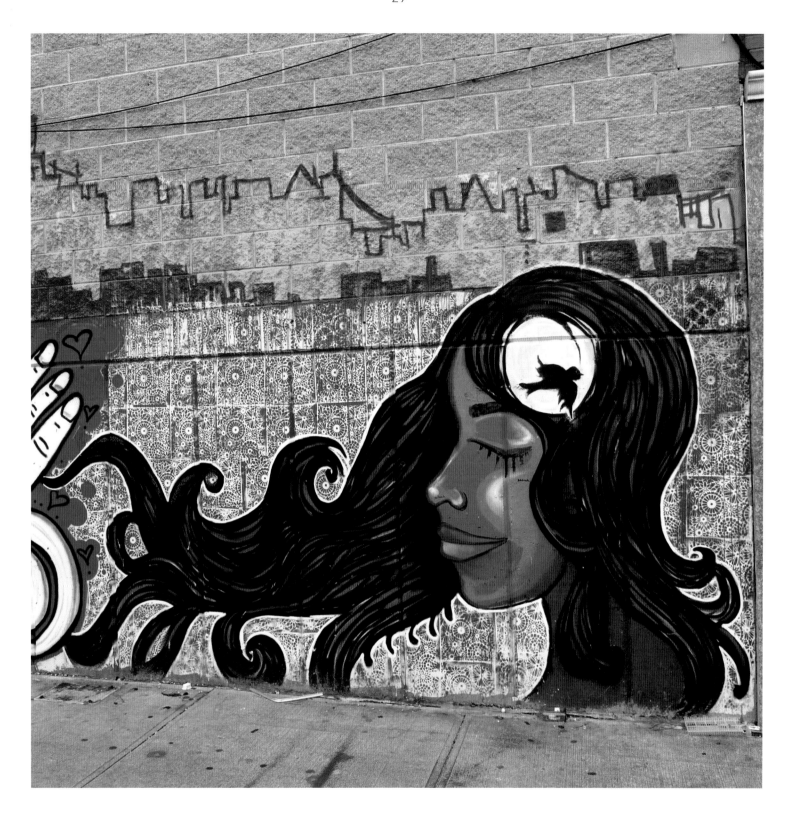

LINDEN ST., BUSHWICK, BROOKLYN

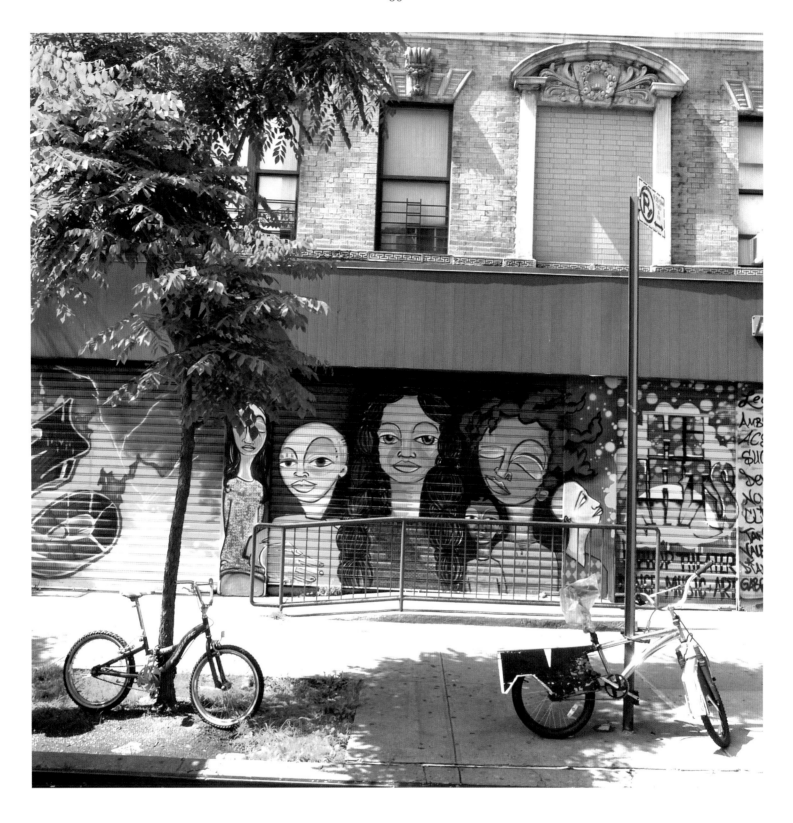

101 ST., MANHATTAN

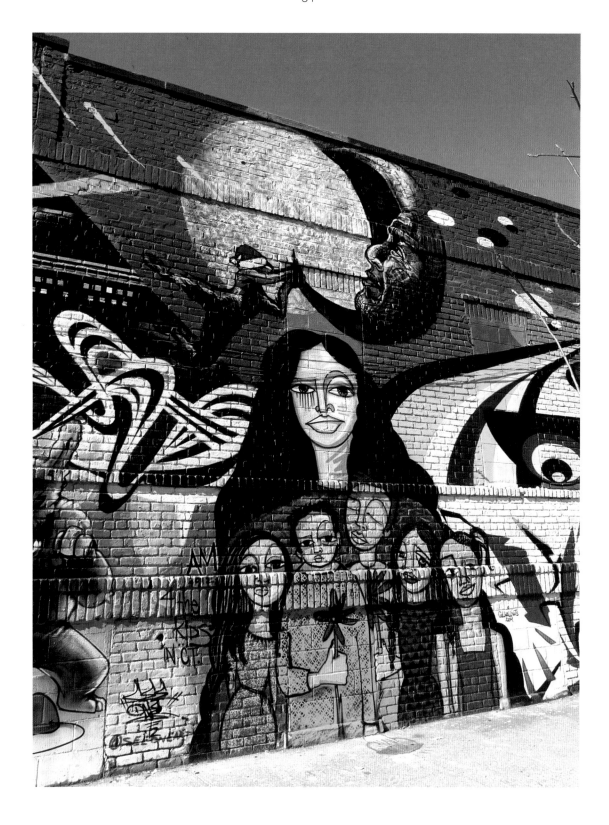

TROUTMAN ST., BUSHWICK, BROOKLYN WITH LUNARNEWYEAR, JOE IURATO AND GILF!

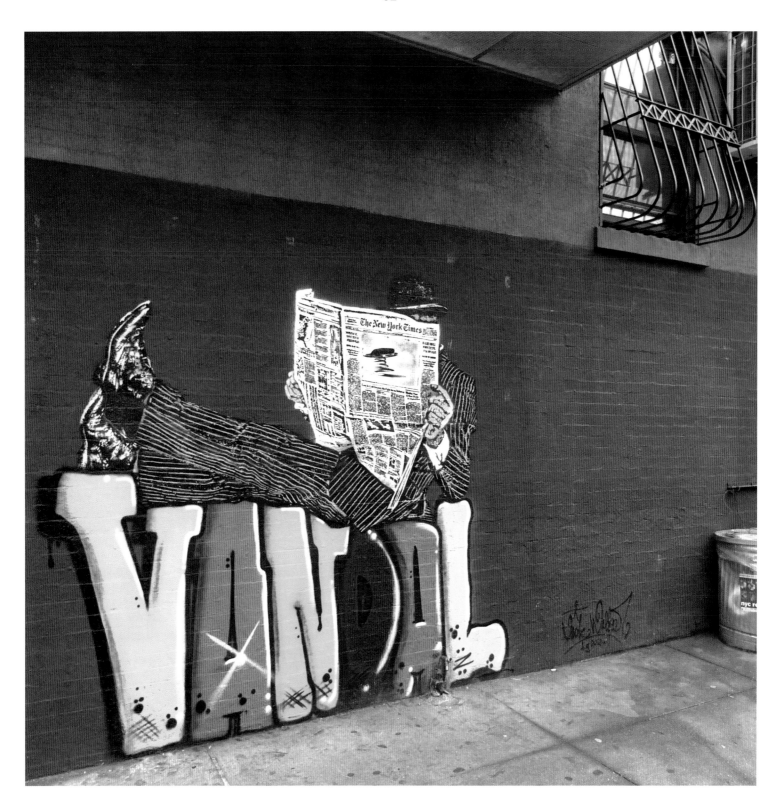

ELDRIDGE ST., MANHATTAN

NICK WALKER

Born in 1969, Nick Walker emerged from the infamous and groundbreaking Bristol graffiti scene of the early 1980's. Nick draws on the energy and imagery of graffiti but he succeeds in combining the freedom the spray can brings with very controlled and intricate stencilling. The methods he uses retain their forcefulness and integrity on the traditional medium of canvas.

NICK WALKER SPEAKS…

ON STREET ART

"Street art is for the masses; it's for people to enjoy, plain and simple, art with no fee. The current forms are just a product of our environment like it was to begin with, nothing has changed; it's still about individuals who want to shout just as loud as the advertisers and advertisements that we are bombarded with every day of our lives. Street art and those who practice it will often comment on what's happening around them and be inspired by cartoons and other popular culture at any given time in any given or non given place. Street art is the most current and contemporary art form there is."

ON PERSONAL ART

"I was always into art as a kid. I always loved the mad graphics and logos on cereal boxes and used to copy the poster art on the video covers. When 'Wild Style' and later 'Subway Art' got released it was like all the rules suddenly changed and a completely different stage was set out in front of me. I was obviously very influenced by the American artists around at that time but around the 90's my style came into its own and I've been trying to add and twist it up ever since.

I also work in the studio but I like to keep an equal balance with studio and street-based work. In fact, I get more enthusiastic about creating pieces for the street these days. When I decide on a particular image it's generally two things I encroach on; first, some ridiculous stuff that makes me laugh and second, a little bit of social commentary from time to time."

ON NYC

"It's the best city in the entire world. You would have to be mad not to want to spend as much time as you could here or even end your days here. It's where the whole graffiti and hip-hop scene started. This city makes anyone feel alive.

I see a new generation or wave of writers that are trying to hit harder than the last few years. I also think that the street artists these days tend to paint or paste up whatever is going on in their head at the time! I like the Lower East Side and Chinatown. There's a lot going on there and less gentrification, it still seems like old New York.

I remember one time we were painting in Brooklyn around 2011 and I'd just finished a painting of a man holding a snake wearing a lab coat and a bowler hat. Whilst packing up I jokingly said 'all we need now is a person with a snake to walk past', so we could get the perfect photograph. We head off up the street and get to Metropolitan and Roebling and there's some kid there holding the exact same snake I just painted! The maddest stuff happens in this city. It's the city of serendipity without a doubt. That was also the first time I held a snake; time and a place for everything I guess!"

ON THE FUTURE

"I'm currently working on some new projects in New York City and also new material for a show later in the year. It's time to release a bunch of concepts that have been running around in my head for a while now.

The future will have new artists bringing whatever they have to the table each year and the genre will keep reinventing itself. As long as artists realize that if they call themselves street artists they do actually have to have a presence on the street and not just produce work for a gallery because that shit is just lame. If artists stay true to their craft the streets will be an interesting and vibrant place. I'll definitely keep my foot in when and wherever I can."

ON YOUR PROCESS

"Learning freehand graffiti styles is purely about picking up a can and playing with it until you can get your head round the pressure of the can and what pressure to put down on the nozzle. When it comes to stencils, I began by sticking an image on three pieces of paper because the consistency of the paper and glue made it good to cut with. Now I use a stencil card as it's stronger and I work a lot bigger than when I first started. One word of advise would be to find one of those print out shops that does the architectural plan large format prints because it will save you a whole load of time and the need for stitching your image together."

"THE CURRENT FORMS ARE JUST A PRODUCT OF OUR ENVIRONMENT LIKE IT WAS TO BEGIN WITH, NOTHING HAS CHANGED; IT'S STILL ABOUT INDIVIDUALS WHO WANT TO SHOUT JUST AS LOUD AS THE ADVERTISERS AND ADVERTISEMENTS THAT WE ARE BOMBARDED WITH EVERY DAY OF OUR LIVES."

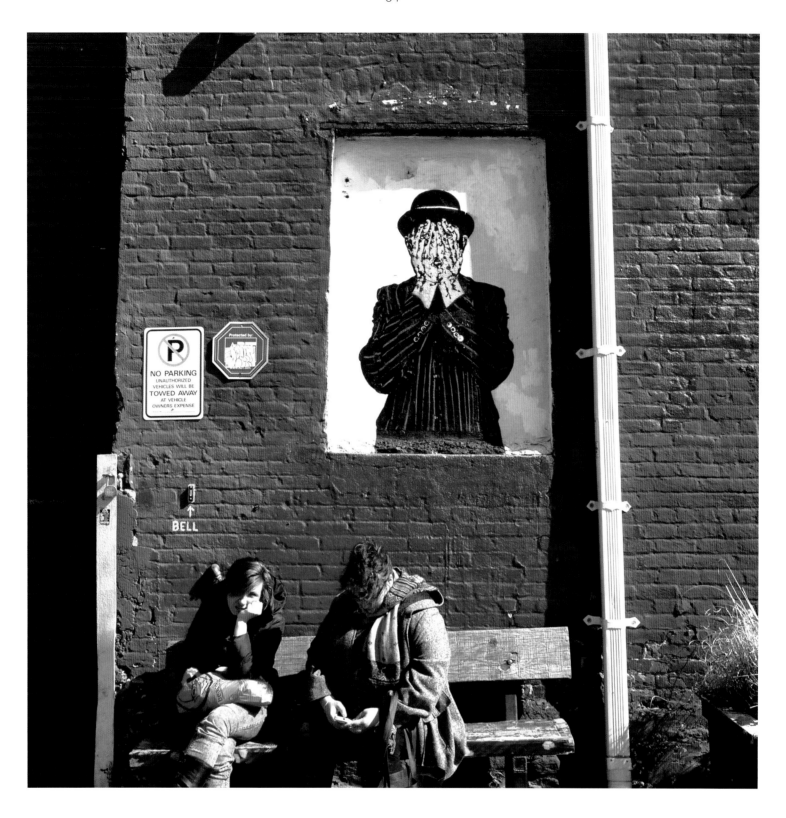

WYTHE AVE., WILLIAMSBURG, BROOKLYN

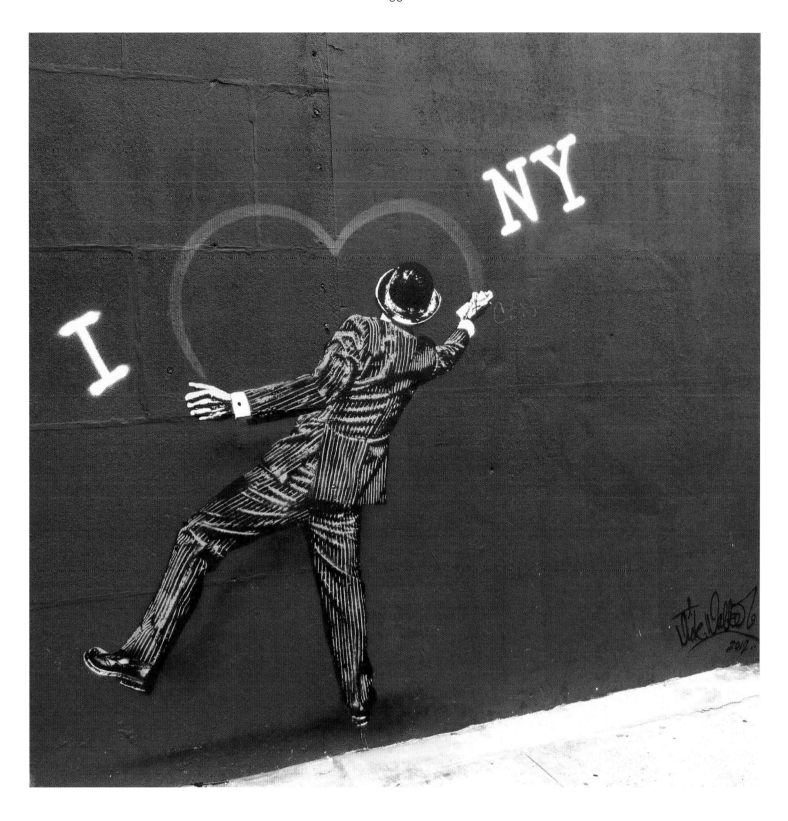

LUDLOW ST., MANHATTAN

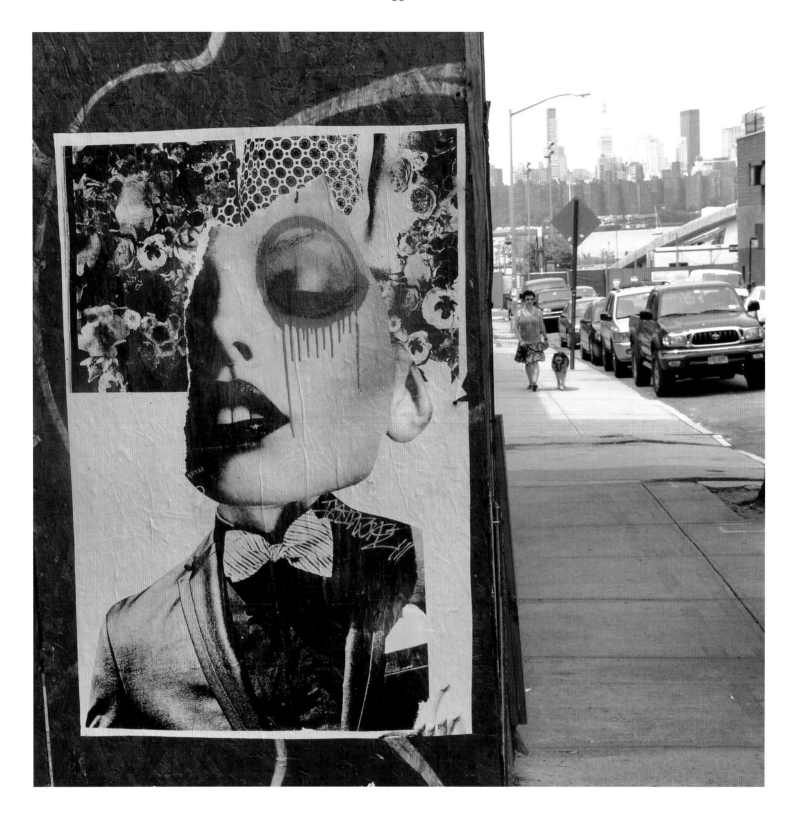

WYTHE AVE., WILLIAMSBURG, BROOKLYN

DAIN

DAIN SPEAKS…

ON STREET ART

"I just find art on the streets to be so unexpected. It constantly changes and evolves with time and weather."

ON PERSONAL ART

"I started messing around with graffiti when I was 8-years-old; it was something my friends and I did for years. I really love bringing the work into the studio and gallery."

ON NYC

"I like working in New York City because it is the only city I have ever lived in. There really is no other place like it. Growing up in Brooklyn has taught me a lot about people, art, culture etc. Each neighborhood has something to offer if you look for it."

ON THE FUTURE

"I think we will see more street art in fashion as well as in museums and galleries."

ON YOUR PROCESS

"My work is mostly collage, silkscreen, found house paint and old posters found on the streets. I still use a lot of spray paint and graffiti in what I do."

"I STARTED MESSING AROUND WITH GRAFFITI WHEN I WAS 8-YEARS-OLD."

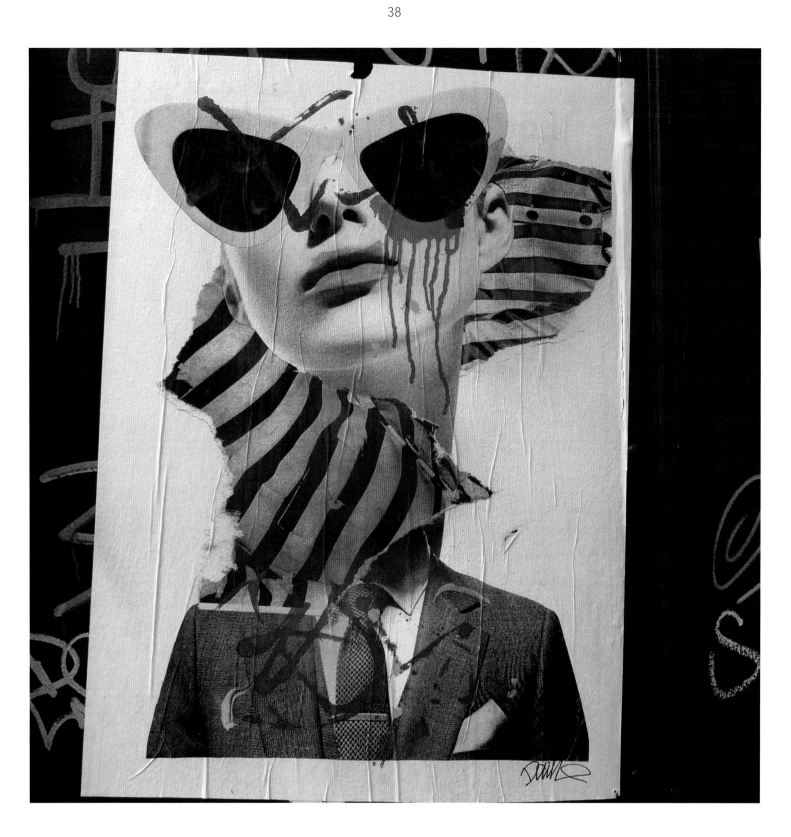

NORTH 6TH ST., WILLIAMSBURG, BROOKLYN

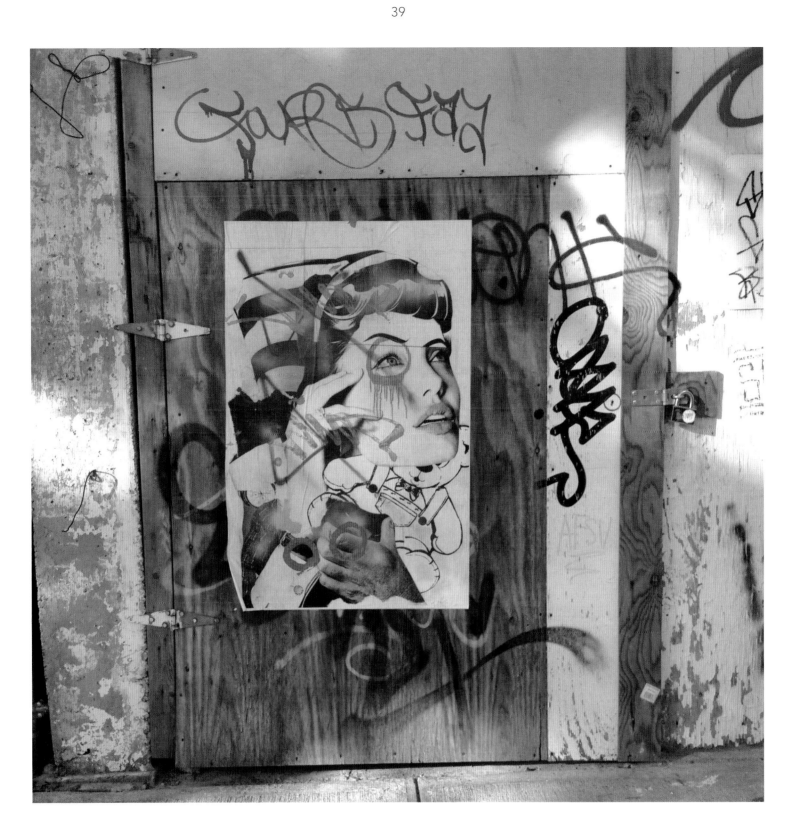

NORTH 8TH ST., WILLIAMSBURG, BROOKLYN

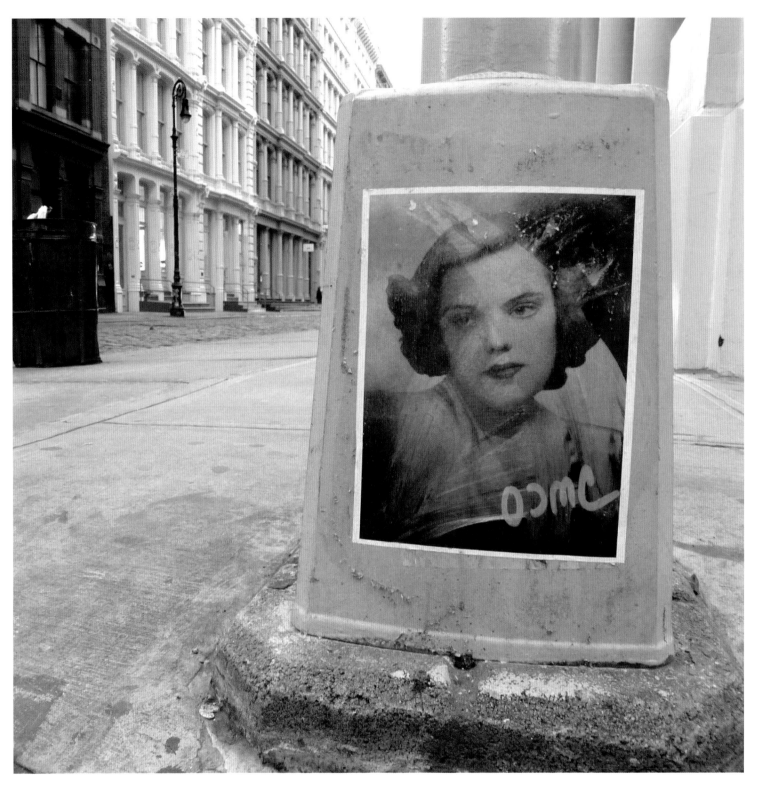

PHOTO COURTESY OF OCMC

SPRING ST., MANHATTAN

OCMC

OCMC SPEAKS…

ON STREET ART

"I always think of something Marc Schiller of Wooster Collective once said. He described the formation of kids tagging as 'life affirming' for those kids. It was a way of saying, 'I'm here and I exist'. I find that to be very profound. I suppose anyone familiar with what I do can interpret me as stating 'I was here, I existed' as well. Living in New York City we are constantly bombarded with advertising at every turn. Almost everything displayed here is for the sole purpose of selling you something. In contrast, most art in the street is not trying to sell you anything. In what can sometimes be a hostile landscape for our senses, street art can serve to simplify and beautify the environment we come across.

Now more than ever people want to express themselves, they want to say something. Look around: Facebook, Twitter, Instagram etc. Some people may not be able to convey what they want to say in a status update, or in words, they may need to do it more artistically, and their forum is the very public itself."

ON PERSONAL ART

"I was always artistic as a kid, drawing all the time. I was very attracted to film and music and have been involved in it later in life to some degree. I am a skateboarder and the skate community is very artistic and that exposure was my gateway. I was involved in a bad accident, where I lost memory. While recuperating, the time I would have spent skating was replaced by some walks around galleries in the city taking in pop art. I just felt 'I want to do that'; it's how I get into most things. I don't know how to do something but once I think 'I want to do that', that's really all it takes… I'll figure out how to as I go along. I always loved Andy Warhol. It's a long story, but I wound up learning how to silkscreen from one of Andy's silk screeners. One of the earliest things I made was the painting of **my grandmother** that many know on the street as me. I was aware of street art. I remember seeing Shepard Fairey in the mid 90's around SoHo and Faile in the early 2000's around Canal Street, but I never thought I would do it myself. It started as just being about my grandmother. When she died she left a hole in me the size of the universe. I went out one night and pasted prints of her on the path I took from my apartment to my job so I could see her when I walked to and from work each day. Then it grew to paths I took around town. Now she has been to Paris, Germany, Spain, Poland, Brazil and more. I get to walk down my street and say 'Hey Nan' when I walk by her. I started to do it for some friends as well. It's a fairly

unique experience to walk around a corner and notice 'there's my grandmother, or mother, or father across the street'. That was the beginning for me.

I'm not really sure how my work is interpreted and I have never viewed myself as being a part of a 'movement' at all. In fact, quite the opposite: art is something I do alone, it's personal, and sometimes I will put out work in public where it takes on a life of its own. Some survives, some doesn't; it may impact someone's day, or it may not. I don't try to highlight anything in my work. I try, in some fashion, to convey a feeling or a mood. Whether or not I am successful in that I don't really know, but many people I've never met contact me because my work touched them in some way. That sort of connection is probably all one can ask for."

ON NYC

"There is a lot of visual noise in the city. Artists are finding a place within that noise to either express themselves or to fight it. I see people who have something to say and they may not feel they are being heard. I think I find myself on the side of the fence- the side that is fighting the noise- and I feel my favorite artists out there do the same. I get to see the city in a way that many don't and at times when many aren't around. I get to affect the surroundings and how they may be perceived. I feel very involved in New York City on a unique level."

ON THE FUTURE

"As far as the future of street art, I think you will always have it. That form of expression has really been here forever. Whether we are talking about the 'Kilroy was here' phenomenon during World War II, kids carving or drawing hearts with their initials to show feelings of love, writing your name in cement with a stick when it was poured on the sidewalks, graffiti, or even way back to cave drawings: people have always enjoyed expressing a part of themselves on walls."

ON YOUR PROCESS AND INFLUENCES

"I love the silkscreen process. I find it very relaxing on some level. It's hands-on yet there are huge elements of surprise involved. I also love to spray paint. I love to manipulate images. As far as influences, a surprising amount actually comes from music, memories and moods. Obviously there are visual artists I love and I enjoy giving nods to them here and there. My technique at its most basic, and sometimes at its most difficult, is me putting something of myself into it by any means necessary."

"IN WHAT CAN SOMETIMES BE A HOSTILE LANDSCAPE FOR OUR SENSES, STREET ART CAN SERVE TO SIMPLIFY AND BEAUTIFY THE ENVIRONMENT WE COME ACROSS."

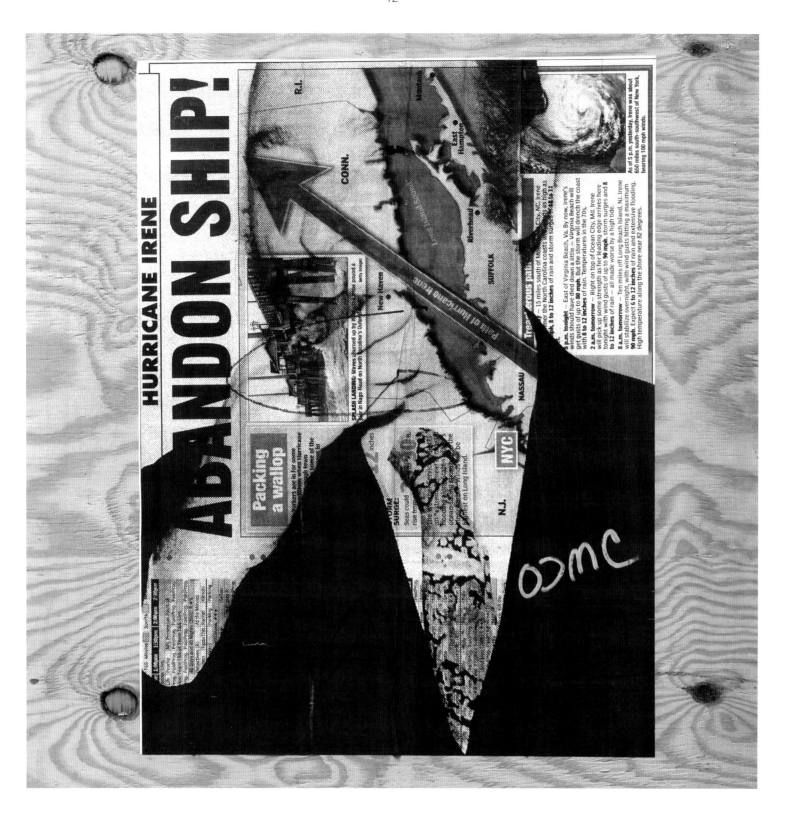

WALKER ST., MANHATTAN

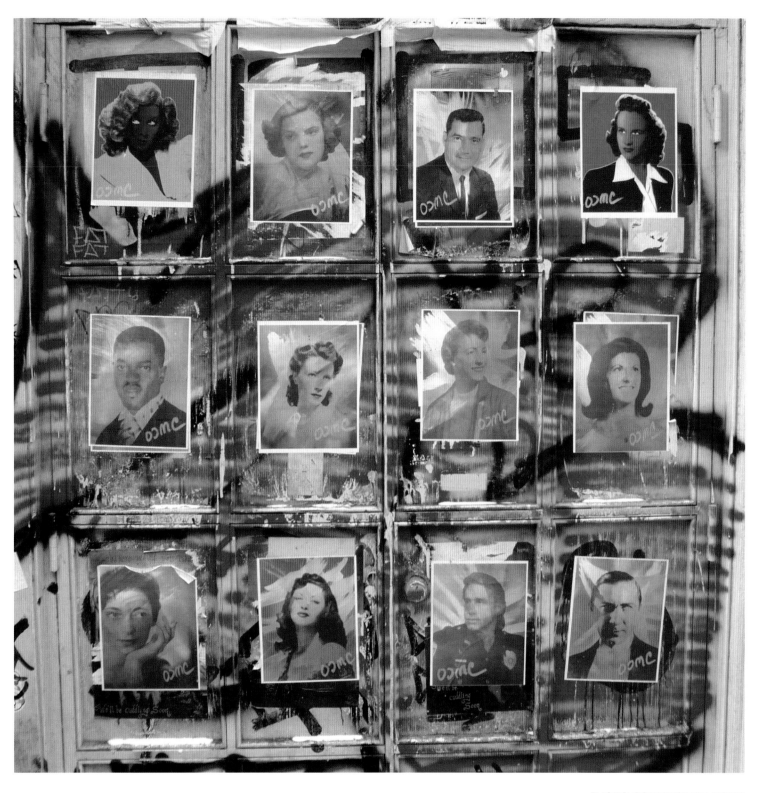

CROSBY ST., MANHATTAN

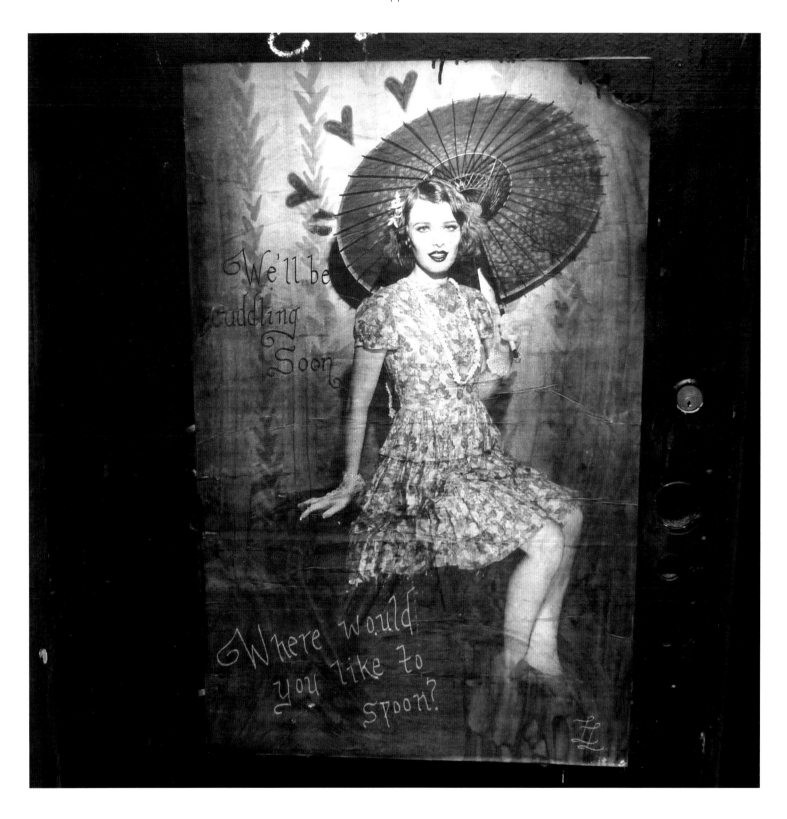

BOWERY AVE., MANHATTAN

LILLIAN LORRAINE

Lillian Lorraine (January 1, 1892 – April 17, 1955) was an American stage and screen actress of the 1910's and 1920's, best known for her beauty and for being perhaps the most famous Ziegfeld Girl in the Broadway revues Ziegfeld Follies during the 1910's.

LILLIAN LORRAINE SPEAKS…

ON STREET ART

"I find it invigorating to share beauty on the streets of New York City. I like allowing others to see half dressed beauties, beckoning you with their seductive and playful entreats, plastered on a tattered wall as you scurry to work in the morning. In the street there is no one telling you the wheres or hows or how muchs, or most importantly the whos - street art is free for thousands of all generations and nationalities to see.

It is important to keep fresh ideas and talent free rather than restrict them by market values, especially with the nauseating practices in the 'art world' these days, and the business and corporate-ness of it all. Having the ability to send your message and imagery out to the public without constraints (other than the risk of getting arrested) is the importance of street art."

ON PERSONAL ART

"Street art for me was more of a stumbling experience. I took some images of two of my darling girls. I had no money to print them properly so I went to Xerox them just to see them. But that wasn't enough. I decided I wanted to see the print on a three-dimensional surface. The girls and I cooked up some flour and water and hit the streets. Two of them were in little dresses, heels, and red lipstick and were my lookouts. From there it grew into an obsession. Sometimes I even dream of the feeling of the warm sticky paste on my hands as I feel the shape of the wall underneath, every mountain and crack. It's like sculpting.

It is important for me to highlight in my work the joy and freedom of being sexual and playful, yet remain beautiful and with dignity. In a world where girls are told beauty involves teetering like storks on heels they can't walk on, with harsh makeup and band-aid-tight dresses, I think it is important to remember sensuality also comes from what is intrinsically feminine; softness."

ON NYC

"My favorite neighborhoods are the Lower East Side and SoHo; the former for its lackadaisical energy and general tolerance of street art, the latter for its foot traffic– so many people stampede through the streets of SoHo daily.

One amusing story I remember involved a fellow street artist who I go out pasting with, OCMC Propaganda. We had been out all night together and came back to finish the eve at the iconic Bowery and Spring building. At first OCMC, being taller, tried to roll our images high up. OCMC slipped on wheatpaste and slid down the wall. My turn; I can do better I thought. I also slipped but OCMC caught me, and then, like some scene from a Marx brothers' movie, we teetered around with me climbing on OCMC's shoulders like an idiotic circus act. I put my feet on a small ledge that was covered in glop and SLIPPPPEEEE both of us ended tumbling on top of each other into a street artist soup. Disgusting.

Another story was when myself and five of my girls (who live the life of indentured lookout servitude), all of us dressed up in ringlets and bows, as if walking out of the posters themselves, got into a borderline street brawl with sprayers in Williamsburg. One guy yelled 'Yo, we fight for these walls!' as one of the girls, eight months pregnant and in red lipstick, seemed to want to punch him in the face. I had to drag her away. The taggers ended up tearing down every poster we put up that night in retaliation. I think they might have even called the police because they were following us at around three in the morning. At one point a cop car pulled alongside me and stopped. I casually walked up to my pregnant girl, rubbed her belly and acted like I hadn't seen her in years. 'How nice it is that you went out for milk, dear, but it is much too late for someone in your condition to be out. Here, let me walk you home.' It worked! I was not so lucky about six months later. My employment of darling models as lookouts ended when a few months ago in Williamsburg (I'll never go back) my girls decided that instead of looking out for undercovers they would sing a horrendous rendition of 'Total Eclipse of the Heart' as I was putting up a five-foot-tall poster. Needless to say, I ended up in Central Booking in Brooklyn for 21 hours and with, yes, ribbons in my hair."

"I LIKE ALLOWING OTHERS TO SEE HALF DRESSED BEAUTIES, BECKONING YOU WITH THEIR SEDUCTIVE AND PLAYFUL ENTREATS, PLASTERED ON A TATTERED WALL AS YOU SCURRY TO WORK IN THE MORNING."

ON THE FUTURE

"I think as the divide between the wealthy and poor continues, street art will flourish and new artists and ideas will continue to come up. For me, I know that I want to continue to share with the public more sweet (mostly naked) ladies that bring smiles to the streets."

ON YOUR PROCESS AND INFLUENCES

"Being a Ziegfeld girl myself a hundred years ago, the photographs of Alfred Cheney Johnson are a great starting point. I take an inspiration, an archaic image or painting; say, for example, nymphs on a swing in the woods. I do not use normal models for my work; I call my girls. All of the women in my photographs are creative, strong forces in the New York City art and culture scene. I believe that photographing strong women is imperative for the right message to be sent. We play dress up, or dress off; I take photographs and shoot video. We dance and laugh. It is the most beautiful part of the process. Then the images are processed; I draw the backgrounds, which include trees, stars and moons. Then the images are Xeroxed and I hand paint every single one with an acrylic wash, mixing every color with gold or silver to make it sparkle in the lights. I mix my own paste of flour, water, cornstarch, and lavender oil. Truly. Walk up to a fresh one and smell it. So delightful."

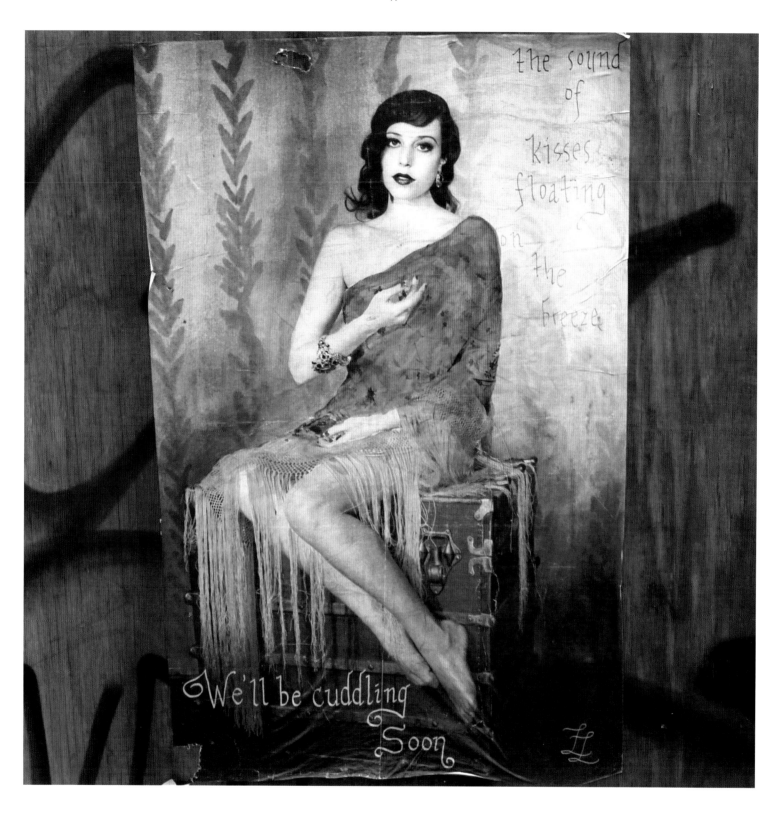

BROOME ST., MANHATTAN

48

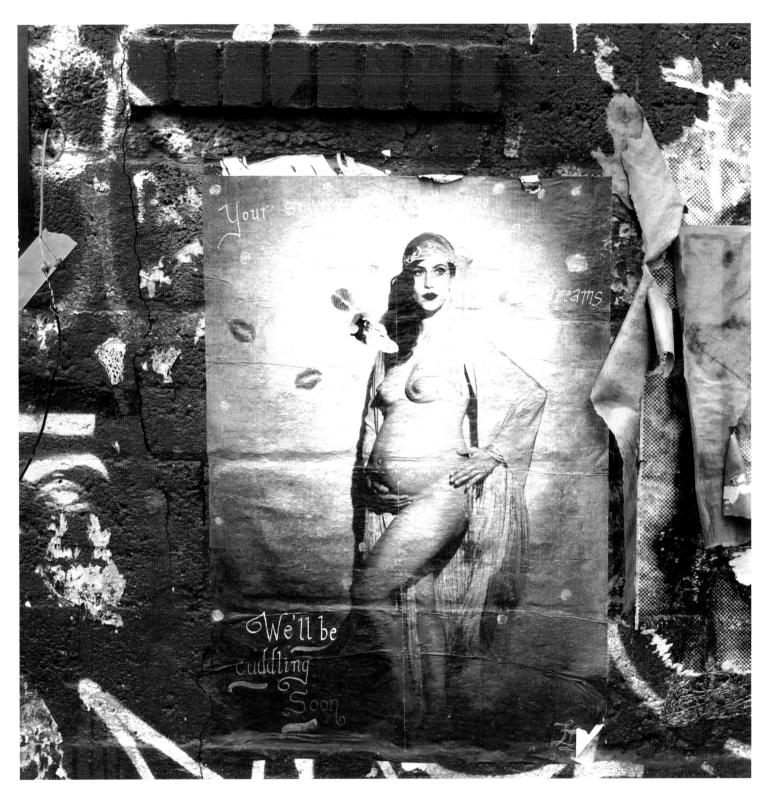

PHOTO COURTESY OF GEORGE HUDES

WYTHE AVE., WILLIAMSBURG, BROOKLYN

LEONARD ST., MANHATTAN

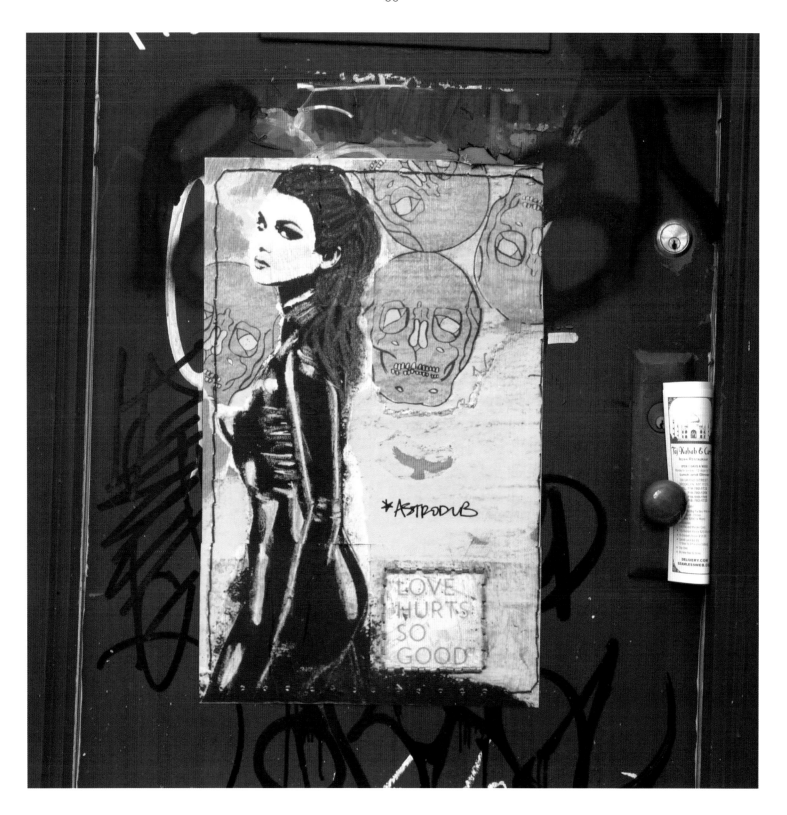

SOUTH 6TH ST., WILLIAMSBURG, BROOKLYN

ASTRODUB / ANGELIKI JACKSON

Astrodub was born and raised on the small isle of Chios, Greece. She immigrated to the United States in 1990 and now lives and works in Queens.

ASTRODUB SPEAKS…

ON STREET ART

"As a struggling artist (perpetually broke), I'd rather stroll the streets of Williamsburg and see some new, fresh, edgy, original art on walls than pay $20 to go see what's mostly 'safe' art at a museum. Our times are characterized by the bad economical situation, which in turn means empty lots, empty storefronts, foreclosed homes and in general, real estate that just remains unattended. That is where the street art and graffiti artists 'go to town', as well as in decayed and abandoned structures."

ON PERSONAL ART

"I can't really identify myself as a street artist. Sure, I have placed reproductions of my art in prominent street art hubs. But at the core, I am a mixed media artist who likes to experiment with different mediums. I started to stencil and wheatpaste publicly because I thought even if no one is buying my art that does not mean it is not worth an audience. If I can't sell it, I might as well share it, right?

My role in the movement started by documenting it. People generally know me as someone who takes photographs of other people's street art and have no idea that I have been creating anything of my own. TMNK compared me to Mr. Brainwash, which really took me aback and made me realize that people don't know jack about me. I find Mr. Brainwash quite amusing, but unlike him, I did not start creating as a result of documenting street art. The documentation of the medium inspired and gave me the boost I needed to make my art seen; art that I have been creating for years and selling for peanuts in flea markets and craft shows.

The femme fatale imagery in my work is meant to motivate and inspire other women to be comfortable within their own skin. It involves digitally distressing imagery of known sex symbols and collaging around them, sometimes adding embroidery and/or found objects to symbolize reinventing oneself with what you already have available to you."

ON NYC

"The majority of street art gets destroyed and written over by other artists/writers (commonly known as haters). Most passersby don't even care if they see you putting something up. Others

may stop and take a picture and a few may hang out. I personally prefer to put my pieces up in Williamsburg, Brooklyn. The pieces get a fair amount of exposure and I find it safer to operate there as opposed to Manhattan. I really like the vibe of the empty streets in the morning when the hipsters are either sleeping, at school or at work. The only people around are the warehouse workers and they don't give two bits if you are wheatpasting or stenciling.

Over the summer, I decided to place my biggest wheatpaste on **Ten Eyk Street in Bushwick**. My 7-year-old was with me and looking out (it's a family affair). I spotted a really nice rusty panel next to a doorway of what looked like a wood shop. While putting the piece up and pasting away, the door kept opening and closing. People were going in and out and saying hello to me as if it was completely natural for me to be there doing what I was doing. My daughter ended up accidentally leaning on the buzzer of the establishment and a person from the window above threw a key out the window to us so that we could open the door and go upstairs. I had just finished putting the piece up and, thinking I was busted, pretended to just be taking a photo."

ON THE FUTURE

"I'd like to see more originality out there. I admire artists like elsol25, QRST and Willow who actually paste original works of art. It's amazing to create something by hand and throw it out in the elements not knowing if it will make it over night. I don't really have any profound statements to make with my art. I simply want to share it with the world and offer passersby something nice to look at on their way to wherever they are going."

ON YOUR PROCESS

"I love working with my hands and I love paper, so naturally collage is at the top of my list. Second would have to be stenciling. I find cutting the stencil quite meditative, stitching and embroidering is also a favorite of mine so I try to incorporate it in my art as much as possible. But this can be quite tedious and there are of course surfaces that it cannot be applied to. As far as my wheatpastes go, it is a bit of a process. Large format color prints can get quite pricey ($40 at Kinko's), so after doing some research I discovered this freeware program called PosteRazor that takes your images and generates segmented, multi-page PDFs out of them. So basically, when you see one of my wheatpastes you see a puzzle that I put together. The biggest one (see above; On NYC) I have ever done (Sweet Little Angel) is 20 pieces. It does take a bit longer to put up, but it's definitely worth it."

"I'D RATHER STROLL THE STREETS OF WILLIAMSBURG AND SEE SOME NEW, FRESH, EDGY, ORIGINAL ART ON WALLS THAN PAY $20 TO GO SEE WHAT'S MOSTLY 'SAFE' ART AT A MUSEUM."

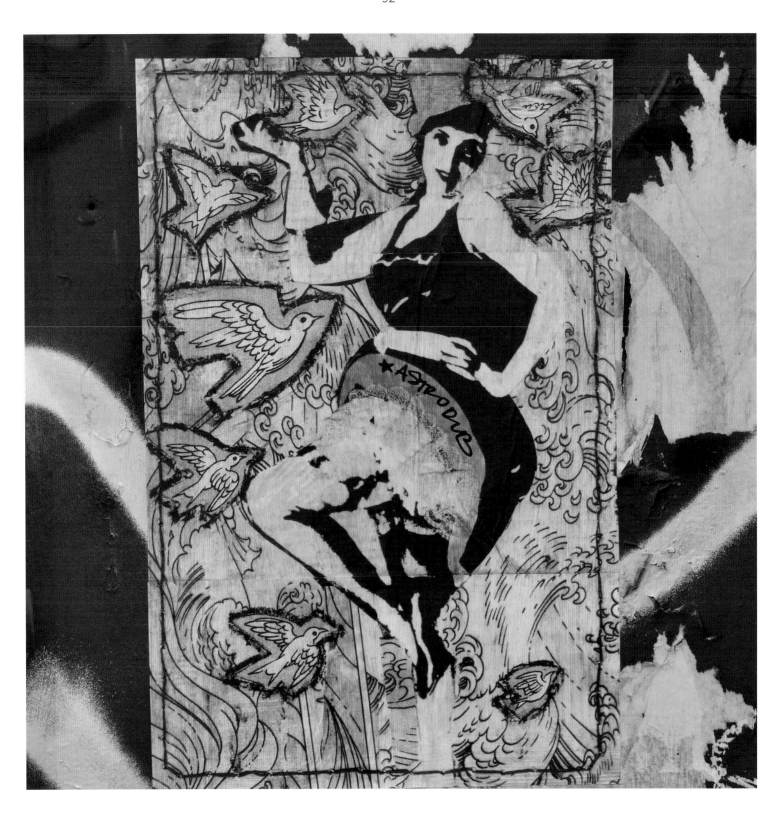

ROEBLING ST., WILLIAMSBURG, BROOKLYN

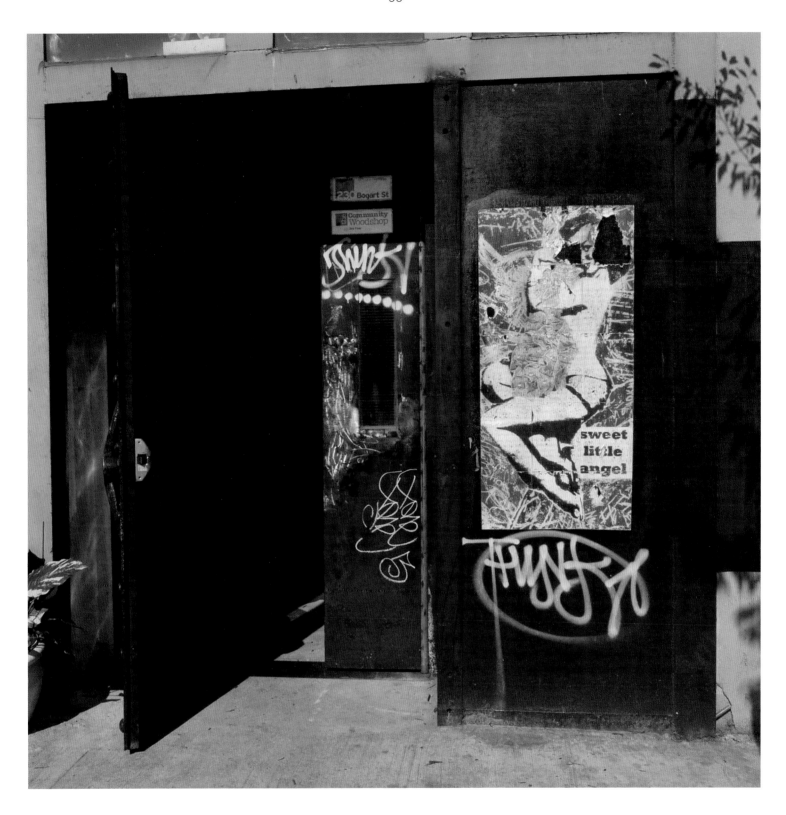

TEN EYCK ST., BUSHWICK, BROOKLYN

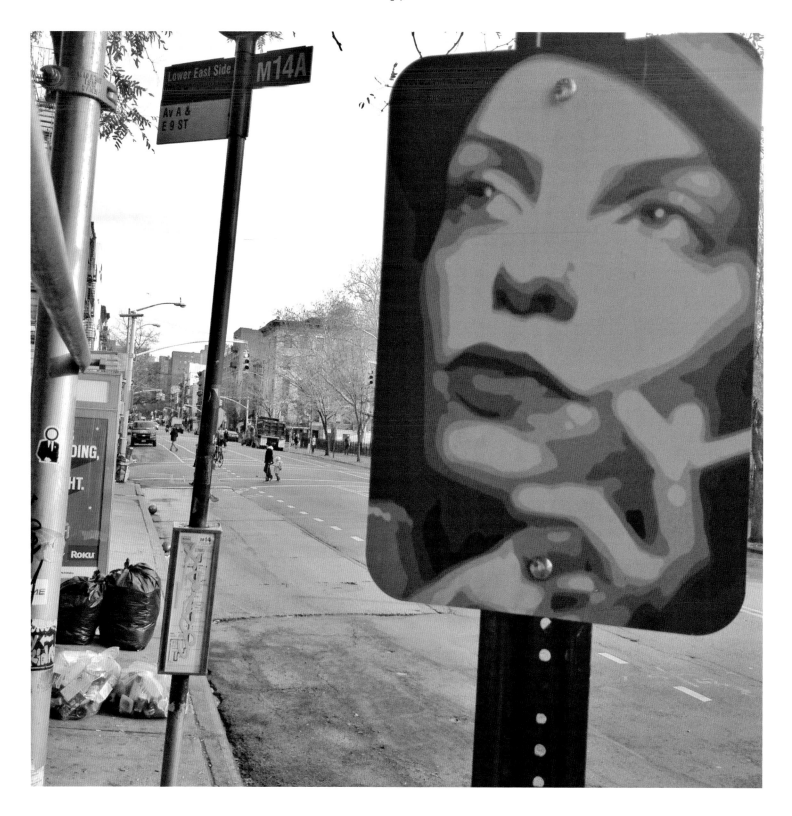

8TH ST., MANHATTAN

RUSSELL KING

RUSSELL KING SPEAKS…

ON STREET ART

"I went to a very structured art school. When I left school I had delusions of showing in a top New York gallery. It wasn't long before I realized I could not play the gallery game: the fakeness, the ass kissing, the popularity contests and trying hard to be as cool or as quirky as possible. I could not be just boring me. A friend of mine asked me to collaborate for a street art show. That collaboration got a full page in New York magazine. At that moment I realized I did not need approval from used car salesmen who control what art we should buy. I would like to make a living off my art. But I do so enjoy when people just appreciate what I do and on the street it gets more viewership than in any gallery."

ON PERSONAL ART

"On the street I just do what I feel at the moment. I keep a thread that ties my pieces together. I noticed that a lot of street art was for the most part, well, very street, often grimy, a product of its environment. I thought it an interesting juxtaposition to put something on the street that was sleek, in a way, out of its element. I love so many peoples' work but I've noticed that much of it references childhood games and T.V. shows or today's celebrities. I wanted my pieces to be more personal. On occasion when the piece calls for it I find my reference but, for the most part, I use material or subject matter of my own."

ON NYC

"I am from Queens and have never lived in any other city so, for me, basing myself in New York was a given. I think there is a lot of potential in other cities to be a big fish in a little pond but in New York you are constantly pushed by new and interesting things others are doing. I get around from time to time, Philly and San Francisco, but the scenes there were never as full.

One time I had a police officer tell me that what I was doing 'just is' illegal but not able to tell me why. That was an argument there was no response for. It just is illegal! Well, you got me there."

ON THE FUTURE

"I don't know what is next for me. I know, though, that I need to do something."

ON YOUR PROCESS

"I am always up for working with new materials till I find exactly what I like. I tend to lean towards silkscreen and stenciling. Stickers are fun but I never remember to bring any with me."

"I NOTICED THAT A LOT OF STREET ART WAS FOR THE MOST PART, WELL, VERY STREET, OFTEN GRIMY, A PRODUCT OF ITS ENVIRONMENT. I THOUGHT IT AN INTERESTING JUXTAPOSITION TO PUT SOMETHING ON THE STREET THAT WAS SLEEK, IN A WAY OUT OF ITS ELEMENT."

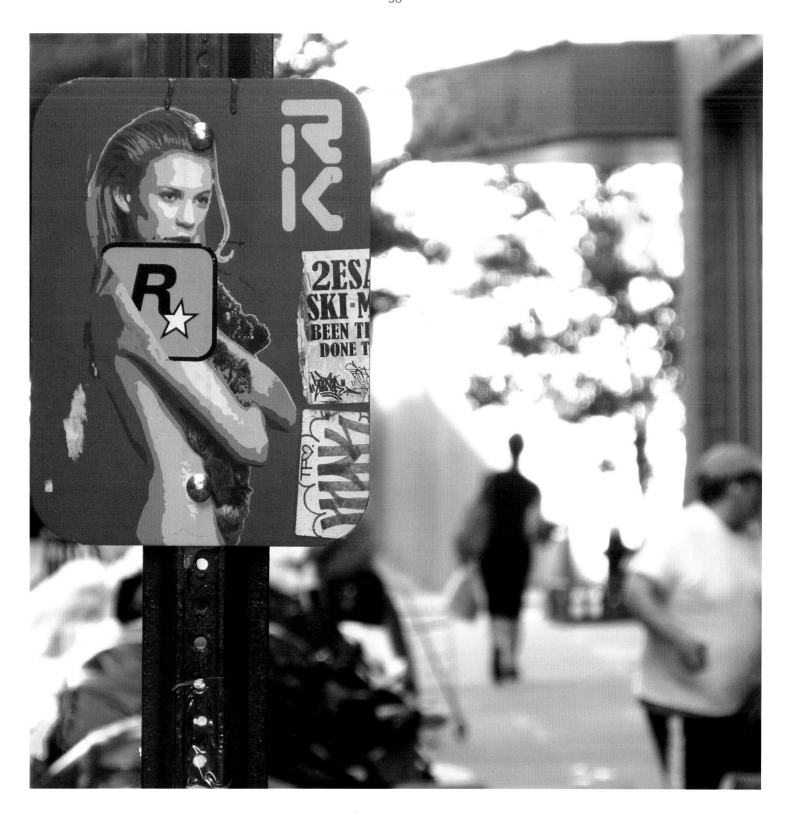

FRONT ST., DUMBO, BROOKLYN

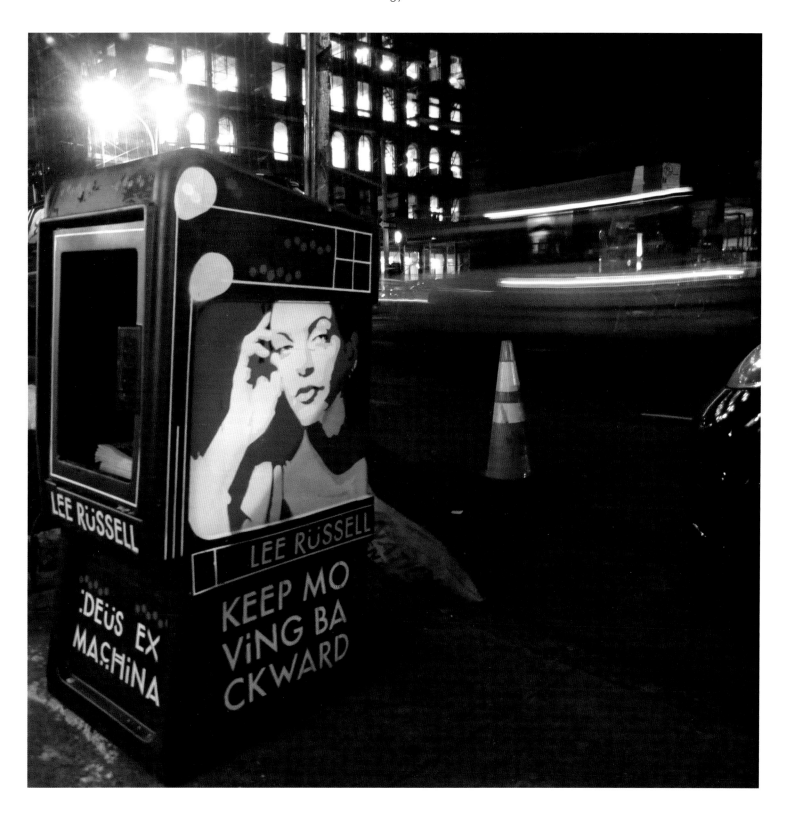

BROOME ST., MANHATTAN

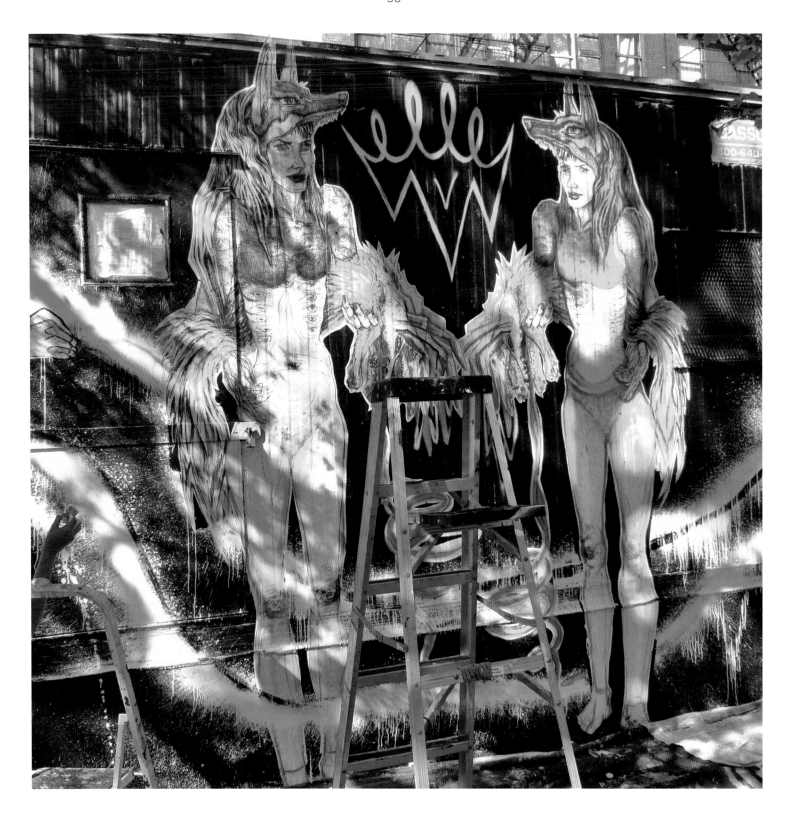

1ST ST., MANHATTAN

ELLE DEADSEX

ELLE DEADSEX SPEAKS...

ON STREET ART

"Art in the streets is the ultimate sign of freedom. What if the old cave painters weren't allowed to paint the caves they lived in? Think of the historical and cultural value that we would have missed out on! I love being able to create work that is instantaneously accessible and exposed to society. Art in the streets represents contemporary culture and should not be locked up in apartments and in storage, or only on view in museums where one must pay to see it. I love the ephemeral nature of art on the streets; how it ages and changes and warps with its environment over time. Eventually the elements and other artists contribute to a piece's evolution. It grows and dissolves like a living thing, always staying relevant."

ON PERSONAL ART

"I started doing street art about four years ago when I first moved to New York City. I was disillusioned with the work that I saw in galleries; nothing was speaking to me. As I walked out of a gallery in Chelsea, I stumbled upon my first street art wall. There was a piece by Gaia, and I remember seeing one by Swoon and thinking, 'This is a gift to society, I want to do this.' I just wanted to partake. I asked around until I found a friend, Ohm, who was pasting and he said he would be willing to teach me. We went out that very night and I haven't stopped since.

Spontaneously finding art around the city is like finding jewels in the dirt; it is such a pleasurable experience. It also becomes fun to recognize artists who consistently work the streets. It's comforting to see familiar work when you're in a foreign place; it's like running into an old friend. It makes you feel like you're at home even when you've never been on that street or even in that city before.

I've always made art and I continue to do so in my studio as well as on the street. I walk and make art. I eat and make art on my plate. It's a lifestyle for me. Wherever I am, I am creating, be it in the street, at home, or anywhere else."

ON NYC

"People don't want to live in a steel stale concrete environment. They want color and life and expression. Ironically, the city fights against that; painting beautiful things over with grey squares and bowel brown. Putting art in the street is like fighting a war against blandness; it's like fighting for a place to exist and be seen in New York City. Almost everything I put up gets taken down within a year. So street work is like this chase against that, a reason to keep going and keep putting up work because someone will one day come along and just paint a big grey rectangle over it. It's like that book 'The Giver'; the higher ups don't want 'the people' to see color because then they'll know there are better things out there. It's my mission to expose society to the other. I like to think of displaying art in public as a mission of beautification. I would still do street art if it weren't a movement. It's more of a solo thing for me. I like forging new territory and exploring places that are off limits, wandering the streets when they're deserted and scouting spots. It's unfortunate that street art and graffiti is only allowed in certain places in New York City, on certain walls etc. And I don't necessarily mean legal walls. The problem in New York City is that 'graffiti free NY' is ruling the mindset of the people. The only places street art and graffiti are able to ride are sanctioned walls, where the owner is ok with the art and won't call the 'graffiti free' removal trucks to buff their walls. Street art gets taken down quickly in most places. The places where the art does ride are visible to other artists and where the art quickly gets side-busted by others who want their work to ride; and suddenly it's a beautiful collage wall, like the walls on the Jay Meisel building on Spring and Bowery. It's so rad that Meisel lets art ride on his building and doesn't call the New York City 'graffiti free' van."

ON YOUR PROCESS

"I paste, paint, sticker, tag and roll, ultimately it's just fun."

"I LOVE THE EPHEMERAL NATURE OF ART ON THE STREETS; HOW IT AGES AND CHANGES AND WARPS WITH ITS ENVIRONMENT OVER TIME. EVENTUALLY THE ELEMENTS AND OTHER ARTISTS CONTRIBUTE TO A PIECE'S EVOLUTION. IT GROWS AND DISSOLVES LIKE A LIVING THING, ALWAYS STAYING RELEVANT."

BEDFORD AVE., WILLIAMSBURG, BROOKLYN

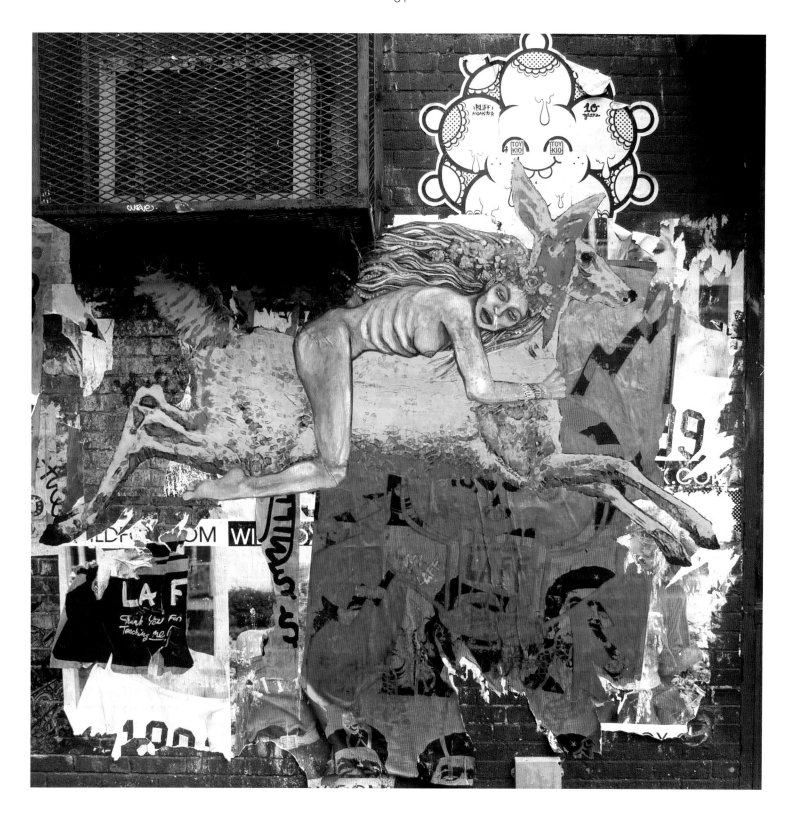

BEDFORD AVE., WILLIAMSBURG, BROOKLYN WITH SHINSHIN

6 LINE, MTA

ADAM DARE

Adam Dare is influenced by the Halcyon days of the 80's and 90's, a time of seismic movement in music, art and style. He blends the Aesthetics of Graffiti and hip-hop. His art is infused with punk rock and heavy metal, undercut by the subcultures that define "Popular culture." Adam Dare is inspired by beauty, infinite and mundane.

ADAM DARE SPEAKS…

ON STREET ART
"Street art is raw vibrancy and pop-culture-punkness, spontaneous splatters, random drips, juxtaposed images, flashes of colors and bursts of energy. There are 2 kinds of street art: socially conscious (art that is commentary on current events and social phenomena) and self-expression (personally significant imagery). Regardless, street art is meant to make a statement. What started out as graffiti and black book exchange has evolved to include stickers used like street art trading cards and wheatpastes. Street art is the metamorphosis from writing graffiti on trains. I never really did anything on the streets during the period I wrote on trains. It eventually became impossible to write on trains and then the only place left was the streets. If you had graffiti in your blood and were a true public artist it was the natural progression."

ON PERSONAL ART
"I'm an artist. Both my parents were painters and I have painted since childhood. I put my art on the street because I needed to express myself and started by writing graffiti on trains. Writing got something out of my system as well as inner city fame and recognition. I've evolved to doing street art because I wanted to get the rush of doing illegal art like I used to on trains and I really wanted and needed to continue to incorporate self-expression in my art. I do studio work as well as street art. Studio work is (for the most part) methodical and intricate, whereas street art is all about instant gratification."

ON NYC
"New York City is the mecca, the incubator, and the genesis. It's where graffiti and street art were born. The art here reflects the current concerns and observations of the artist, whether commentary on personal events or worldwide.

My favorite New York City neighborhood is the East Village. I should say West Village. What is my favorite neighborhood? You can't have one favorite neighborhood! New York City is too diverse, there are too many good things going on, and in this day and age, why have a favorite? They are all my favorite!

I remember it was Friday during rush hour on Bedford Avenue in Williamsburg, Brooklyn. I was putting bunnies up on a boarded up store. As I was putting up the posters a street art tour walked through the neighborhood, spotted me and stopped to take pictures and close-ups of me. At the same time a police car rolled by; I was ready to book, but they just waved. So…. I finished and left. Plastered the whole corner with bunnies. Couple dozen."

ON THE FUTURE
"The future is now and right now street art is at an all-time high. I don't predict the future of street art in any way. I'm just doing me and keeping it real."

ON YOUR PROCESS
"It's up to each individual artist to figure out his individual technique. I make art because I have to. If you have the passion, stoke the fire."

"STREET ART IS RAW VIBRANCY AND POP-CULTURE-PUNKNESS, SPONTANEOUS SPLATTERS, RANDOM DRIPS, JUXTAPOSED IMAGES, FLASHES OF COLORS AND BURSTS OF ENERGY."

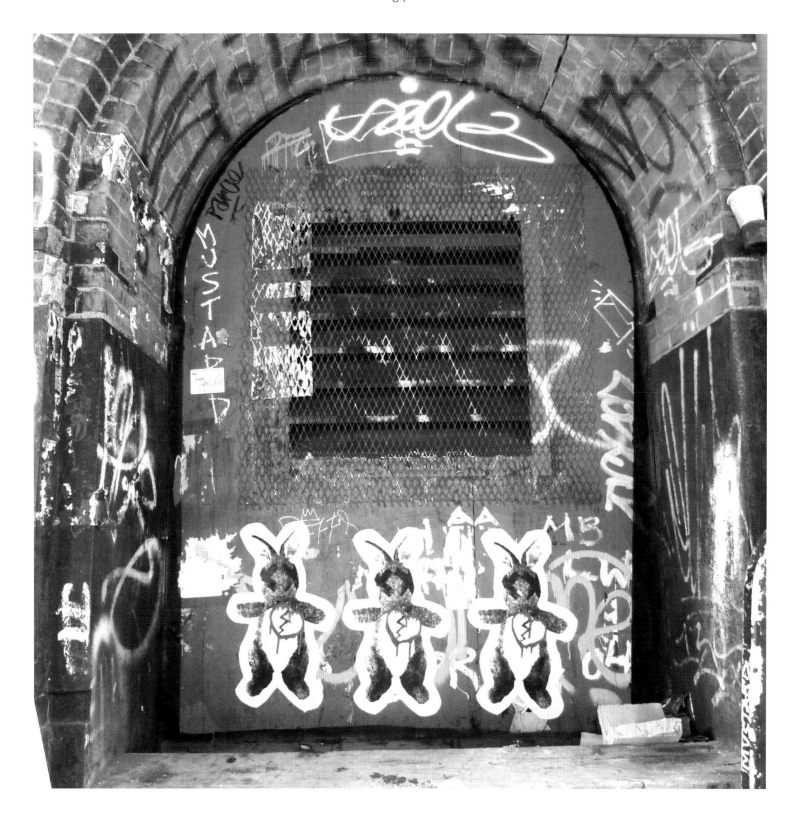

WATER ST., DUMBO, BROOKLYN

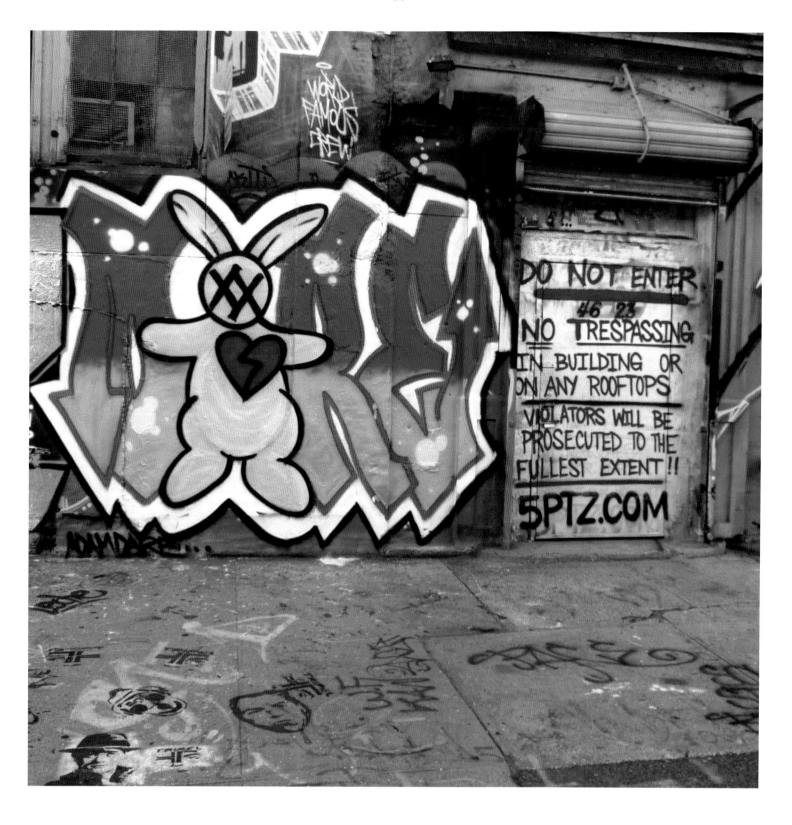

5 POINTZ, LONG ISLAND CITY, QUEENS

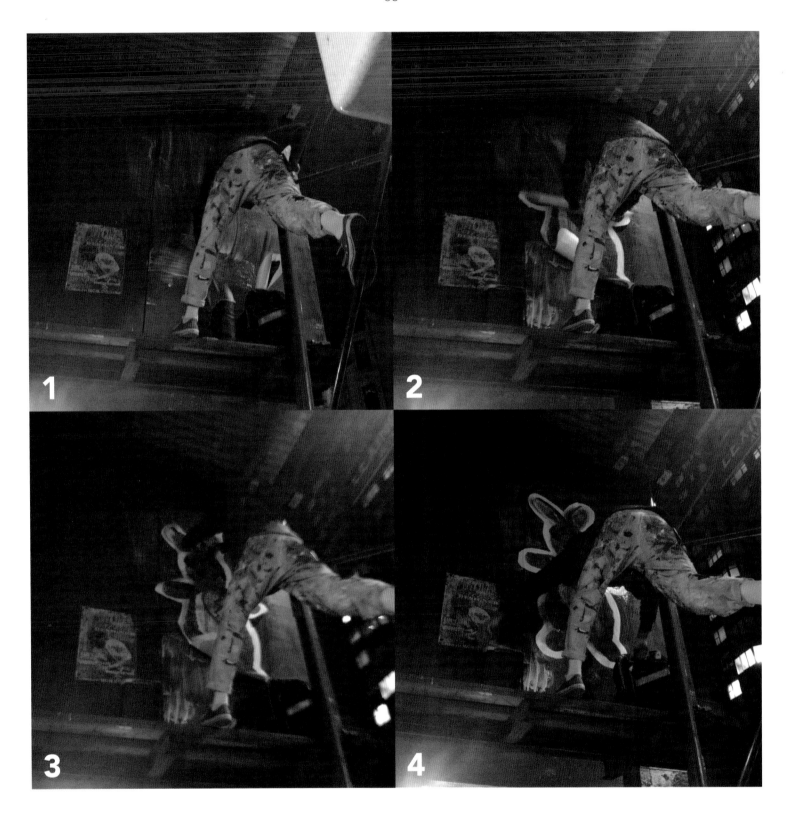

ADAM DARE PROCESS

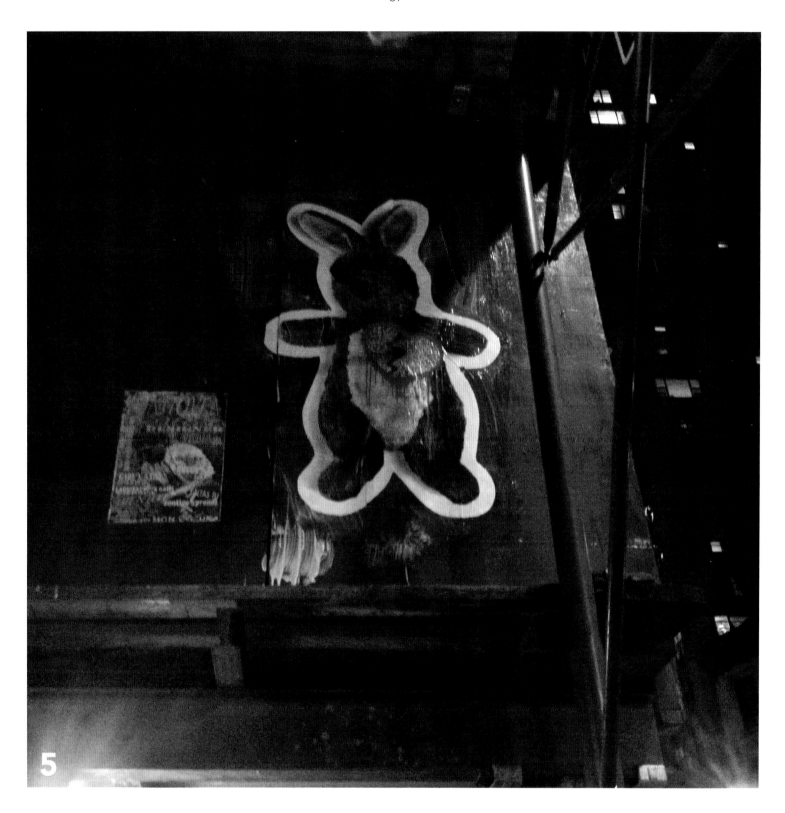

1. APPLICATION
2. APPLY ADHESIVE
3. REMOVE BUBBLES
4. PRESS OUT

5. FINISHED

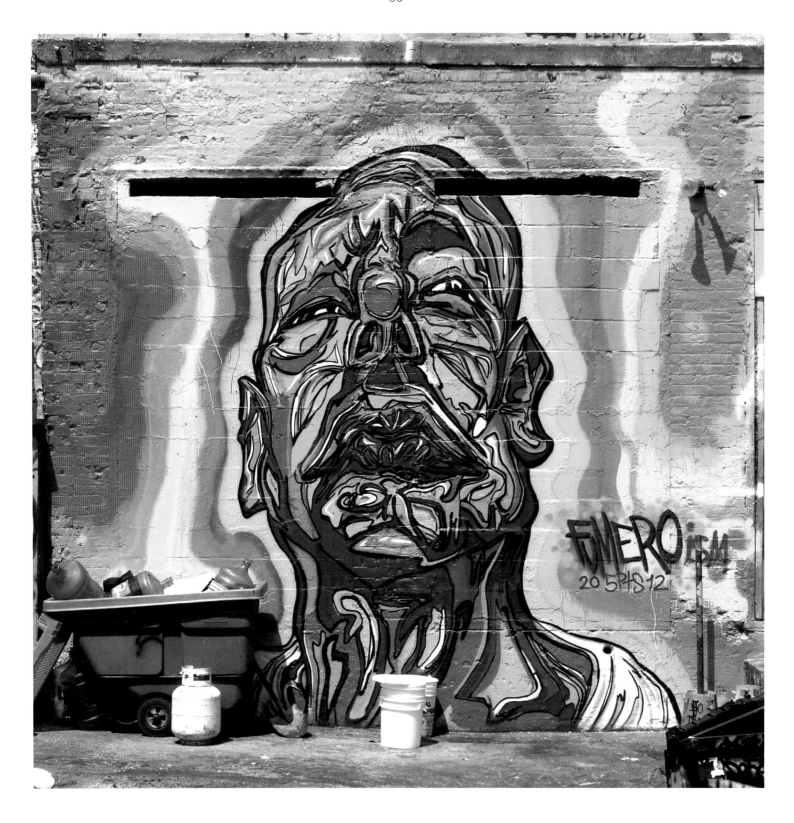

5 POINTZ, LONG ISLAND CITY, QUEENS

FUMERO

FUMERO SPEAKS…

ON STREET ART

"The streets are a gateway for the public to gain access to art and the best exposure for a fine-artist.

Street art is the contemporary genre of our times, in the same sense that Impressionism was in the late 19th Century. Just as Impressionism was scorned by the mainstream art critics and initially excluded from the Parisian Salons, street art also had to strive to gain social acceptance with the galleries and is steadily creating an impact in today's mainstream market."

ON PERSONAL ART

"I picked up where I left off as a graffiti artist during my teens. Getting-up street art has replaced bombing tags, throw-ups and pieces. The purpose of my street art is to present my fine art canvas paintings and translate them from paper to walls for the public arena. A major theme that is a core of my visual approach is how 'the table' brings families together; the family that breaks bread together stays together. Another artistic highlight revolves around the exaggerated interaction among line, shape and color, and when these are combined they create movement of dynamic energy."

ON NYC

"I have two favorite neighborhoods in New York City, the Lower East Side in Manhattan and Williamsburg, Brooklyn. These two neighborhoods are lush with street art oases everywhere."

"STREET ART IS THE CONTEMPORARY GENRE OF OUR TIMES, IN THE SAME SENSE THAT IMPRESSIONISM WAS."

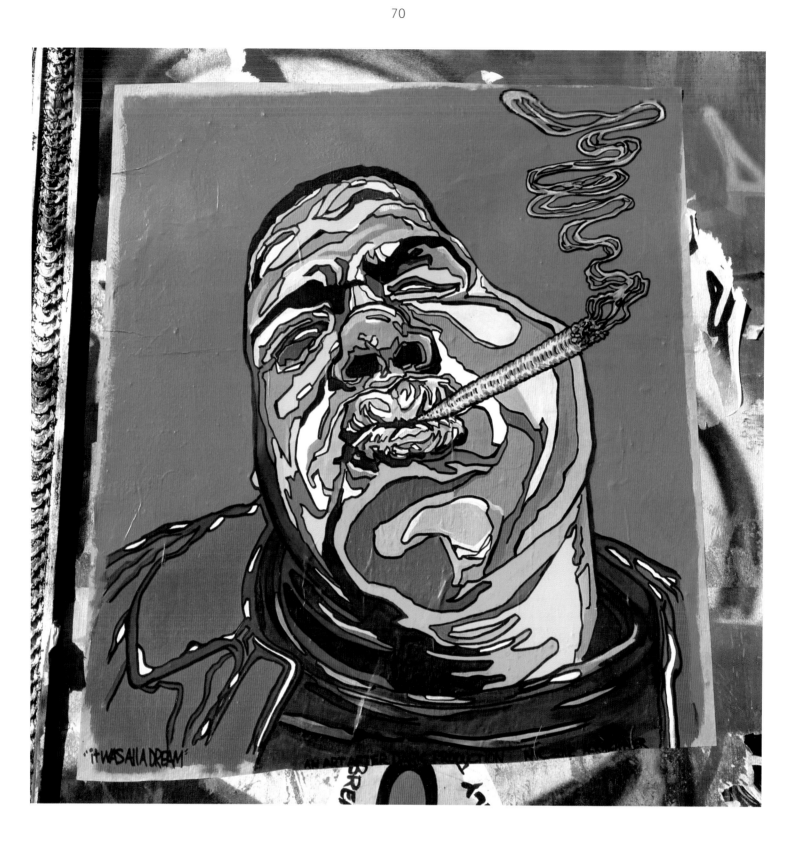

BOWERY AVE., MANHATTAN

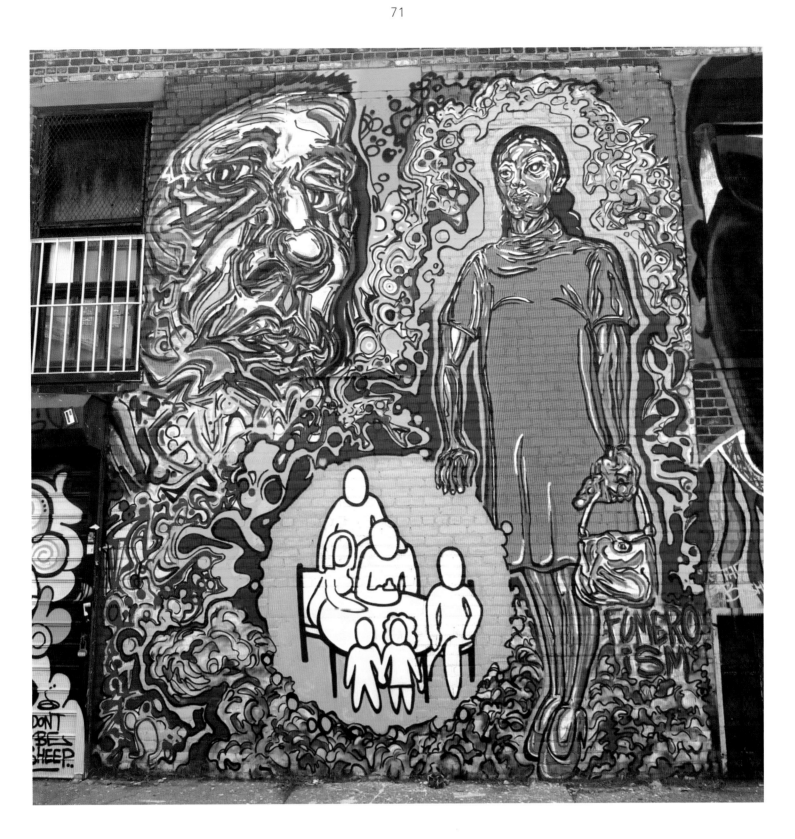

TROUTMAN ST., BUSHWICK, BROOKLYN

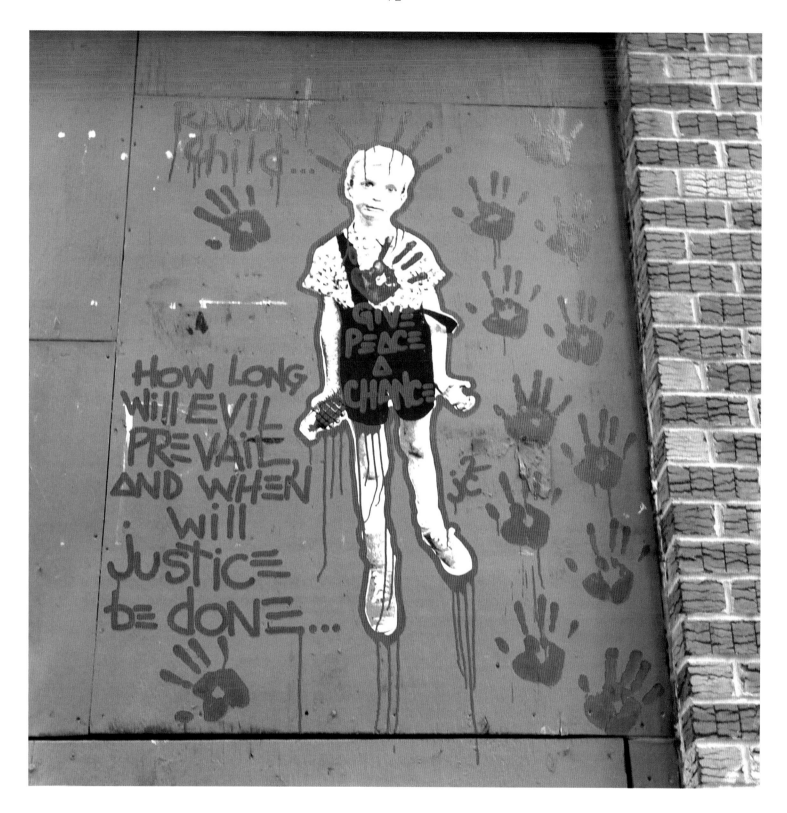

SPRING ST., MANHATTAN

ARMY OF ONE / JC2 / JEF CAMPION

Jef Campion, aka Army of One / JC2, is an artist illustrator, painter, collector, sculptor, curator, and a former New York City Fireman.

Jef's commitment is to be a peaceful revolutionary and raise awareness regarding the effects of war on children as well as our government's deficient support services for soldiers who have served and the resulting suffering of their families. Jef has seen how lax and irresponsible our government has been with rehabilitating soldiers who suffer from physical injuries and post-traumatic stress disorder (PTSD) when returning from the battlefield. One striking image Jef uses is of a boy with a grenade, an image that serves as a metaphor for the suffering and pain children and soldiers undergo due to war, poverty and disease. The image is from a photograph by Jef's favorite photographer, Diane Arbus. What inspires Jef most are the beautiful children he sees day in and day out at the Ronald McDonald House in New York City, where he has been a volunteer for the past 17 years. The most horrific diseases affect these children yet they still have the will and desire to play and live normally.

Jef is a veteran of 26 years service with the NYC Fire Department in Yonkers. His experiences at Ground Zero on 9/11 were the catalyst for his inner-self and his commitment to promoting a better world for children. Jef has affiliated with charities that offer love and support in order to make a difference in the lives of children and soldiers. In addition to The Ronald McDonald House, these include the Wounded Warriors project and Hope for Heroes. Jef says, "If we as human beings don't show the less fortunate that we care about their welfare, who will? Certainly not the government or corporate America."

ARMY OF ONE SPEAKS...

ON STREET ART

"I don't care if you take away all the paint, all the spray paint, markers and pencils; there will still be street artists creating art and making a statement out of whatever medium they can find. There is no way to stop street art. It dates back to the cave dwellers, the Egyptians and the Romans. Now, with the genre entering the art world and gallery spaces, it has become more mainstream and artists are finding ways to make money from 'legal' wall space. I am devoid of the inner me within gallery walls; my art is meant for the streets.

Army of one/ JC2 donates 50-100% of the profits on street art gallery shown to the wounded warrior project and the Ronald McDonald house in New York City."

ON PERSONAL ART

"I got to a point where, following my self-induced madness post-9/11, I 'woke up' and decided that I'm not satisfied sitting around watching TV and listening to the media, listening to politicians and corporations crushing the hearts and souls of the impoverished and working-class and failing to promote positive change in this world. I decided that if I'm not willing to jump into the deep end of the pool then I do not have the right to critique anything, to go home and hate life, turn on the TV and lay on the couch. The two things I see too much of in the world are complacency and mediocrity. In this world, one has to fully believe in what one does because you'll be challenged by naysayers, other artists and yourself every day. I did not just become an artist, or a 'street artist.' I was born an artist, and I became a New York firefighter.

There's a great saying by the Russian-born New York City artist, Mark Rothko: 'Art is an adventure into an unknown world, which can only be explored by those willing to take the risks.' And its true! Paint differently, think differently and you put yourself in a different world."

ON NYC

"The East Village and the Lower East Side in Manhattan still maintain the dirt and grittiness of the New York City that I grew up in during the 70's and 80's. That was a time when the streets were alive with artists and poets."

ON THE FUTURE

"The future of our art is about our message and mission, it's about one child at a time, one mind at a time. Even if I can make a difference in one person's thoughts and get them to start giving to and caring for the less fortunate, I'll have done my job. Because of our art, that one person is going to carry the message to another person and it will create a positive domino effect."

ON YOUR PROCESS

"Army of One's technique is to have none at all. The dichotomy between my personalities, spending time fighting fires and the way in which I approach street art, is paradoxical. I fully live in both of the moments. I search the streets and back alleys for any materials I can use in my art. Technique cannot be restricted to just one style or idea."

"THERE WILL STILL BE STREET ARTISTS CREATING ART AND MAKING A STATEMENT OUT OF WHATEVER MEDIUM THEY CAN FIND. THERE IS NO WAY TO STOP STREET ART."

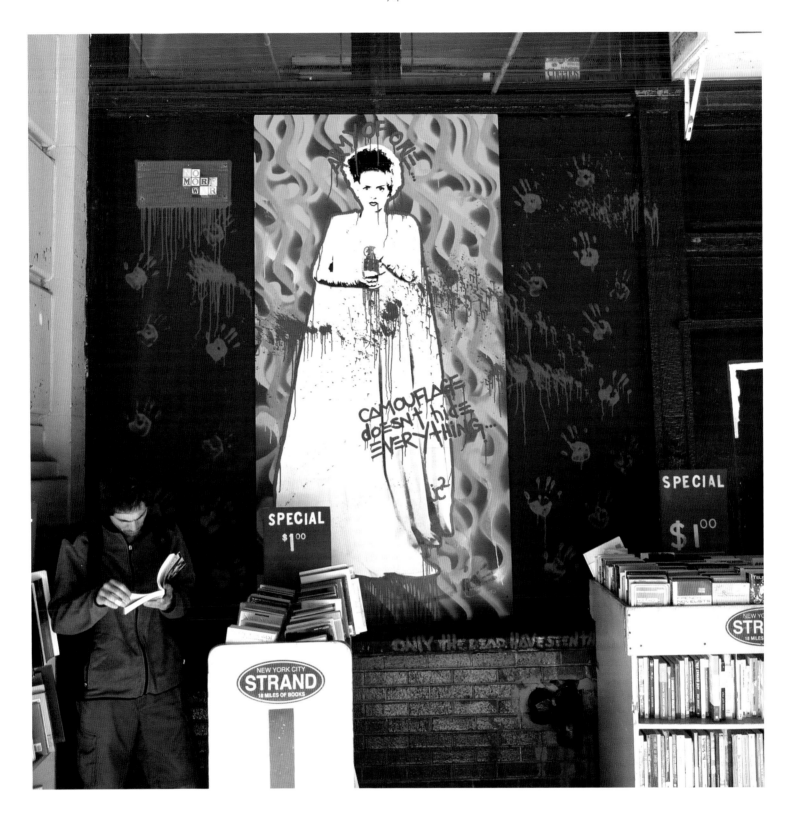

BROADWAY, MANHATTAN

ORCHARD ST., MANHATTAN

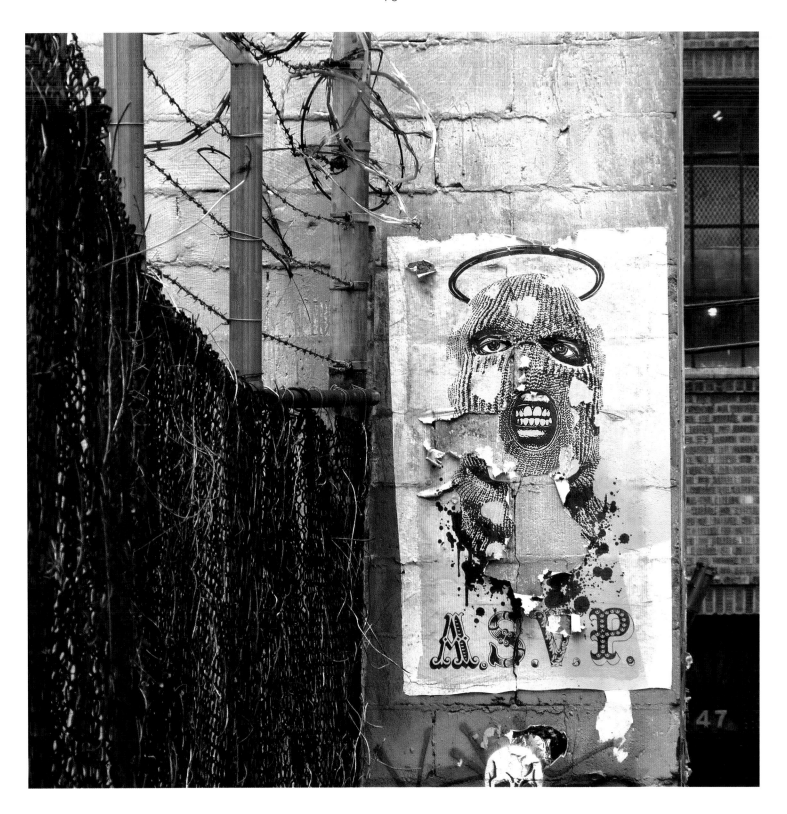

VANDERVOORT PL., BUSHWICK, BROOKLYN

ASVP

ASVP SPEAK…

ON STREET ART

"Placing work on the streets allows a level of exposure and interactivity that is hard to achieve anywhere else. Art on the streets combats the never-ending supply of dumb advertisements and mindless messaging that people are constantly bombarded with when they walk in a city. It's nice to offer people something more substantive to look at and take in."

ON PERSONAL ART

"We (we're a team of two) used to spend a lot of time doing projects for commercial clients but ultimately found it exhausting and felt totally uninspired. This is what initially motivated us to start doing more of our own work and to share it with others."

ON NYC

"New York City is our hometown, that's why we're mostly working here. We like every neighborhood for different reasons; the diversity that they provide is what makes the city so inspiring. Though New York City is our home base, we're constantly working all over the world and are just as inspired by working in new places."

ON THE FUTURE

"Earlier this year, we teamed-up with fashion designer, agnès b., on a series of pieces. It was very inspiring to collaborate with an artist of her ability and with her level of vision. We're currently working on a massive project that is comprised of 25 large-scale pieces, and is scheduled to be completed in fall, 2013. Currently, we're also working on two, large-scale outdoor pieces that will be displayed this summer in Wicker Park, Chicago and Bushwick, Brooklyn. We're also working on a series of pieces for a solo show in 2014 and several group shows throughout the rest of this year."

ON YOUR PROCESS

"Our images are first drawn by hand. The final pieces, whether on a street or in a gallery, are hand painted and/or silk-screened. Our work is made with our hands and some paint. The whole process is very analog, there's something we really love about that."

"ART ON THE STREETS COMBATS THE NEVER-ENDING SUPPLY OF DUMB ADVERTISEMENTS AND MINDLESS MESSAGING THAT PEOPLE ARE CONSTANTLY BOMBARDED WITH WHEN THEY WALK IN A CITY."

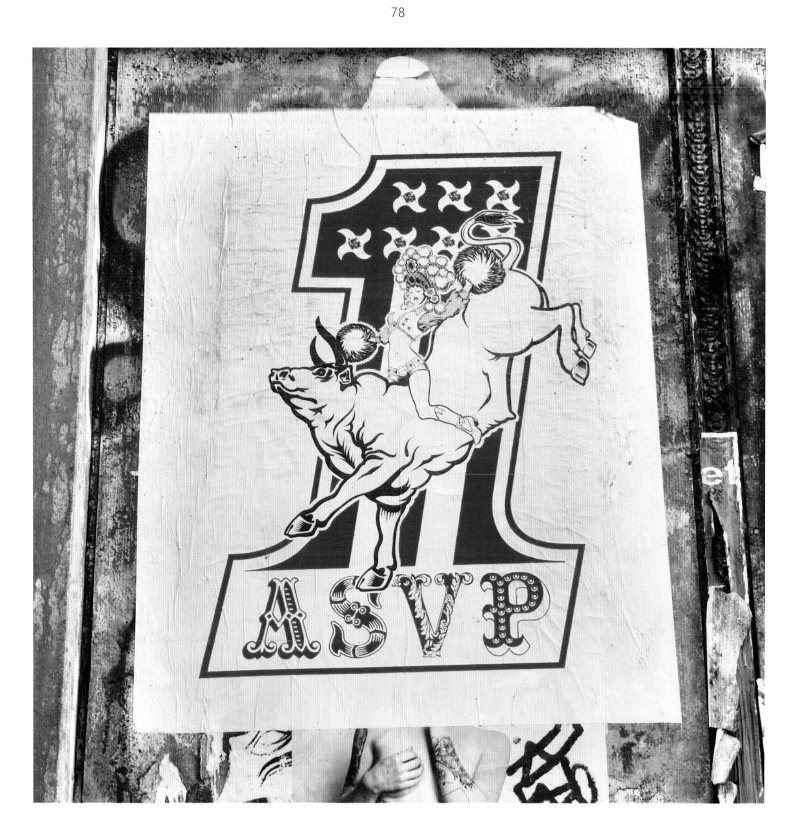

BOWERY AVE., MANHATTAN

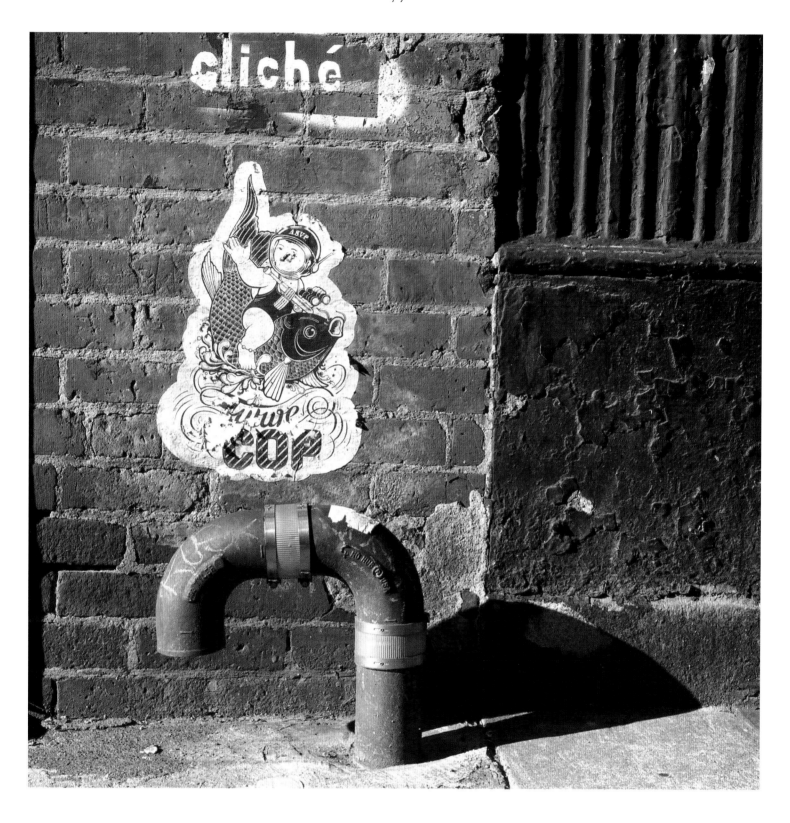

SULLIVAN ST., MANHATTAN

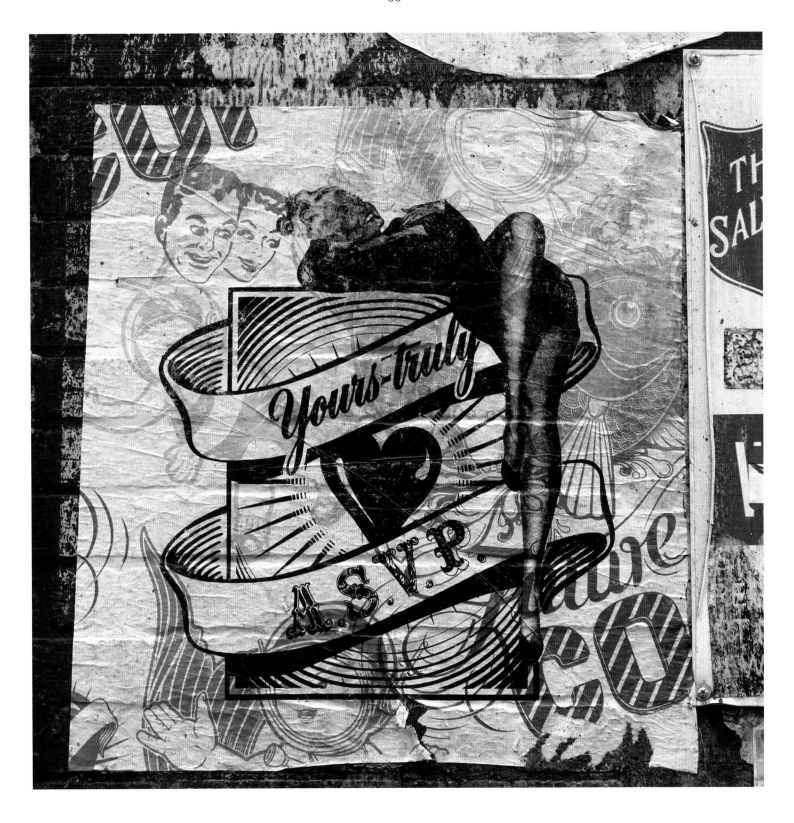

NORTH 7TH ST., WILLIAMSBURG, BROOKLYN

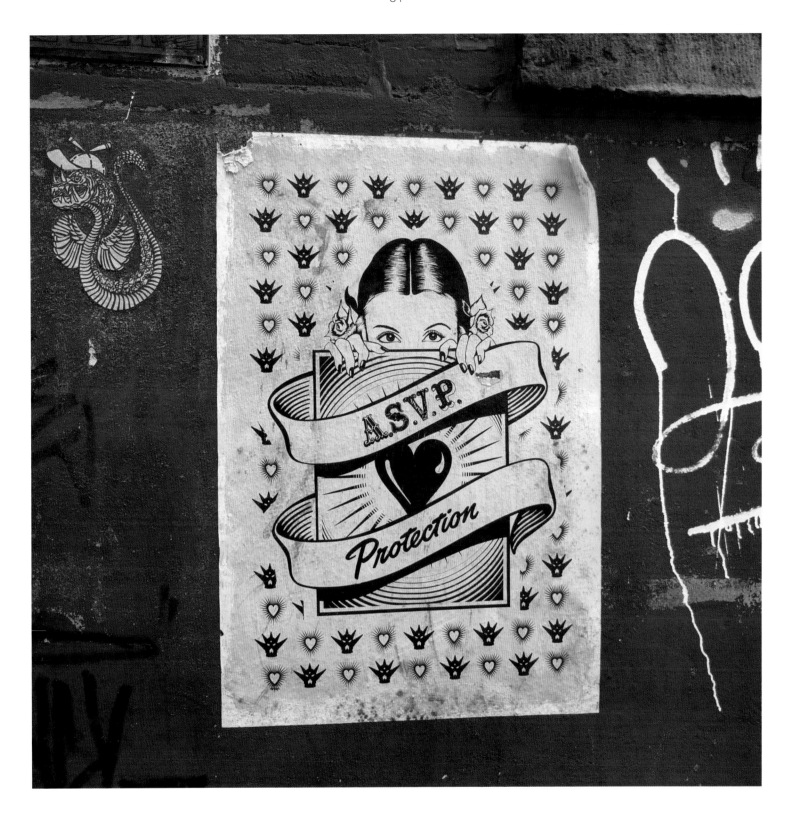

MORGAN AVE., BUSHWICK, BROOKLYN

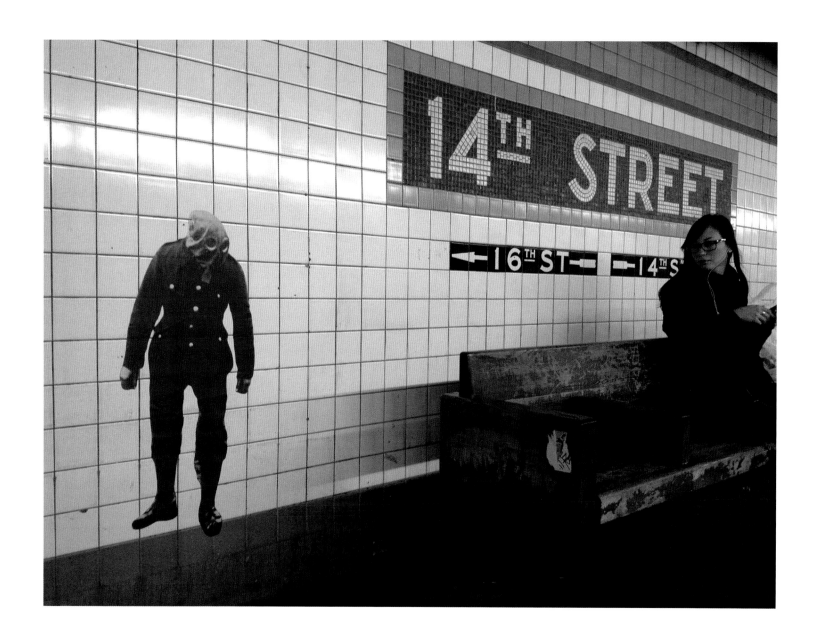

14TH ST. AND 6TH AVE., MANHATTAN

JILLY BALLISTIC

Jilly Ballistic is a paste-up artist out of Brooklyn known for tagging the New York City subway system with site-specific historical images, revamped idioms as policy advisories, and computer errors inserted onto advertisements on platforms or in train cars. Ballistic has been featured on numerous blogs and international culture magazines, including: AnimalNY, BuzzFeed, Hyperallergic, HUCK and Time Out New York, which declared her one of the best underground artists (issue 843)

JILLY BALLISTIC SPEAKS…

ON STREET ART

"Street art is so highly accessible. It is available to everyone and can be done by anyone. No topic is taboo. Everything is on the table; from politics to pop culture, class structure to sex. All of it can be analyzed, mocked, simply stated or represented in some witty manner, so the creative aspect is massive. And remember, street art was the first social media; you said what you wanted and people heard it. We're social media obsessed today and street art feeds that obsession. It fits."

ON PERSONAL ART

"I started rather traditionally, spray-painting fiction on any large piece of trash left on the curb, like a refrigerator or sofa. The more I tagged, the more ideas and projects came to mind. I wanted to work with more materials. The subway felt like the place for me to be. I'm extremely comfortable down there and the environment has so much you can work with: ad spaces, info kiosks, seats, signs…the list can go on. It's very inspiring, to say the least. Challenging too, in terms of cameras and the constant flow of people. Nevertheless, you want to respond to everything around you and, to do this, you have to come up with some great ideas. I hope my work inspires others to get back underground."

ON NYC

"I was born and raised here; she's my first love. All of my work is influenced by New York City. For example, the historical images are placed where they are because there is a relationship with the space; there is a connection with the modern location. And the modified policy advisories have a New York sense of humor, as do the digital errors. When writing either of those, I'm definitely thinking as a New Yorker and responding to advertisements as one.

I have a soft spot for older stations in lower Manhattan and Brooklyn; they haven't been completely modernized. The pillars, signs and staircases are practically ancient and falling apart, but so photogenic and calling out to be worked with. Usually I put up pieces during the day, so my most memorable experiences are interactions with fellow straphangers. They watch me, curiously, trying to understand what I'm doing and putting up. I love observing their reaction to a piece, which includes everything from laughter, taking a photo with a phone or striking up a conversation."

ON THE FUTURE

"I see street art growing in terms of materials used. It's no longer just spray paint. People want to push the movement, make it evolve, take risks and try new concepts. Technology will expand what we will be able to create and get out on the street. It's going to be an exciting time and I'll be a part of it."

ON YOUR PROCESS

"Materials, Currently Used: Wit. Humor. Honesty. Paper. Printer. Ink cartridges and pens. X-acto knives. Hands. Rulers and mathematics. Adhesive. History. Past. Present. Consumerism. Psychology. Pop culture. Social media. Word of mouth. New York itself.

Techniques, Recommended: Timing. Develop a system of tagging but trust your instincts. Always be open to new forms of style and communication. Collaborate with artists. If you are asked to be featured in a book, do it!"

"STREET ART WAS THE FIRST SOCIAL MEDIA; YOU SAID WHAT YOU WANTED AND PEOPLE HEARD IT. WE'RE SOCIAL MEDIA OBSESSED TODAY AND STREET ART FEEDS THAT OBSESSION. IT FITS."

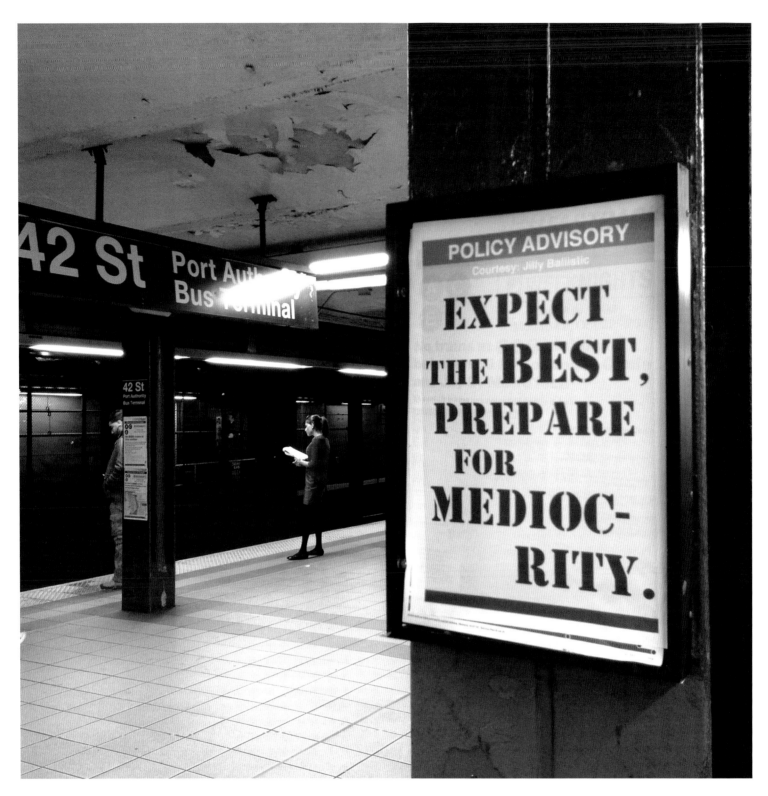

PHOTO COURTESY OF JILLY BALLISTIC

PORT AUTHORITY, 42ND ST., MANHATTAN

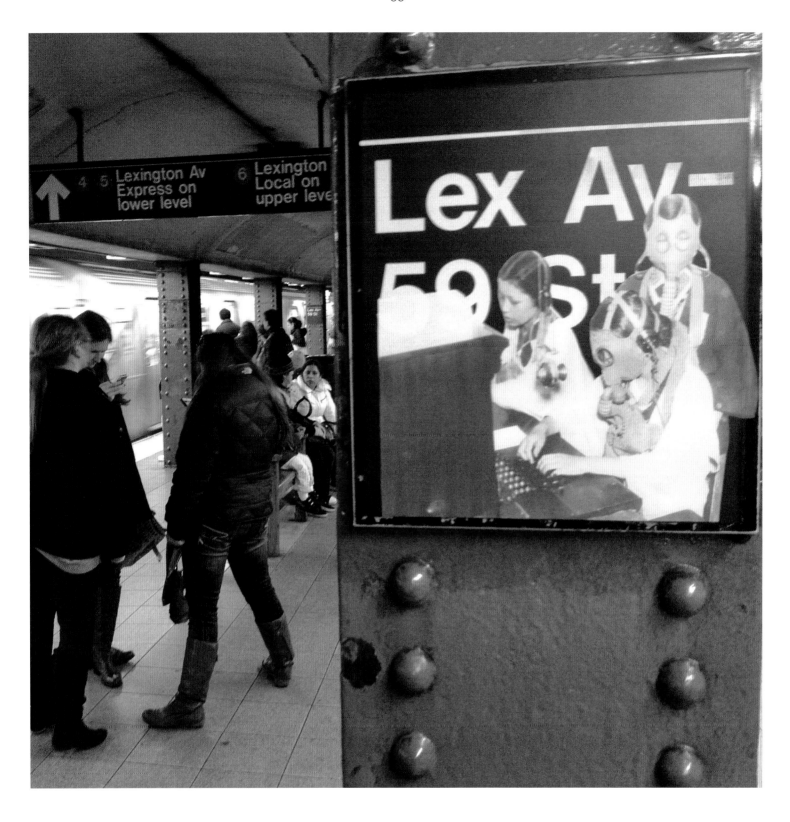

N Q R LINES, 59TH ST., MANHATTAN

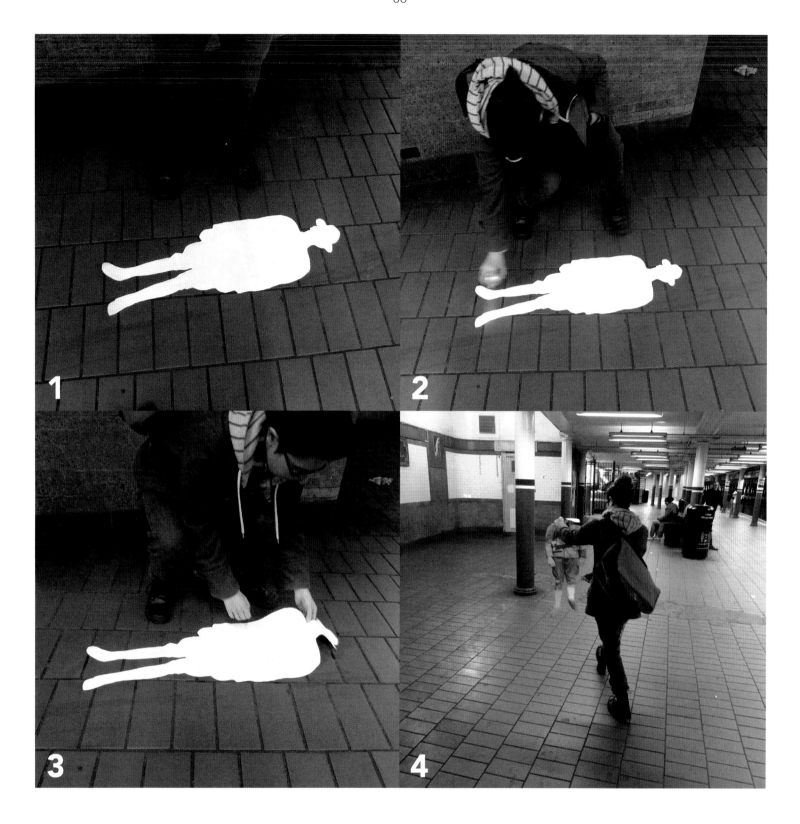

JILLY BALLISTIC PROCESS

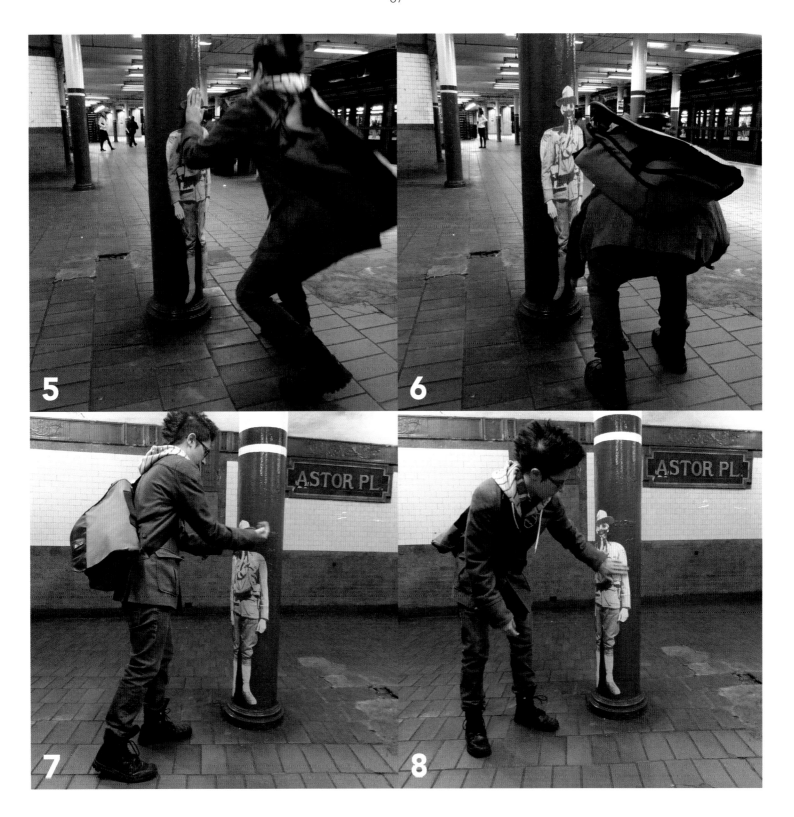

1. APPLICATION
2. APPLY ADHESIVE
3. LET ADHESIVE DRY
4. SCOPE LOCATION

5. APPLY
6. PRESS OUT
7. REMOVE BUBBLES
8. PRESS OUT

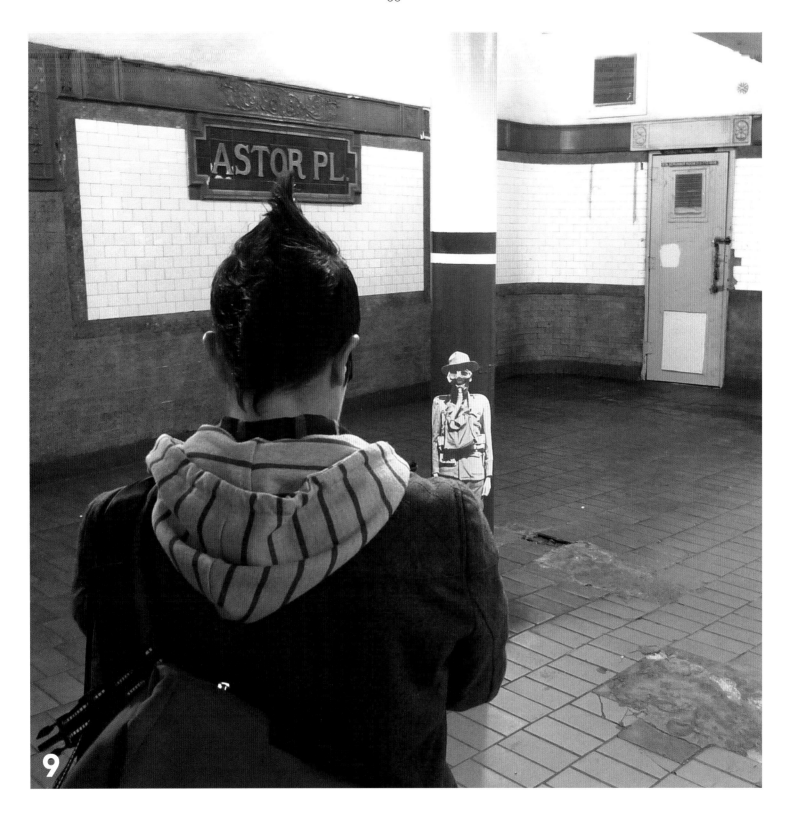

9. TAKE A PICTURE AND POST

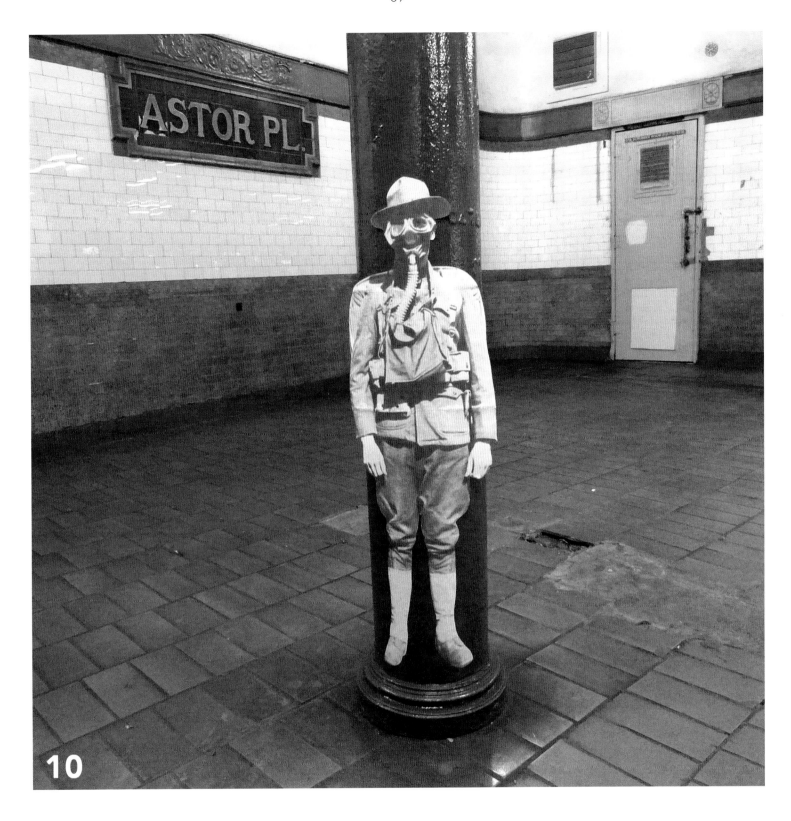

ASTOR PLACE SUBWAY STATION, MANHATTAN

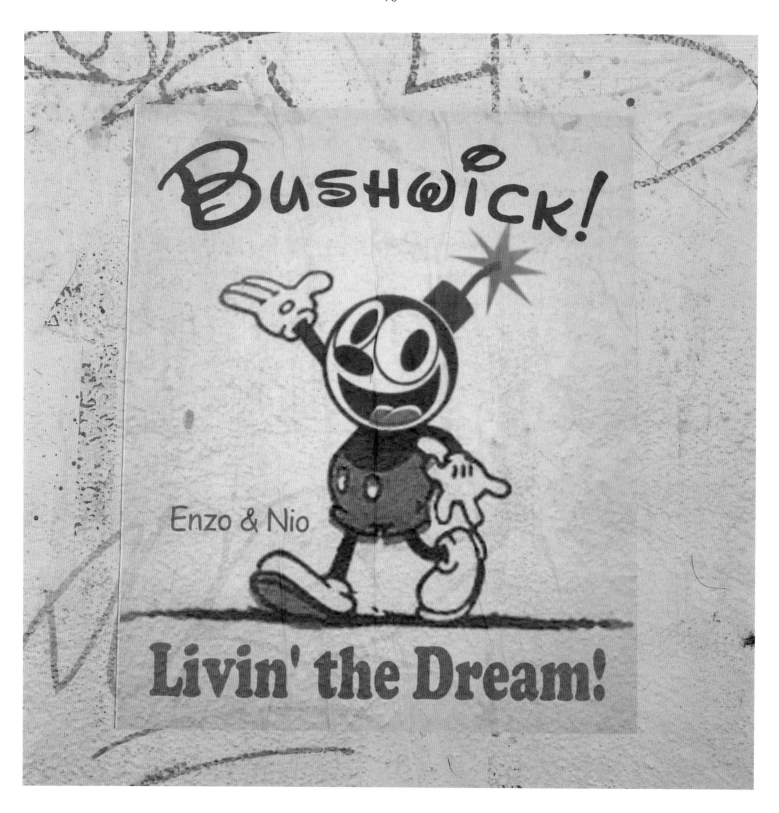

GRAND ST., BUSHWICK, BROOKLYN

ENZO AND NIO
(ENZO SARTO AND NIO GALLO)

Enzo Sarto is a liar and a charlatan, a direct descendant of Romulus or Remus. He was born in a small village outside of Rome, Italy. He grew up poor and bored, often skipping school in favor of spending long days in the local library. In 1980 Enzo moved to the USA with his family where he was ridiculed for his accent and large pumpkin-like head. After a considerable struggle and concerted effort, he eventually overcame his accent but his head still resides awkwardly atop a modest but strong neck.

Nio Gallo was born from the joining of two extraordinary and famous Italian dynastic families. The Gallos were successful firework manufacturers and the Murgos were famous circus performers. From this synergistic genetic cocktail sprung an ultra-intelligent boy with a penchant for getting himself into precarious situations.

Enzo Sarto met Nio Gallo in 1994 when both were hired a-day-apart to work at an undisclosed tree farm at an undisclosed location. They developed a friendship based on a love of hard work, the outdoors, music, dancing, absurdity, sexual excess and hallucinogenic drugs.

ENZO & NIO SPEAK…

ON STREET ART

"Street art offers us a great deal of freedom to go where we may or explore what we like. Enzo & Nio's approach to our art enables us to exercise the license to create what we want. This is not possible in the conventional art market. There are unbending rules, restrictions, motivations and influences that can corrupt or curb what you want to do, or at least what we want to do. Galleries and museums vet and qualify the work contained within their halls and galleries. On the street, the individual viewer vets and qualifies things for him/herself. If the viewers like it, they may take photos and share them and the location with friends. If they hate it, maybe they'll mark it or spit on it. Try that in a gallery or museum! We want the freedom to do anything we like and only the street offers that kind of freedom. Go to the Museum of Modern Art and write on something you don't like there and see the freedom that they offer.

The experience of art is a shared one between the artist and the viewer. We believe that the more convention placed between the artist and the viewer, the more distant the art experience becomes. Enzo & Nio feel that one of the advantages of street art is that it strips away at convention and creates a more honest exchange. With our street art we pursue our vision, philosophies and whims freely and with few limitations. Street art allows us to mindfully abandon the tradition of a singular identifying style and instead opt for identifying our work using branding, featuring our bomb logo or our names prominently displayed. Advertising agencies have trained the public to recognize branding. Enzo & Nio, like many other street artists, bend that training to our own anti-advertising advantage.

The work of Enzo & Nio is incomplete until it is placed on the street. There it begins a term of completion that is not over until it finally disappears. The same lack of convention that we claim in creating it, the public confidently claims in experiencing it. People photograph and comment on it. Others steal it or write things on it. Other artists add to it or take away from it. Some folks hate it so much they mock it and tear it. All because there is no convention, there are few rules. They have the same freedom that we do; freedom that they cannot exercise in a gallery or a museum without serious consequences. Our work truly lives on the street, on dirty walls in the hard light of the sun where the public and the elements have their way with it. It is never finished until it disappears forever. You may love Enzo & Nio or you may hate them, but when you come upon our work you can't ignore it. It is right there. In turn, by the nature of our shared experience and the freedom offered by it, we can't ignore you either. That is why we do what they do.

Why do we always hear things like 'take it to the streets', 'word on the street' and 'what does Main Street think?' The answer to these questions are, the street is the common denominator, the bell curve and the barometer of all things. You go to the street when there is nowhere else to go. You go to the street to shout at the world. You go to the street to gather those who are like you, to assault whomever or whatever stands against you. You go to the street because it is the great equalizer. The streets serve as a mirror on society.

Art is a large part of that reflection. Art addresses any and all the things that need to be addressed by a culture: anger, frustration, love, happiness, humor and parody. They all find their place. From hand-scribbled cocks on mailboxes to the most beautiful and

"THE STREET IS THE COMMON DENOMINATOR, THE BELL CURVE AND THE BAROMETER OF ALL THINGS. YOU GO TO THE STREET WHEN THERE IS NOWHERE ELSE TO GO. YOU GO TO THE STREET TO SHOUT AT THE WORLD."

elaborate paintings spread across the sides of buildings, all of it plays into exactly what is going on in a society. We're all street artists at one time or another, aren't we? Who hasn't taken chalk to sidewalk, pen to bathroom wall or lipstick to mirror? Humans need to communicate and we do. Enzo & Nio are no different."

ON PERSONAL ART

"Our first sticker campaign was with some friends at a concert in the 90's. Really though, our first street art was probably that first time either of us as a child scrunched some fat chalk against the concrete with all that freedom to draw as big and as messy as we liked. We all do it somehow, some way, at some time in life. In doing it, we are really saying: 'This is me!' 'I exist!' or 'Fuck you!' And it feels wonderful, doesn't it? Street art is the base art, the real art from which all others are derived. It started when our ancestors scrawled in the sand or on cave walls and has continued ever since. Humans make marks and express themselves. It all started before we built our first structures or ever placed a seed in the soil, with a primitive human getting some kind of enjoyment by making marks in the dirt with a stick.

In our public art we highlight anything at all really! We decided early on we wanted to do ANYTHING we wanted. We wanted the freedom to go creatively wherever we chose. Funny, cutting, arty, weird, stupid, anything. Wheatpaste, stickers, stencils, markers, piles of money, all kinds of things. We go where we like. There is no highlight, no single style, no real unity, only a license to do what we like how we like. Enzo & Nio have no style."

ON NYC

"Graffiti and street art are such integral parts of the New York City experience. That has a lot to do with a certain amount of acceptance and tolerance by the populace. As a street artist you become keenly aware of how many people think what you are doing is entertaining or valuable. We put a lot of stock in vibe. The vibe in New York City is authentic and real. The people are so true and matter-of-fact. Maybe it is a lack of pretense or whatever, but street art is just an integral part of the New York City experience. There is so much going on. There is newness to the scene on a daily basis. As a street artist, you can hit up every other city on the planet. But, until you are up in New York City, something is missing, no?

Our favorite neighborhoods are Williamsburg, Bushwick and Greenpoint in Brooklyn. It's the vibe and the flow. We really enjoy walking around late at night doing our thing and sometimes watching other people do theirs. Art ninjas, you know! They're everywhere.

We have many memorable experiences. Just putting up our larger pieces is, at the least, always very memorable. It's basically about the work and how excited you are to get it up on the street. You're always taking a chance and there is excitement about that. Sometimes, though, the memorable parts can be right before or after you hang the work, when you're in the bar just chilling and laughing. It is cool when people interact with you while you're doing your thing. Drunk girls can be funny as shit."

ON THE FUTURE

"A great deal of street art is becoming conventional and legal. In a lot of ways this is good for the genre because it offers access to a greater audience. However, commercial interests always seem to dictate what has the public's eye and they distort it for monetary gain. There are corporate sponsors now for some work. How depressing and lame is it when you see actual corporate logos or themes in some pieces? Plus some artists are becoming corporations in and of themselves. It gets complicated. There is a line you cross, when you cease being one thing and become something altogether different.

Luckily, some types of street art will never be establishment-friendly because they're purposely anti-establishment, anti-government, anti-commercialism, etc. A lot of good street art is just about the common man or woman saying 'I exist!' or telling the big man to go fuck himself and that stuff resonates.

As far as street art's role in society, it depends on the piece itself, the artist's intention and the public's interpretation. Street art is as wide open as any other genre and anything can be found within it.

Our role is taking things that we want to say and trying to present them to the public. Whether it is anxiety, anger, humor, fear or beauty; if we need to say it, we are going to say it. That is what street art is. It's a person's voice. We'll always be involved in it. It has been rewarding, it feels right."

ON YOUR PROCESS AND INFLUENCES

"We do a little bit of everything really. From wheatpastes, stencils, photography, painting, bundles of money, etc. right down to the tiniest of stickers and tags. That's because of that whole 'going where we want to go' thing. Traditional art has a lot of limits if you're trying to become successful; stay with one style, paint what the market buys and things like that. With street art you are talking freedom. Why not exploit that?

As far as influences, we can't really say. Anything or anyone can influence work. A song, a news report, a woman and all kinds of abstract things. Tough to say. We both have our own sources and influences. It's unlikely either of us could be specific."

93

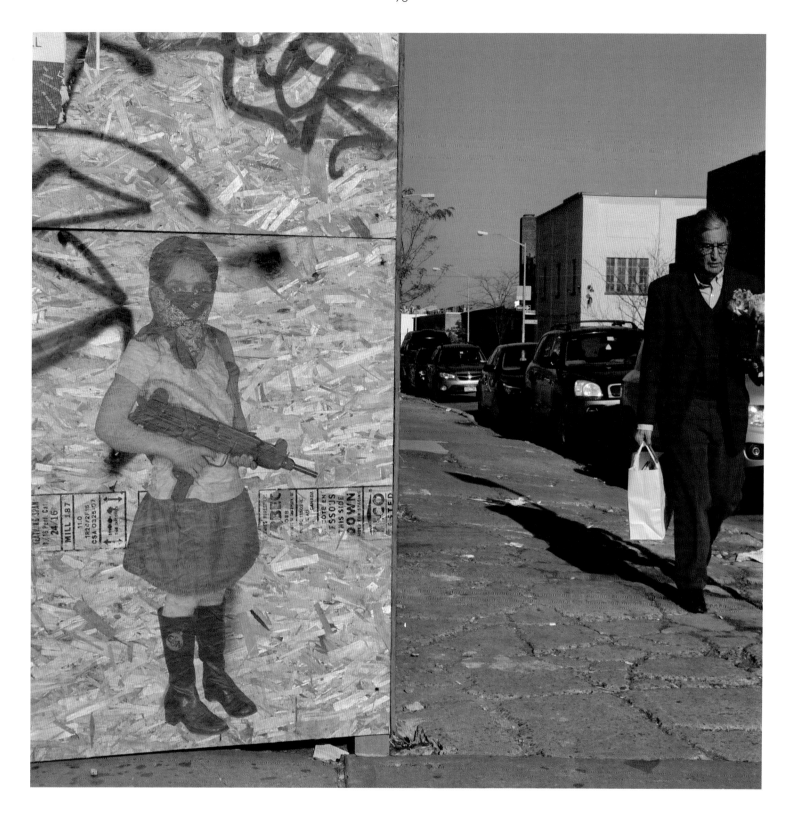

WYTHE AVE., WILLIAMSBURG, BROOKLYN

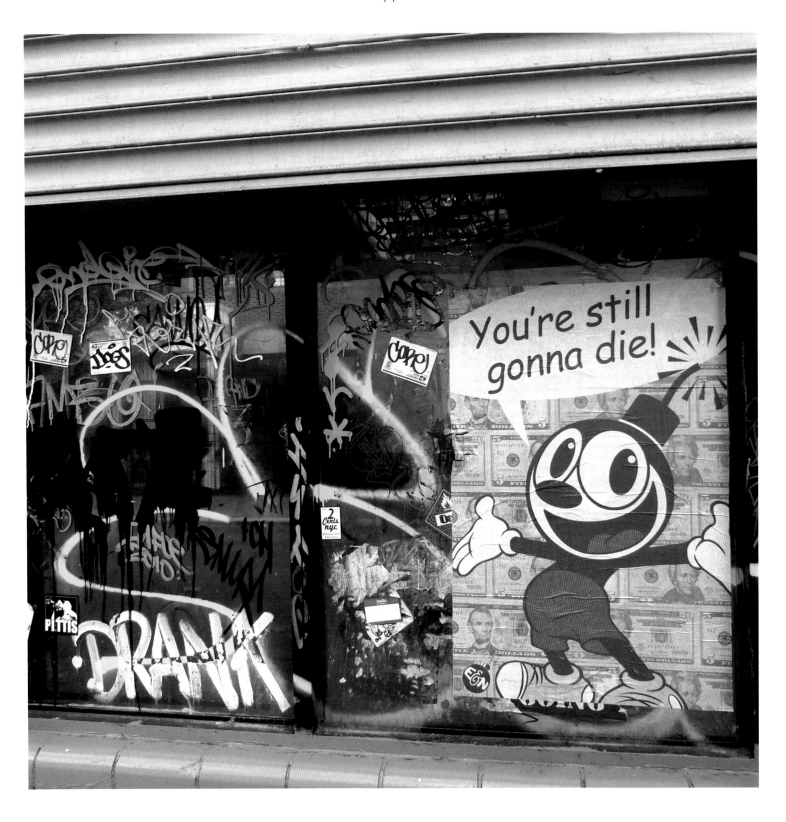

BOERUM ST., BUSHWICK, BROOKLYN

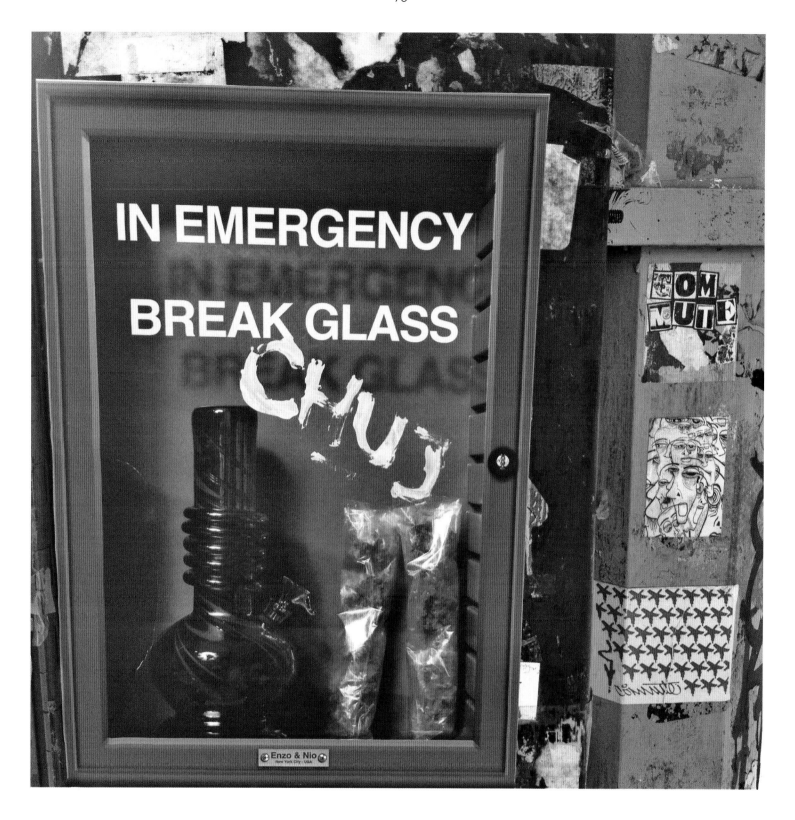

METROPOLITAN AVE., WILLIAMSBURG, BROOKLYN

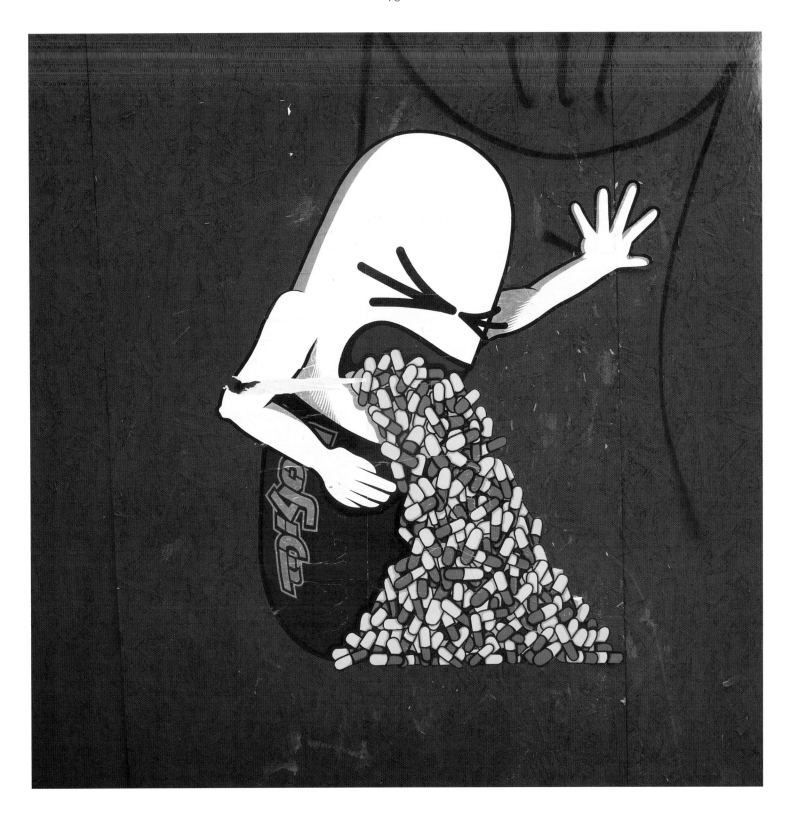

BERRY ST., WILLIAMSBURG, BROOKLYN

MIYOK

Miyok Madness hails from 'da' Bronx, New York. Heavily influenced by 90's graff culture, hip-hop and cartoons, Miyok started making t-shirts with a pill character he designed as a way to embrace the vices everyone indulges in.

MIYOK SPEAKS…

ON STREET ART

"Public art forces people to stop for a second and either admire or spit in disgust. Either way, the art engages the public, confronts everyday norms and attempts to arouse a response. Street art is getting very ostentatious with giant murals and public installations. In the era of social media and smart phones, it has become accessible to a wider audience. Human society has become more liberal with the arts and this has led to some commercialization of art in the streets.

I see graffiti artists doing canvas work as well as street work and being able to live off their art. That is a huge change from the previous dynamic. I mean, it wasn't unheard of but I think graffiti culture becoming mainstream has paved a way for more artists to live comfortably. The 'struggling' artist lives on but opportunities are more abundant now. There is also more daring and advanced application of installations that interact with the urban scenery. For example, Joshua Allen Harris' black garbage bag installations on the subway sidewalk vents."

ON PERSONAL ART

"I started looking to street art as a way to market my t-shirt designs. This may have been an attempt to tackle the street wear industry but the foundation of my motives has been and is to promote my art. The art on my shirts was meant to highlight my pill character and the Miyok message. Street art enabled me to appeal to a wider audience. I guess I was attempting to bring a different style to what was already an eclectic palette of urban art. I don't know if I hold any significance in the movement. But if I can be considered a part of it, then I am humbled.

My goal as an artist is mainly to highlight and question certain social stigmas in this generation. Miyok means drugs in Korean. Culture sees drugs as a taboo subject and anyone who partakes is denigrated. People are shielded and oblivious to their own vices and behaviors but are quick to label others. The way I see it, not everyone conforms to the dominant zombie lifestyle. I want everyone to realize that we are all weird, and to promote it."

ON NYC

"In any civil society creativity should be encouraged, especially in a melting pot such as New York City. In NYC we produce a myriad of styles and art forms thanks to the city's diversity. The street art movement continues to evolve and inspire new artists, different approaches and a multiplicity of techniques. Some critics say that street art is vandalism and it depreciates the New York City landscape, but we – street artists - are a part of the urban life and we are interpreting it through the landscape. I think it's important to have this freedom and this outlet to express ourselves as artists. Whether using street art, propaganda or other media, New York City is the most appropriate place to showcase how a civil society can embrace street art and not see us as a landscape blight.

Of all neighborhoods, I really like SoHo. But I have to say, much love also goes to Williamsburg, Brooklyn. I just get the sense that the people in Williamsburg are more in tune with their environment.

I remember one time when I had dodged a cop car a few blocks down the street, I decided to turn a corner, which would get me out of sight, and apply a Dr. Mario wheatpaste. Unfortunately, there was an unmarked car coming across the intersection and towards me, which I could not see. Soon enough it was all flashing lights, constant questioning about if I had needles (I understand his caution), and I was taken to 24 hour lock-up with only cheese and mayo sandwiches. Fun!"

ON THE FUTURE

"BLOW UP AND GO INTERNATIONAL! I want to spread my brand all over the world. I think the more people embrace street art, the more amazing the work will become. Fine art may not be for everyone, but street art is for the public. It's going to get bigger and I hope I can leave a lasting impression, however big or small, in this lifetime."

ON YOUR PROCESS

"I started off bombing with spray paint but limited myself to tagging. Then I switched to using the USPS mailing stickers for the on-the-go application. Being an old man now with limited time and an ambition for bigger pieces, I find that the most effective method for me is wheatpasting. Just me, a brush, some paper and paste. For my t-shirt designs I usually freehand a sketch and then use Illustrator or Photoshop to bring them to life."

"WE – STREET ARTISTS ARE A PART OF THE URBAN LIFE AND
WE ARE INTERPRETING IT THROUGH THE LANDSCAPE."

WYTHE AVE., WILLIAMSBURG, BROOKLYN

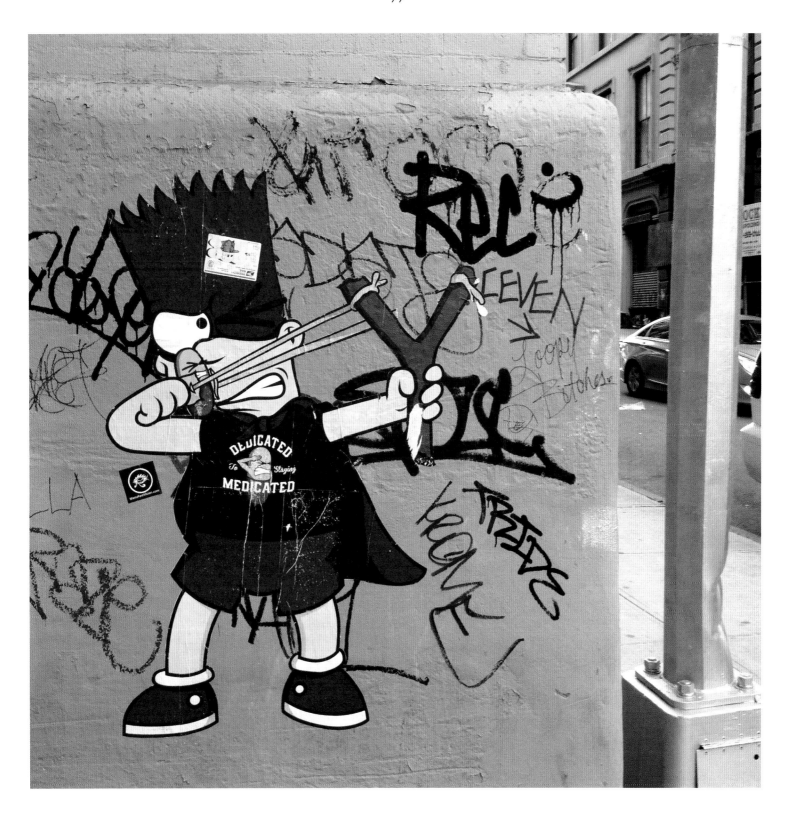

FRANKLIN PL., MANHATTAN

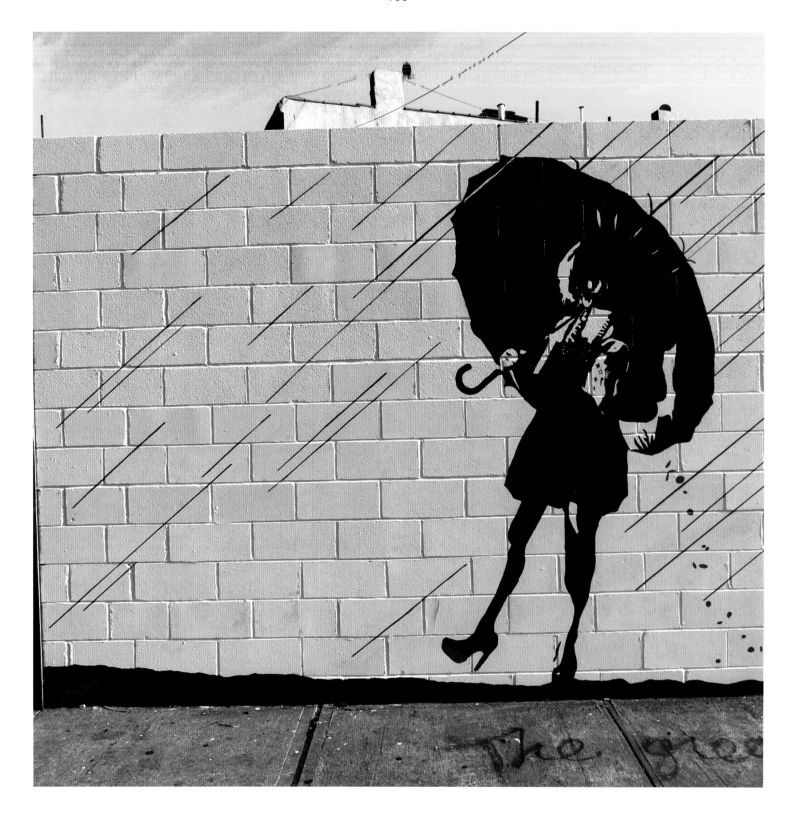

GRATTAN ST., BUSHWICK, BROOKLYN

GILF!

Gilf!'s work shines a spotlight on society's current state of self subscribed apathy and intentional ignorance. Inspired by the dialog gilf! creates with the viewers, gilf! chooses to create bright graphic presentations to grab the viewers' attention while simultaneously catching them off guard with a specific underlying suggestion meant to push them to question their reality. You'll find gilf!'s work on the streets throughout the United States and in galleries around the country.

GILF! SPEAKS…

ON STREET AND PERSONAL ART

"I abandoned my formal art training after graduation from school to work in furniture and interior design. But, living in post-9/11 New York City, I became disenchanted with the world around me. The erosion of the Constitution by our 'leaders', the exponential inflation of the Military Industrial Complex and the complete disregard for the environment sparked my need to speak up. Inspired by the always-beckoning wheatpastes of the artist Swoon, I cut my first stencil in 2008. My environment and the political climate inspired me to create again. With all the noise, the distractions and indifference in today's society, it was art that came through as a means of connecting with those I felt were most affected by our rapidly changing world.

Art is the most effective way for me to communicate. Otherwise, I feel there is so little being discussed. People are infused with entertainment on a 24-hour drip, which they translate to habitual behavior. You can't reach them through TV. Music does its part, but the mainstream garbage I hear in every bar I'm in makes me want to vomit on the DJ.

Gotta go guerilla, into the public domain, if you're going to get people's attention, if you're going to open their eyes. Street art allows you boundless freedom to say and make whatever you want. You are only governed by the limitations you set upon yourself."

ON NYC

"New York is a very outspoken city. Street art in New York City is just like the city; so much diversity, so many styles and countless stories and perspectives. One can understand (so) much about the cultural climate of New York City by looking at its walls. For me, the best neighborhood is Chinatown in Manhattan. It's so raw

and visceral. Sometimes I love the nastiness of it all, sometimes the madness is enough for me to swear off it for months. Every time I'm there I learn something new, I absorb a totally foreign culture and that to me is what makes New York City so special. You can throw yourself out of your comfort zone just by wandering a few blocks out of the way.

One of the last times I was out putting work up I got into a bind. I was on a super busy street and miscalculated the size of my piece. I got 3/4 of the way through it and realized I couldn't reach the top. Standing there alone covered in wheatpaste goo, I searched for anything that could boost me up. Nothing was around. Suddenly, two strangers stumbled by, completely wasted. Of course they were totally down to help. Not only did I get the lift I needed, but we also ended up grabbing breakfast and becoming friends. These moments, this energy in New York City, will always fuel my drive. The community is here; you just gotta take out your ear buds and put in a little effort."

ON THE FUTURE

"The future of street art? I'd rather not speculate. It's an ephemeral art form, which means it will be forever in flux and continuously evolving. Putting any confines on it is the antithesis of the freedom that art allows us. To quote Bjork: 'I don't know my future after this weekend, and I don't want to.'"

ON YOUR PROCESS

"When I started making street art I strictly used stencils, not for any other reason than my love for their graphic quality. Within the last year my materials and techniques have expanded tremendously. I've been working with wheatpaste, fabric, moss, screws and a bit of freehand spraying. I've always been fascinated with different materials and how they affect the viewer's perception of the work. Richard Prince once said: 'The subject comes first, the medium second.' I couldn't disagree more; I find the subject is born from the material. It's far more challenging to create a strong piece inspired by the material than to only think in a linear dimension and create from within the confines of your previous understanding. If it's not challenging, I'm not interested."

"WITH ALL THE NOISE, THE DISTRACTIONS AND INDIFFERENCE IN TODAY'S SOCIETY, IT WAS ART THAT CAME THROUGH AS A MEANS OF CONNECTING WITH THOSE I FELT WERE MOST AFFECTED BY OUR RAPIDLY CHANGING WORLD."

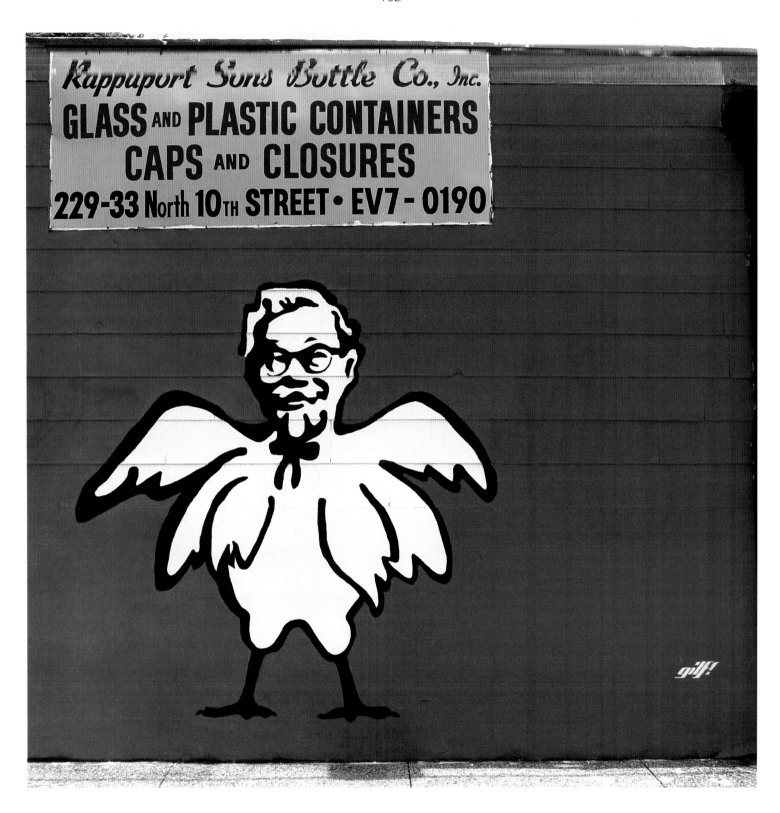

NORTH 10TH ST., WILLIAMSBURG, BROOKLYN

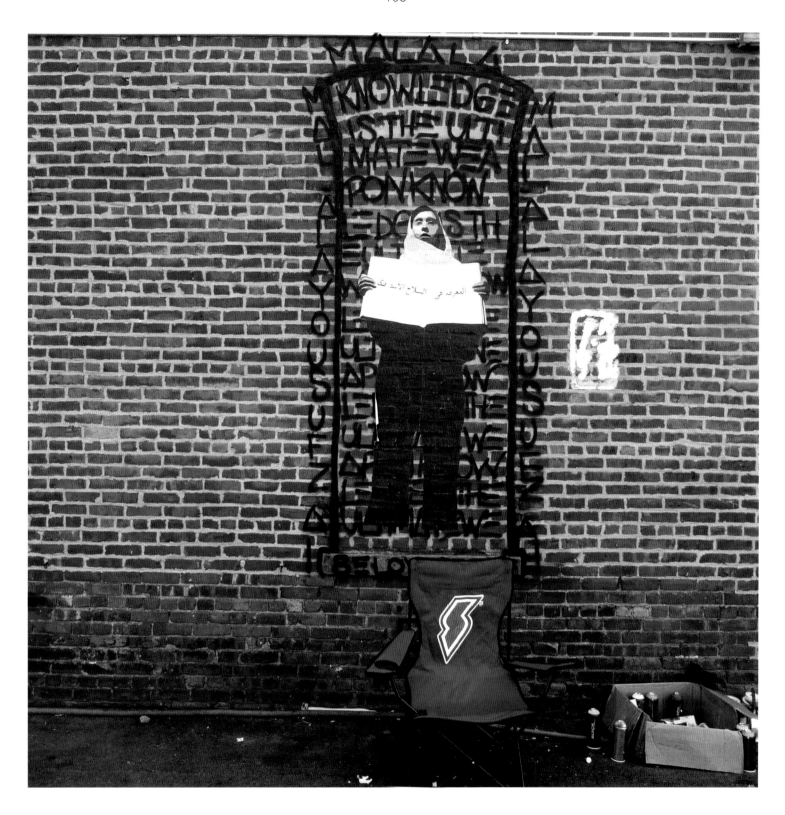

GEORGE ST., BUSHWICK, BROOKLYN

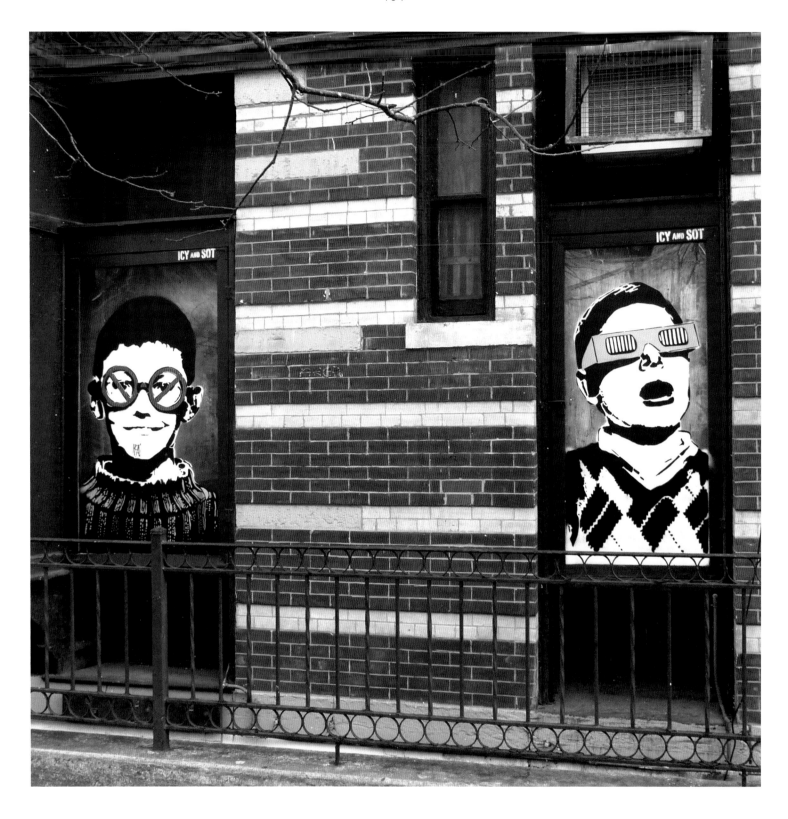

PRINCE ST., MANHATTAN

ICY AND SOT

ICY AND SOT SPEAK…

ON STREET ART
"The whole point of placing art in public is to make it accessible to a large audience and to make walls alive. Street art promotes a dialogue between the art and the people and by doing so, it may change peoples routine by transmitting important messages."

ON PERSONAL ART
"Our work on the street, especially Sot's, started as skateboarders. We used to make small stickers and stencils and put them in our favorite spots and gathering places.

We also do studio work and are showing in galleries around the United States. The main difference is that we really love to work on the streets because that's where we started as artists and it's where our art belongs. We will continue to place art in the street for as long as we can."

ON NYC
"It's been amazing how the different people in New York City interact with the art and vice versa. Each piece we've done has its own special characteristics that we love."

ON THE FUTURE
"We can't predict what's going to happen but know its definitely changing, for better and worse. We hope for the best and have been very fortunate to be at the present place in our careers. We loved street art from the very beginning and will continue doing it."

"STREET ART PROMOTES A DIALOGUE BETWEEN THE ART AND THE PEOPLE AND BY SO DOING IT MAY CHANGE PEOPLES ROUTINE BY TRANSMITTING IMPORTANT MESSAGES."

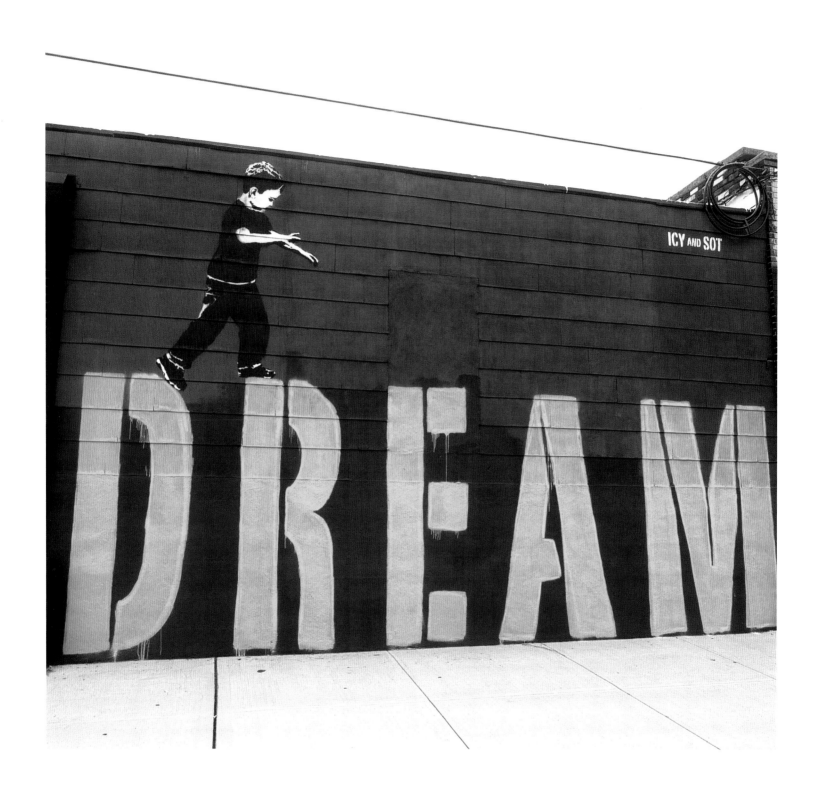

NORTH 10TH ST., WILLIAMSBURG, BROOKLYN

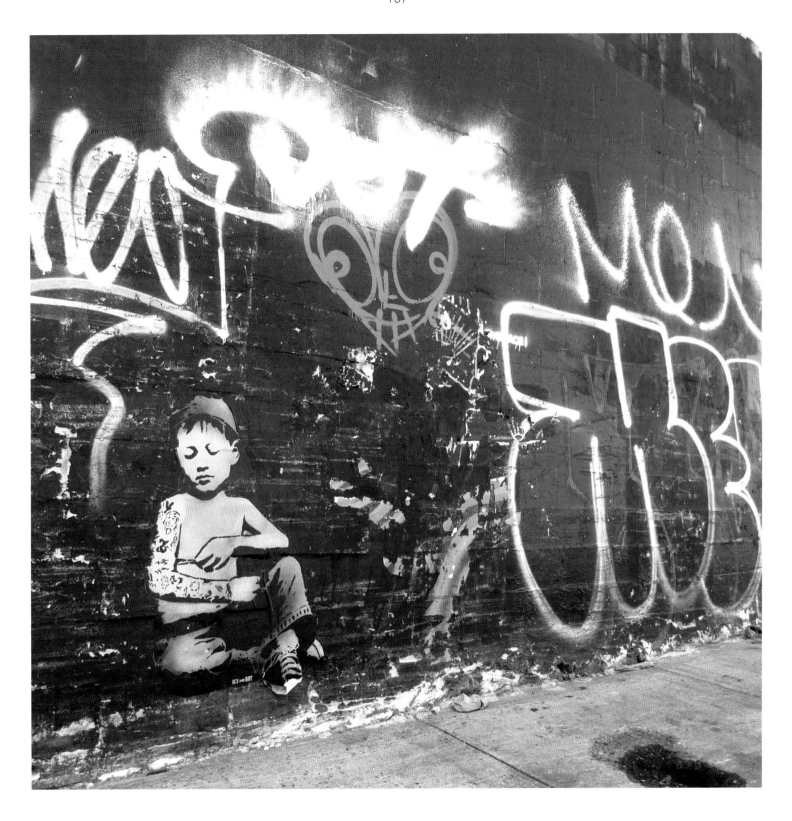

THAMES ST., BUSHWICK, BROOKLYN

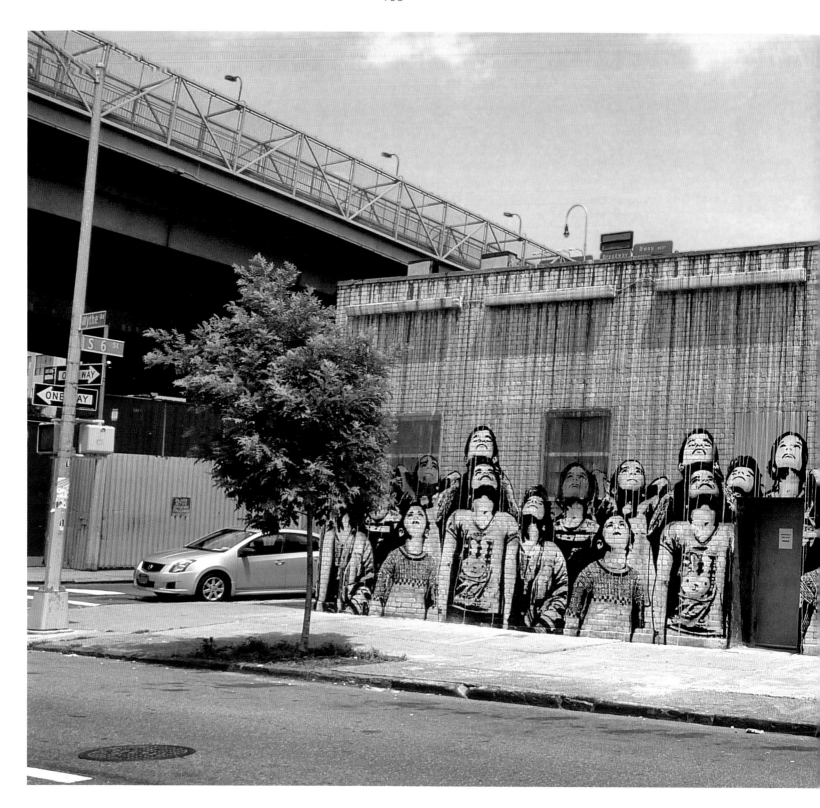

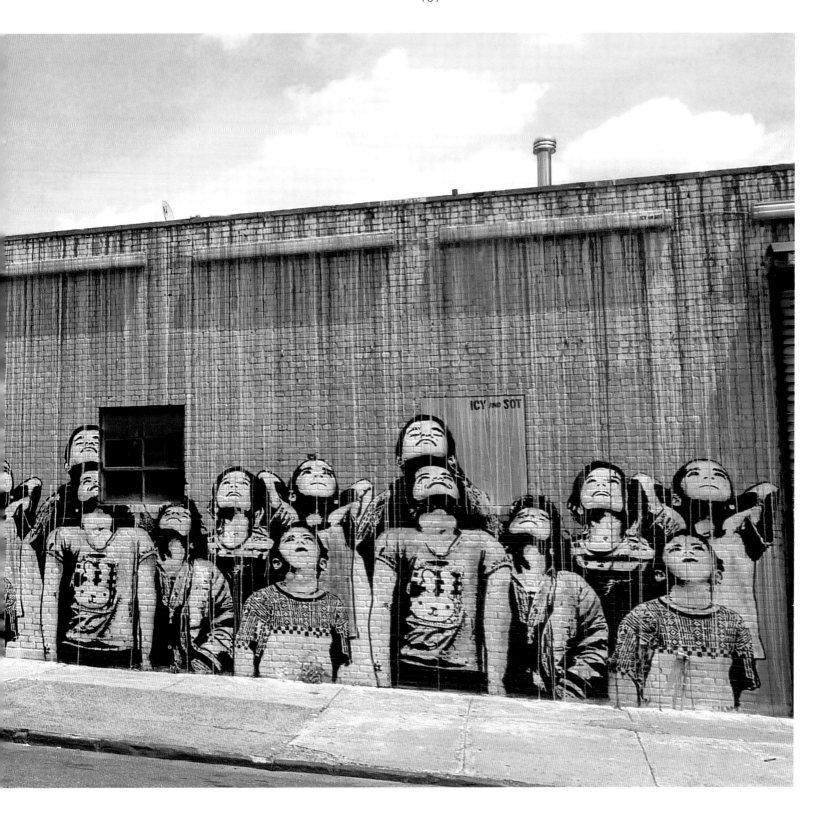

WYTHE AVE., WILLIAMSBURG, BROOKLYN

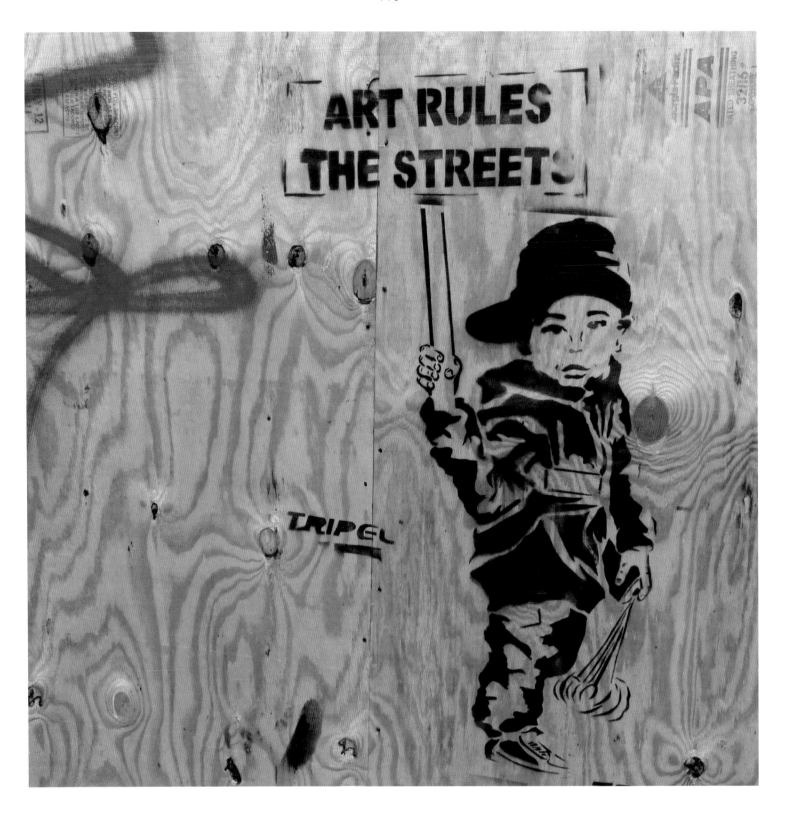

NORTH 5TH ST., WILLIAMSBURG, BROOKLYN

TRIPEL

TRIPEL SPEAKS...

ON STREET ART

"I chose to put my work in the street because I wanted to get an immediate response. Before street art I was just showing my art to my friends and family and hanging it on the wall.

The significance of art in the streets is that it symbolizes the people who live in them everyday. You are giving a piece of yourself to the street and sharing it with the world."

ON PERSONAL ART

"My main goal is that when I die I don't want to be just a regular person that slowly fades away in people's memory. I want to leave my mark on the world and be remembered for something positive that I did. To know that my work could influence others gives me great satisfaction.

I work from home as well as my friend's studio. For me, the difference between studio and street work is that in the street you get a rush when you pull off something in a great spot. You also get a quick response to your work, which gives you assurance that people dig your stuff. You have to be very quick and smart about how you go about your business outdoors.

The first main image I was putting everywhere was based on a guy who really came from the street and I felt he represented a piece of who I am. The Lucky images represent New York's true history, the side most people know very little about. Lucky was a man who ran the streets of New York City in the early 1900's. He also represents my culture as a Sicilian American. He made it through the struggle by any means necessary. I was born in Palermo, Sicily (Mafia central). My grandfather was a man of honor in Palermo who was shot and killed before I was born."

ON NYC

"I grew up in Brooklyn and this is my home. I chose to take advantage of living in the biggest, best city in the world; a city where you can put something in the street and thousands of people can see it everyday. New York City breeds creativity-motivated risk takers who will go to any means to express themselves.

One time my buddy Lambros and I got caught on a Friday in Chelsea putting up our new stencils near the galleries. We took way too long and chose a horrible spot. We spent the whole weekend in the tombs in lower Manhattan, which totally sucked. It was all worth it in the end. The funniest part was the public defendant was an old street artist and put me on to the artist Faile."

ON THE FUTURE

"Just going with the flow, trying to progress, wishing for the best. I think the street art movement will continue to grow and become huge!"

ON YOUR PROCESS

"I draw and paint, as well as do graphic design. I use mostly stencils and posters and stickers. I use paper and a projector to make my bigger pieces. All my designs start as drawings and then I perfect them on my computer. The main thing to keep in mind when doing very detailed stencils is to maintain good bridges to keep the stencils strong and durable."

"MY MAIN GOAL IS THAT WHEN I DIE I DON'T WANT TO BE JUST A REGULAR PERSON THAT SLOWLY FADES AWAY IN PEOPLE'S MEMORY. I WANT TO LEAVE MY MARK ON THE WORLD AND BE REMEMBERED FOR SOMETHING POSITIVE THAT I DID."

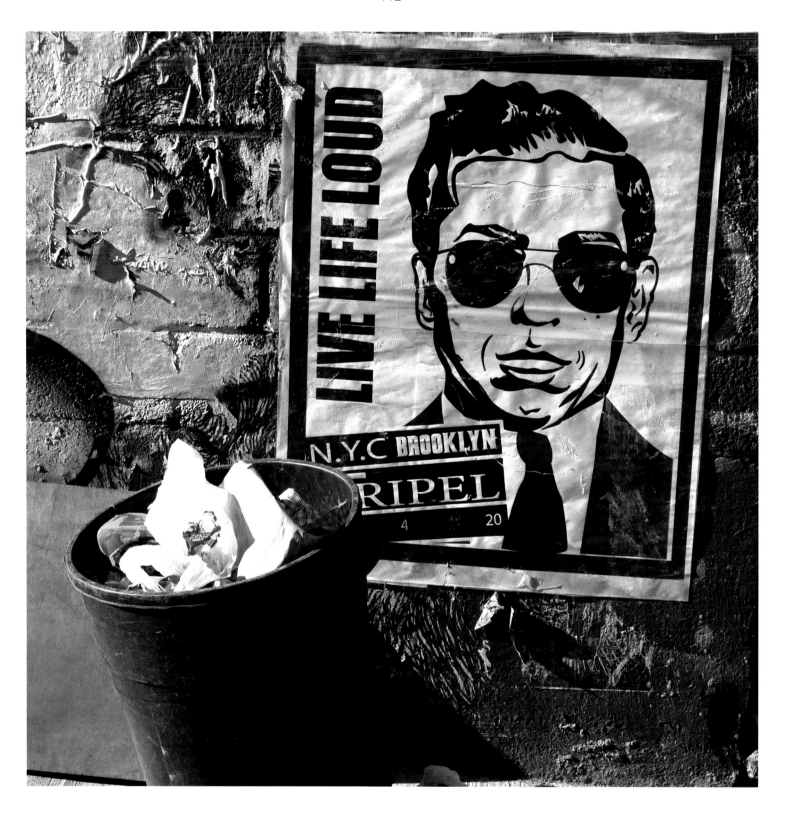

WYTHE AVE., WILLIAMSBURG, BROOKLYN

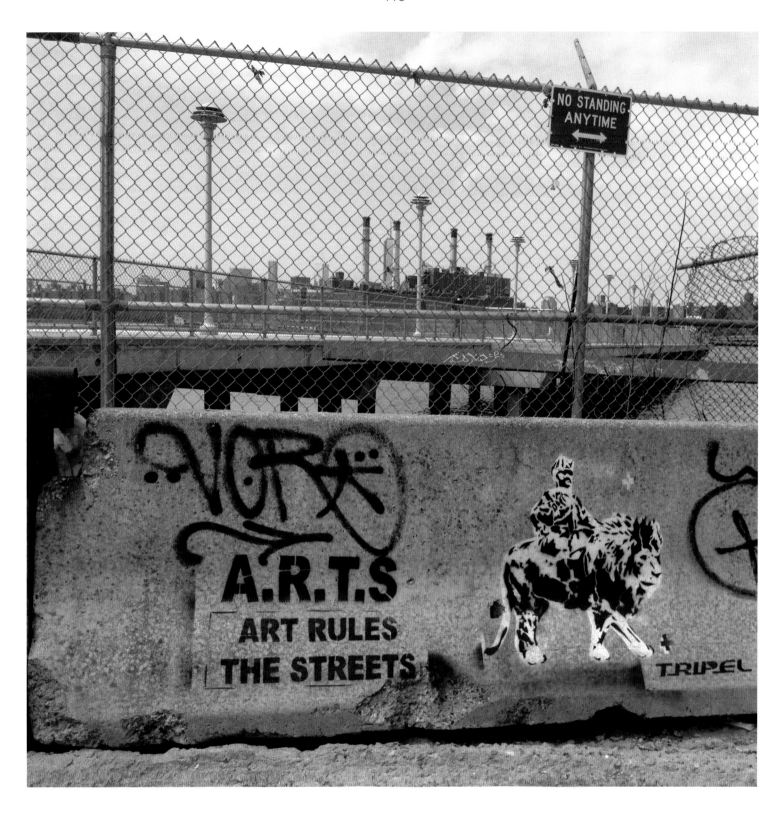

INDIA ST., GREENPOINT, BROOKLYN

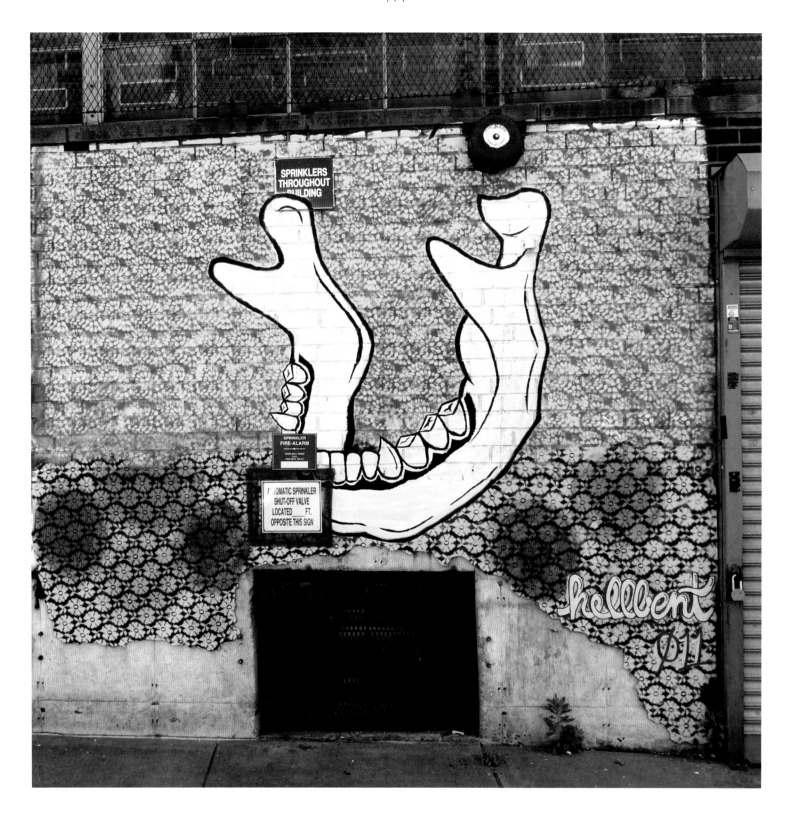

WELLING COURT, ASTORIA, QUEENS

HELLBENT

Hellbent is a Brooklyn-based artist. He has worked with most different street art techniques: spray cans, rollers, wheatpaste, and stickers, but became known for his hand carved wooden "plaques" of human jawbones and attacking animals with delicate floral stencil backgrounds. These backgrounds have become the main focus of his recent work, evolving in complexity and color toward total abstraction.

HELLBENT SPEAKS…

ON STREET ART

"I love the democratic nature of street art; it is open to anyone walking down the street. The gallery world is so wrapped up in who you know and there is only a limited audience who will get to see it in a gallery. People have no problem telling you what they think when they see something on the street. In contrast, people might feel stupid if they don't like something in a gallery because they feel that if it is in a gallery it's supposed to be good so they must not get it. It's not up to someone or some institution to tell you what is great. A tolerant society is able to deal with thought-provoking art in public, not just advertisements."

ON PERSONAL ART

"I started making art in the street about 13 years ago. I was still living down south and was influenced by the 80's art scene in New York. Discovering artists like Richard Hambelton, Basquait (SAMO), Barbra Kruger, and Jenny Holtzer and the work they were doing in public blew me away. My first works for the street were text-based pieces that I put up around town. The messages varied from censorship of art to socio-economic issues to word plays (one example read, 'Rat, Tar, ….').

I do studio work and it has evolved out of the work I started in the street. Obviously the studio work is a lot more refined and takes more time than the stuff going onto the streets. Now, I put hand carved wooden 'plaques' on the street with intricately stenciled backgrounds and these take time to make, more so than Xerox, wheatpaste or a character spray-painted on a wall. In doing this I emphasize the craft of working with your hands and with wood as a medium. It seems that in street art there exists a notion that quantity is more valuable than quality and I have a problem with that."

ON NYC

"When I moved to New York City 12 years ago I was blown away. At the time, there were still a lot of tags around but it was starting to shift. There were artists like Faile using a more graphic design sort of style; Revs and Cost with their massive rollers; UFO, Earsnot and Neck Face among others using humor; along with the old school tags that I found just as exciting. It gave me something to look at on my way to my shitty job at the time. It added another element to city life. I think the street art that's out there today is a reflection of the humor and intelligence of the city itself. My favorite neighborhoods have always been in Brooklyn. About 10-12 years ago Williamsburg was amazing and I feel that same energy that was there then, is now in Bushwick. Greenpoint also has a special place for me because it was the first spot I lived when I moved here.

I remember one day my buddy Elvis and I were set to do a roller on top of an abandoned building in Greenpoint. Cops got tipped off that we were there and we ended up sleeping in the building all night. We were on one floor while they were on another. We hid somewhere and then moved. They had the only entrance blocked so we were stuck. At one point we were under a desk hiding and the cops came into the room; we thought we were fucked. They were talking about where we could be and one of the cops even sat on the desk we were under. They never looked on the other side of the desk. After 8 hours they gave up and we strolled out."

ON THE FUTURE

"I think that, just like any art movement throughout history, street art evolves and grows. My work of late has become more abstract. It is no longer about just getting your name out there. Artists are also becoming more sculptural and using technology to create exciting new work that is expanding and reinventing what is possible."

ON YOUR PROCESS AND INFLUENCES

"I have used many different techniques over the years. I really enjoyed doing rollers years ago. It was exciting working upside down and hanging off the side of a building. Lately I have been doing a lot of hand made stickers. It is fun in that you can try different hand styles and lettering just to keep yourself from getting bored. Mainly my work focuses on using lace as stencils to create geometric abstract motifs.

I think the biggest influence on my work has been the work coming out of Brazil years ago. Artists like Zezao and his use of abstraction were an inspiration, Augustine Kofie in LA also for that reason, along with several artists in Europe. I have always wanted to do something different and I think it is good to know what is going on around the world."

"A MORE TOLERANT SOCIETY IS ABLE TO DEAL WITH THOUGHT-PROVOKING ART IN PUBLIC, NOT JUST ADVERTISEMENTS."

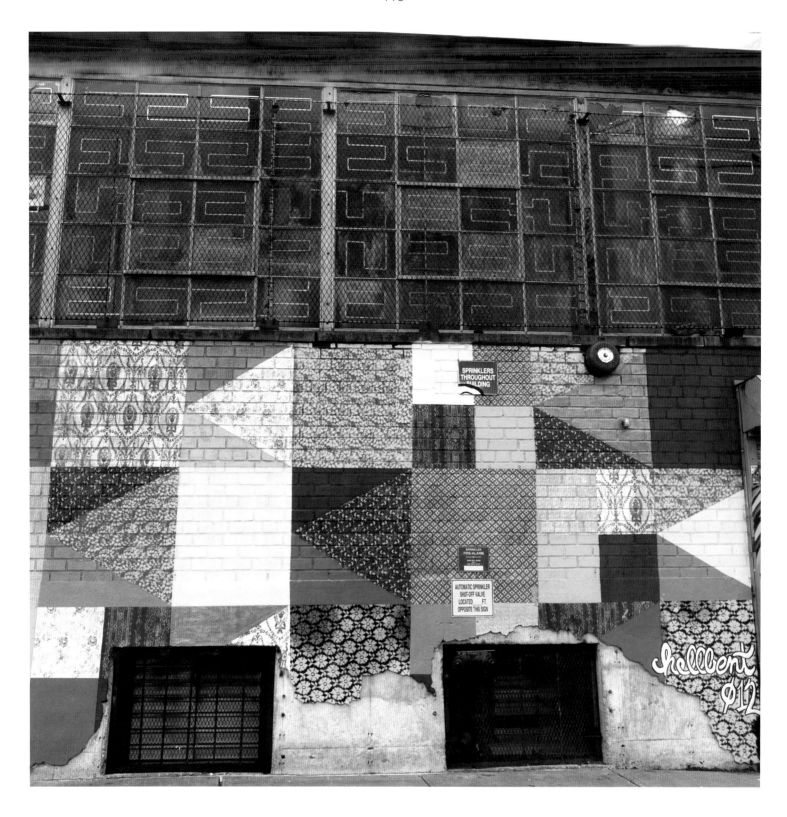

WELLING COURT, ASTORIA, QUEENS

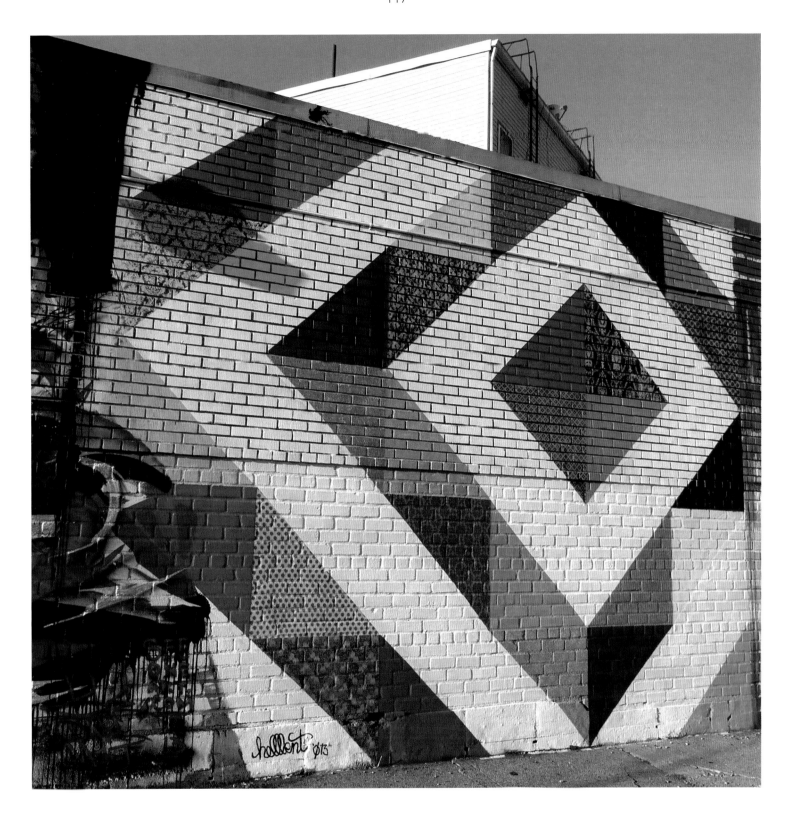

29TH AVE., ASTORIA, QUEENS

ST. MARKS, MANHATTAN

EKG

i am the hammer. i'm a killing device, and you'll die if you think my name. - dethklok.

EKG SPEAKS...

ON STREET ART

"why tagging? because of the simplicity and power, speed and portability, safety and crudity.

the tag was the original modern illegal aesthetic manifestation in the late sixties, dubbed 'writing' which over time became more universally known as 'graffiti', a simple mark, the primitive shout, the protester's fist, heavy metal's devil-horns salute, #occupy's anonymous mask, a quick effective and direct transmission, a rambunctious and unapologetic symbol on a mission to make a connection utilizing guerilla broadcast tactics, causing ripples and resonance throughout the aether with minimal risk and maximum impact on populace, an all-city marked geographic territory suggesting massive vision and limitless strength, an infinitude of geographically dispersed illegal marks delineating the boundaries of an entity, circumscribing its outer planes, the ghostly silhouette of an omnipresent presence with a sense of engaging omniscience, a mythological semiotic entity as large anonymous mysterious heroic as the imagination of the receiver

this intention, transmitted at the core of any illegal public aesthetic manifestation, inherently questioning the dominant system, challenging all structure and control, like this textual space in relation to this context, hacked spliced rechanneled onto a rebellious literary trajectory in order to create a theoretical and philosophical construction, a concrete metaphor representing it's content, a pyre of signs fuming, a crystal ball snow globe sparkling boiling and churning, a television channel of blinking flowing static that makes sense as language on some other perceptual level, more personal theoretical subjective-analytical, a smoky visage illuminated by laptop-blue-glow contours fluctuating like a mist in the windowpane superimposing our sparking faces over the glowing circuitry of the urban grid, a brilliant map of bio-data movements and economics, as shimmering in its self involvement as in its frenetic activity, the populace speaks in sparks and curves, anomalies and trajectories, irruptions and comets

a functionally-autistic empathic transmissionary semiotic relay tower, wraith rendered in sparking snowy static, a multi-dimensional log running equations, raining-down and wafting-up in vertical singularity and tumescence, ignited by biochemical neurological censures and wormy cerebral tendrils, rendered by the dusty schematic scroll, a blurry data feed streaming back-and-forth within the neuro-electrical semiotic interstitial space, triggering behavioral mechanizations and aesthetic visions, protocols embedded in the machinery of transmission, the demiurgent gears and cogs of the aether, metallic intestines rendered by star-delineated figures in an astronomical map of the heavens, between analytically-derived emotional algorithms and fragile visionary illuminations, singular aesthetic forms connecting, shimmering streaming rippling with the resonance of emanating transmissions signals heartbeats pulses, neurons firing, galaxies igniting, universe born"

ON PERSONAL ART

"the passion drive output strategy and remnants of an artist's street actions schematize, render and broadcast a portrait of the artist's identity and personality, choosing to use illegal aesthetic manifestations as a means of transmission imbues the artist's statements with the aura of rebellion and revolution, inherently defining them as anti-status quo marks, ironically defined by the very structures and mechanisms that deny and censor them, the dominant class evident metaphorically in every detail of the architecture and infrastructure of any urban space, but individuals are the heart of all cities, semiotic bootleggers, values and transactions defined by individualistic human motives, love affairs and communities connected, alternative distribution channels and under-cover-of-dark methodology, each illegal aesthetic action creating a meta-tag, a link to an identity, another philosophy another universe of singular depth and horizon, data flux across aetherial transcircuitry, these signs of creation and signifiers of life decoordinate and resystematize en masse representing the pulse of the city as a grid of many intersecting matrices, the heartbeat of the city, the voice of the populace

unsurveyed undesignated unmonitored secret agents infiltrating the cathedrals and catacombs, zorro and robin hood revolutionary spaces become the petri dishes of freedom and experimentation, creating new rules, new communities, new algorithms eventually to

"... THE SYMBOL, THE TRANSMISSION, THE SIGNAL, THE BLIP, THE WAVELENGTH, THE PULSE, THE HEARTBEAT IS A METAPHORICAL META-TAG HYPERLINK, DESIGNED FOR SPEED MYSTERY ABSTRACTION DEPTH INSPIRATION CONDUCTIVITY AND CONNECTIVITY AD INFINITUM."

replace the outmoded cogs and gears, the body politic in reaction to abstract systemic control at its purest, creates dialogue and influences decisions affecting society and culture, as well as on a poetic individual emotional existential level for each viewer, each resonating on their own wavelength, but then also blending together on progressively higher levels of frequency, the intersection, a spectrum of wavelengths defining an individual residing within connection and community on the one channel, the street, its visible public surfaces, the display nodes, stone age monitors broadcasting blood sweat and stone chiseled surfaces, covered with scribes paint ink spray paint stickers wheat pastes rollers extinguishers

engage, encounter, embed, click on the remnants of their revolutionary aesthetic actions, the performance residue, the intellectual sparks and cerebral instigations, emotional connections and personal relationships, all deviations from the proscribed boundaries, coloring outside the lines, creating dna-html hyperlinks, fresh neurological connections, double-clicked pigment, another page opens revealing a landscape of vibration: personalities, philosophies, political ideologies, psychotic ramblings and so on, en masse, graffiti and street art are an expression of the diverse and plural populace of a city, a stone tablet inscribed with their voices, their visual manifestations of individuality emotion humor confusion surprise ideas love protest … ekg … the symbol, the transmission, the signal, the blip, the wavelength, the pulse, the heartbeat is a metaphorical meta-tag hyperlink, designed for speed mystery abstraction depth inspiration conductivity and connectivity ad infinitum. EKG is an acronym for electrocardiogram, a limb for the tree to hang from, a heart on the sleeve, a pulse in the veins, a light bulb in the head"

ON NYC

"and then there were coordinates: everything, all beings, all physical landmarks, all surfaces, all interactions and exchanges, all forms, actions, energies, marks, are abstracted, designated, mapped, and digitized, even as they continuously shift and reconstruct as scrolling geometric formulae spooling out like rolling waves on all axes, in all dimensions on all psychic and physical levels, resonance tumescence and value transparent and sparkling in a mist of vectors and code, signals and data, symbols and transmission, universal and institutional diagrammatic

renderings glow on the surface of consciousness psychic peripheral vision, a cyborg guidance system, a video game dash board, illuman pregnant with purpose and direction, full of suggestions and choices, denials and regulation, defining a universe, a world, an entity, reality, the aether

an undulating, three-dimensional polygon, wireframe-rendered environment of electromagnetic waves, string theory and intersecting graphed and charted surfaces creating a sea of rippling planes, numerically derived surfaces rising and falling, swooping and flowing, boomerangs and comets, satellites and asteroids, grinding numerical intestines scribing DNA poetry on mirrors glass tiles retina, instigating flailing internal frission, manifesting in that breath of adrenaline and connection, that sweet spot between groups of bio-statistical apparitions, a pedestrian rhythm composed by the street lights' metronome, a pulse designed from patterns based on the systemic collection of data from the quotidian motions of the masses of biological organism's defining pertinent equations and taking poetic license back from the economists accountants and legislators, creating a pulse and an absence, an unregulated space, an unsurveyed moment, a temporal allowance by default, defining a pause in time, a glitch in the system, cloaking device in effect, an invisible wraith unnoticed by the radar, a choice moment to tag, lean down physically, rise up culturally, innocence and domination, just tying my shoe, orange laces over and across, horizontal line, squiggle, shift, second horizontal line, almost always left to right, shoe tied, david slew goliath, check phone, smoke, subway"

ON THE FUTURE

"illegal aesthetic action! and its semiotic resonance, meaning and mutation, as it trickles up, infiltrating and mutating culture and society, as action painting leapt from the canvas to all other surfaces of reality: kaprow! onto the floors walls and ceilings of studios to the streets walls subways of the modern urban environment to the monitors nodes and display surfaces of the new millennium aether, all subcultural elements, transmission techniques, and formal aesthetic elements of the illegal aesthetic manifestation aka graffiti and street art, the alternative channels of distribution, are all defined by the illegality of the modern rebellious signal

signals, transmission, the interaction, the conversation, an interchange on an emotional biological and mental level between the mark and the viewer, an internal and interstitial exchange, sparks and threads strung back and forth, or why would artists continue to seek out this form of communication to broadcast and find connection? Why would an audience continue to be puzzled, fascinated and moved to passionately support these artists involved with illegal aesthetic manifestations? why would so many different types of dedicated artists risk personal physical safety and legal social ostracism because of the illegal nature of the unsolicited public aesthetic activities? since birth, on the radar, designated with coordinates and expectations, forever free to wait for the light, smile for the camera, under surveillance and under threat, for our safety and intimidation, the resulting physiological state of this biological form vibrating within that bio-electromagnetic net, utilizing an aesthetic tool on a public surface, imbuing the shape size content materials of the art form with the essence of the new millennial gesture, the actions of one watched, that which is watched in a certain manner reacts in certain ways, influencing all actions on some level in relation to the emotio-physiogonomy of the artist creating art while in an environment being viewed and monitored, an uneasy desire for personal connection and cultural recognition in contrast with having to remain masked, empowered by being anonymous unnamed unnumbered unenumerated"

ON YOUR PROCESS

"numerical designation and physical surveillance affects the form and style of the manifestations in terms of speed technique and size, so those who see the art are also aware on some level just what was put at risk to transmit that signal, even the personality of the artist through his control, placement and affiliations, creating a massive alternative identity, an aerosol avatar, a geographically-expansive physical presence, by getting up all-city, all-world, all-universe, multiple coordinates defining an omnipresent and omniscient avatar, multiplicitous and idolatrous, voodoo against the gods, blood stains on the tiles and in spills on the graph paper, squeezing and whizzing through the fizzing interstitial spaces, arms spread wide, hands clutching revolutionary aesthetic tools, bubbling and churning vats of homemade inks splashed and setting fire to walls, caps and cans controlled explosion,

belton molotov cocktails and montana twin anti-psychotic aerosol propellant systems, made manifest, smooth and opaque, yet antisocial, grumbling and fuming

writing and graffiti and aerosol art and bombing and piecing and productions and public art and street art, a cornucopia set afire, a dog with its ear listening to the blaze, the flames kicking their ears, clouds of smoke billowing from its bounty, hand-mark typography and wheat-pasted pages of idolatry, prophesy and illumination, ornate and elaborate in their illustration and commentary, print and digital manuscripts, different channels, similar revelations of the holy infrastructural doctrine of all systems, releasing alpha-beasts scurrying up the cloud of grey roiling air and floating elements of markers spray paint stickers wheat paste liquid nails rollers fire extinguishers creating a physical presence through mount Everest flag-placement and surreptitious dissemination tactics, the body is evident in the marks, the gesture is embedded in the code, personal jeopardy is defined in the placement of the mark in the spot, mysterious anonymous identity auras manifested in the disconnection between action and viewing, all signs releasing a pollen of transgression, hulahoop halo mind games, lightbulbs bursting with eternal flame snatched from the mouth of the dragon as it was slain by the hammer"

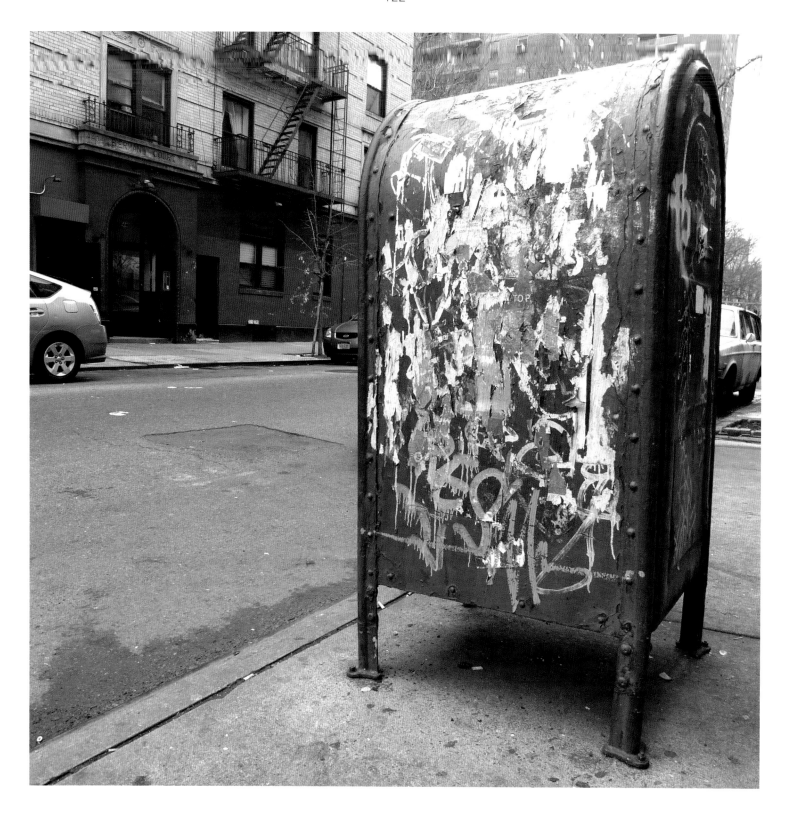

ST. MARKS, MANHATTAN

NORTH 10TH ST., WILLIAMSBURG, BROOKLYN WITH ADAM COST

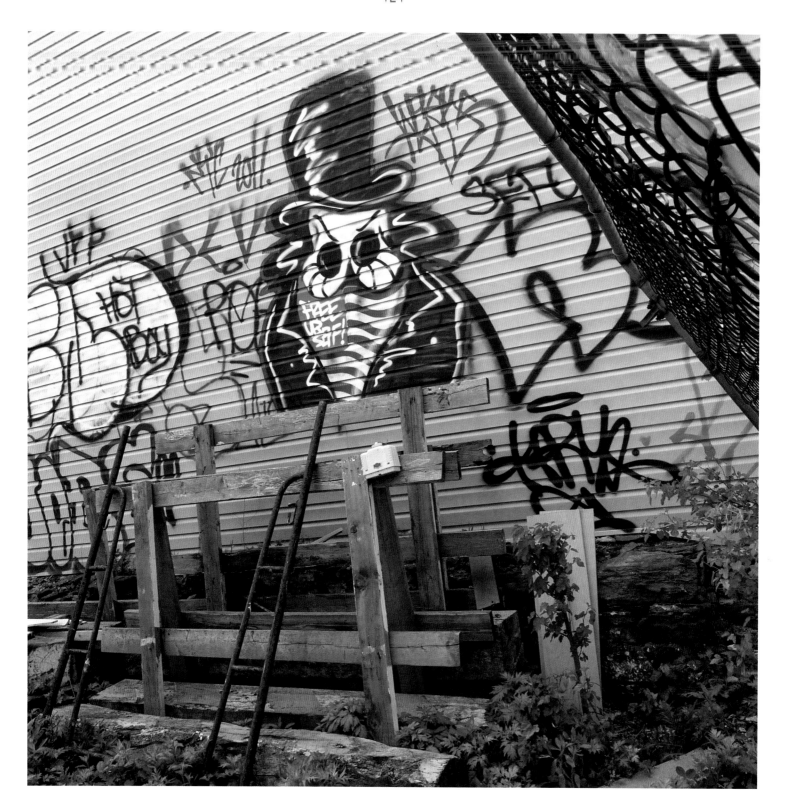

INGRAHAM ST., BUSHWICK, BROOKLYN

OPTIMO PRIMO

OPTIMO SPEAKS…

ON STREET ART

"Street art is the new name for graffiti. It's a way of communication and it documents people's expressions during any given era. Nowadays people often use images that are edited with digital technology as references. I have even seen people use projectors to reflect images that they then trace onto walls. Some people consider this 'cheating'. Some people just have raw skill and don't need a crutch."

ON PERSONAL ART

"I'm a product of my environment. Growing up in New York City in the late 80's and 90's, graffiti was a natural thing to do; sort of like moving your body when music plays or getting aroused when the opposite sex gives you provocative gestures.
I started painting more characters and slowed down with letters and then the public started to consider me a street artist as well as a graffiti artist. It is important for me to highlight my thoughts, signature and year it was done.

I also do studio work. Studio work is private and the intent may be different. It depends if the work is meant for sale, for display, for self-pleasure, a commissioned piece or a gift for someone. If a painting is meant as a gift, then it serves the same purpose as a public piece, whether illegal or legal."

ON NYC

"New York City is the heart of graffiti and where I was placed at the beginning of my path. New York City street art reflects the constant flow of different ethnicities, genres and different messages each individual wants to put out when making their mark. Civil society is warming up to seeing a more colorful city, though I feel people are brainwashed by having seen this or that 'street art video.' A couple of millionaires can change the way the public perceives street art.

My favorite neighborhood is Bushwick, Brooklyn. There's a lot of graff homies out there and girls who are down to chill with us as we are. It's a bit of old New York with a mix of the new. Growing up in Manhattan you forget that the world is not as diverse as The Big Apple. Bushwick reminds me of going downtown to Greenwich Village with my sisters to chill in the 80's. It was fun to see all types of 'muda fajain' people throughout a day. Now I'm one of them.

One time I worked on a piece that was as big as a five-story cliff in Jersey. The piece I painted was close to 40 feet long and 8 feet high. I worked on it through the night and was stuck up there. I called all my homies and no one picked up their phones. I thought about calling the fire department but felt like that would just be snitching on myself, so I fell asleep and woke up with the sun in my face. I was pretty twisted that night so when I did wake up, I was like, 'What the fuck? Yeah this is my life.'"

ON THE FUTURE

"Same as always, paint till I faint and no sleep till my mission is accomplished!

In the future there will be more legals than no-permits and more people doing street art for the wrong reasons. People should give themselves a chance to fall in love with the craft before they consider making a living off of it. Lots of people are getting into the game for the wrong reasons, sort of like with skateboarding."

ON YOUR PROCESS AND INFLUENCES

"If I could use spray paint for everything I would. I learned through my ups and downs to be pretty diverse with mediums and materials. A true artist will work with what they have.

I've been influenced by the people closest to my surroundings, most remembered were graffiti writers: WOLF1, SHARP REAS AOK, A CHARLES, REVS & COST, SABE KST, TOOFLY, MERES TD4, WANE COD, EWOK 5MH, LACE NYC, LEAH, OUCH R.I.P, GOAL RTH, THE WHOLE AIDS KREW and most of all my mentor, second in command, MOK DR.WHOM."

"GROWING UP IN NEW YORK CITY IN THE LATE 80'S AND 90'S, GRAFFITI WAS A NATURAL THING TO DO; SORT OF LIKE MOVING YOUR BODY WHEN MUSIC PLAYS OR GETTING AROUSED WHEN THE OPPOSITE SEX GIVES YOU PROVOCATIVE GESTURES."

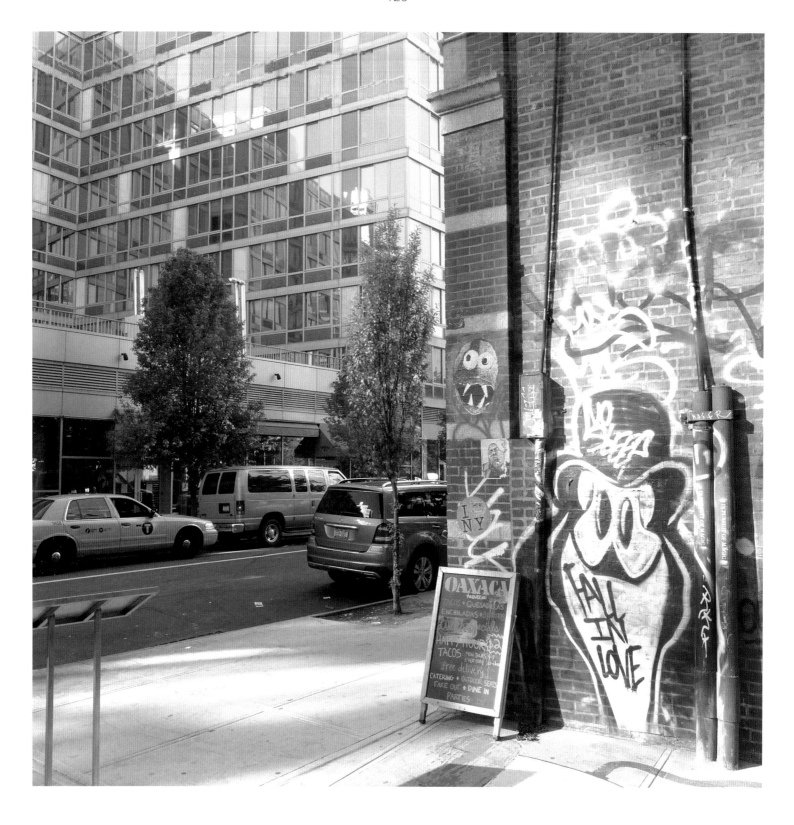

1ST ST., MANHATTAN

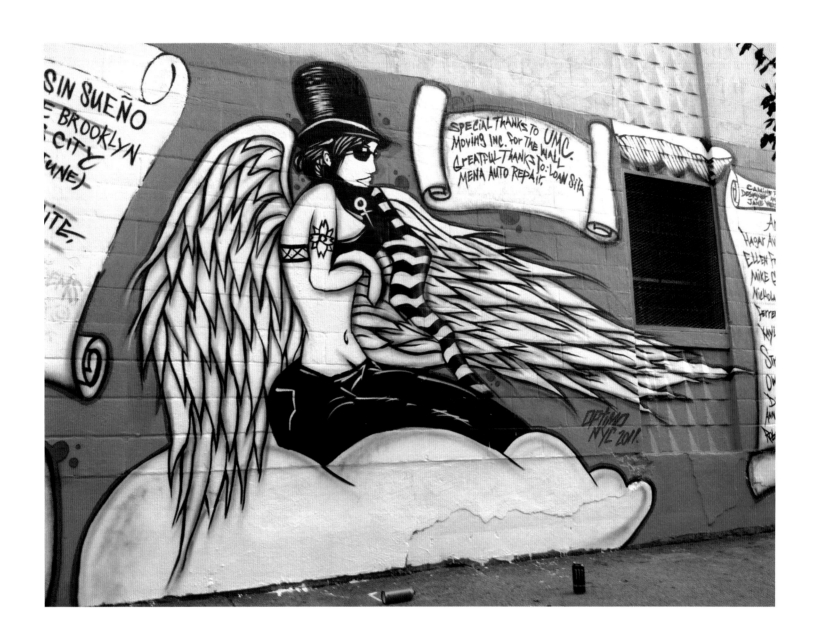

STARR ST., BUSHWICK, BROOKLYN

WELLING COURT, ASTORIA, QUEENS

ROYCER /ROYCE BANNON

Royce Bannon is a born and bred Harlem artist whose infamous monsters can be seen pasted on doors and walls throughout the five boroughs. His iconic monsters are recognizable with their emotive eyes and, often, razor sharp teeth. As a member of the street art collective, Endless Love Crew, Royce has participated in various collaborative live paintings, group art shows, and solo art shows throughout New York and the world. On any given day you can find Royce painting monsters, silk-screening t-shirts, spraying stencils, or slapping stickers up on various spots in New York. Royce also curates shows that feature a variety of artists including fine, graffiti and street.

ROYCER SPEAKS…

ON STREET ART

"I like to see art on these boring drab streets, plus it's fun to do. I guess some artists see it as a way to get their art to the masses as not everyone can be in a gallery show. I really haven't been into street art lately; it's getting kind of corny and oversaturated, so you have quantity over quality. I have been looking towards the graff(iti) scene, which never ceases to amaze me."

ON PERSONAL ART

"I started doing more graffiti when I was in my teens but wasn't very serious about it. It was just a way to be rebellious and have fun. My gallery work tends to be more refined; I take my time on it. The street work is rawer in feel. I do characters, so I'm not really trying to relay a message; I just like to surprise people with my characters."

ON NYC

"I was born and raised in New York City and graffiti started here, so why not continue the movement? I think each artist in New York has a different message. Some artists want to put a message in their work; some folks just want to get up. Not all artists are from urban areas, so I guess it just depends.

One thing I will always remember is getting arrested. It is always memorable no matter what because it sucks!"

ON THE FUTURE

"I'm gonna keep doing what I do and hopefully make some money off of my art. That would be nice. Otherwise, as for the future, who knows?"

ON YOUR PROCESS

"Lately, I've just been tagging a lot and drawing my characters directly on the streets and making stickers. I love stickers because you can keep them in your back pocket and put them up very easily. I usually use a lot of krink or mean streaks."

"I STARTED DOING MORE GRAFFITI WHEN I WAS IN MY TEENS BUT WASN'T VERY SERIOUS ABOUT IT. IT WAS JUST A WAY TO BE REBELLIOUS AND HAVE FUN."

12TH ST., ASTORIA, QUEENS

MESEROLE ST., BUSHWICK, BROOKLYN

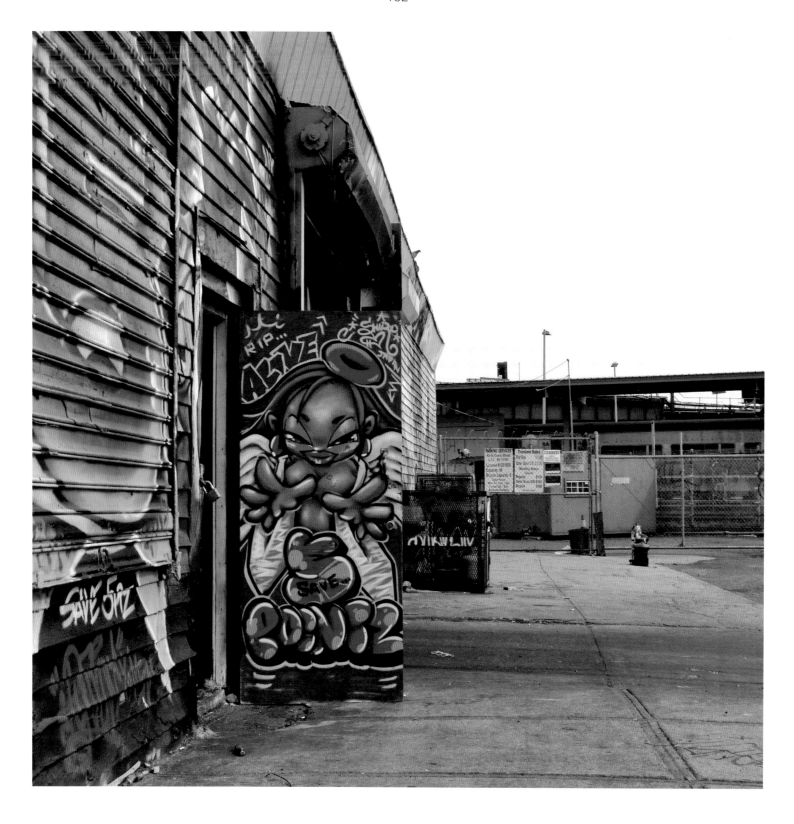

5 POINTZ, LONG ISLAND CITY, QUEENS

SHIRO

SHIRO SPEAKS…

ON STREET ART

"Public art is more free, fun, communicative and dynamic than art on canvases in museums. I work a lot on the streets and I have my studio in which I do fine art. My motivation for studio work and street art is almost the same. I can play with different mediums when I do studio work but I much prefer spray-painting large-scale pieces outside."

ON PERSONAL ART

"My character 'MIMI' is my alternate self. 'MIMI' reflects experiences and emotions I go through in my life; feeling happiness, sadness, lonely, scared, angry and horny. I just want to develop with 'MIMI' and look forward to seeing how she turns out in the future. I just follow the flow of my destiny."

ON NYC

"When I watched the movie 'Wild Style', I decided to move to New York City. I used to live in Queens and Brooklyn between the years 2002 and 2004. When I first came, I started looking for friends who were into graffiti but initially couldn't find any. After I spent all my money, I decided that I had to go back to Japan. However, right before I went back, I met Toofly and ACB (R.I.P.) and painted a mural at Hunts Point in the Bronx for the women's hip-hop festival. That was in 2004. That first project launched my artistic life in New York. Nowadays, I come back every summer and every other chance I can get. New York City is an amazing city; each area is unique for its different character, style and flavor."

ON YOUR PROCESS

"I like painting large scale and quick, so I like spray paint the best. Controlling spray paint cans is difficult but it can facilitate many forms of expression. Learning how to use spray paint never ends. I work with stencils, stickers and different kinds of paints as well."

"MY CHARACTER 'MIMI' IS MY ALTERNATE SELF. 'MIMI' REFLECTS EXPERIENCES AND EMOTIONS I GO THROUGH IN MY LIFE; FEELING HAPPINESS, SADNESS, LONELY, SCARED, ANGRY AND HORNY."

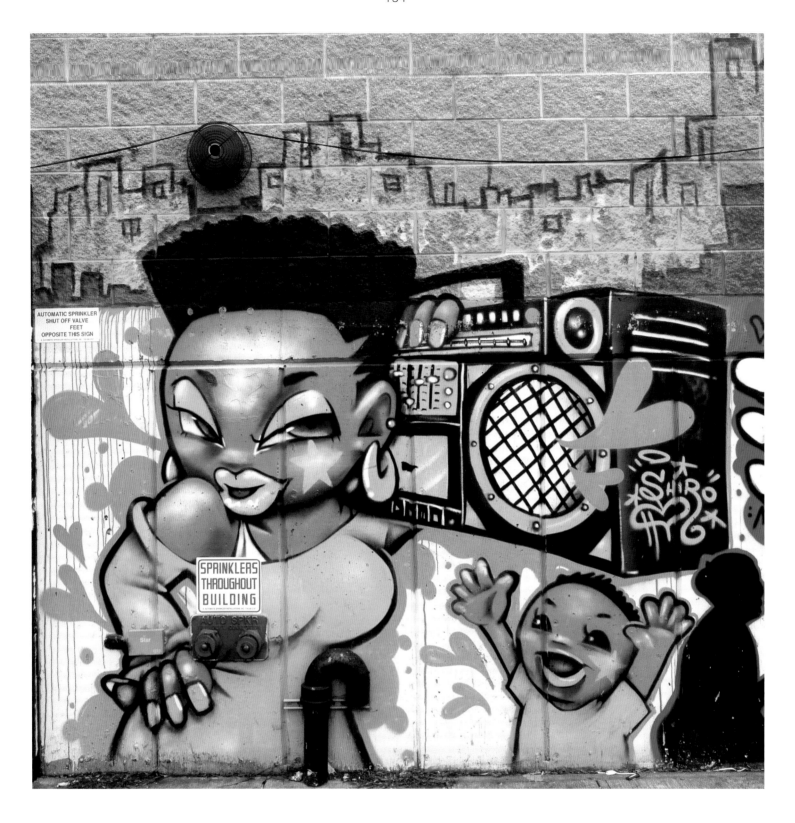

LINDEN ST., BUSHWICK, BROOKLYN

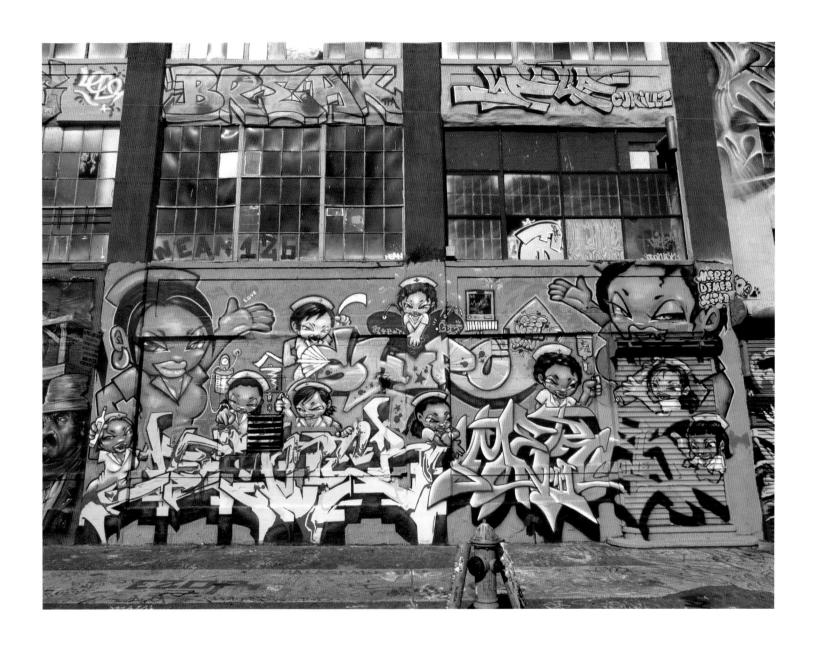

5 POINTZ, LONG ISLAND CITY, QUEENS

BOONE AVE., THE BRONX

INDIE184

Indie184, born as Soraya Marquez in Rio Piedras, Puerto Rico by way of the Dominican Republic, grew up in the boroughs of New York City. She has been active in the graffiti culture for over a decade. Determined to express herself through art, Indie quit college and taught herself how to sew, paint and design. Influenced by all things colorful, happy and sexy, she is known for her classic New York simple yet playful feminine graffiti style, infused with exuberant bold colors bursting with hearts, stars and bubbles. You can find her graffiti pieces in the streets, from the South Bronx to Oslo, Norway. Indie's dedication to painting in the studio has transitioned her to mesh her graffiti style inspired by the city streets onto mixed media creations on canvas. Her paintings are raptures of vivid Caribbean-inspired color, textures fused with imagery, and designs juxtaposed with messages. Aside from painting, Indie also translates her graphic aesthetic direction onto her other passion, Kweenz Destroy, her independently owned street wear clothing brand.

INDIE184 SPEAKS…

ON STREET ART

"Graffiti is my culture. Growing up in the hood, street art or graffiti were part of my environment and everyday routine. I was exposed to graffiti when walking to school and passing by the tags and pieces in the schoolyards. While taking public transportation in New York City, I remember seeing the bombed tunnels and streets as completely natural sights in the urban jungle. The transit system and the city streets were like a public museum. This early exposure made me want to get up too! I started tagging my real name around my neighborhood in Washington Heights, then played around with some other tag names, and finally found one that I felt confident with. I felt I wanted to blast the street walls with my new tag name, which integrated colors and styles like the ones I saw in Martha Cooper and Henry Chalfant's book 'Subway Art.' My first big opportunity was when I met the artist Cope2, who put me down on my first wall in the South Bronx. At this point I felt like an amateur, but I was full of motivation and excitement, so I went to Home Depot and got busy with paint and stock caps. Painting with other writers made me hungry for more and more walls; I got bitten by the graffiti bug! I wanted to expand my graffiti book with different styles and locations. As I evolved, I wanted to work on a bigger scale, not just painting locally, but globally.

Graffiti started out in the hood but now it's a universal language. Artists communicate their personal story to the community using letters, characters, words, colors and designs. It represents the artists' state of mind, thoughts, emotions and dreams. You can connect with just about anyone in any part of the world and paint all over the planet. I love the hustle and grind of graffiti; it makes me fearless to make a statement. Graffiti is about action, you can't be all talk! Do it and go hard!

STAYHIGH149 trademarked it best – 'Voice of the Ghetto'. Graffiti is a form of expression first used by mainly Black and Latino kids in the inner city as an outlet for having fun and a way of gaining recognition. Constantly evolving, street art bares the responsibility of capturing the experience of life in the urban metropolis. Street art reflects the memento of youth, culture and social politics of our generation. I also see street art as a way to beautify the forgotten unmaintained city walls.

I remember several years ago when we painted a wall on West 182nd St. and St. Nicholas Avenue, in the Bronx. The wall was decayed and made the neighborhood look dark and ratchet. Once we finished painting our pieces and characters with bright colors, it immediately transformed the entire block. People were happy that we painted it and believed it would increase the value of their real estate. It just showed me that perspectives change on how valuable and positive street art can be."

ON PERSONAL ART

"I was born an artist. When I was 5-years-old, I went to the Dominican Republic for the summer. My grandfather was a carpenter and I would visit his studio. He carved wood and used colorful paint to restore furniture. He had so many cool tools and gadgets and could build anything. My mom was a seamstress who worked in factories in Brooklyn and would create many of our holiday outfits from scratch using a huge factory-sized sewing machine that was in our living room. She would sew everyday and used to take me along to buy fabric and patterns on Fulton Street, Brooklyn. I was always drawing as a kid and was into fashion design. I used drawing to communicate with my mother

"CONSTANTLY EVOLVING, STREET ART BARES THE RESPONSIBILITY OF CAPTURING THE EXPERIENCE OF LIFE IN THE URBAN METROPOLIS. STREET ART REFLECTS THE MEMENTO OF YOUTH, CULTURE AND SOCIAL POLITICS OF OUR GENERATION."

what I wanted to wear and I'd also compose the family portraits. In my early teens I used to work summers together with my cousins in my uncle's construction company, painting apartments all over the city for some quick cash. I always loved working with my hands. I always said if I could, I would be a construction worker. I loved being all dirty with paint and plaster.

Becoming an artist in New York City happened naturally, though I didn't go the route of studying in an art school, which never appealed to me. Rather, I learned art by watching others and teaching myself. My first attempt at street art was experimenting with stencils. I created stencils from Jesus images and spray painted them on sidewalks in the city, on t-shirts and on canvases. But the stencil game wasn't for me at the time; I wanted to do something with more impact. Truth is, I wanted my name up like everyone else and was out for fame. I was also into photography. I snapped many photos of people in the street, friends, family and artists. During that time I met many graffiti writers and got into the culture, going to art shows and jams. Deep down I always wanted to be an artist and live off my art; I just didn't yet know how to make that dream a reality. Doing graffiti really gave me an outlet and motivated me to create something out of nothing. I learned about the art and the artists involved by reading 'Spraycan Art' and 'Subway Art' and watching 'Style Wars' and 'Wildstyle', where I discovered my first artist heroes. I was inspired how LEE, CRASH, DAZE, LADY PINK, SEEN and others kept consistent over the years and turned their street art into full-fledged art careers.

One time I had the opportunity to go to LEE's studio in Brooklyn and see his paintings and how he worked. The lifestyle intrigued me. I loved the large paintings, the tagged up walls and the paint splats everywhere. He would talk about his art technique, even telling us that when he swept up the studio floors he would save and later use the dust and dirt in his paintings. So real and genius! That same day Jose Parla, whose studio was nearby, came by to visit LEE and I found myself kicking it with them, talking about art and graffiti. I was intrigued how Jose evolved from doing graffiti pieces to being successful in the gallery world. At that time I also met Cope2 and was impressed by how he lived off his art. Cope2 inspired me to take the leap with him and quit my design job to work on my art full time. I have since had the

privilege to paint with many great originators such as CASE2, T-KID170, WEST, JONONE and many others.

Nowadays I'm in the studio full time. For the past year I have transitioned from doing only graffiti pieces on canvas to evolving into mixed media works. Preparing for my first solo show, 'Go Hard' in Los Angeles in 2012, catapulted me in the sense that I felt confident that I can create many works in a short period of time. Less than one year later, I successfully put up my second solo show, 'Wild at Heart' in Paris, France. It's a hustle to create paintings and book shows but I love the challenge. I prefer painting in the studio because it's a private setting. I love taking my time on a piece, just putting all my energy into my art, shutting off everything else and focusing. My studio work is much more personal; I get to fantasize with words, imagery, color and texture. Painting in the streets is fun but it involves many logistics; weather, wall permits, spray paint supply and coordinating a babysitter, for starters. Not to mention worrying about police trying to arrest you even if you have permission. Then you need to deal with local people from the neighborhood letting you know whether they love or hate the wall. Even after I rock the wall and get my photos, I still have to worry about the city buffing it or some toy writer going on me. That said, I still like to paint in the streets, as it's pretty satisfying. But with a canvas painting, it's a different feeling of satisfaction. I know that my painting will have much more longevity and appreciation with a collector. On the other hand, as an artist you have to stay relevant. One of the best ways to do that besides gallery shows is painting in the streets; it creates a dialogue between the public and your art. So, when the weather permits, I make my way to paint a nice wall."

ON NYC

"I AM New York City. This is where I'm from and have always lived. It's the mecca, the motherland of street art and graffiti. It all happened naturally for me; graffiti is part of my environment so I guess I'm a product of it.

My favorite neighborhood is Washington Heights, as I spent my youth there. Long before my time it was the home of TAKI183, SNAKEII and the original writers bench on West 187th street and Amsterdam Ave. One day I want to be part of that history too! I love the energy of the people in the Heights. Even when drug

dealers reined the streets it still felt safe to me. Plus, it's home to my favorite subway line, the A train, where the graffiti in the tunnels are still embedded in my memory. I also love painting in the streets of the Bronx. The people are really opinionated and blunt, so you can hear many interesting comments like 'You go girl!' or 'What the hell is that?'"

One time we were shooting a short video for a website and needed an impromptu wall so we didn't have time to go uptown. We found a wall in SoHo and we got verbal permission from the shop manager. The minute I started painting a worker from the shop next door started cursing me. He was so belligerent that it was sad. He kept threatening us that he was going to call the police, which he eventually did. A few minutes later two rookie cops showed up and started asking if we had permission from the landlord. Apparently having permission from the shop manager wasn't good enough for them, so they threatened to arrest us. Since it was the weekend, the shop manager couldn't get a hold of the owner and I got nervous. I was not interested in getting arrested for a quick wall that was supposed to be legal. I had to talk to the cops and then just packed up and left before I got to finish. I did go back at night without anyone's permission to add the last touches. There can be so much hate from neighborhood 'heroes', cops, and the city buffing your wall and other writers. You're better off just doing street art on your own terms illegally. The city is a battle zone; you need thick skin to succeed, that's for sure!"

ON THE FUTURE

"Throughout the years Mayor Bloomberg's Graffiti Free New York City has been buffing many street walls. As a result it is more difficult for street art but especially graffiti to have longevity in the streets. Thank goodness others and myself have documented my work on video and photos! I love New York but it is so difficult to express yourself sometimes. I feel Paris, Berlin and Madrid are much more tolerant of art in the streets.

I don't think specifically about my role in society as an artist. I think about my personal journey as an artist. I create with what I am feeling or experiencing at the moment, both consciously and subconsciously. I just let it all flow and live in the moment. In the future, I want to work with other mediums, not just paint on canvas or street walls but also create sculptures and installations.

I'd like to keep creating in the studio and take my painting style to the streets doing mixed media walls. Staying active is crucial to keep your art alive."

ON YOUR PROCESS

"When I do a graffiti piece in the streets, I only use spray paint In the studio, I use many mediums such as acrylics, enamel markers, oil markers, spray paint, house paint, paper and vinyl stickers; whatever I can get my hands on. I usually work with either stretched or non-stretched canvas. I also enjoy using shapes and patterns of stencils, which I first design in illustrator, then print on thick card stock paper and finally cut by hand using an xacto knife and cutting mat. I love working with black and white photography, which I usually get from books or the Internet but they have to be large enough so the image is not pixelated. I brighten up or recolor in Photoshop, then print out in a large format printer (or send to a local print shop). Lastly, I wet the paper by using a spray bottle and wheatpaste with a brush onto the canvas."

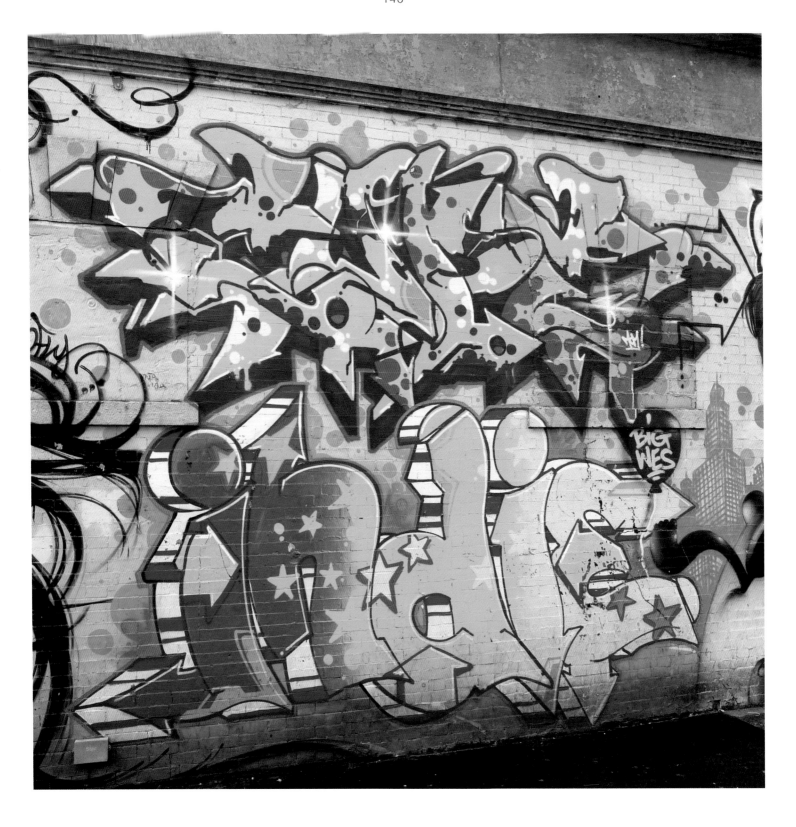

181 ST., WASHINGTON HEIGHTS, MANHATTAN WITH COPE2

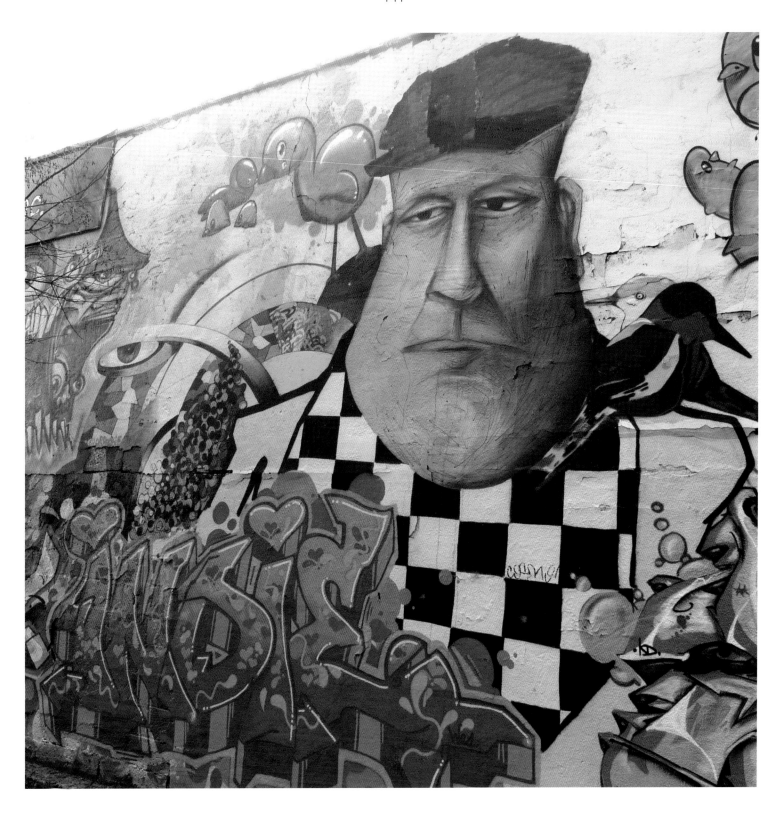

EAST 173RD ST., THE BRONX WITH VENGRWK AND CERN

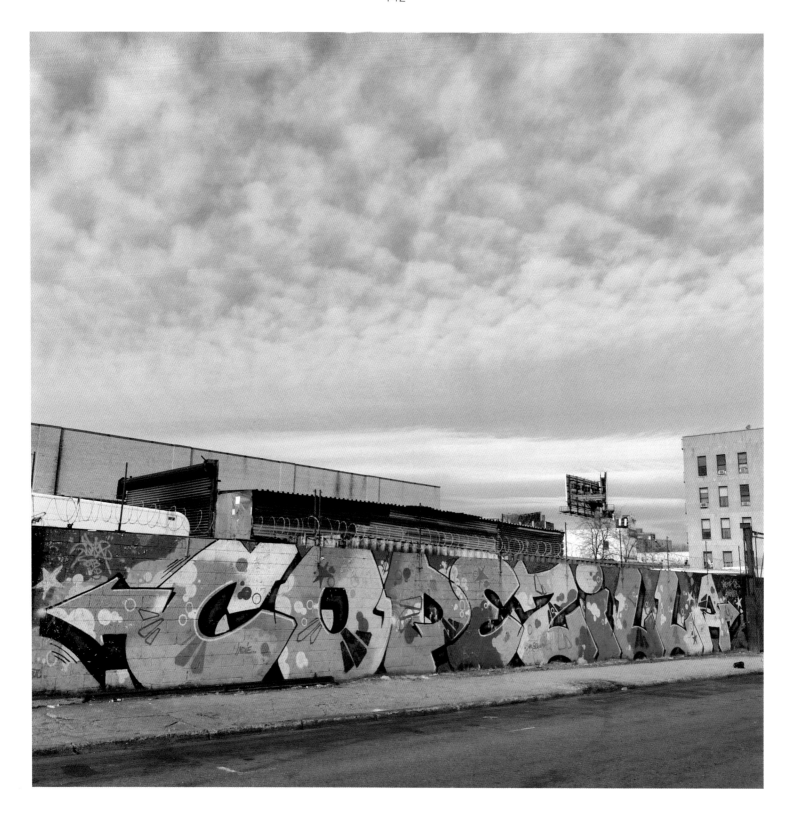

PARK AVE., THE BRONX

COPE2

COPE2 SPEAKS…

ON STREET ART

"I am a legendary New York City graffiti artist. I come from an era of painting the subways in New York City. When the subway era died in the mid-1980's, I went on to painting my name on the walls in the streets. So, I guess you can say I've been doing real street art for many years. The movement started with Jean Michel Basquiat tagging 'Samo!' everywhere and continued with Keith Haring doing walls and myself doing wild-style burners in the streets of the Bronx and other boroughs in New York City. Every time I did a burner on a wall in New York City people would walk by and say, 'Wow that's amazing street art.' We're talking late 80s through the 90s, up until now. Our movement has gone global. I find that simply amazing!

I guess to put your name, craft and art out there is significant because it is not just a sign of your love for the art, but also a way to share your art and yourself with the public and the world. The art you see today is really amazing, not only in the streets of New York City but worldwide. The different styles artists have developed blow my mind. I feel blessed to be part of this art form for many years."

ON PERSONAL ART

"I've been doing graffiti art for decades. Today it is just what I do and it is simply how I make a living. Art is my passion; I love to paint walls on the streets not only for myself but also for the public to enjoy. I was always an artist and I became a street artist because once the trains died the walls were all we had left to paint on, whether it was legal or illegal. Today I'm more into paintings; spending more time in my studio preparing for art shows in galleries, auctions and museums worldwide.

Although nowadays I don't paint trains or walls as much, I still try to keep my originality and authentic Cope2 style in my paintings. It is very important as a real artist to keep your originality in your artwork. It is important for me to keep my original style, which I highlight in all my artwork. It makes an artist more official and authentic and I try to be true to myself at all times. That's the difference between me and other artists who try to paint Mickey Mouse, Sponge Bob, flowers, birds, fish and skulls; instead of just staying original they go elsewhere in their art. That's cool if that's what they want to do, but not me; I stay original and people love that about my new paintings today."

ON NYC

"New York City is just where I'm from. I'm born and bred in the South Bronx. Many of us painted subway cars in the 70's and 80's and went on to painting our art on walls in the streets. We had to find an outlet to express our inner selves and the many experiences we were going through living in New York City. Whether it was the Bronx, Brooklyn, Queens or Manhattan, many of us artists grew up really poor and having not much but some spray paint to have fun and make something creative with. My favorite area is the Bronx 'cause it's where it all started for me and where I was most comfortable painting walls in the streets. People would love it when you came to their neighborhood and painted a whole wall. They would say: 'Wow!! Now the neighborhood looks better with your art; now thank you.' That felt really good.

Every wall I painted was pretty fun and memorable. I always loved when some people would come and offer you drinks or food just because you were painting a nice wall in the streets in their neighborhood. People would come out and support you. That is what I always loved about painting in the streets of New York. I'm grateful for the really cool and great times and memories."

ON THE FUTURE

"I just keep on going with the flow. I'm more focused on putting my art on canvas, creating some amazing paintings and showing them in galleries, museums and auctions around the world. I have some collaboration walls in the works with some great artists. I'll always paint art in the streets, not only for the public's eye but for me 'cause it is what I love to do as a real artist. It's my passion and profession and to just keep on rocking in this movement - that's my role, being me: Cope2!"

ON YOUR PROCESS

"I've used spray paint for many years. I used to use mostly the American brands like Krylon and Rustoleum but today you have available all these new European spray brands that are amazing. The colors they make are unreal; all the shades and the caps come either fat or thin. There are so many markers it's really amazing and great for us street artists and painters 'cause you have more of a variety to choose from. I use a lot of acrylics and real house paint like enamel. I love it because it is really strong paint and when you use some good spray paint on a canvas you know it will last for many years. I use many different brushes as well."

"IT'S MY PASSION AND PROFESSION AND TO JUST KEEP ON ROCKING IN THIS MOVEMENT - THAT'S MY ROLE, BEING ME: COPE2!"

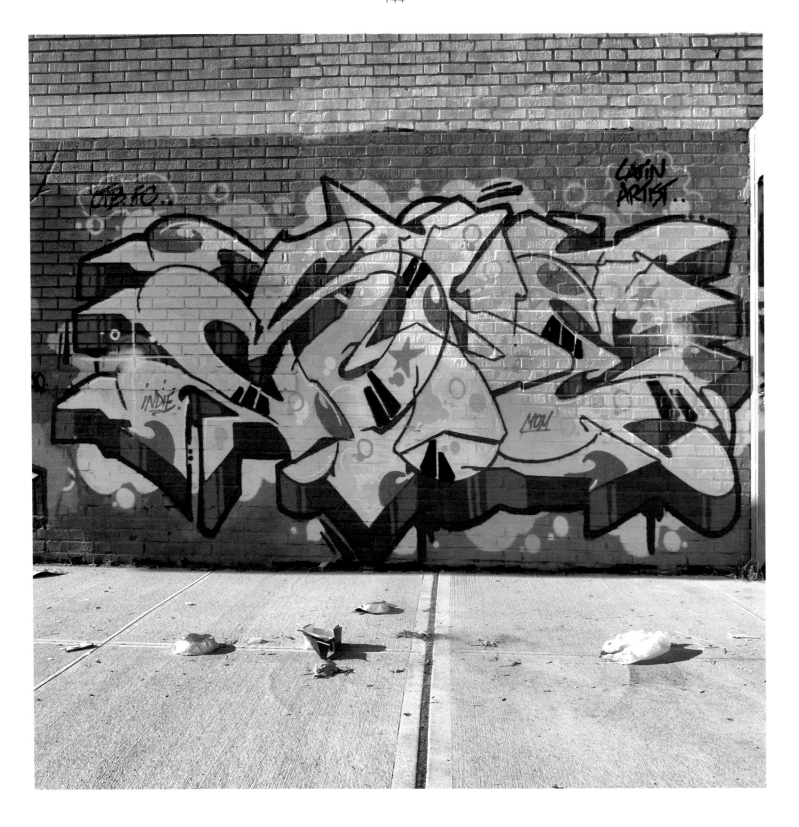

BOONE AVE., THE BRONX

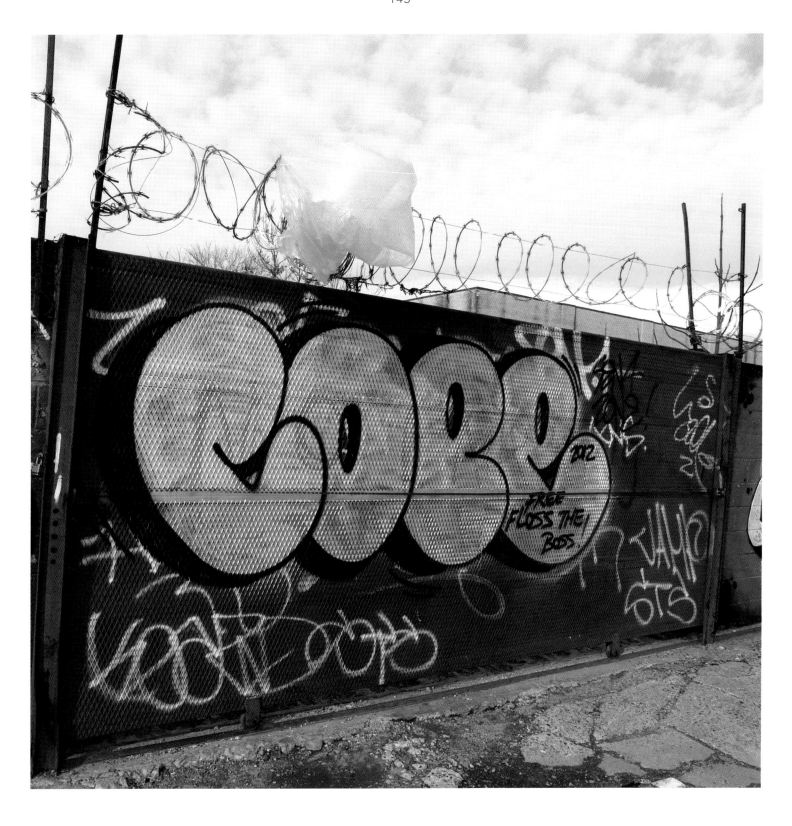

PARK AVE., THE BRONX

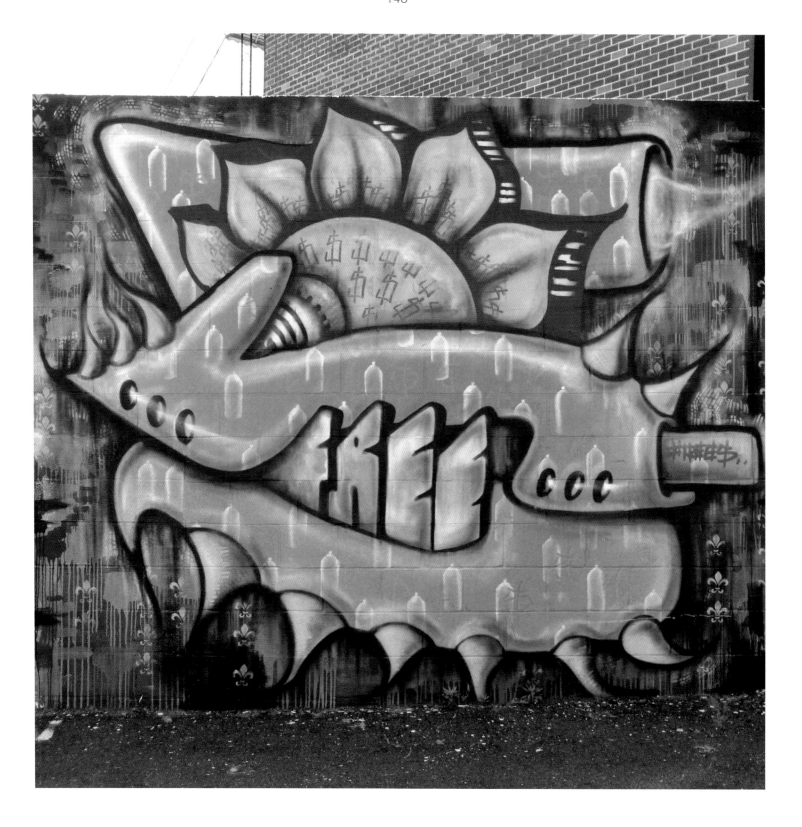

WELLING COURT, ASTORIA, QUEENS

FREE5

Free5 is a graffiti artist/graphic designer. Free5 has been painting for over 25 years and is from Queens, New York.

FREE5 SPEAKS...

ON STREET ART

"I became a street artist by hanging out with other train writers and soaking up all the graffiti around me and wanting to do it myself. So, I just did. I think street art is a powerful and low-cost way of reaching a large public and potentially becoming famous as a result. In addition, with street bombing comes an addictive rush. Putting your tag on the wall just feels so good!"

ON PERSONAL ART

"I see my role in the movement as simply to be myself. I am always a versatile artist, changing with the times, being original in my style. Originality is the most important quality of my work."

ON NYC

"New York City is the Mecca of graffiti, where culture and diversity is everywhere around you."

ON THE FUTURE

"The main idea of street art, getting your name up on a wall in public, will not change in the future. The medium and the way you put up your name will change. I imagine myself making my own spray paint cans with glow in the dark paint so people can see it at night! Just buggin. Graffiti lives!"

ON YOUR PROCESS AND INFLUENCES

"Spray paint is my favorite medium to paint with. It's versatile, is available in an endless amount of colors and it's the number one tool for graffiti artists. My second favorite medium is bucket paint. It's cheap or sometimes free, covers well, there exist endless amounts of colors to choose from and you can mix your own colors. It can also fill a lot more areas than spray paint can. It's just a bit messy, but I like that.

My influences include several different types of artists changing from graffiti writers to contemporary artists. Graffiti writers who inspired me during my first years include SANE R.I.P, SENTO TFP, GHOST SEEN, Lady Pink, MUZE, HUSH, and Keith Haring. I was also very influenced by Salvador Dali who has greatly affected the surreal aspects of my work. Combine all these artists together and you get me- FREE5."

"I THINK STREET ART IS A POWERFUL AND LOW-COST WAY OF REACHING A LARGE PUBLIC AND POTENTIALLY BECOMING FAMOUS AS A RESULT."

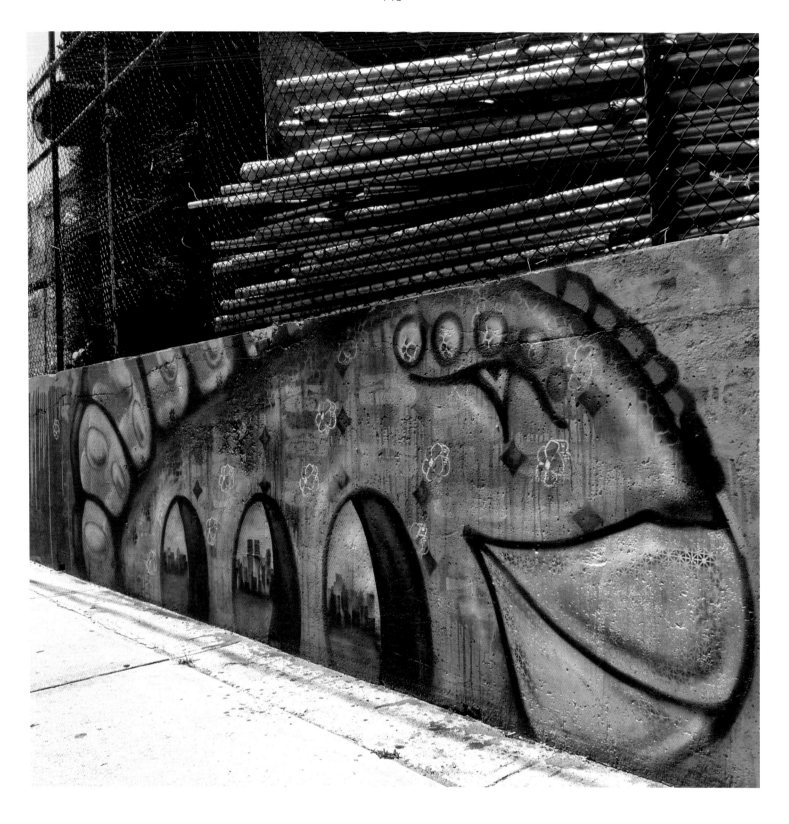

12TH ST., ASTORIA, QUEENS

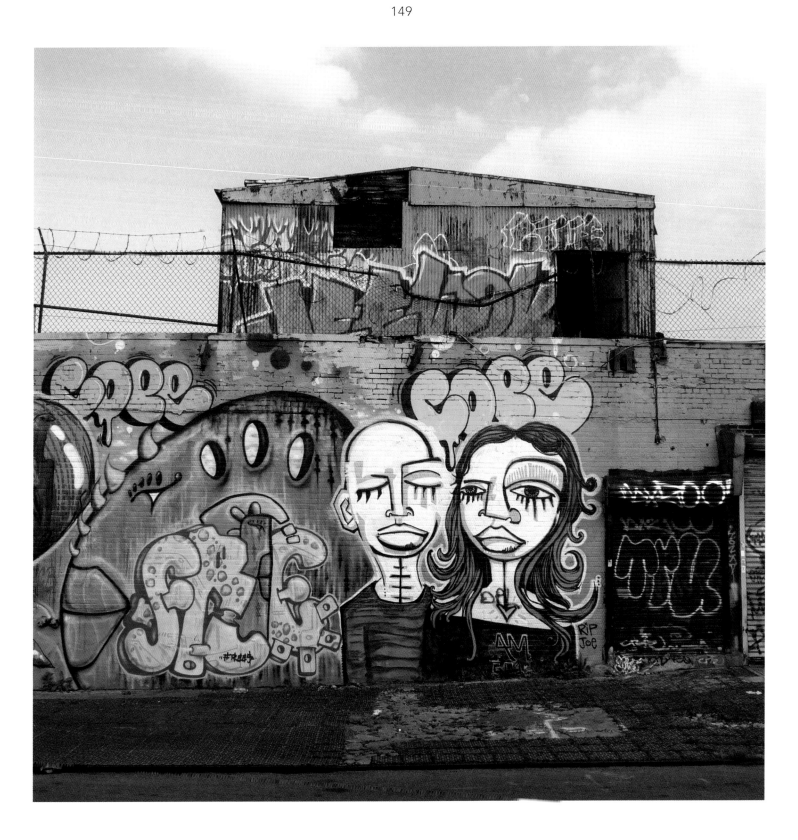

BOONE AVE., THE BRONX WITH ALICE MIZRACHI AND COPE2

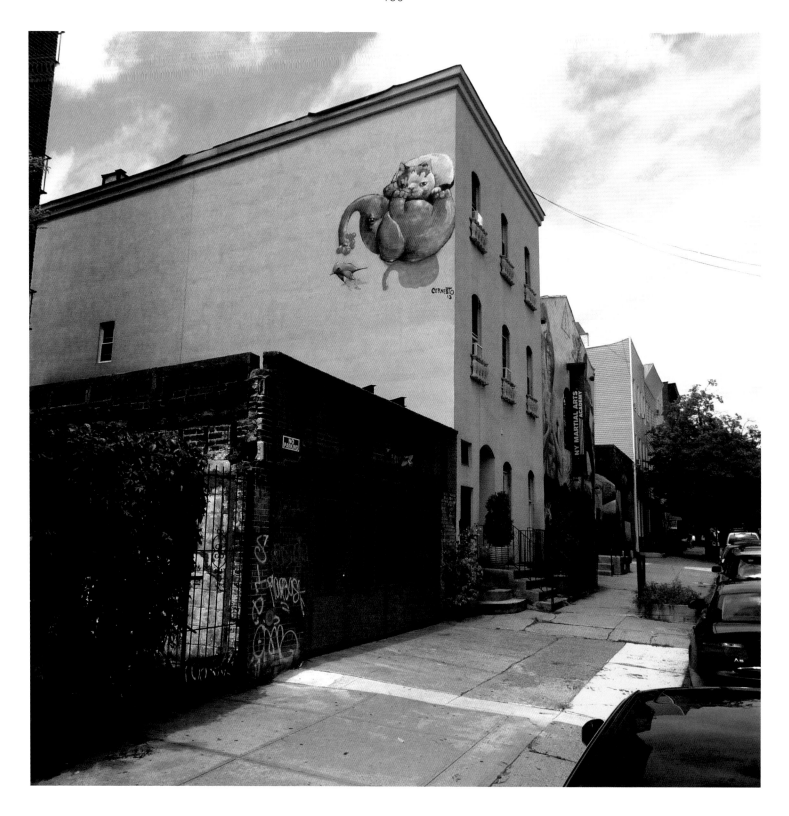

NORTH 8TH ST., WILLIAMSBURG, BROOKLYN

CERN

The New York borough of Queens gave rise to the artist known as Cern. Since the 1990's, Cern has been creating art as a means of connecting with others. Experiential and cultural transactions drive his myriad travels to paint around the world with reverence Firmly grounded in the tradition of "writers", Cern's style nods to the past with deference and defies definitive categorization.

CERN SPEAKS...

ON STREET ART

"Art in the streets, art that is created by any means, maintains significance as a powerful language that is always shared amongst people and their environment. From individuals to corporations, people contribute casually or go to great lengths to share or impose their ideas and visions with society.

Street art is a sign of our times in that it is always utilizing evolving mediums and media. It gets shared with the rest of the world through several channels; publishing in print, digitally and via various products. Artists nowadays have a lot more access to materials, reference to style and instant ability to document and share what they are seeing and doing. Public art in its early modern form has been going strong for 40 or so years.

Today spray cans are made especially for artists and graffiti is taught in classes. I sometimes wonder about the history of wheatpasting. Basically I see everything in full motion at this point with an array of styles for current practitioners to build on, constantly pushing the limits of this art form."

ON PERSONAL ART

"Growing up in New York City I was very influenced by graffiti and when I began writing I didn't really see it as art. I always felt inspired to develop and find my own path within it. I began painting larger murals and I guess that's where I fall under the umbrella of 'street art'. I also do studio work and am always experimenting with different interests regarding art and music. The difference between public art and work in the studio is about the control I have over the environment, the music, climate, privacy and access to materials. Both lead me to discover things that I try to take from outdoors into the studio, or vice versa.

What is important for me to highlight as a street artist depends on the situation...the community, the event and the space I work in, whether urban, desolate or more natural. I generally try to transcend myself and find the magic that a particular day brings about; it's what I aspire to."

ON NYC

"Street art, or lack of it, in New York City reflects a variety of things regarding this city's society. Specific styles are generally concentrated in certain neighborhoods within the city. I believe at this point street art, advertisements, graffiti art and private property owners are all competing for similar spaces with a lot of shared methods. I think the area where the work is done often reflects the artists' target demographic. Growing up here I have a bit of a love/hate relationship with New York City and it is really hard to say what my favorite neighborhood is; each is special in its own way."

ON THE FUTURE

"I'm sure there will be a lot more of the same for street art both the positive and negative aspects. There will always be new artists with fresh perspectives, new supporters and those who want to make business out of it. I'm sure there will be a lot more connections between street art and technology. The world is constantly becoming smaller and I think this results in a fast exchange of ideas and styles between different locales. I'm not sure what's next but I'm certain new things will develop, as well as new ways of using older ideas. My personal role in the movement will most likely stay consistent; I can't seem to stay inside too much."

ON YOUR PROCESS AND INFLUENCES

"I've always admired artists with diversity in mediums and styles. I have pretty much found myself using most kinds of paint. But by this point, I find myself working with almost anything, or anything available, depending on the situation. I think the challenge in the use and mastery of many forms of expression and creation as languages is to find how to use the language to say something. The translations between mediums are often where some of the magic lies. It's of course great if a specific mode of creation is natural to you or a high level can be developed through practice. Spending as much time as I have in urban areas, color always seemed to be desperately needed. As a result, I found myself obsessed with bringing colors to the grey and maroon city. Painting became the focus for me; it seemed to transform a space and capable of changing it from moment to moment as the work grows.

My main inspiration came from graffiti artists from New York City and worldwide who in the early nineties had pushed the style and technique to a new place with high quality large-scale collaborative murals. I feel this played an important part in a lot of what has followed internationally over the last twenty years."

"STREET ART IS A SIGN OF OUR TIMES IN THAT IT IS ALWAYS UTILIZING EVOLVING MEDIUMS AND MEDIA."

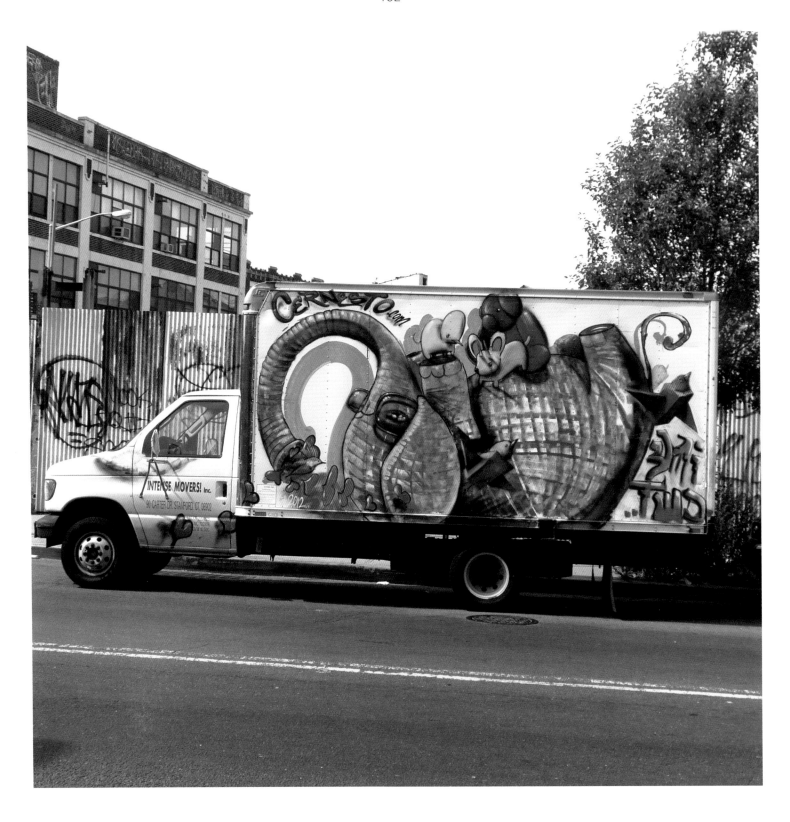

FLUSHING AVE., BUSHWICK, BROOKLYN

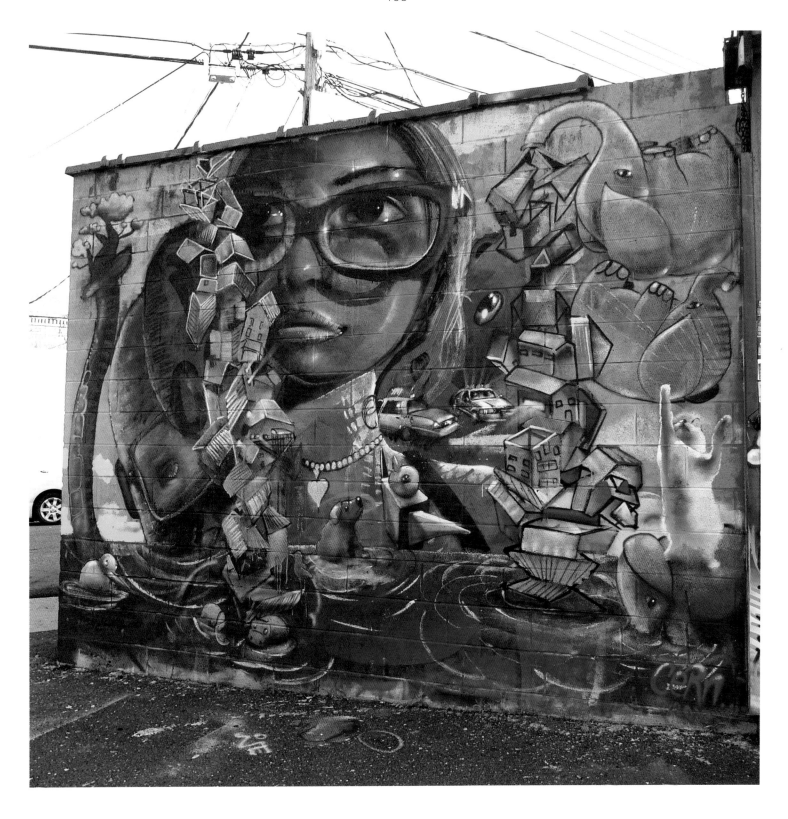

WELLING COURT, ASTORIA, QUEENS

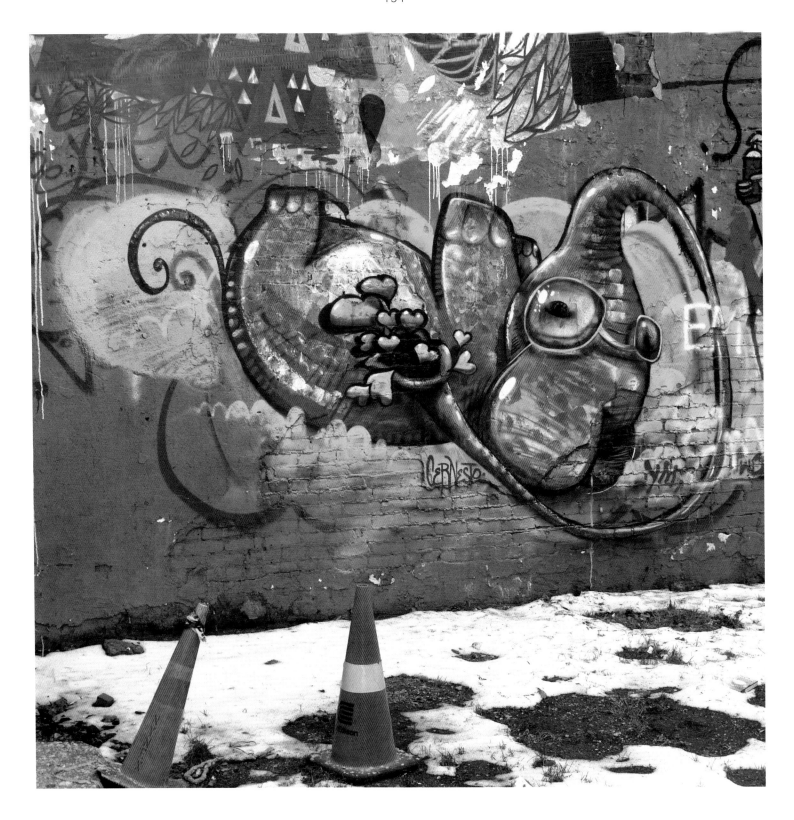

LUDLOW ST., MANHATTAN

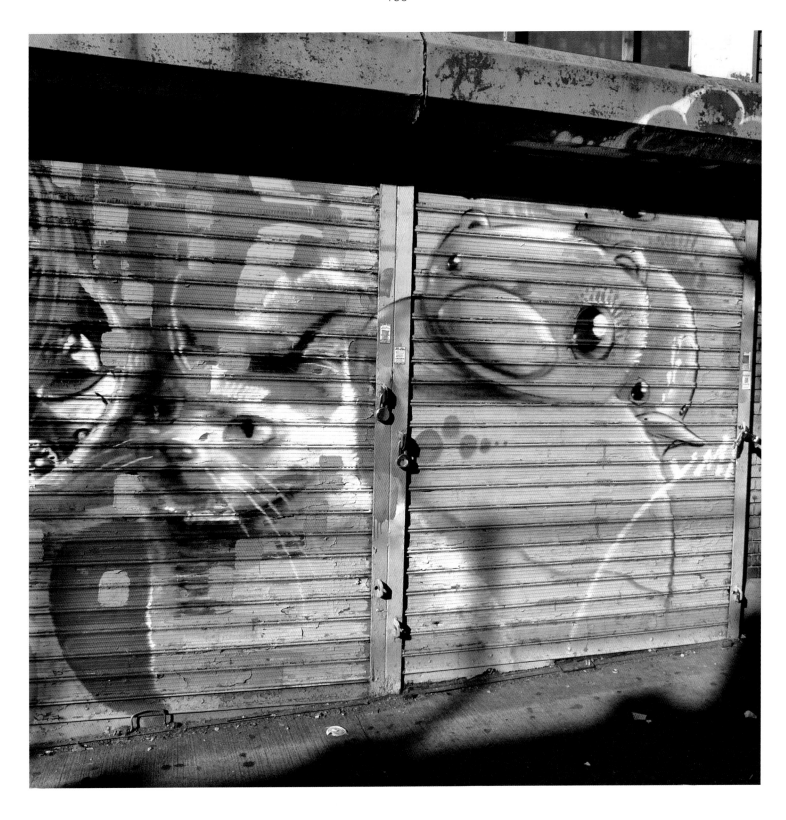

WESTCHESTER AVE., THE BRONX

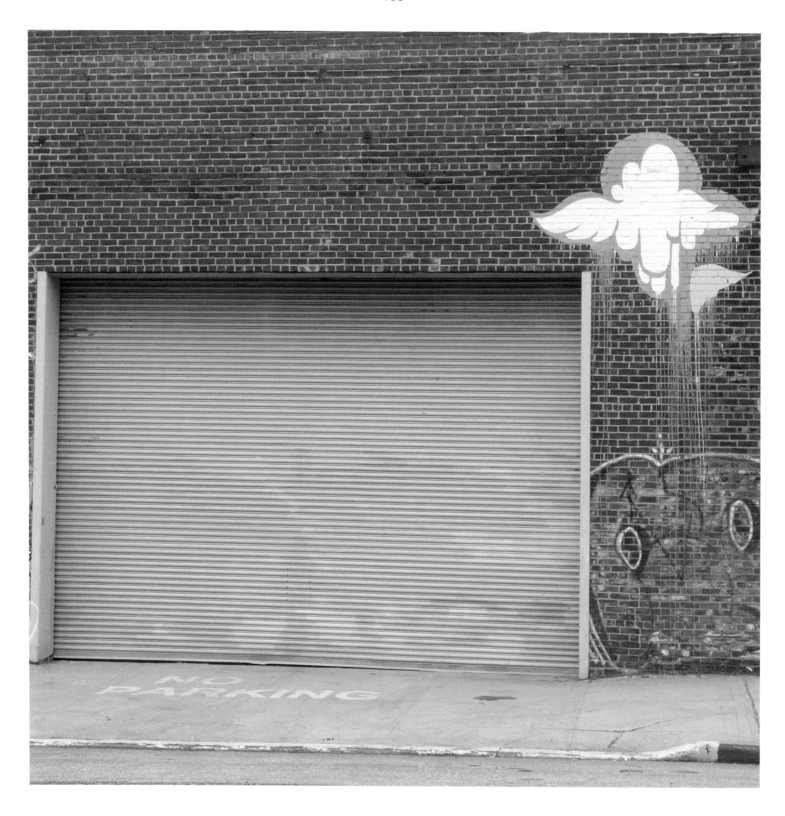

4TH ST., GOWANUS, BROOKLYN

SOFIA MALDONADO

Born in Puerto Rico of matriarchal Cuban decent, Sofia Maldonado's unique vision issues from the inherent complexities of her identity as well as the energies of the youth cultures that have informed her creative practice. Her work draws inspiration from abstraction; deconstructing post-colonial urban landscapes that intertwine with nature, developing her own interpretation of nostalgia. She participated in the 2011(S)Files Biennial, El Museo del Barrio, New York and Skate My Patria in the 10th Havana Biennial, in Cuba.

SOFIA MALDONADO SPEAKS...

ON STREET ART

"After painting in the streets illegally for many years, I became interested in public art commissions that would enable me to explore a different approach to the urban landscape. My first public art commission was by Real Art Ways, in Connecticut. The mural had some wood cutout 'Chicas' (female characters). That allowed me to collaborate with some nail salon artists. The wood cutouts got installed in the mural after the ladies of the salon 'pimped' them up. I was glad to collaborate with local nail artists, who were also gang members. A year later the Times Square Alliance commissioned me to paint a large-scale mural in New York City on 42nd Street between Eighth and Seventh avenues. This was a very controversial mural. It gave me a big street-wise wakeup call by having to explain my work, concept and my usage of female imagery in the mural to a broad public. I learned the difference between street art and public art. It's incredible when a project teaches you so much and you mature along with people's critical view of your work. Since then, I have split my mural work into three categories: Public Art Murals (commissioned by a museum or private entity); Street Art Murals (painting for the love of it with friends) and; Community Murals (collectively painted with students or community members). This allows me to have peace of mind and better understanding of each project's creative process."

ON PERSONAL ART

"I started wheatpasting original drawings during my high school years, back in Puerto Rico, while searching for a 'tropical mural style.' As a teenager I was constantly looking for different arenas to display my art. Rather than choosing to paint with spray paints, I opted for the cheaper version; latex pre-mix paint, which came in gallon-sized containers that people were typically denied in hardware stores. I found myself working with a rare mix of colors like vivid greens, sky blues, pinks, and many other vivid colors. Every weekend I would go painting with my writer friends around San Juan, Santurce and Trujillo. By my early 20's I started to paint skate-parks and spots that created a dialogue with skaters.

I moved to New York in 2006 to study for my MFA at the Pratt Institute. That is where a new journey began for me. After graduation I was lucky enough to present my work at a solo show in Chelsea, where I installed a mini-ramp inside the gallery. During the following years I traveled extensively in order to be part of various public projects, museum exhibitions and group shows. Nowadays I have my own studio in Brooklyn and it's one of my biggest joys! It provides me the space to experiment with different painting techniques. I have been developing a more abstract body of work for the 'Into Gray' solo show at Magnan Metz Gallery."

ON NYC

"I always dreamed of living in New York City. It's well known that street art has revived various areas of Brooklyn. For some reason, street art is more accepted by the public than graffiti, though it comes along with the evils of gentrification. I love the neighborhoods Bed-Stuy and Ditmars Park and the amusing Victorian houses! Sunset Park is becoming my second home because my studio is located there. It feels great to be by the water and have the pleasure of enjoying the sunset and a view to the Hudson."

ON THE FUTURE

"In the past two years I have been more involved in sharing my mural techniques with kids living in the outskirts of New York City and the students of Cre8tive Youthink, a nonprofit organization. As for my personal projects, I am looking to do more site-specific installations. It is evident that my studio practice is taking a very different direction than my murals, but this is all part of the evolution of my creative process.

Public Art is growing in many directions. I do admire the artists that have been in the field for many years and have been able to evolve along with their art. My friends Lee Quiñonez and Jose Parla are two excellent examples."

ON YOUR PROCESS

"As for my murals: latex paint, a roller and a brush...that's all it takes! I love to climb up high and spill big drips of paints from the highest point of the mural. I am getting more into the color and viscosity of the materials and how they play in the urban context. If the project allows it, I would add up some of my woodcut pieces, giving bi-dimensionality to the mural."

"IT'S INCREDIBLE WHEN A PROJECT TEACHES YOU SO MUCH AND YOU MATURE ALONG WITH PEOPLE'S CRITICAL VIEW OF YOUR WORK."

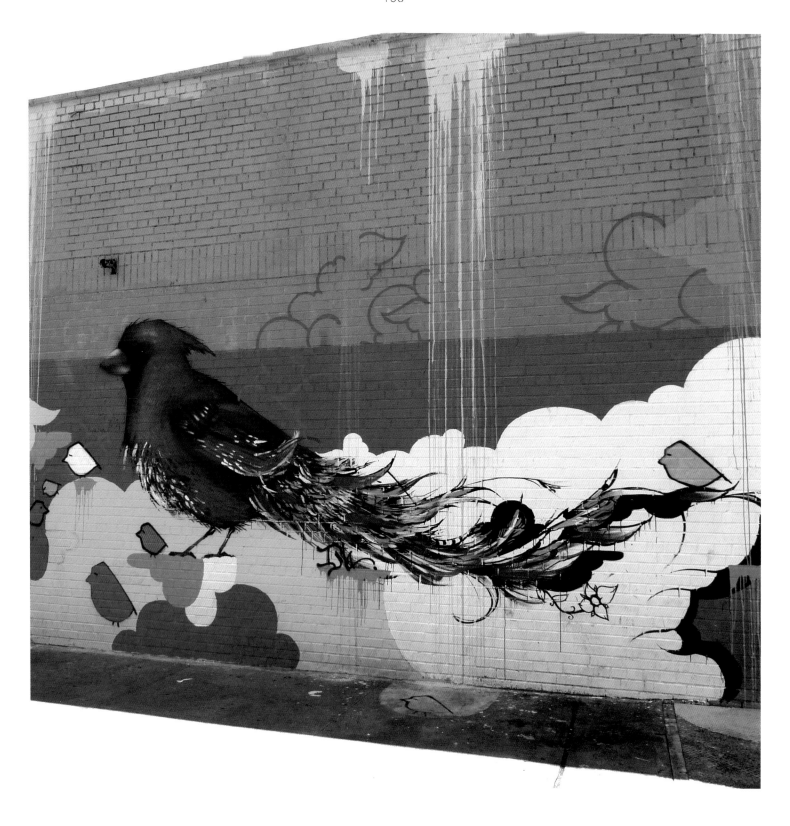

EAST 5TH ST., MANHATTAN WITH VENGRWK IN COLLABORATION
WITH CRE8TIVE YOUTH*INK AND THE LMCC

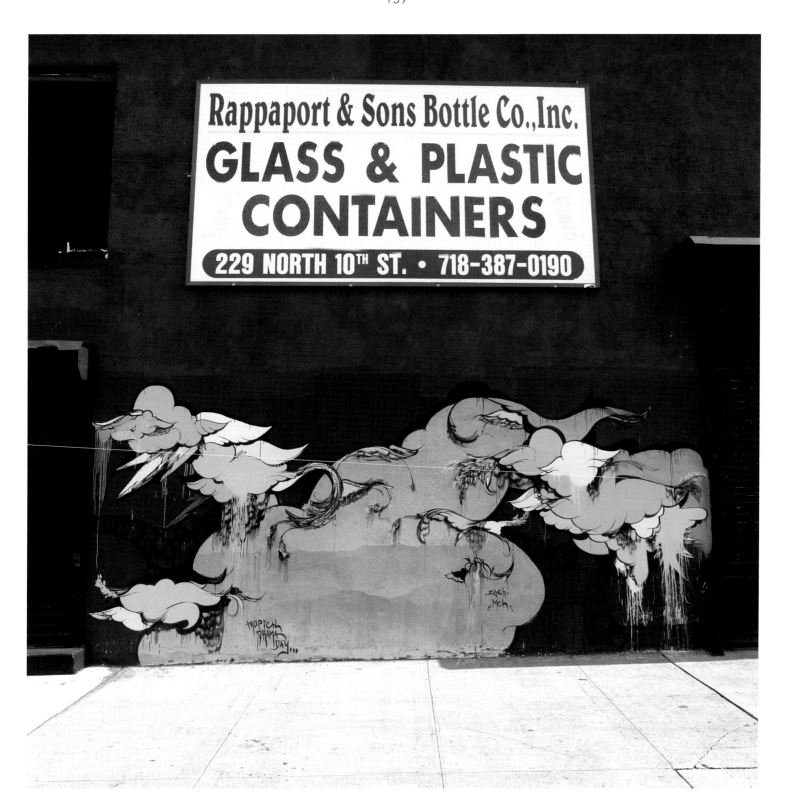

NORTH 10TH ST., WILLIAMSBURG, BROOKLYN

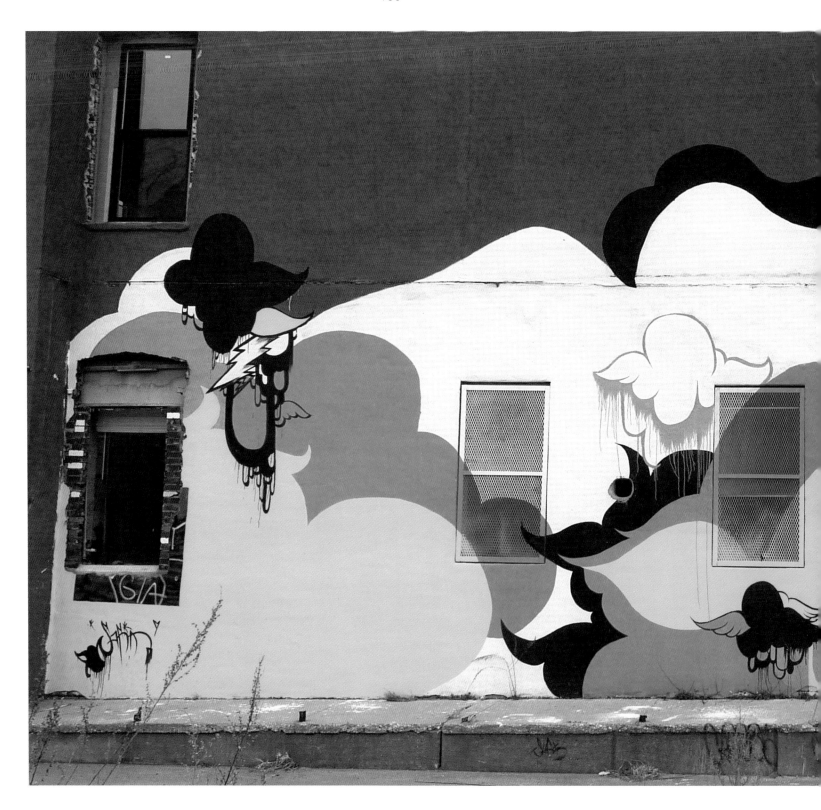

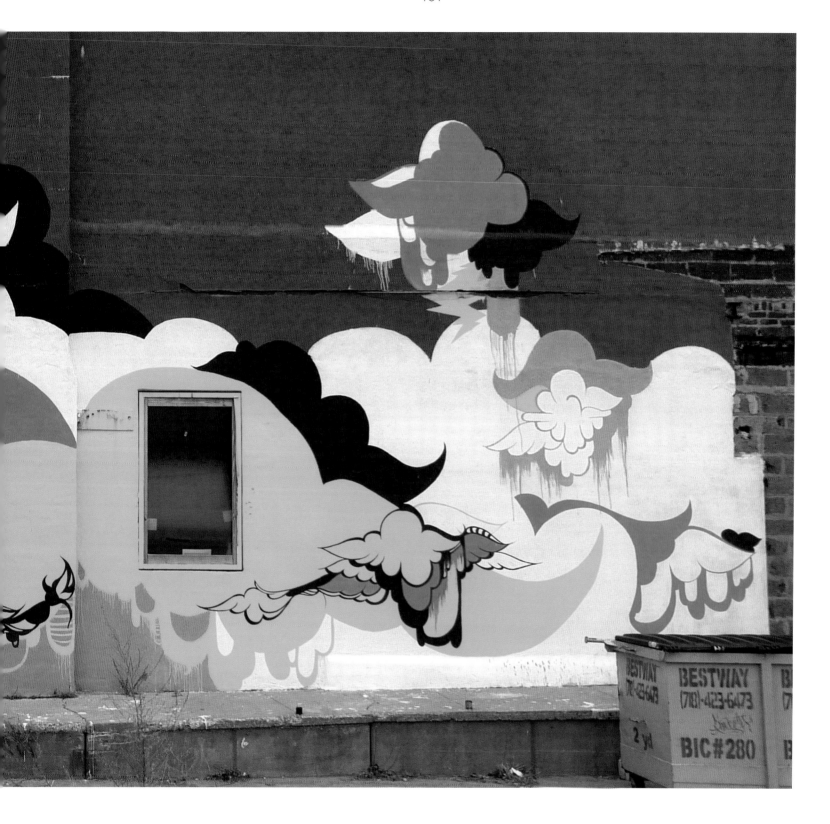

4TH ST., GOWANUS, BROOKLYN IN COLLABORATION
WITH CRF8TIVE YOUTH*INK AND RAY SMITH STUDIO

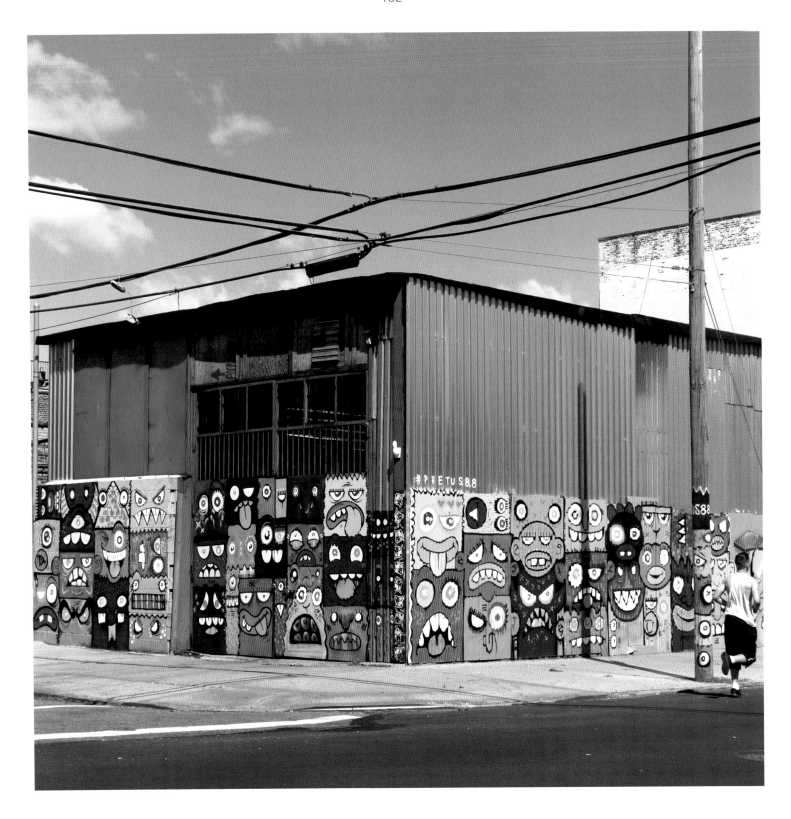

MORGAN AVE., BUSHWICK, BROOKLYN

PHETUS88

PHETUS88 SPEAKS…

ON STREET ART
"Public art keeps the pulse of the streets alive. The constant rotation of artists that come and go keep the street culture evolving. Besides, it's much better than bare walls!

I think the complexity of artists and styles parallel the complex issues within every day society, no matter the origin of the artist or the location the art has been created in."

ON PERSONAL ART
"In my work I aim to emphasize quality, detail and cleanliness, which hopefully translate into passion and integrity within the work. I failed art class all thru my experience in the education system so it's been a life long process to prove myself.

The natural progression of my work seems to be moving into studio work. Studio work is different in that it is in a controlled environment; adrenaline levels are low in contrast to when painting in the streets."

ON NYC
"New York City's uniqueness comes from the 5 boroughs having distinct identities but all coming together as a whole. I was born and raised in Long Island so New York City is a 25-minute ride across the bridge. I find street art in New York City is a fast paced, dog eat dog reality.

Every time I paint on the street it is an adventure. All I can say, is ask anyone who's painted at the same time and place as me and I'm sure they can tell you a story or two."

ON THE FUTURE
"Street art will continue to grow, and at a fast rate. I believe it will one day be the biggest art movement in history and I aspire to leave my mark on the walls amongst the masters.

I want to tackle the rest of the world!"

ON YOUR PROCESS
"I like all aspects of techniques and styles. I prefer spray paint while working on the street, doing large-scale pieces. I don't mind lower grade paint for fill and higher quality grade paint for detail and outline; I'll pretty much work with what is available at the time. When I paint I never have anything drawn out because it never ends up the way it is on paper. So I may have a formula on laying down fill and detail while creating my work, but never an exact idea. I kinda just go with whatever happens at the end of the day.

I prefer not to do lettering only because I feel it gets lost amongst the many other names out there. I can only hope that by creating a vibrantly patterned piece with a variety of characters and facial expressions, it will stand on its own and shine, no matter what may be displayed next to or around it. Stickers are my favorite way of spreading my icon around and making them yourself only makes you want to put them up yourself; it's a small vice within the overall graff/art scene. Same with stencils; I like to make my own. The only thing with the stencils is that it's a pain in the ass carrying around wet cardboard sheets! Over all it's all good, so grab a can of color and have at it!"

"IN MY WORK I AIM TO EMPHASIZE QUALITY, DETAIL AND CLEANLINESS, WHICH HOPEFULLY TRANSLATE INTO PASSION AND INTEGRITY WITHIN THE WORK."

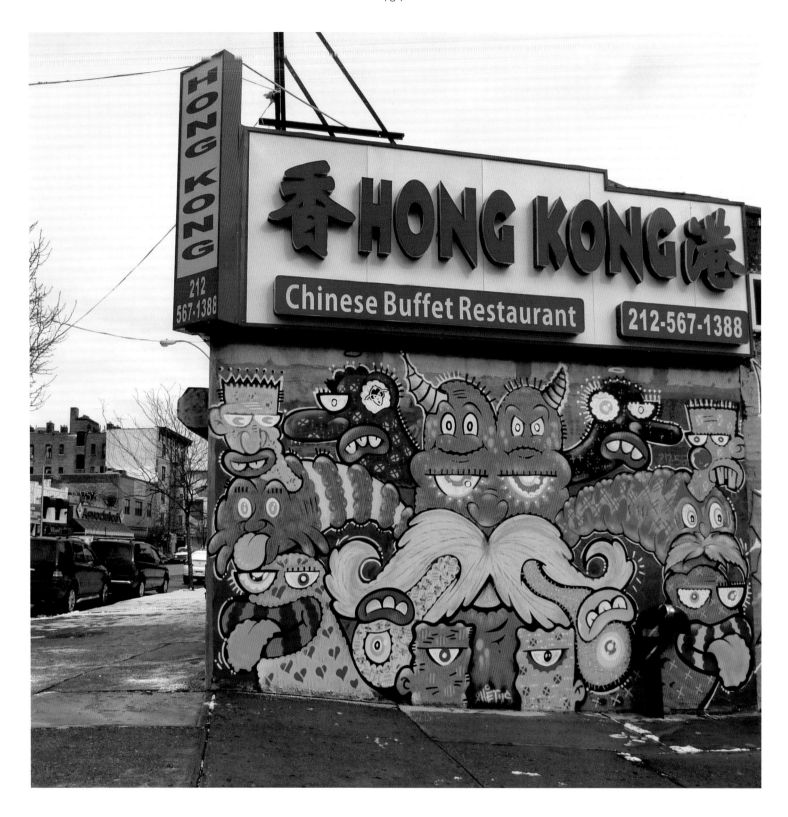

215TH ST., THE BRONX

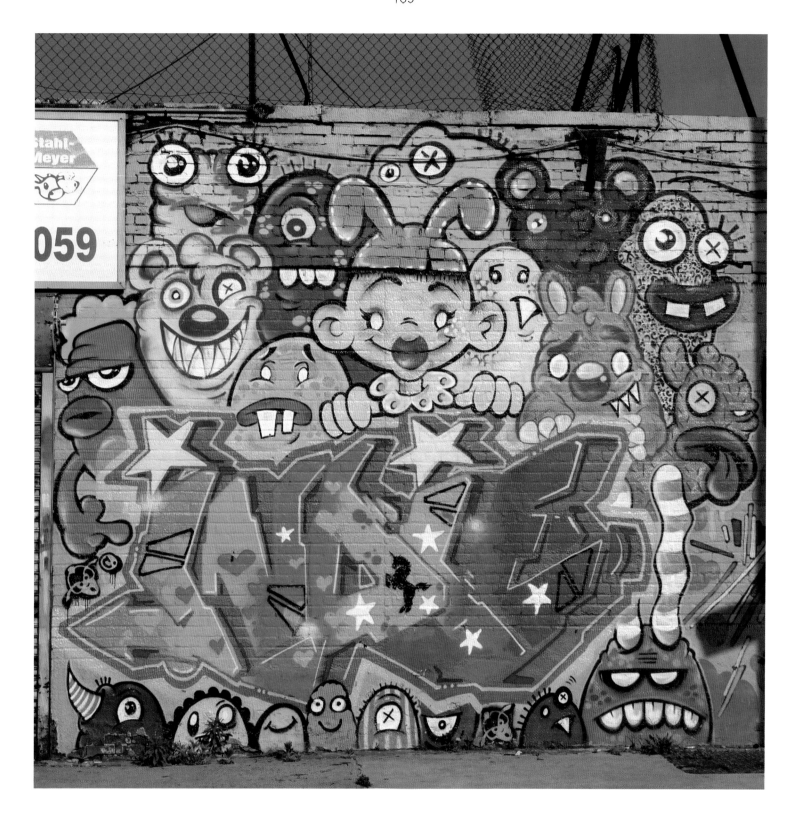

BOONE AVE., THE BRONX WITH INDIE184

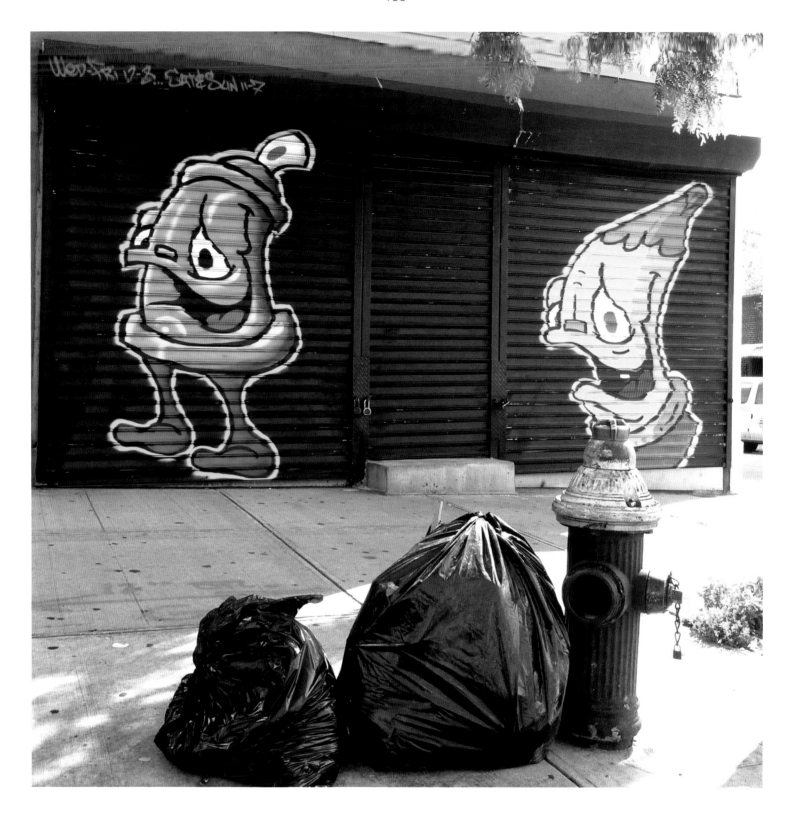

CENTRAL AVE., BUSHWICK, BROOKLYN

BISHOP203

BISHOP203 SPEAKS…

ON STREET ART

"I have been doing graffiti for over 20 years now. The thing that really attracted me more towards the street art side of things in the past few years was not so much the art but the people. Everyone was just silly nice, while we graff heads are generally not so friendly. Plus there seems to be little politics that comes with it: not this crew has beef with that crew, blah blah blah… But after doing it for a bit, it felt nice that you can throw up a piece and people seem to really relate to it. Good or bad, a lot of street art can evoke some kind of emotion from people. On the other hand, most people can't read or understand the graffiti. Fuck it, it's just fun!"

ON PERSONAL ART

"I started out not taking art too seriously and still don't. I like just enjoying what I do and not stressing the greater meaning of it. Hell, my graffiti name is JAT (Just Another Toy) sooooo yea… I do work on canvas and have fun doing it but there is nothing compared to the street, or even better, a good old rusted-out freight train!"

ON NYC

"New York City is a grey, gritty city. I feel like that comes across in our style of not just street art but also the way cats skate, bike, do graffiti, etc. I feel like our style is rawer than in other places, a little more 'fuck you.' I love and live in Bushwick, Brooklyn. That is where it is all happening now.

I have quite a few interesting stories but keep them close. Though I will say that it's a great feeling when you meet someone that you have been digging and they know who you are through your work already."

ON THE FUTURE

"I honestly have seen a trend come up in the past year where cats are trying to get up but are putting no effort in any kind of style or skill. Just putting up crap for crap's sake. I'm hoping this fades out soon. Street art has become so damn trendy that it attracts people who otherwise wouldn't give it a second look normally."

ON YOUR PROCESS

"For the streets spray, markers and stickers are the move. Stickers are great because you can get up without having to break stride. You can put up 100 in 30 minutes while taking a lil walk. But lets be honest here boys, size does matter…"

"THE THING THAT REALLY ATTRACTED ME MORE TOWARDS THE STREET ART SIDE OF THINGS IN THE PAST FEW YEARS WAS NOT SO MUCH THE ART BUT THE PEOPLE. EVERYONE WAS JUST SILLY NICE, WHILE WE GRAFF HEADS ARE GENERALLY NOT SO FRIENDLY."

ROEBLING ST., WILLIAMSBURG, BROOKLYN

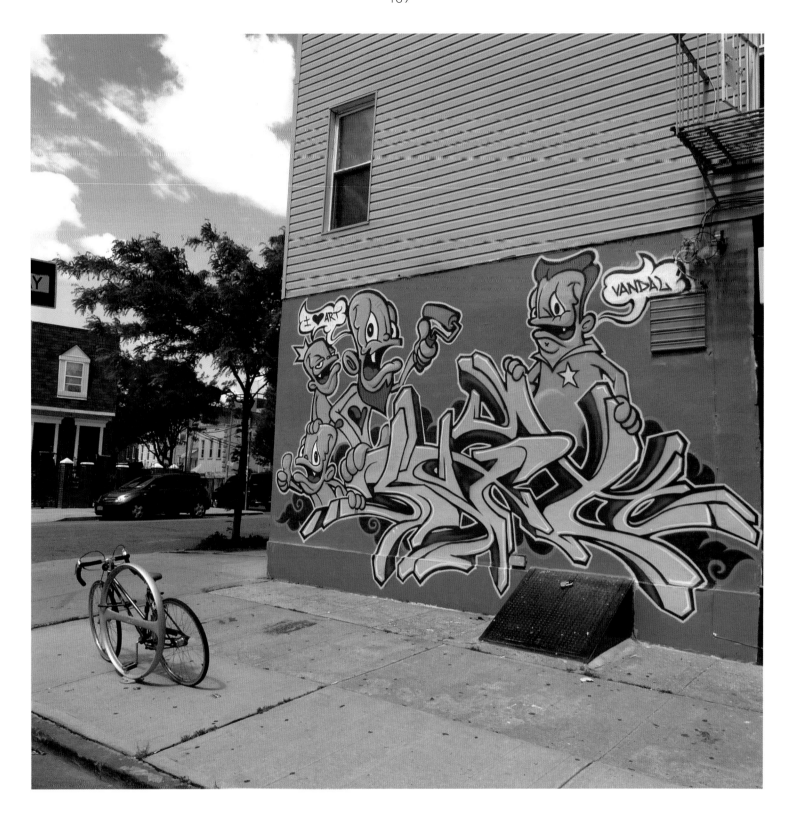

WILLOUGHBY AVE., BUSHWICK, BROOKLYN

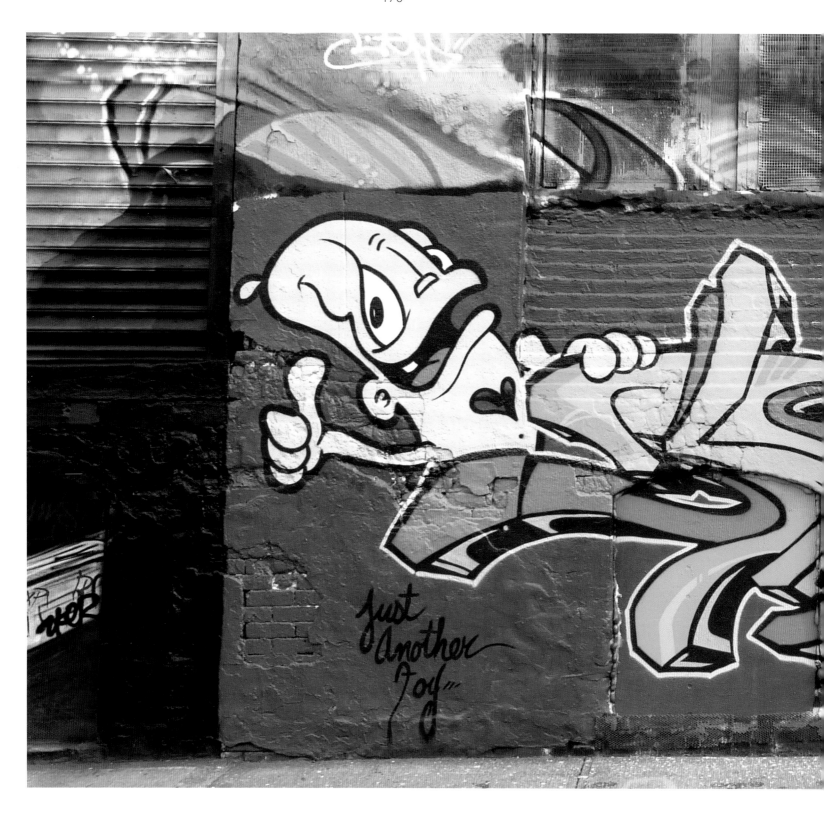

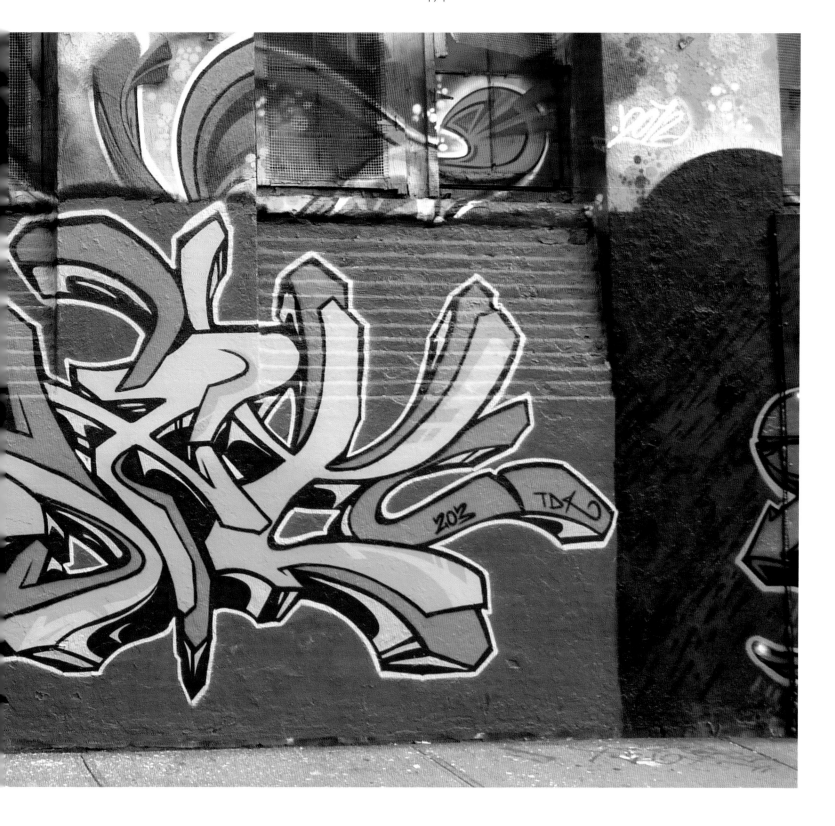

5 POINTZ, LONG ISLAND CITY, QUEENS

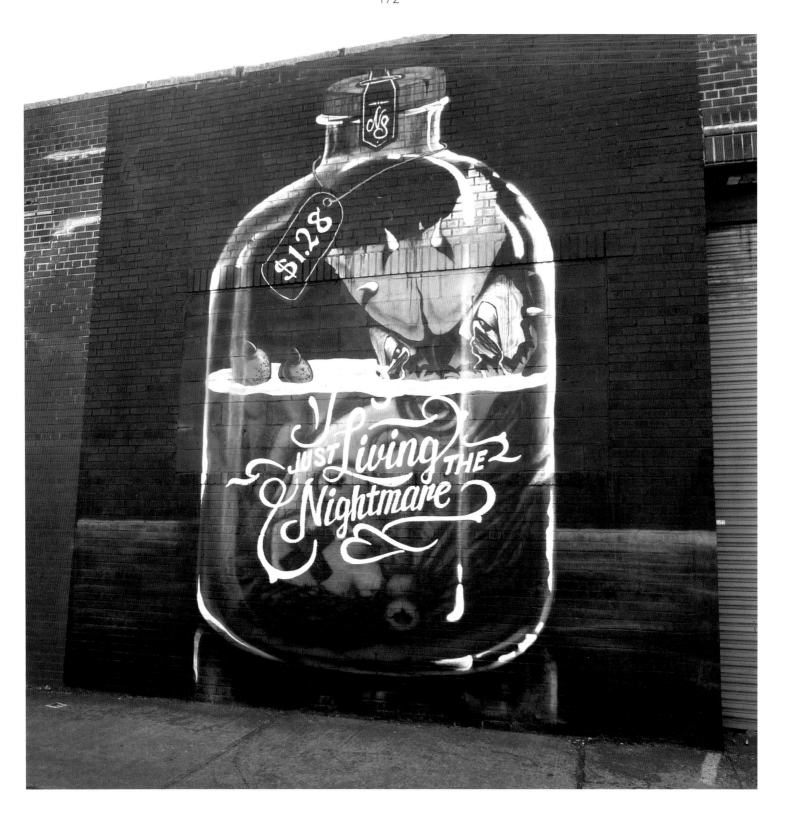

TROUTMAN ST., BUSHWICK, BROOKLYN

NEVER SATISFIED

Some cynical prick that likes to whine about his personal problems on walls.

MR. NEVER SATISFIED SPEAKS...

ON STREET ART

"I personally am sick of the phrase 'street art.' I feel it's become some kind of pop culture term these days. There are a lot of artists who use that phrase as a marketing tool when in actuality they have spent little to no time wandering up train tracks, climbing over fences, painting in weird places amidst crackheads, and being shat on by the general public. I paint on walls because I like to be outside interacting with the environment around me. I like everything about the feeling of painting large-scale walls in crazy places. It relaxes me. I also love that there is a sense of community between artists who work on the streets. It's a very strange sub-culture, socially speaking. It's honestly quite hard to explain. There is a lot of animosity in the scene, yet I can travel just about anywhere and get linked up with other artists. Being able to collaborate with someone regardless of language and cultural barriers is a beautiful thing.

As far as what other people think. I don't usually try to think that much into how other people react to the work. Matter of fact, I can pretty confidently say recently that I've just completely stopped caring. I try not to take it all too seriously. What I do find funny is how riled up and threatened some people can get over a piece of art on the streets; yet, they are perfectly okay with looking at advertisements everywhere they go. I love seeing work out in public and I love looking at work that is genuine to the artist that created it and not some watered down community friendly BS commission mural."

ON PERSONAL ART

"I started 'tagging' words on things when I was around 15-ish. I used to be really into skating and I was first exposed to graffiti through that. I started actually going out and writing shit on walls when i was 16 after a girlfriend at the time cheated on me. I got a kick out of writing the word 'trust' everywhere and pissing her off. At the time I didn't realize all of the politics behind what I was doing. After getting into several run-ins, both with law enforcement and with other 'writers', I learned quickly and

adapted myself to better understand the politics and culture behind the art form. Now, 13 years later, here I am again whining on walls about my personal problems. I guess it's good to stay in touch with your roots.

I pretty much quit trying to be involved in the art show scene. Not to say I have a problem with people trying to sell their work in galleries. I personally just get no enjoyment out of sitting inside some studio somewhere and trying to confine my work to fit into a small rectangle hoping that some rich guy with absolutely no understanding of what I'm doing will buy it. I also don't like creating work with the hope of selling it. My work is very personal to me and my emotional problems are not something I want to try to market right now. To me, the moment you produce a piece of work with the motive of selling it, you are dumbing down your message. I try to keep what I do for a living separate from painting sad shit on walls. But again, that's not to say I'm against occasionally throwing something up in a gallery show for fun. It just rarely happens on my end.

Through my work it is important for me to genuinely express my thoughts, my feelings and myself and remain true to that without compromise. As most people know, my work has a tendency to be pretty gosh-darn 'negative'. What drives me to paint is negativity. Whenever I feel like shit about something, rather than trying to hide it, I just embrace it and channel it out onto walls. It's a release but it's also a bit of an addiction. I'm at a stage in my life right now where I'm really trying to push myself to have a career and not play the 'starving artist' role anymore. So I try not to be too sucked into all of it."

ON NYC

"I don't know if I plan to stay in New York City forever. But I've been coming up here for a long time and the thing that I am most attracted to about this city is its diversity. There are a lot of talented people here from every corner of the world. And there are constantly other artists visiting here from all over. That is an endless source of inspiration for me. It's nice to feel connected to the rest of the world. It humbles me to consistently be exposed to such international talent.

"I LIKE EVERYTHING ABOUT THE FEELING OF PAINTING LARGE SCALE WALLS IN CRAZY PLACES. IT RELAXES ME."

My favorite neighborhood is Bushwick, Brooklyn. There is a lot of artwork and a lot of creative energy there right now. It is quickly being gentrified and pretty soon rent will be up so high that yuppies will take over and turn it into something it is not. So I'm enjoying it while I can.

As far as funny scenarios I've been in, when I try to recall a single memorable experience, too many come to mind! Mostly having to do with witnessing public masturbation, watching crackheads be...crackheads, discovering meth labs, getting into retarded fist fights, etc. etc. etc. I don't even know where to begin - so many hilarious stories. That's just one of those things you'd have to discuss with me over a beer. I grew up painting in Atlanta, Georgia. There are a lot of rabid crackheads in that city. I'll just leave it at that."

ON THE FUTURE

"I grew up in the 'graffiti' community. I had to constantly get into un-productive arguments about the differences in the two scenes (street art versus graffiti). The way I see it, the lines between graffiti culture and street art culture will just continue to blur as true talent continues to emerge. Real talent should shine through all barriers and stereotypes. While a lot of graffiti artists have bitter feelings about the 'street art movement', they definitely recognize those who have a real drive as opposed to the posers who paint one thing on a legal wall and try to sell prints of it in a gallery. Street art will continue to become popular and commercialized and that will produce more and more posers who start doing it. The way I see it, it will just create more competition; meaning artists will really have to push their skills if they want to stand out from all the mediocrity. It is a constantly evolving art form and that is the appeal of it."

ON YOUR PROCESS AND INFLUENCES

"Use whatever you can get your hands on! Innovate! If you find some way to turn human shit into an organic oil-based medium, then go for it! I grew up using spray paint, but I'm open to experimenting with any medium that comes to mind. I often find objects around me and play around with them on walls. In the past few years I've been painting a lot more with gallon paint because it is way cheaper then spray-paint and I can cover larger

surfaces with it as well as water it down to get interesting effects. I pretty much always do my detail work, though, with black and white spray.

As far as past influences on my style, I've gone through a ton of phases and experiments in my work before I got fixated on these fucking owls. I don't feel like typing up a novel about all that crap."

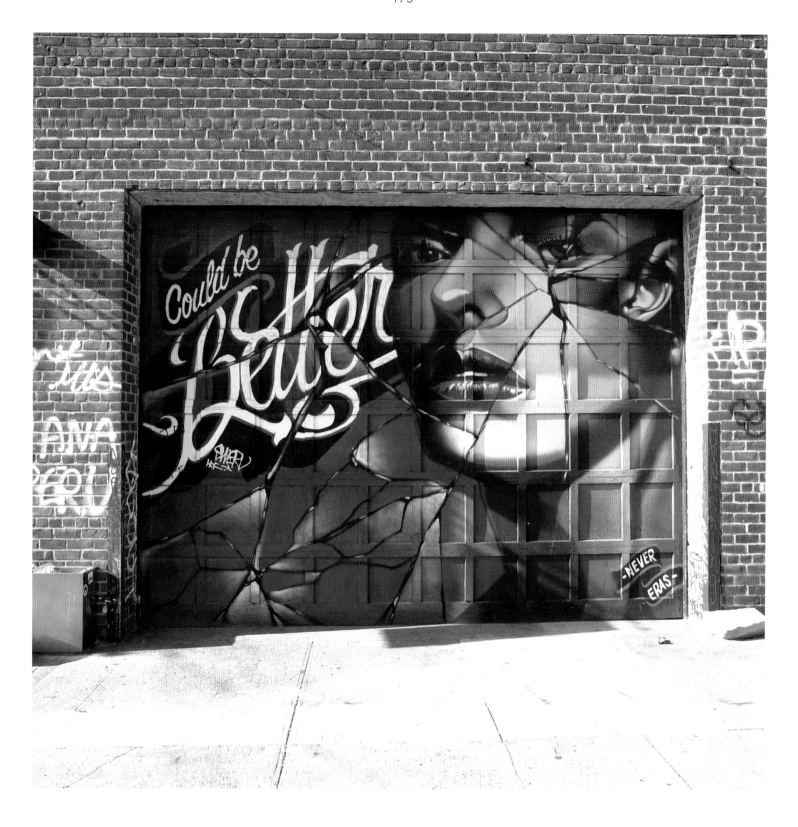

WATERBURY ST., BUSHWICK, BROOKLYN WITH ERAS

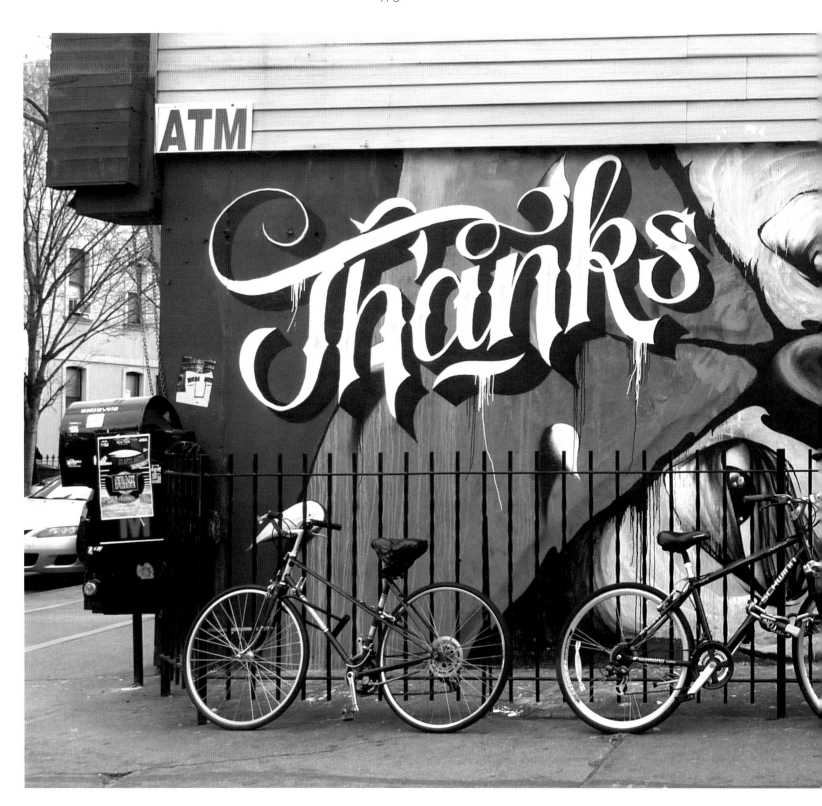

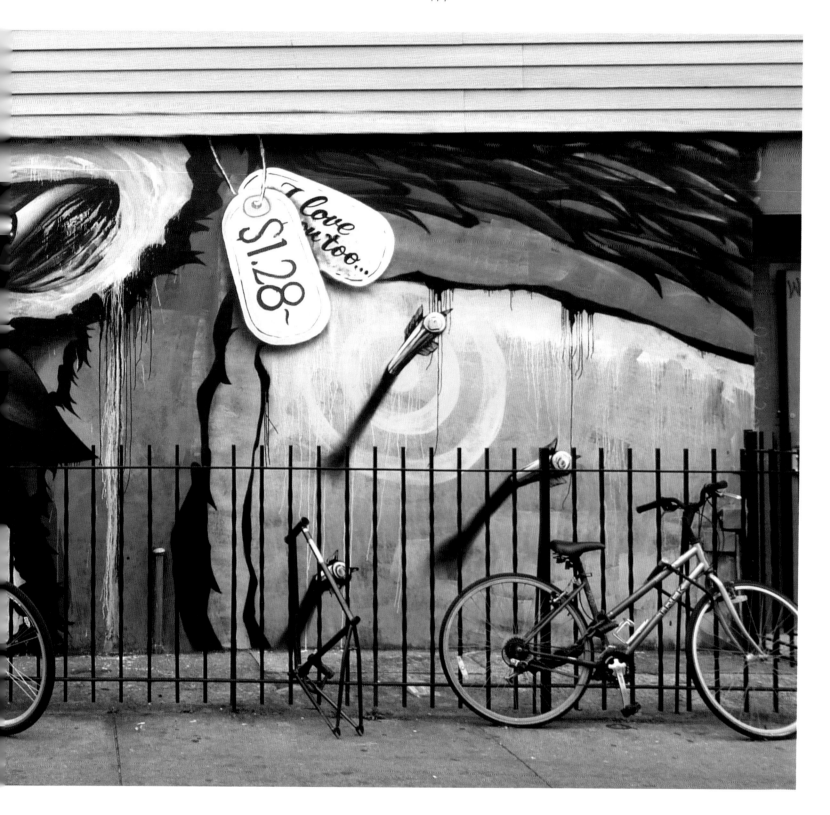

BEDFORD AVE., WILLIAMSBURG, BROOKLYN

NORTH 8TH ST., WILLIAMSBURG, BROOKLYN

CHRISRWK

Chris is a child of the 80's. His world was often completely flooded with the imagery and ideas presented by television, comic books, and the music and movies of the time. Immersed in these various mediums, Chris began to store the images brought forward through everyday experiences in what he refers to as a "mental journal". This journal was a haven for his thoughts that he could refer back to whenever necessary. Chris's paintings frequently cite past conceptions of popular culture embedded in his psyche's cache. This use of intertextuality also serves to offer a comfort or familiarity of sorts to the viewer. Chris's works frequently reveal everyday musings and people that could easily be passed by on the street without thinking about further or looking twice. These stashes also aid Chris in the creation of a visual language comprised of his own iconographic imagery. Through the repetition of this imagery, Chris strives to familiarize his viewers with the language he has constructed. Chris believes that the notions within his pieces serve as a backbone for the many stories created by the onlooker when he or she is viewing the work.

In 2001 Chris set in motion RobotsWillKill.com. It is an arts site dedicated to community and its exposure to artists/media often disregarded by the mainstream art world. Rather than featuring his own work exclusively, he opened it up to allow the possibility for it to become whatever it evolved into being. RWK has a core group of artists, including himself, Kev/Psyn, Veng, Mike Die and OverUnder. Along with overseas affiliates ECB (Germany), Peeta (Italy), Flying Fortress (Germany) and JesseRobot (Belgium), this extended roster of artists helps to promote RWK as they push the boundaries of art.

CHRISRWK SPEAKS…

ON STREET ART

"I started getting into graff when I was young. My brother and his friends wrote so I fell right into it. I was around 5 years younger than them so I'd tag along and take pictures and pick up pointers. From graff I started getting into other forms of art. I loved the idea of the freedom with graff and street art. Places like galleries and art shows are great but can turn people off. When the art is on the street anyone can appreciate it."

ON PERSONAL ART

"I try and start the viewer with an idea and then let them take it from there. I like to take the unnoticed person and put them directly in front of the viewer. I try and command their attention in every medium I work on, murals, studio work, stickers etc. I like to think that my work touches on a certain place in people's hearts and minds, sparks a story and brings them into my world."

ON NYC

"I was born and raised in New York City so it just made sense. Every part of New York City has it's unique character. From the always changing streets of Brooklyn to the busy streets of Manhattan.

One time while I was painting, this little old lady walked up to me and right away I heard in my head 'you criminals are ruining the neighborhood' but instead she said: 'Thank god! These walls were so boring!'. Small stuff like that makes doing art outside worth it."

ON THE FUTURE

"Street art has come a long way. In some ways positively and in some ways negatively. Positively in the sense that more places accept it as a serious art form and negatively in the sense that everyone wants to do it. But with all things considered, the real artists stick around. I think the movement will over-expand and then eventually thin out."

ON YOUR PROCESS

"I've always loved stickers. It started when I was a kid. I remember going to the grocery store with my mom and having to get a sticker from the machine. From there it was skateboard and punk rock stickers. When I started writing I saw stickers as a quick up but with some time put into them. As time went on I focused more and more on doing them. I recently won Sticker Artist of the Year from Bomit for 2012.

Another main focus is murals. I've been lucky enough to do them all over New York and a few other states. Most are done with spray paint, latex paint and acrylic paint. Over the years I've experimented with some other mediums: wood cuts, lino cuts, screen printing, stencils, hand painted clothing, painted boards put out on the street and many others. I always return to stickers and murals though."

"I TRY AND START THE VIEWER WITH AN IDEA AND THEN LET THEM TAKE IT FROM THERE. I LIKE TO TAKE THE UNNOTICED PERSON AND PUT THEM DIRECTLY IN FRONT OF THE VIEWER."

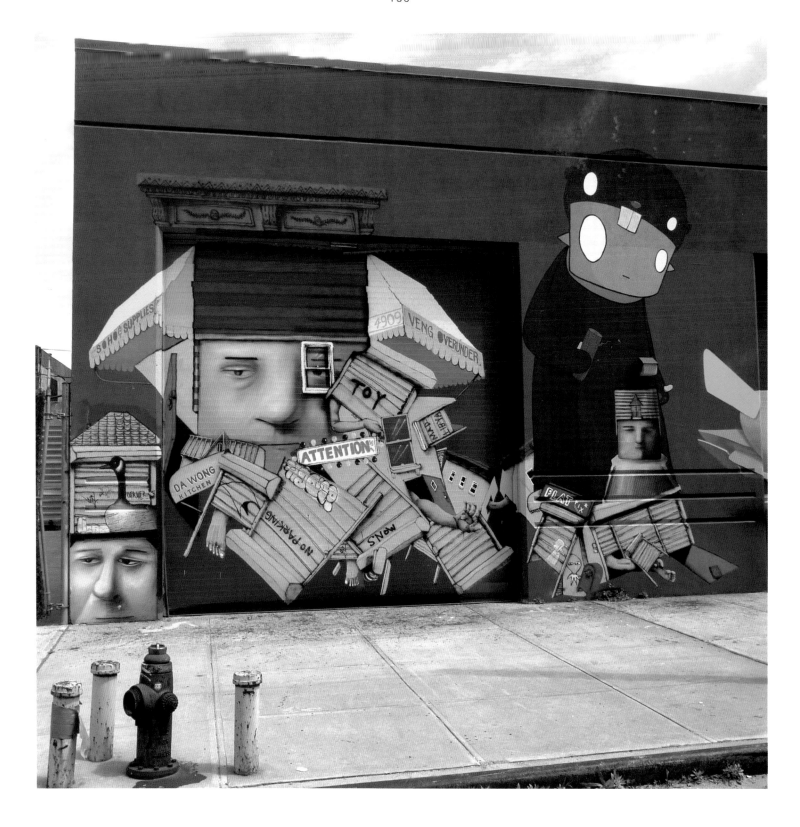

GARDNER AVE., BUSHWICK, BROOKLYN WITH VENGRWK AND OVERUNDER

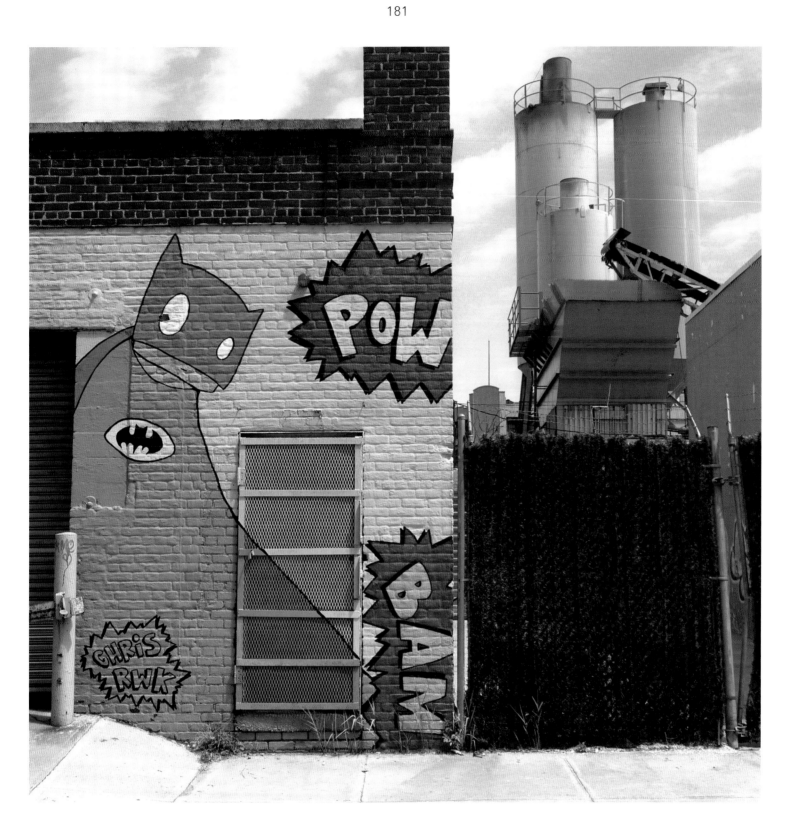

GARDNER AVE., BUSHWICK, BROOKLYN

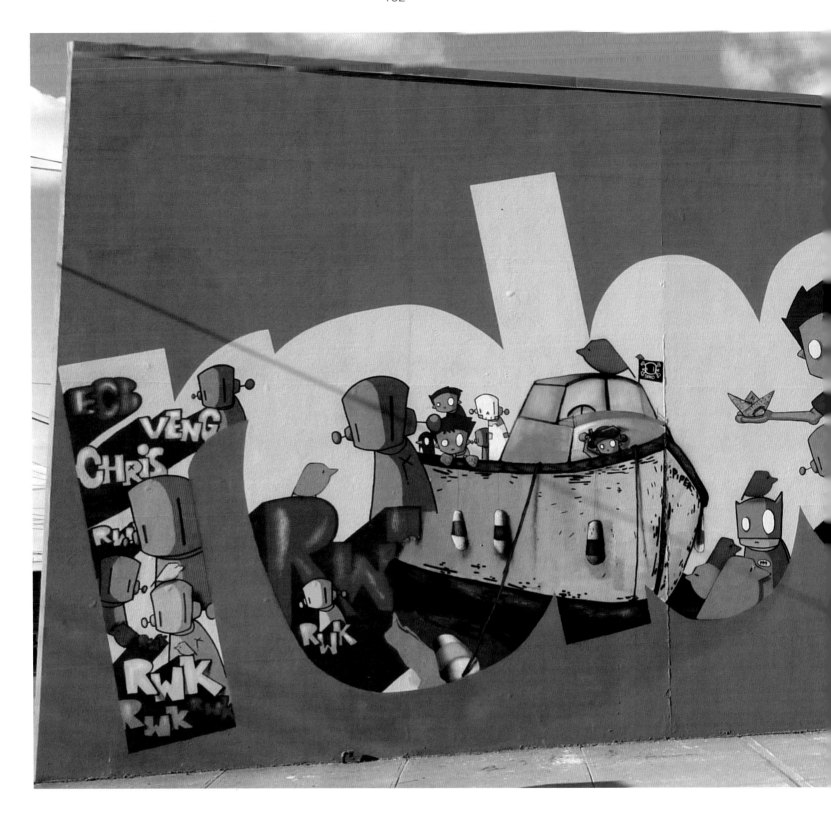

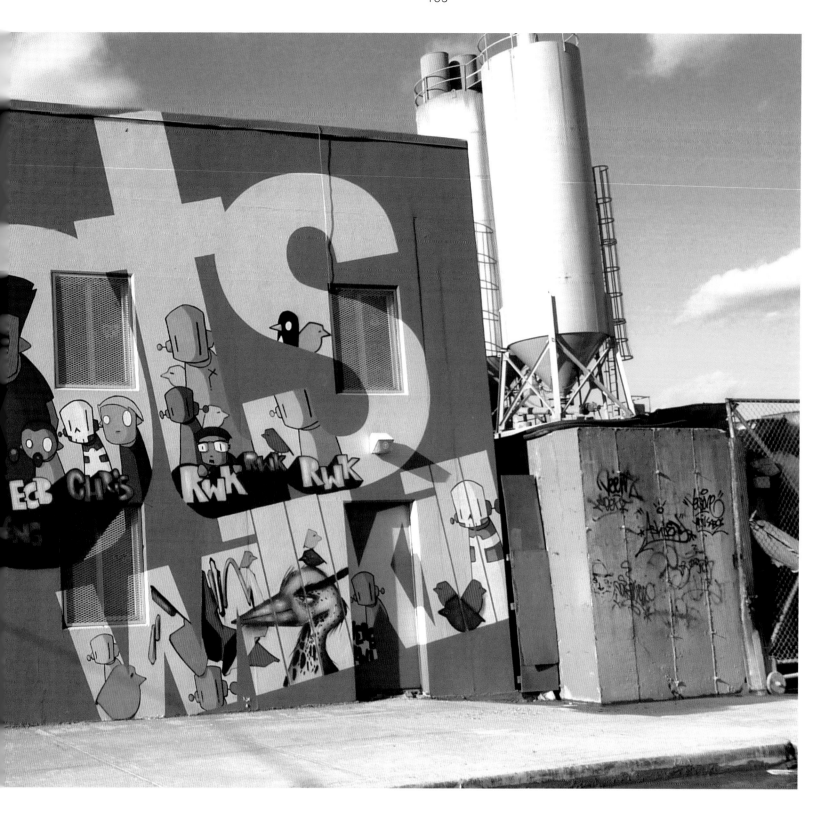

INGRAHAM ST., BUSHWICK, BROOKLYN WITH VENGRWK AND ECB

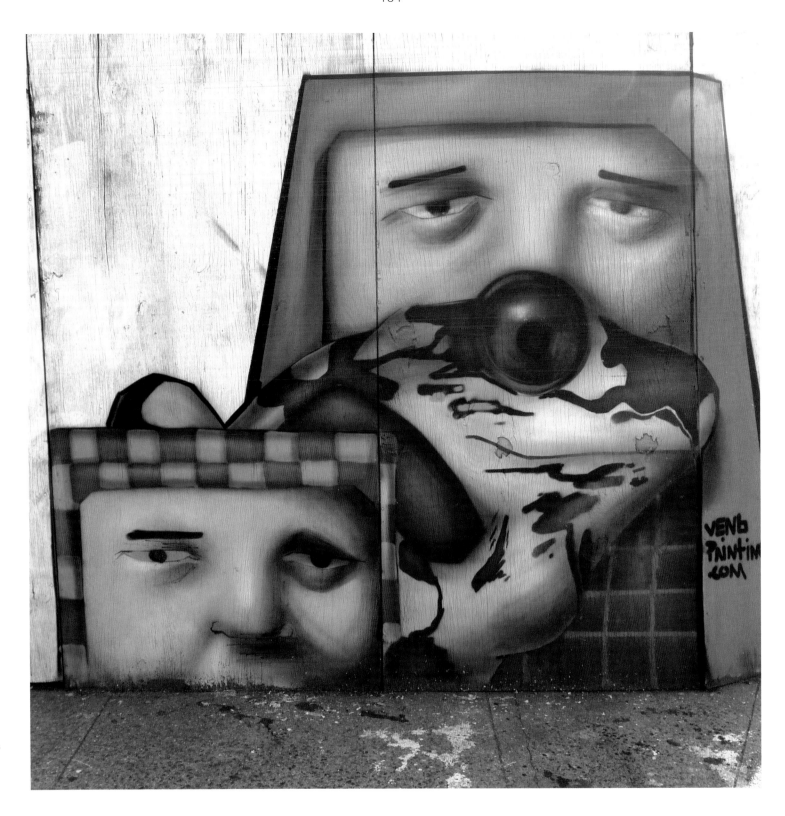

GRATTAN ST., BUSHWICK, BROOKLYN

VENGRWK

VENGRWK SPEAKS…

ON STREET ART
"The main reasons for putting work on the street are: first, to use an endless amount of space and different environments to work in conjunction with the piece and second, to put the work out for feedback from the public, be it good, bad or otherwise."

ON PERSONAL ART
"I always had an interest in painting and, being a teen into skateboarding, I eventually met people who tagged. I then just dived deeper and deeper into graffiti. Since I can remember I've always wanted an artistic job, (and) painted on canvas and worked (working) on earning money through my painting.

The difference between studio and street art to me are the reactions generated. With public work you are out there open to all sorts of feedback, whereas with the studio you are alone and in complete control of your environment."

ON NYC
"My favorite neighborhood in New York for putting work out is Bushwick in Brooklyn. I can't think of just one memorable experience of doing street work; there have been too many. This is why a big city like New York has so much to offer; it is always offering something new."

ON THE FUTURE
"The street art movement will, like everything else, go in and out of style and change. Those who do work for themselves and in order to be artistic, not just part of a fad, will be a constant within it. I only hope I can paint as long as God lets me."

ON YOUR PROCESS AND INFLUENCES
"Since I was a kid I've never been too far from my oil paints and some spray paint. In the last few years I've also started some work with watercolors. Inspiration comes from artists of the past and fellow contemporary artists. Nature also plays a big role in my art and I find it invaluable."

"BEING A TEEN INTO SKATEBOARDING, I EVENTUALLY MET PEOPLE WHO TAGGED. I THEN JUST DIVED DEEPER AND DEEPER INTO GRAFFITI."

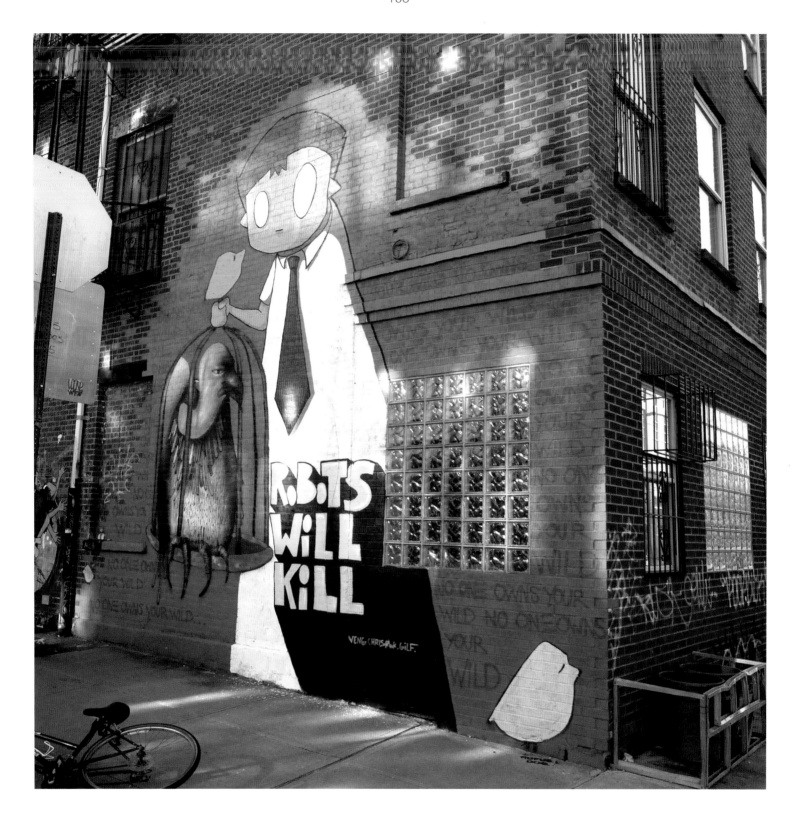

NORTH 1ST ST., WILLIAMSBURG, BROOKLYN WITH CHRISRWK AND GILF!

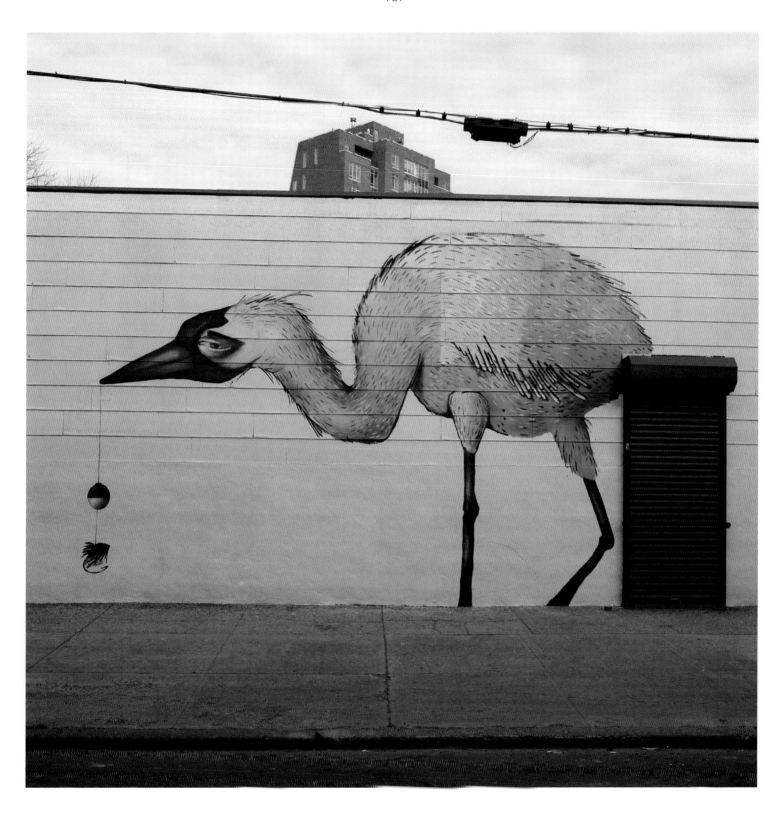

NORTH 10TH ST., WILLIAMSBURG, BROOKLYN

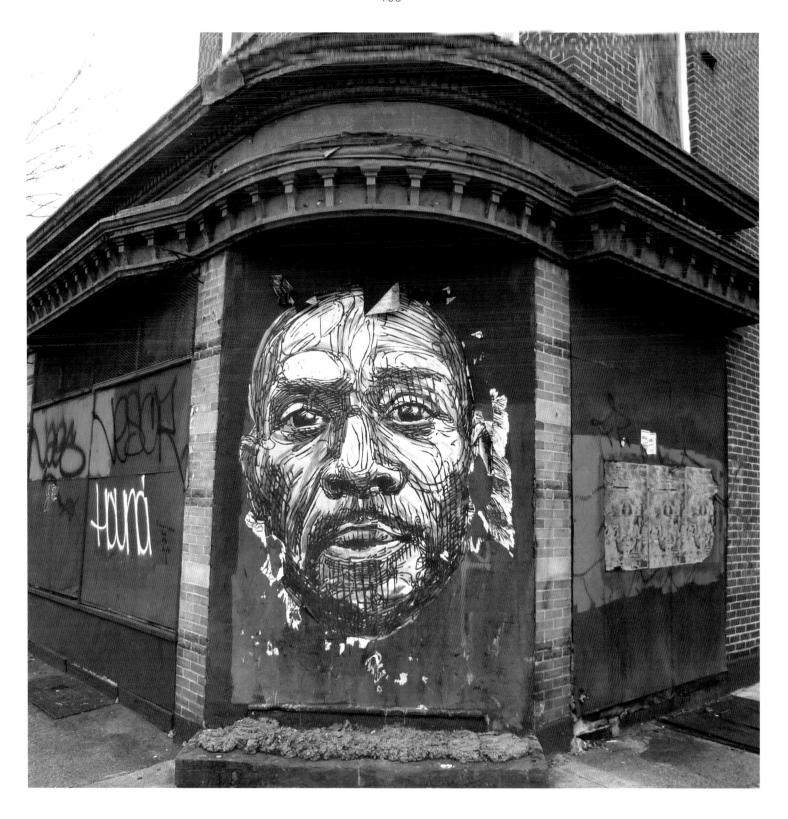

HALSEY ST., BEDFORD-STUYVESANT, BROOKLYN

GAIA

GAIA SPEAKS…

ON STREET ART

"In the United States, the resurgent interest in art in the streets can be attributed to a renewed interest in urban living. American cities are becoming the focus of lucrative redevelopment. As money flows back into the urban environment, murals and street art have become pertinent again. Since private interests and not the old guard of public entities fund so many street art projects in the United States, community has become secondary to style. Other projects have emerged in response to this trend in an effort to reproach community art with interesting new strategies."

ON PERSONAL ART

"I became a street artist by observing the movement from afar, online and not from skateboarding or any other form of urban navigation. I used to only go out at night alone and slowly became a part of the greater global community, especially after I left New York to attend the Maryland Institute of Art.

In my opinion, street art should be as specific as possible. The artwork should not only respond to the architectural characteristics of a space, but also the history and narrative that defines the surrounding environment. If the artwork is disembodied, its only real purpose is decoration. My studies are situational depending on where I am painting and for whom; whether it is a grocery store owner or a multinational corporation. Additionally, my work revolves around the mythological construction of past and contemporary identity in addition to my exploration of global markets and power structures."

ON NYC

"New York City once had quite a robust street art scene with artists such as Elbowtoe, Swoon, Bast, Faile and the like populating the streets with some of the finest specimens of illegal work. Now that those artists have moved on, the vacuum has been filled with generally unambitious artists who don't venture much farther than downtown Brooklyn where art in the streets is to be expected. Whereas in other cities, street art is just a refined form of a broader communication on the walls, the second wave of street artists in New York are very career-oriented. And, because of heavy policing, illegal work is only produced by the most courageous rather than being a natural process practiced by everyday people.

My favorite neighborhood in the city is the Upper West Side, Manhattan because it's gorgeous and a little stiff and is right next to the park. But besides the rare tag, there is no street art."

ON THE FUTURE

"The future of street art is moving away from illegal practices and towards larger legal walls. The simple illegal gesture no longer carries the same attention as it once did. This is evident when surfing the Internet. There will be a greater divide between relatively few exploding careers and local communities of artists all over the world who are relatively unknown beyond their city but continue to paint in the streets with permission. The true street artist does not give the public what they necessarily want, but Speaks truthfully and provocatively about the realities of our streets and culture. Illegal street work will always be pertinent because of the potential that it holds to break beyond curatorial structures."

ON YOUR PROCESS AND INFLUENCES

"When I first began producing posters to put up illegally in the streets I strictly stuck to linoleum engraving. My initial foray into the world of printmaking was very much inspired by the work of Swoon and Elbowtoe. Over the years I continue to carve blocks, but have also expanded the format using reprographics printers. The print medium was too constricting in character and I have since elaborated upon my repertoire to include large-scale mural making. Now I prefer hand-painted posters that are site generated or to create murals both large and small. I save the printed images for bombing. My direction has also changed with the impact of new influences and I now look to the work of Alfredo Jaar, Mierle Ukeles, Dennis Adams, and Escif."

"THE ARTWORK SHOULD NOT ONLY RESPOND TO THE ARCHITECTURAL CHARACTERISTICS OF A SPACE BUT ALSO THE HISTORY AND NARRATIVE THAT DEFINES THE SURROUNDING ENVIRONMENT."

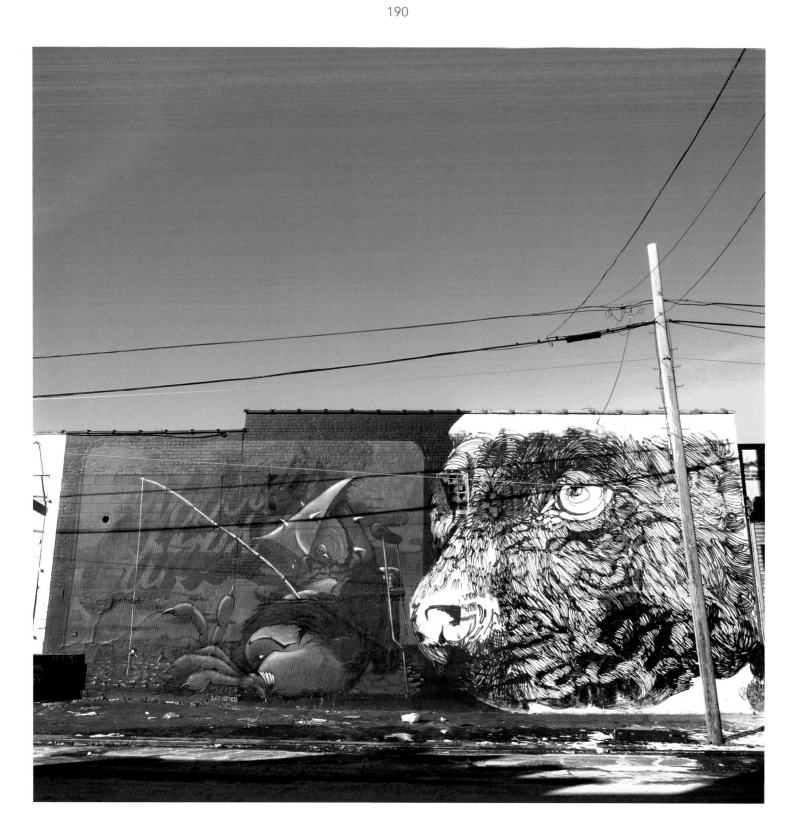

MESEROLE ST., BUSHWICK, BROOKLYN WITH NEVER SATISFIED

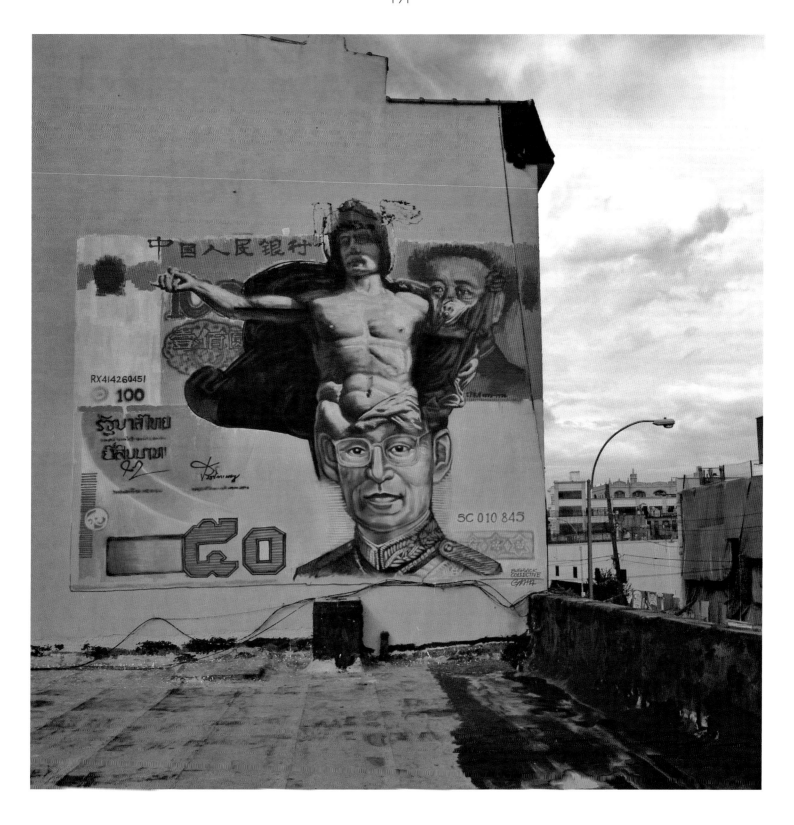

TROUTMAN ST., BUSHWICK, BROOKLYN

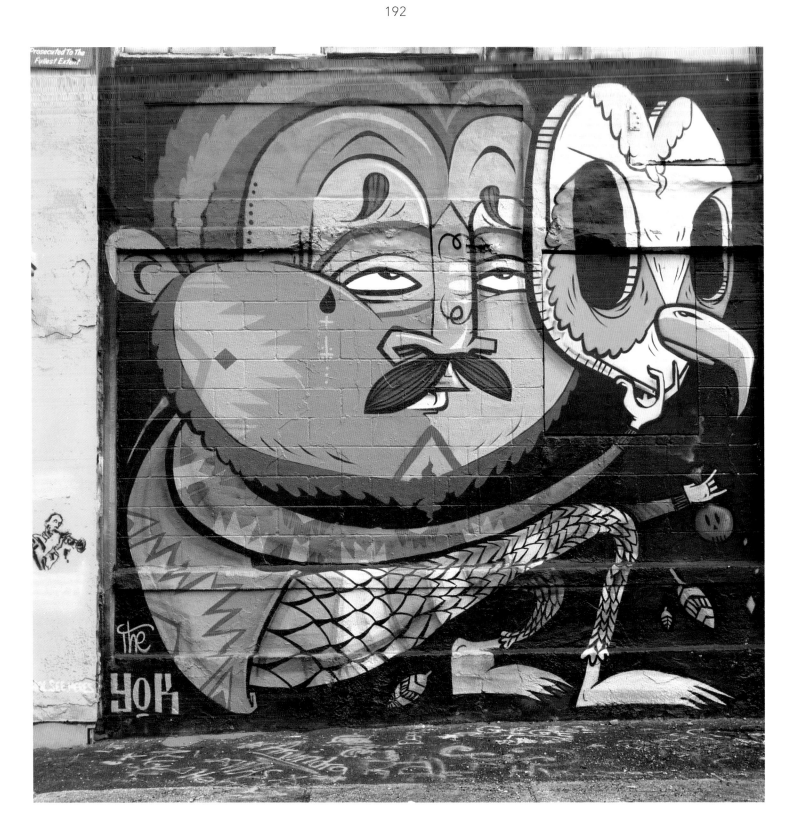

5 POINTZ, LONG ISLAND CITY, QUEENS

THE YOK

THE YOK SPEAKS…

ON STREET ART

"Displaying your work in our streets and neighborhoods is a great way to show your work to a greater audience. It's cool to see people expressing themselves in the street. Observing people splash paint wherever they feel like it helps give the city a bit more color and life. It's great to look back and see what was on peoples' minds when they painted – to see what was affecting and influencing the artists and any one nearby with access to a can.

Street art has lately become very popular. I'm not sure it's a new thing; people have been painting in public spaces for a long time. Cave paintings, I think, started the movement. Hahaha!"

ON PERSONAL ART

"I started with the Ayem crew, a graffiti crew in Australia. They encouraged me to pick up a can of spray paint and, after that, I was hooked.

I do a little bit of studio work. Studio work, though, isn't as fun, immediate or exciting as street work. So I tend to do more street work. I like to highlight storytelling in my work."

ON NYC

"The city welcomes art in all forms and is very supportive of artists trying to do their thing. I love New York City and I get so inspired just walking down the street.

My favorite neighborhood is Bed-Stuy in Brooklyn. I went to a rad party there and the people are some of my favorites.

I remember one time an elderly gentleman (someone's dad) randomly gave me $50 to buy more paint because he had a win at the races."

ON THE FUTURE

"Street art will probably lose popularity and go back underground. It will always remain a great way for people to express themselves."

ON YOUR PROCESS

"I prefer to use spray paint; the medium is so fun to use, it's immediate and unforgiving. You can cover so much area in such a short time, which I haven't found possible with any other form of paint, except maybe a roller. When you think about it, it's such a difficult medium to try and master. You have paint shooting out of a can, at high pressure, your hand is moving all over the place. No wonder it's hard to control… I like this challenge."

"IT'S GREAT TO LOOK BACK AND SEE WHAT WAS ON PEOPLES' MINDS WHEN THEY PAINTED – TO SEE WHAT WAS AFFECTING AND INFLUENCING THE ARTISTS AND ANY ONE NEARBY WITH ACCESS TO A CAN."

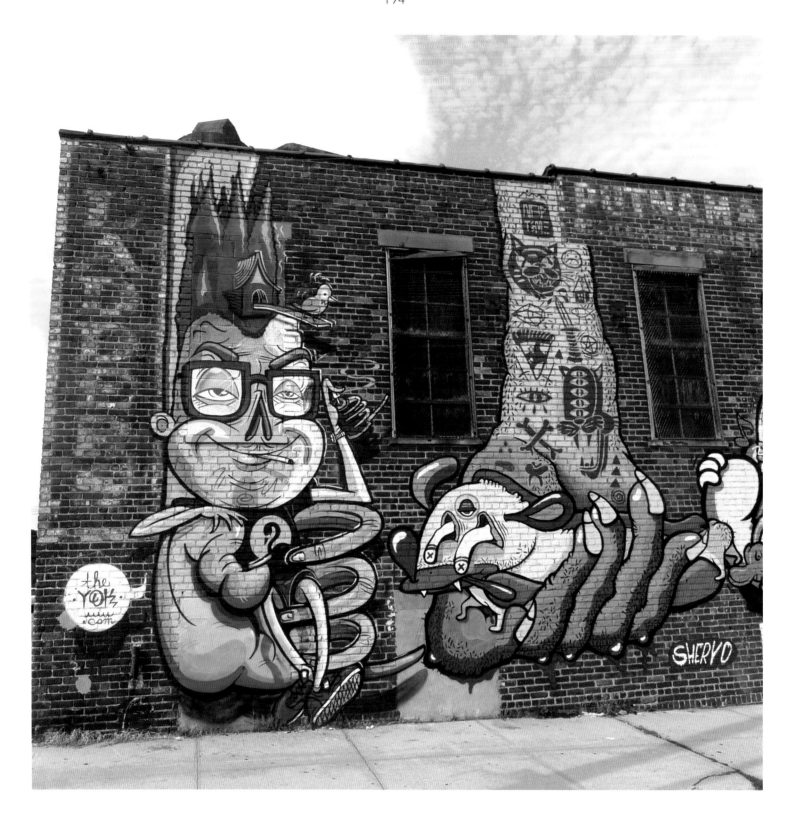

ST. NICHOLAS AVE., BUSHWICK, BROOKLYN WITH SHERYO

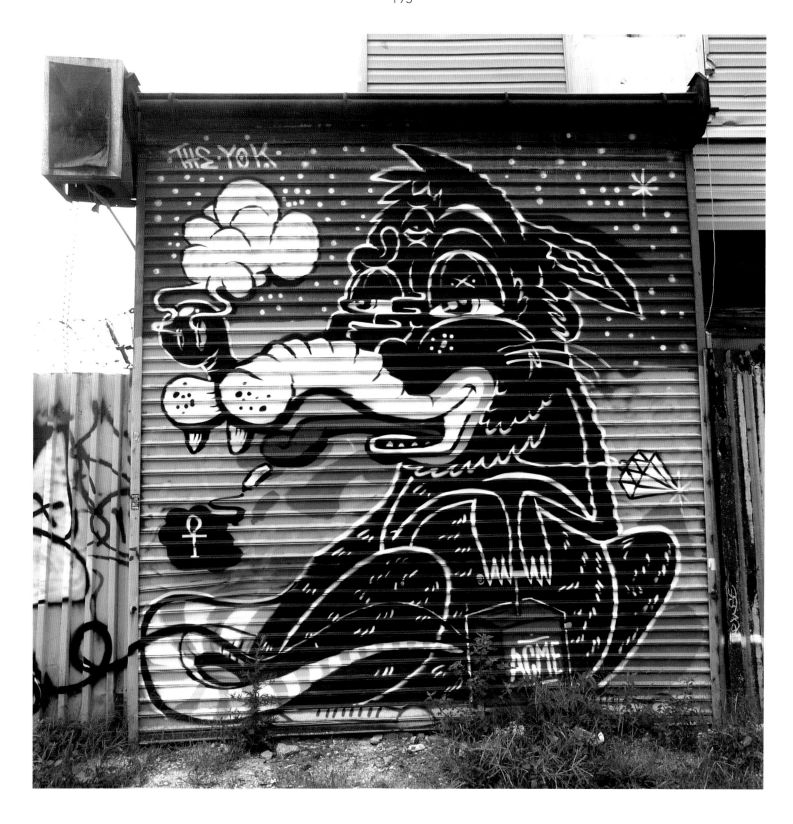

ROEBLING ST., WILLIAMSBURG, BROOKLYN

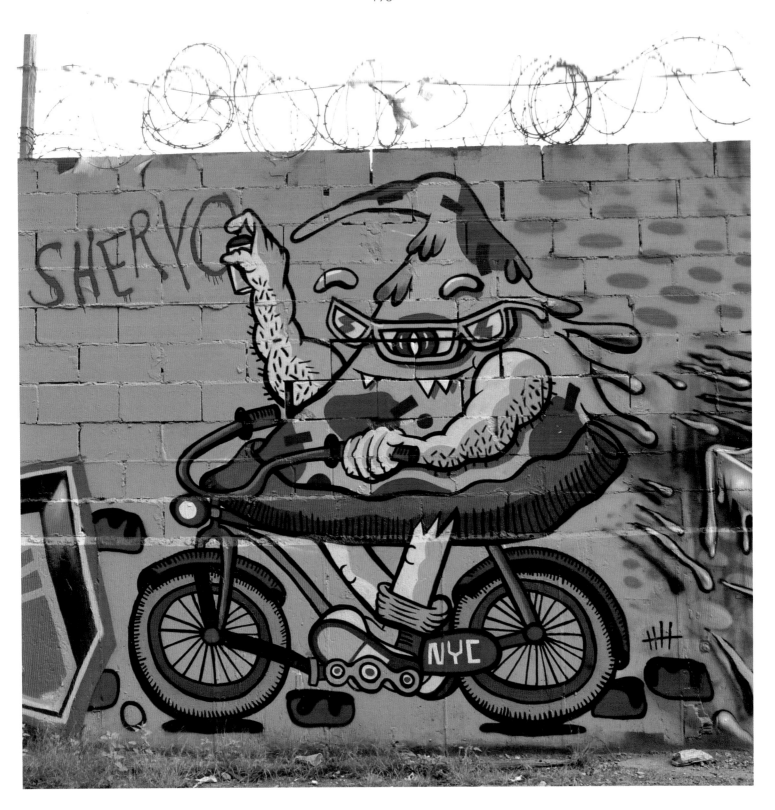

MOORE ST., BUSHWICK, BROOKLYN

SHERYO

SHERYO SPEAKS…

ON STREET ART
"Fun stuff."

ON PERSONAL ART
"Wonky, leprosy, calming to disoriented souls."

ON NYC
"Awesome place, awesome people."

ON THE FUTURE
"Keep travelling and painting."

ON YOUR PROCESS
"No particular technique. If it's no fun, I don't wanna do it."

"IF IT'S NO FUN, I DON'T WANNA DO IT."

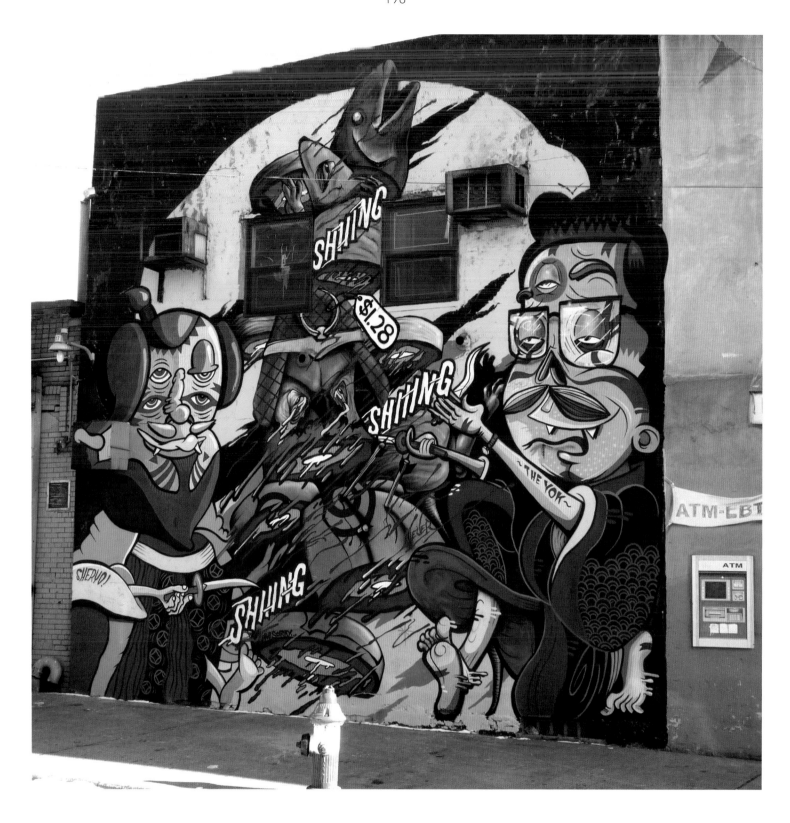

TROUTMAN ST., BUSHWICK, BROOKLYN WITH THE YOK AND NEVER SATISFIED

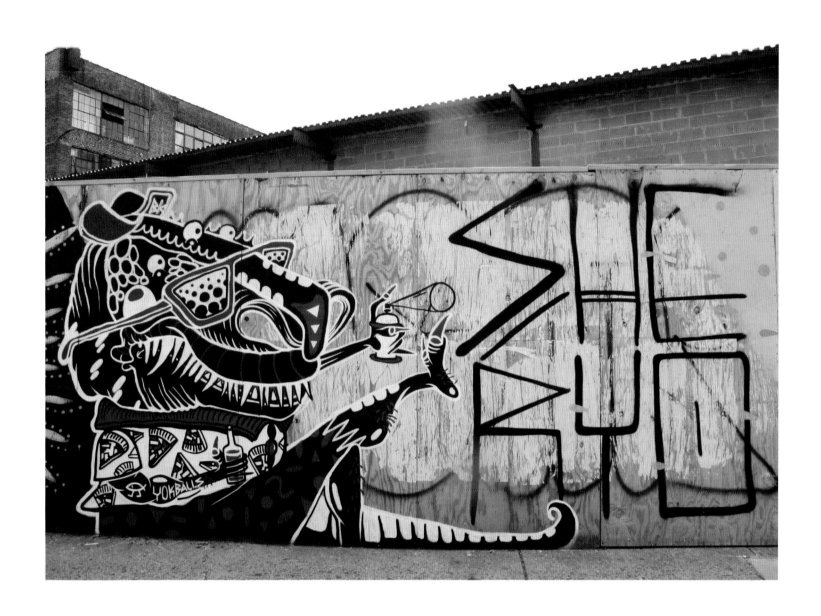

KNICKERBOCKER AVE., BUSHWICK, BROOKLYN

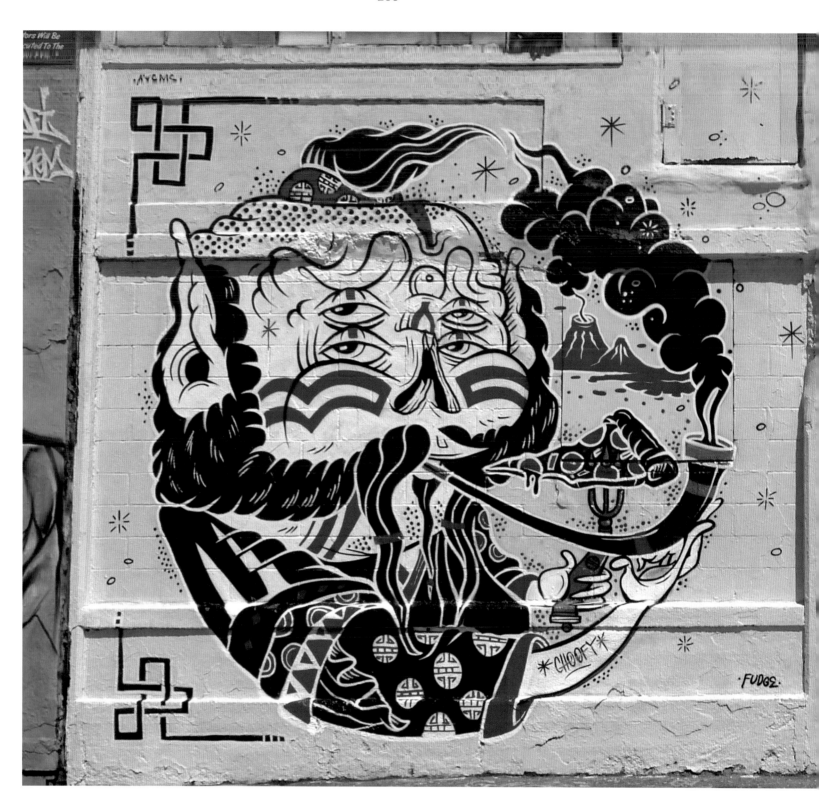

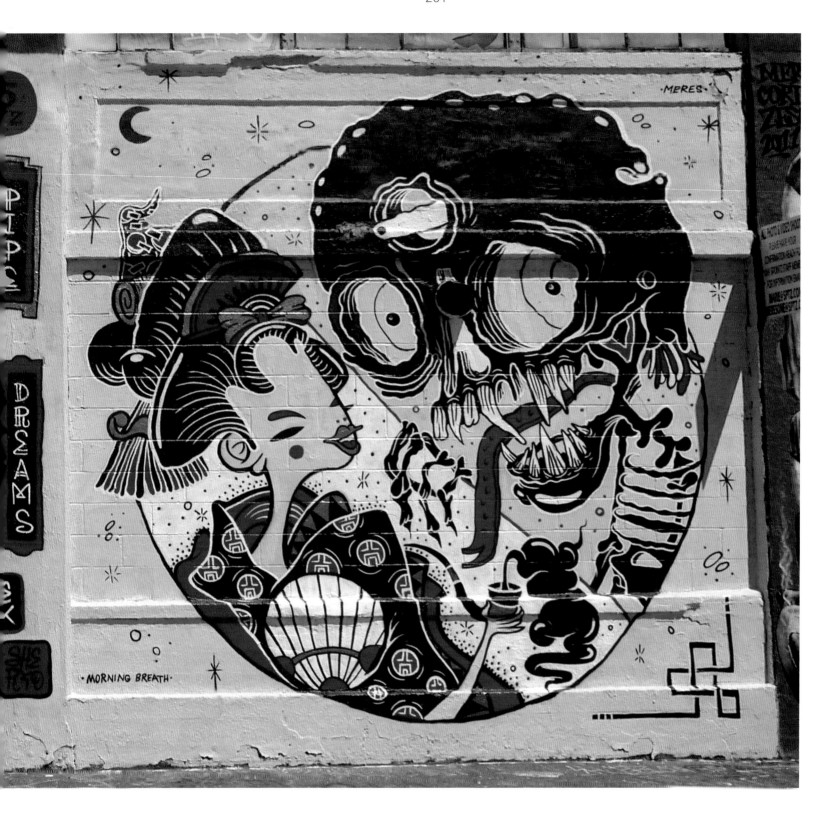

5 POINTZ, LONG ISLAND CITY, QUEENS WITH THE YOK

PHOTO COURTESY OF KRAM

LOWER EAST SIDE, MANHATTAN

KRAM

Kram is an illustrator and street artist born in Barcelona.

KRAM SPEAKS...

ON STREET ART
"I believe that Graffiti and street art are the most remarkable art movements of our time. Street art comes in the wake of pop art, which wanted to bring art to the people and make it accessible to all. Street art is made with the sole intention of being seen and shared, attempting to communicate with the impersonal and dehumanized society. Simply put, it is art for art's sake, not as a commercial product."

ON PERSONAL ART
"I started painting graffiti letters when I was thirteen. I recall that as a child I was always drawing. One day I walked around the corner from my house and found some freshly painted walls. That image and the idea of being able to draw and paint on the street has seduced me ever since.

Sixteen years later I'm still painting walls, though my art, graffiti and work methods have varied over the years. My work on the street is very different from my commercial work in my gallery. For me these are parallel worlds that have little to do with each other."

ON NYC
"Displaying my art in New York City has always been a dream of mine. It is the birthplace of many of the fundamentals of what we know of today as the urban subculture. For example, New York City is where graffiti took off as a phenomenon. I have the great honor of working and displaying my work in the streets of New York. My work there encapsulates my styles; I can feel the history when I work in New York City, like the graffiti letters first spray-painted on trains. New York is not like a European city such as Barcelona, my home. To live and work in New York City is like starring in a Hollywood film where you are casted as the leading actor!"

ON THE FUTURE
"Continue painting - more, bigger, better!"

ON YOUR PROCESS
"I like to use all kinds of painting techniques; just keep trying, experimenting and researching. Currently I'm using acrylic paint and rollers so that I can make murals on much larger walls, complementing it with spray.

Lately, I'm also painting on paper in my studio and then pasting it in the street (paste up). This technique allows me to leave work behind in places where I could not, for legal or other reasons, normally paint for a few hours."

"STREET ART IS MADE WITH THE SOLE INTENTION OF BEING SEEN AND SHARED, ATTEMPTING TO COMMUNICATE WITH THE IMPERSONAL AND DEHUMANIZED SOCIETY."

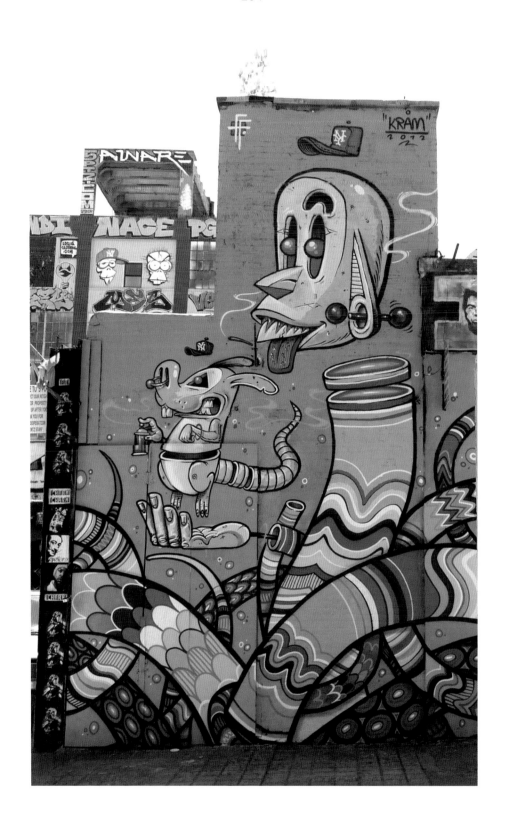

5 POINTZ, LONG ISLAND CITY, QUEENS

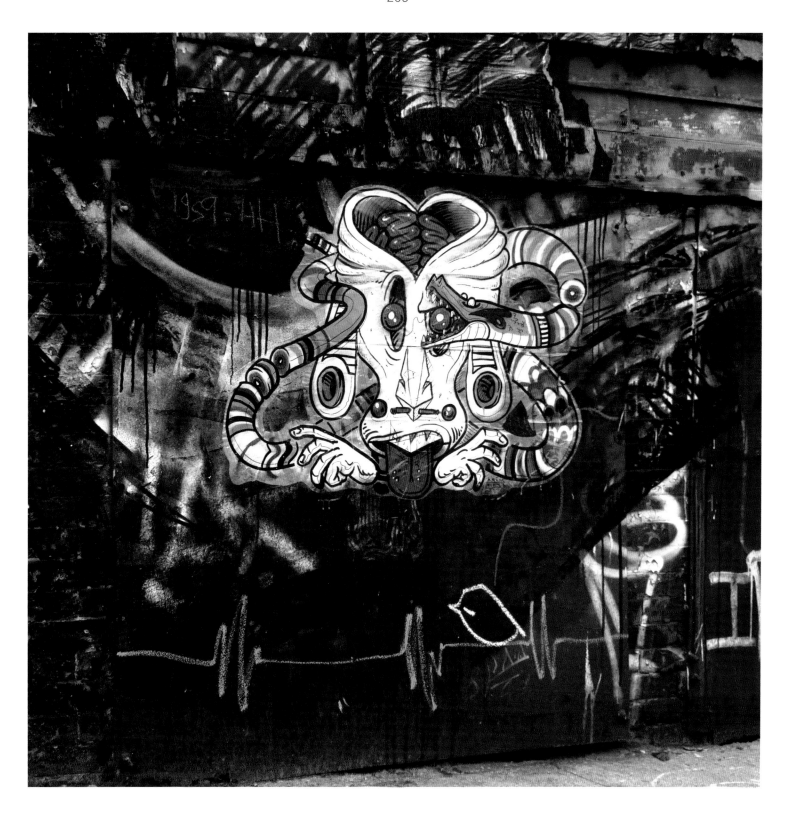

BOGART ST., BUSHWICK BROOKLYN WITH EKG AND VENGRWK

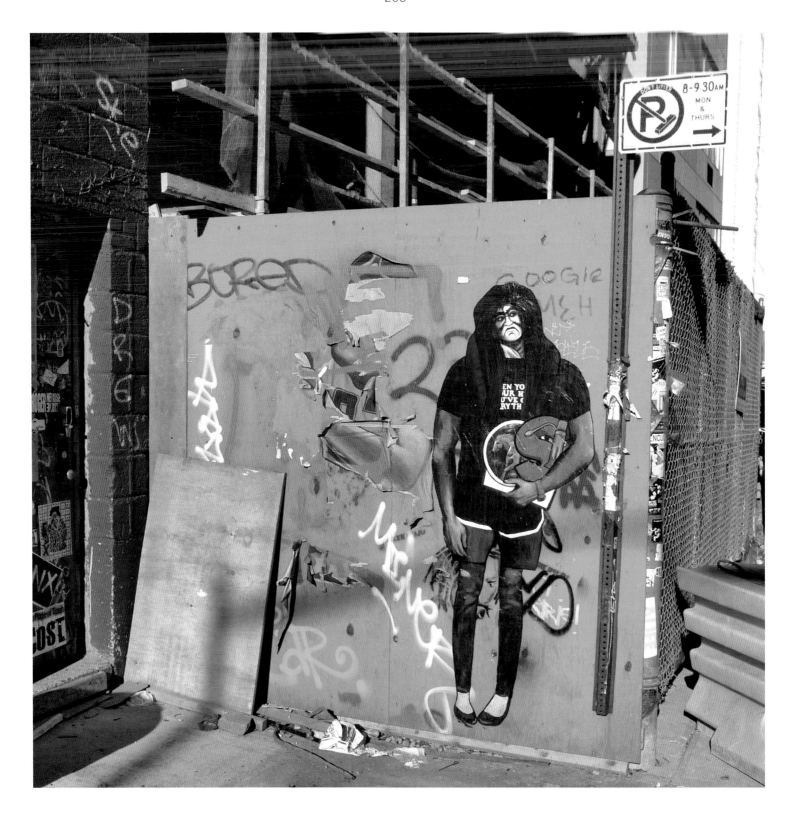

WYTHE AVE., WILLIAMSBURG, BROOKLYN

ELSOL25

ELSOL25 SPEAKS...

ON STREET ART

"The primary focus of my work in the streets is to communicate a somewhat cryptic message that can be interpreted in many different ways by many different people. There's no better way of connecting directly with people. The streets provide the opportunity to touch, bewilder or possibly offend people at a much larger capacity. Current trends in street art are really just unleashing opportunities, which is great."

ON PERSONAL ART

"I came from a mainly graffiti-based background. After enough arrests and people's misinterpretation of the graffiti medium or aesthetic, I quickly converted to making work for the streets that was the same or parallel to the work I was creating in the art studio.

Art for me is all about the process and my way of maintaining my healthy and creative spirit. I hope to bring that out in others with both my studio and street works."

ON NYC

"New York City is the epicenter of the world. I spent many years of development in places that did not give two shits about street art or the street art movement. New York City provided me an environment in which to flourish. There is not only a close following by other street artists, but also a seemingly genuine appreciation from your everyday pedestrian. My favorite neighborhood to get up in is Williamsburg, Brooklyn for this very reason. I always paste my work in the middle of the day, right in front of everyone.

I was once putting up a piece when a typical wealthy young Williamsburg mom and her young child walked past me and I just smiled and continued pasting. The child asked: 'mommy what is he doing?' To which the mother replied, 'he's just putting up some new art'. She said it calmly, without thinking twice, and with a smile."

ON THE FUTURE

"I see dangerous but necessary trends. People are immediately advancing themselves in the art world via popular media such as the Internet and promoting themselves as established and credible street artists. Lots of galleries that are motivated by the current buzz and popularity of street art continue to misinform the genuine supporters of this legitimate art form. The world will have to develop a sharper palate, if you will; an understating of street art's long history of pioneers and a true appreciation of its original style. I envision a future of artists driven by passion and concern for longevity."

ON YOUR PROCESS AND INFLUENCES

"I like paper, paint and glue. Past influences are all of the greats and all of the losers. Influences on my particular style include insult, privilege, shoplifting, racial division and cosmic intersection."

"THE STREETS PROVIDE THE OPPORTUNITY TO TOUCH, BEWILDER OR POSSIBLY OFFEND PEOPLE AT A MUCH LARGER CAPACITY."

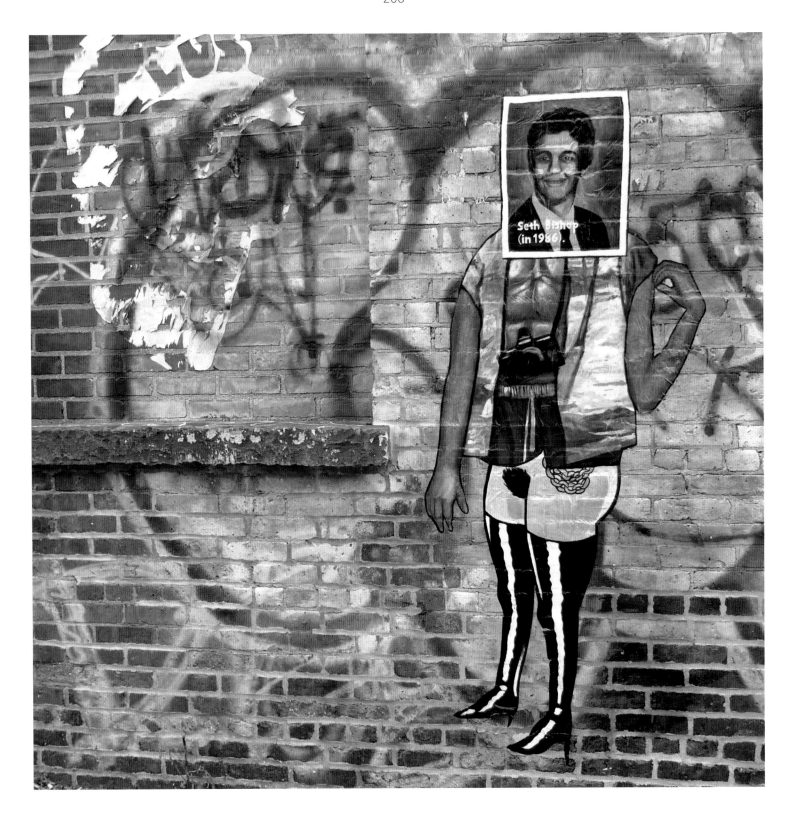

NORTH 9TH ST., WILLIAMSBURG, BROOKLYN

DRIGGS AVE., WILLIAMSBURG, BROOKLYN

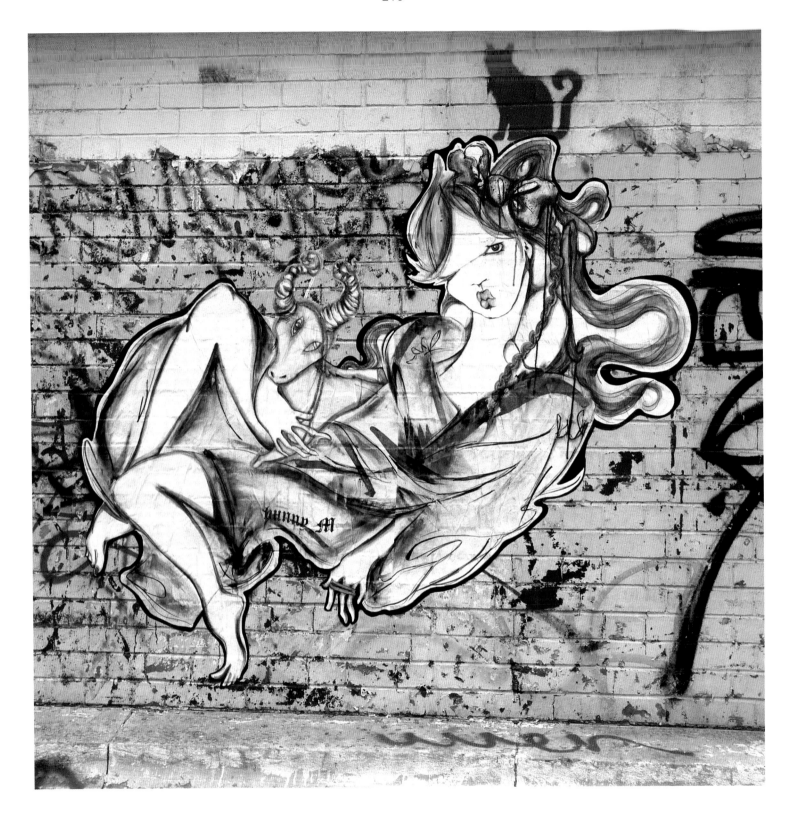

10TH ST., MANHATTAN

bunny M

bunny M SPEAKS…

ON STREET ART

"Art in the streets brings humanity back to an environment. If you need it, you can find visual evidence in any city that you are not alone in wanting something different than what is already out up around you."

ON PERSONAL ART

"I always try to share something that is still alive. That usually means it is not completely worked out and dominated, and yet not half-formed or lazily conceptualized either. The balance between control and abandonment creates something still nebulous and changing. In that way my pieces can adapt to their new environment once they're up.

Lately I've been observing the seasons more carefully than normal and the work has reflected that. The two Queen Catherine paintings are an example- the fleshed out version was created in autumn as I was thinking about the loss of power, life and influence. And the skeletal queen was put up over her in NYC that winter when I was thinking about the dead. I only painted skeletons that winter.

I think about what ideas I'm introducing to the street, how they fit in there, what significance they may have in a city. I research, dream, become obsessed with and live certain ideas until they burn out, then I move on."

ON NYC

"I particularly like giving work to New York City; I love the city and the city loves me. Every piece I have ever given to the streets is hand painted. It can be hard when so much has been destroyed within hours of going up. Like any act of sharing, it's not all sacrifice. The physical work may die but I put my heart into it, so my foundation gets stronger; I breathe that into the next piece and so on. It's a balanced cycle."

"ART IN THE STREETS BRINGS HUMANITY BACK TO AN ENVIRONMENT."

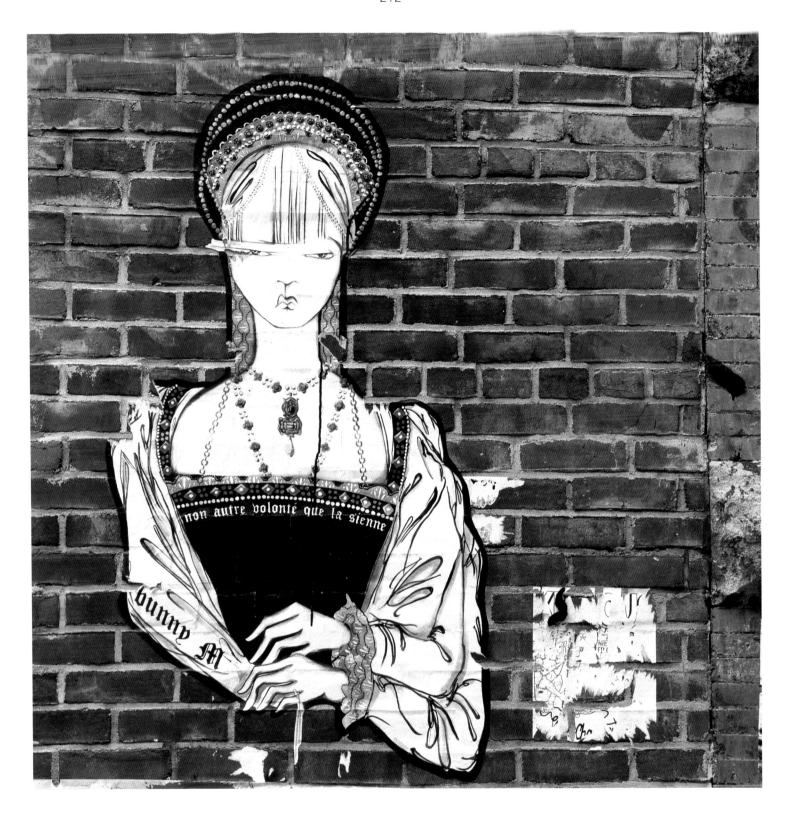

BOND ST., MANHATTAN

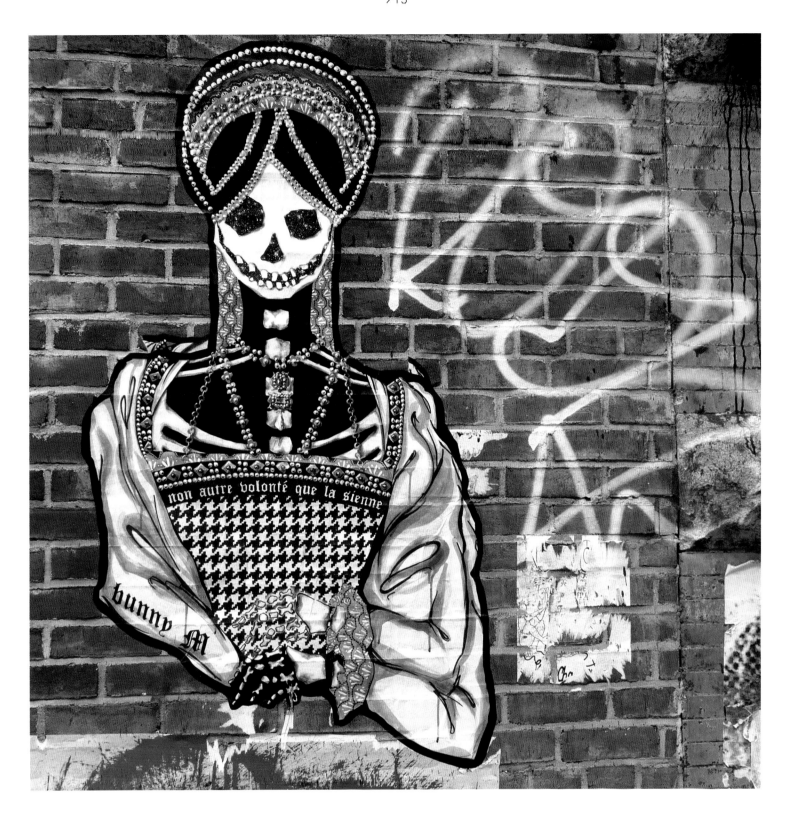

BOND ST., MANHATTAN

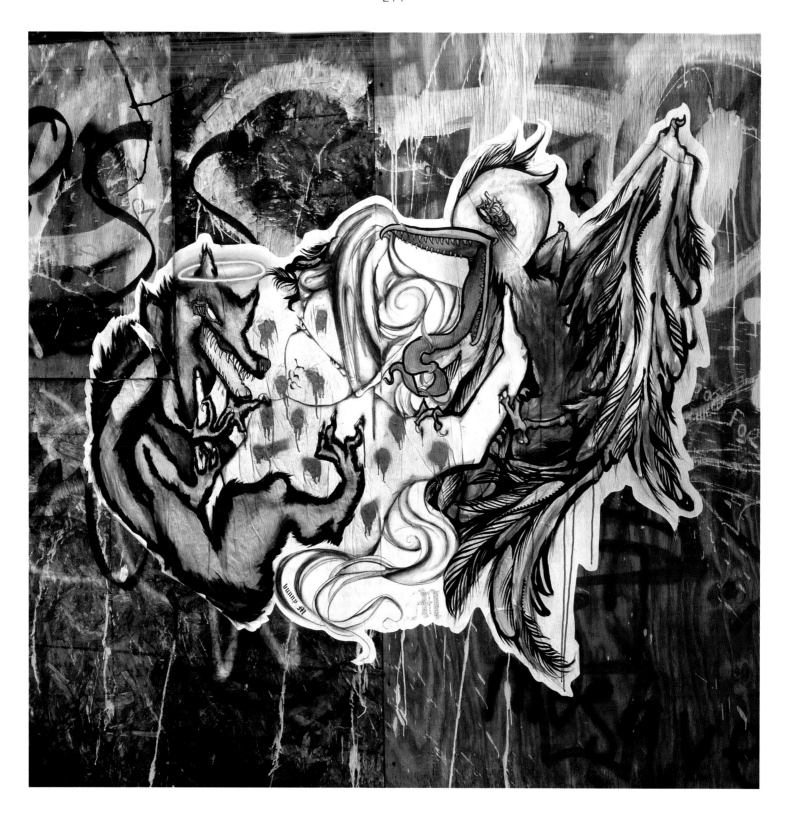

NORTH 5TH ST., WILLIAMSBURG, BROOKLYN

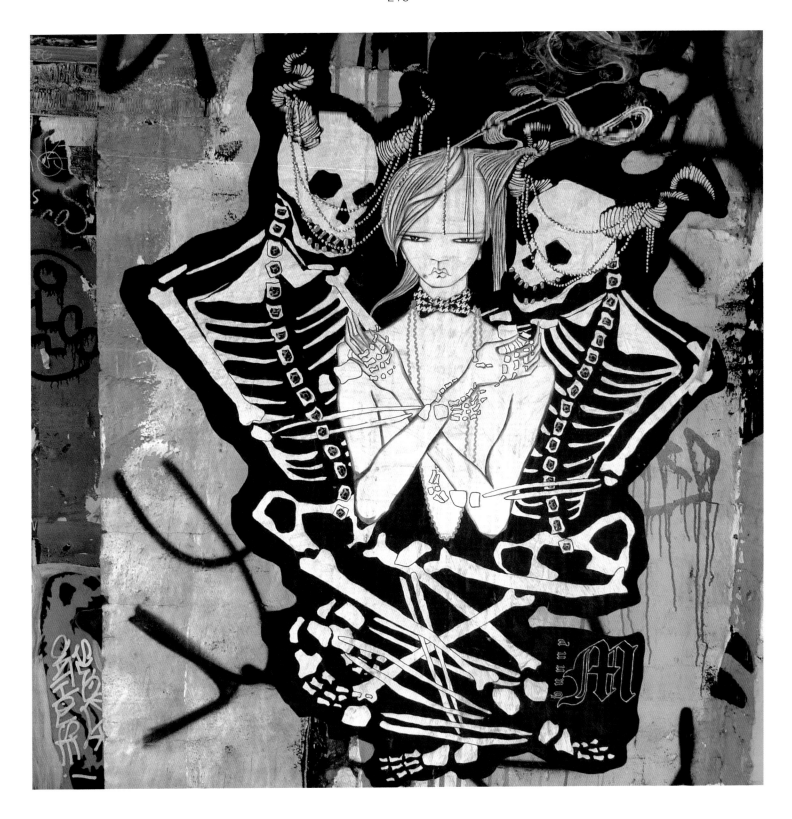

KENT AVE., WILLIAMSBURG, BROOKLYN

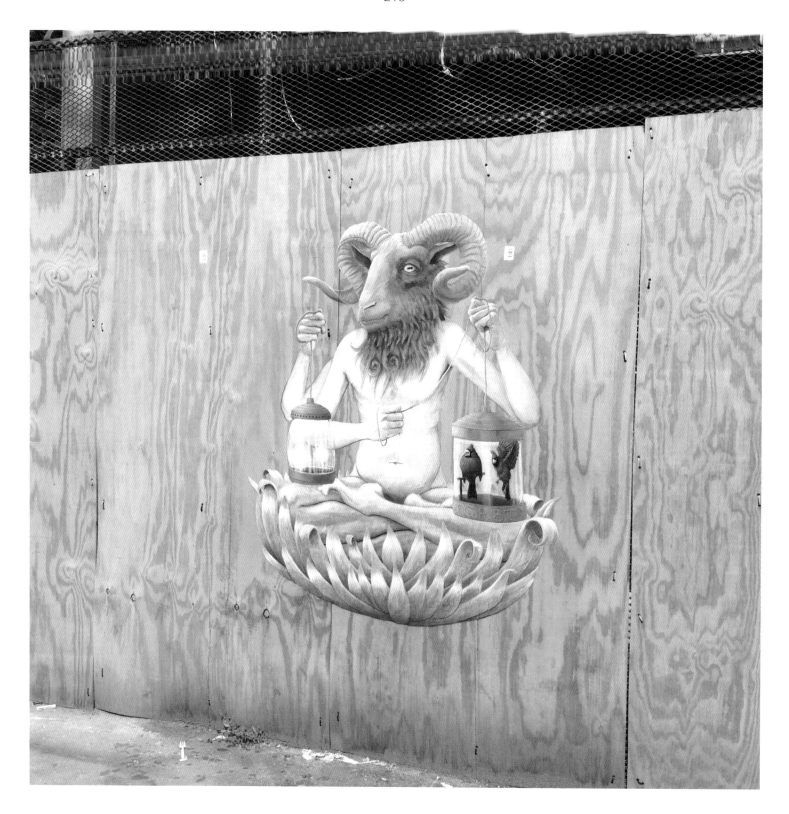

TROUTMAN ST., BUSHWICK, BROOKLYN

QRST

QRST SPEAKS...

ON STREET ART

"Street art is popular right now for a number of reasons, a few of which can probably be linked to ease of photo sharing. Artists are influenced by what's around them and by each other and that's always been the case. I don't think street art has a monopoly on being a barometer of our times beyond any other creative endeavor. Any piece of art is going to be a product of its time. Street art, being a little more immediate and generally short-lived, maybe conveys a feeling of being more 'in the moment.'"

ON PERSONAL ART

"If we're going to be throwing around labels and self-identifying terms, I think of myself as a painter. I put some paintings up outside and sometimes I make drawings and prints, but in my head I hold on to the word 'painter'; not even artist, not street artist. I'm a formally trained studio painter and there is now a very close connection between my gallery work and what goes up outside.

I began wheatpasting sometime around 2004 in San Francisco. A couple of my friends and I started making small prints out of a couple of simple design ideas. I would then go out late at night and put them up. Over the course of the next two years or so I started paying more attention to what people were doing outside, both in San Francisco - because I was out seeing it everyday - and then images on the web of pieces in other cities.

At the time I was living above a print shop and they would give me their left over rolls of paper. So I began making some larger drawings between doing my paintings. In fairly short order I realized that I should start putting these drawings outside, and before long I was making stuff specifically for the street. Over the course of the next few years these outside pieces became increasingly complicated and more closely tied to the paintings I was making. Though it started as a lark, working on pieces for the street now takes up about half of my studio time. Most of what I put up outside is knotted together in some way with several other pieces, some gallery work, some drawings and sometimes sets of other pieces that go outside."

ON NYC

"Street art in New York City is just about as diverse as the art that you can go see in New York galleries. We're lucky in that we get a lot of work from people around the country and all over the world, so it's not usually just a local discussion. Beyond that I don't think it reflects any one quantifiable thing about New York or society.

I absolutely tend to put things in Williamsburg and Bushwick, Brooklyn. To be honest, that's primarily a matter of laziness. I know, or knew, a lot of spots around those neighborhoods so it makes looking for places easier. Williamsburg seems to be closing out now so I'm kind of searching around for some different areas. Downtown Manhattan also has a number of good spots.

I like to keep the times working outside as unmemorable as possible."

ON THE FUTURE

"I imagine street art will be just like everything else in the art world. It's probably not going away any time soon, although the interest of critics, gallery owners, collectors and the public in general will wax and wane. I'm sure it will be pronounced dead as frequently as painting has been over the last 40 years. I expect that people will keep putting work up outside. The majority of those actually out there are working way outside of the art world mainstream and seem to be doing it for the love of doing it.

I personally don't see myself quitting in the immediate future, but who knows what 10 or even 5 years time will bring. My primary concern is being a better painter than I was yesterday. Some of what I'm making wants to be wheatpasted these days, so out the door it goes."

ON YOUR PROCESS AND INFLUENCES

"I tend to make large, handmade pieces on paper that I wheatpaste to walls. Generally they're a combination of paint and illustrative work: pencils, pens, crayon, pastels and markers. Sometimes I dabble around in screen-printing, but the process seems so strange and indirect that I only like it as an occasional, short vacation from painting. I also like making stickers, which I hand make and then clean up on a computer before sending to

"STREET ART, BEING A LITTLE MORE IMMEDIATE AND GENERALLY SHORT-LIVED, MAYBE CONVEYS A FEELING OF BEING MORE 'IN THE MOMENT.'"

the printer (sometimes I just make one-offs on postal stickers and the like). A couple of times I've been invited to work directly on walls and, while it's a little different because of the qualities of the surfaces, it ends up being essentially the same thing: paint, pencils, crayons, markers, just without the paper to carry it from my studio to the wall. Work in public is different and strange in that I'm used to being left alone in a room while painting.

Swoon is a pretty big influence if I'm asked why I put work up outside. I first saw her stuff right about the time I began wheatpasting and I was blown away. As a painter I think I've been pretty heavily influenced by the pop-surrealist and low-brow movement, especially from the west coast. And then the figurative painter standards like Lucien Freud and Egon Schiele. Being in Brooklyn now, I'm influenced by what's been happening here around me the past several years, my contemporaries, and the folks a couple of rungs up the ladder from me who were getting big right around the time I showed up."

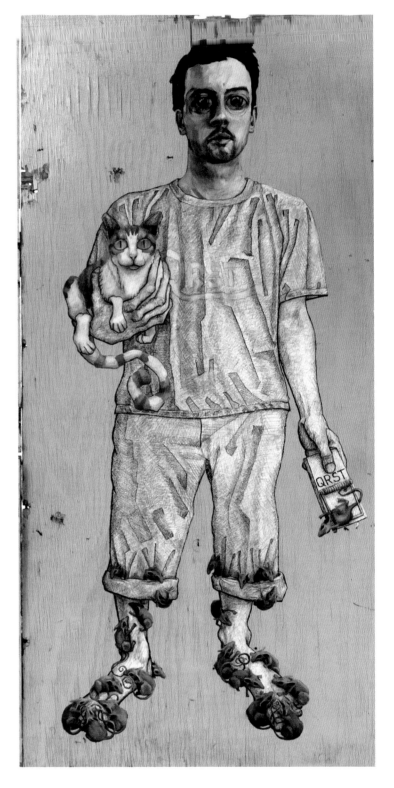

PHOTO COURTESY OF QRST

MONTROSE AVE., BROOKLYN

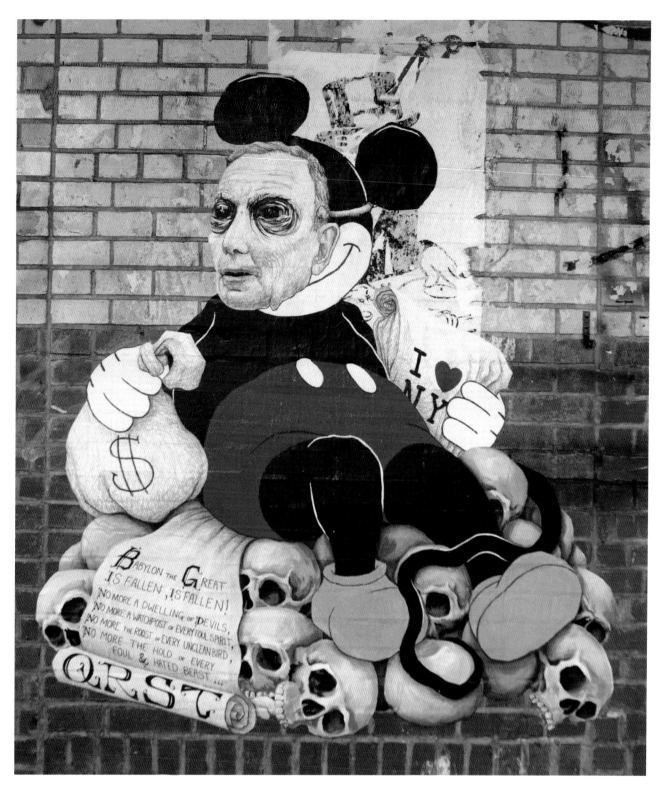

MEATPACKING DISTRICT, MANHATTAN

SUFFOLK ST., MANHATTAN

ND'A

ND'A SPEAKS...

ON STREET ART

"I think doing work in the street takes some of the control away from galleries and allows some artists to free up their styles. To some extent, it allows people to become their own curators. I think some of the people that have been doing it for a while are starting to really hit on new ways of showing their work and it's exciting to see."

ON PERSONAL ART

"My friend OverUnder and I used to hang out and paint together indoors. He convinced me to start putting up work outside and I got hooked. As my outdoor work became more the focus it influenced my indoor pieces. Now I would say that there isn't much difference between the street and gallery practice. Really only the presentation is different."

ON NYC

"New York City is all about diversity. You get people coming from all over the world with innumerable, different styles and they come through to put up work here. As an artist working on the street, I get to witness so much of that.

I really like Red Hook in Brooklyn probably because of all the juicy spots. It's just so pretty out there!

It's always nice when you're putting up a piece and instead of being treated like a criminal, people are actually excited to see it. I've had people invite me to their homes for dinner or come by to have a drink with me at the end of a long day painting. It can be a very positive community experience."

ON THE FUTURE

"As an artist I'm just thinking of ways to improve my craft. I try not to think about my role in the street art movement. I feel like we're right in the middle of the thing. I just intend on keeping busy."

ON YOUR PROCESS

"I tend to use Latex house paint for everything these days. Home Depot is my primary source for art supplies. It's a fun challenge to grab as many 'mess up' gallons at a bargain and then figure out how to make them work. It's always cool effective

As far as technique goes, I like to figure most of it out on the wall I start with large brushes or rollers and then start to thin out my lines. By the time I'm working with a one-inch brush, the form and content is locked in and I'm just making detail decisions."

"AS AN ARTIST I'M JUST THINKING OF WAYS TO IMPROVE MY CRAFT. I TRY NOT TO THINK ABOUT MY ROLE IN THE STREET ART MOVEMENT."

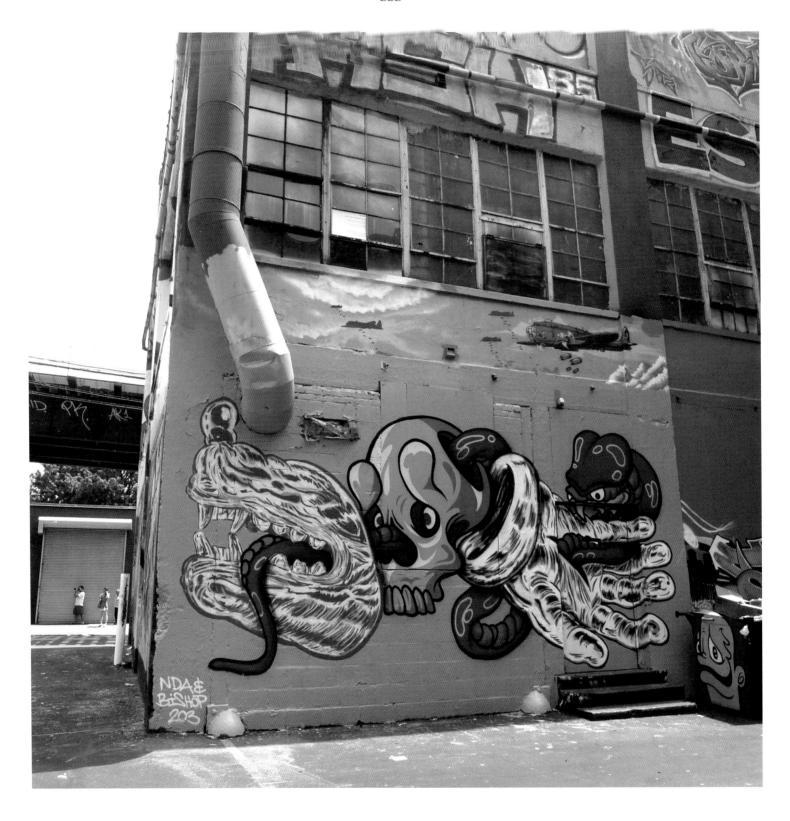

5 POINTZ, LONG ISLAND CITY, QUEENS WITH BISHOP203

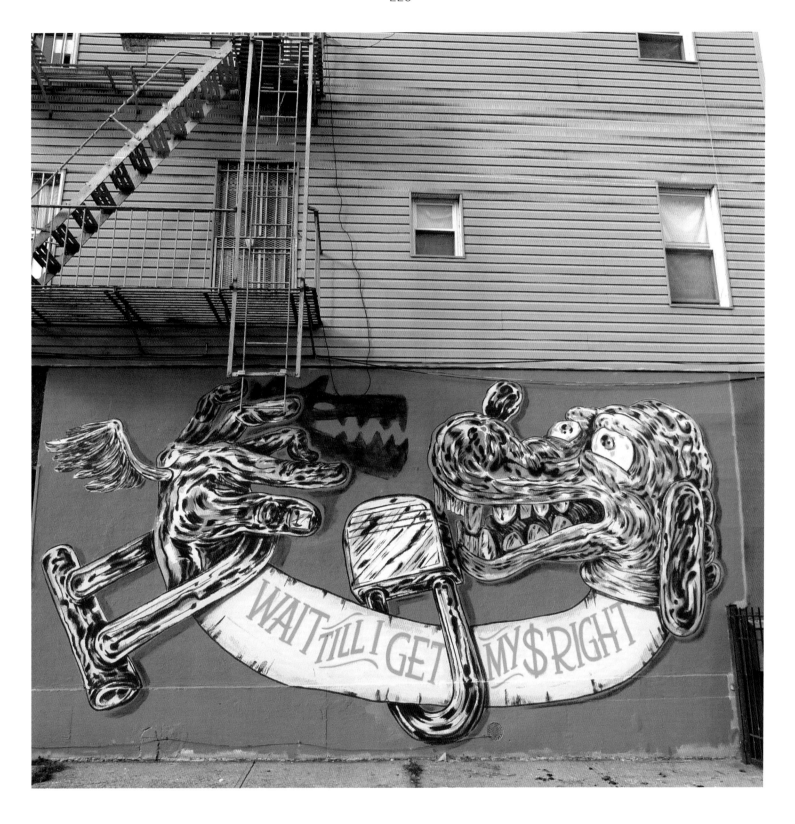

WILLOUGHBY AVE., BUSHWICK, BROOKLYN WITH DIRTY BANDITS

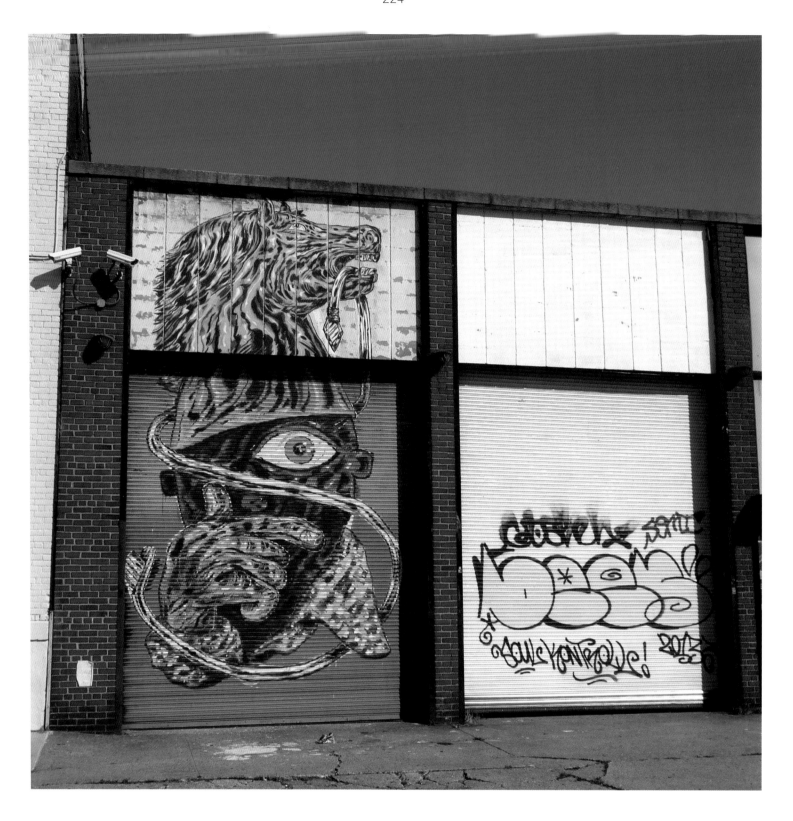

JEFFERSON ST., BUSHWICK, BROOKLYN

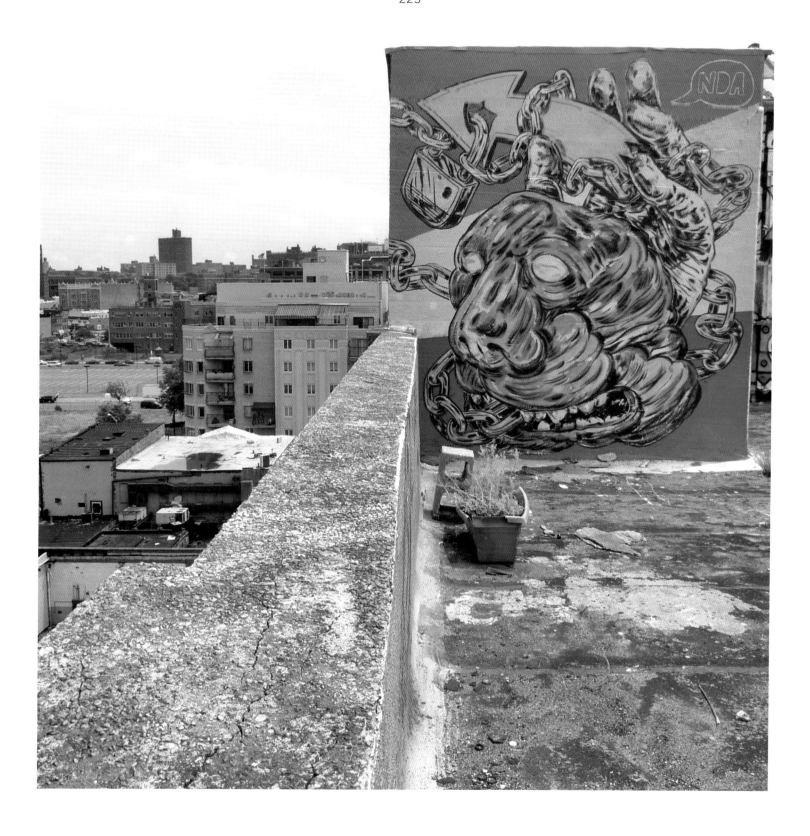

LORIMER ST., WILLIAMSBURG, BROOKLYN

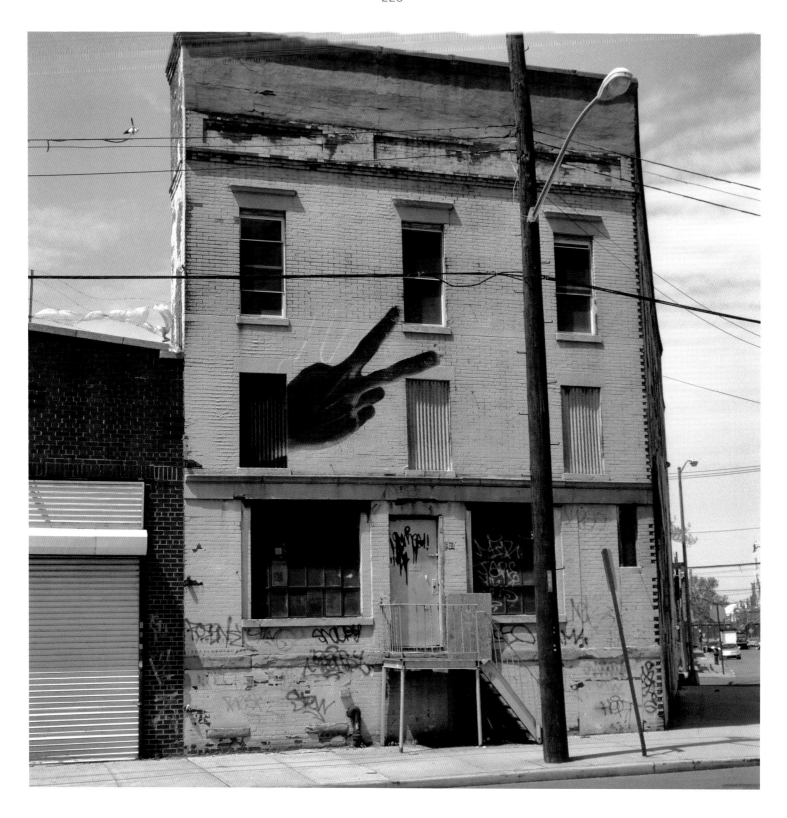

FLUSHING AVE., BUSHWICK, BROOKLYN

OVERUNDER

OVERUNDER SPEAKS…

ON STREET ART

"I grew up viewing the street as a stage. Like most kids, skating was my world. Searching for challenging architecture to create something interesting with has always been a part of my vision, so it was a very natural progression from skating to painting on the street. I never was much into sitting in a studio and painting, just like I've never been into going to the skate park. To me, the street is the ideal petri dish for exploring, innovating and connecting to people.

I think the street is the perfect opportunity for any artist. I mean, making a painting in your studio is the same situation as the question: 'If a tree falls in the woods and no one is there to hear it, does it make a sound?' Eventually all those metaphorical silent trees are taking up a lot of space in your studio, waiting to go off and be seen in the gallery world. I have a fear of acquiring objects, so street art is a perfect solution or more like a perfect symbiotic relationship. In street art the more you make, the more you give. And there is nothing better for the psyche than to develop habits of giving. I truly believe in the power of art to affect people and communities and cities and I can't help but see the gallery as more of a middleman than a stepping-stone.

I think current forms of media influence what we call street art. According to most media, street art is huge murals made with boom lifts. So now most street artists are trying to paint huge to compete with that terminology. But that's not real and it's not practical for a normal person. I mean, most of us started putting our work up illegally because we wanted to bypass the bureaucracy of authority, whether that be the gallery, the art world, the Public Art Councils or even gravity as in the case of these huge murals. So while a select few ride their cherry pickers into the spotlight, the media professes that the sign of our times is that bigger is still better."

ON PERSONAL ART

Like most people I started as a graffiti writer. The Internet was nonexistent so you had to witness it first hand. For me it was going to the Bay Area in the mid 90's and being blown away by the writers in MSK, AWR, and LTS. But then seeing this completely different type of graffiti by people like Reminisce, Emuse, and Twist really set my mind in motion. Later on I found out about Os Gemeos and Phil Frost and I started experimenting with wheatpaste, screwing boards up and using buff marks as fills. Then I had my freight phase and that brought me to Colossus of Roads who I think first started

shaping my ideas of the art I wanted to make. The momentum just kept building and now I am here.

I've seen my role as very small in the grand scheme of things. If anything, I see my role as a return to productivity over production. It is important for me to highlight my story and iconography. All my wheatpastes are one-off paintings with all sorts of clues meshed together representing current events and personal happenings. I've been challenging myself the last several years, making common imagery unique and iconic like the paper bird, the roll up gate, the double happy face, the weight bar and of course elements of architecture. I'm not sure where it's going but sometimes it feels good to go into the unknown."

ON NYC

"New York City is an amazing place to be heard. If you have something to say, all ears are turned your way. I think street art here reflects the confined nature of the built environment, where people are literally stacked on top of each other. Graffiti and pasting out on the streets reflect this feeling. If you know what to look for you can see the relationships, the hierarchy amongst writers. I like bits and pieces of many neighborhoods in New York, but if I had to choose a favorite it would be Red Hook, Brooklyn. The Brooklyn-Queens Expressway cuts it off and since it has no direct Subway service it remains relatively quiet and isolated. It's got a coastal vibe, almost Dutch in a way, and there's a great bar there that shares my Grandfathers name."

ON THE FUTURE

"I envision the future as one long line of surprises. That's what got me interested in it in the first place and what will keep me in it for the long haul."

ON YOUR PROCESS

"Mostly I spray paint on large rolls of colored paper that I cut out and paste up using a mix of Sure Grip and PVA bond. My friend IRGH from Berlin taught me a trick for getting those thin lines, to use a calligraphy cap with some paper under the cap. But I mostly use Rusto's Painters Touch brand with the stock cap because you can get the same effect and you can find it anywhere in the States. My technique grew out of an economical issue of trying to get the most bang-for-my-buck. I barely press the cap down to use less paint and it ends up creating a thin, pointillism-like effect where each speck of paint is heavy yet spread out. I enjoy the vast effects one can get from the science of propelled paint."

"I HAVE A FEAR OF ACQUIRING OBJECTS, SO STREET ART IS A PERFECT SOLUTION OR MORE LIKE A PERFECT SYMBIOTIC RELATIONSHIP. IN STREET ART THE MORE YOU MAKE, THE MORE YOU GIVE."

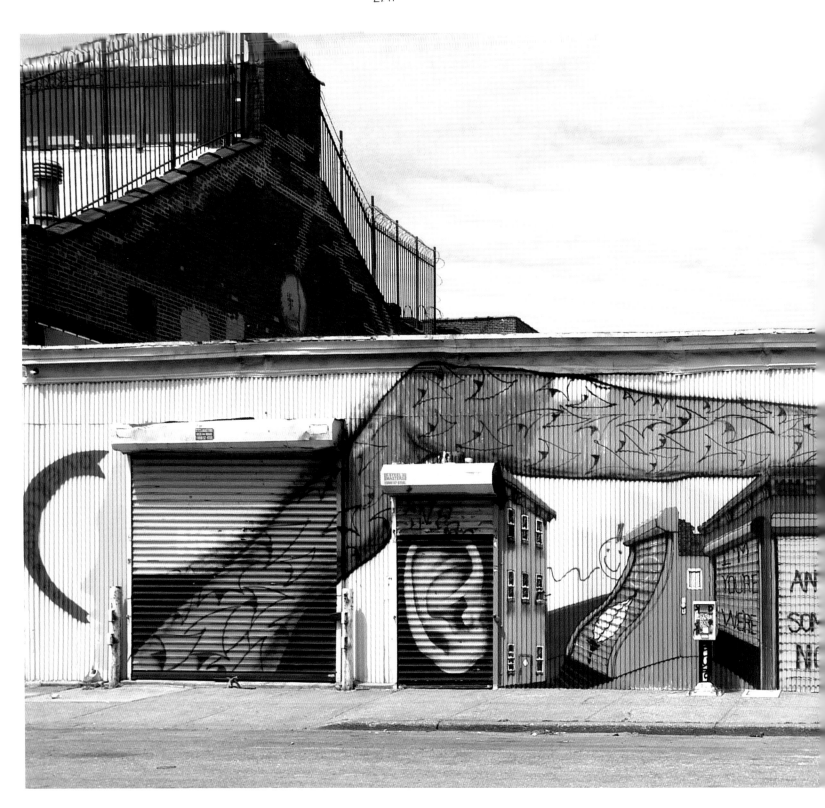

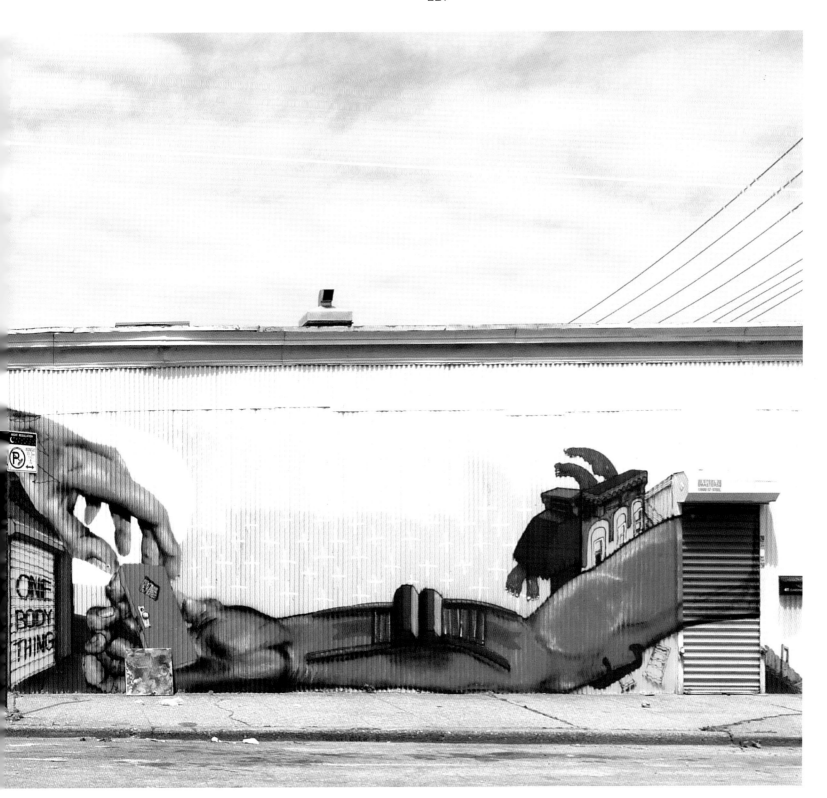

STAGG ST., BUSHWICK, BROOKLYN

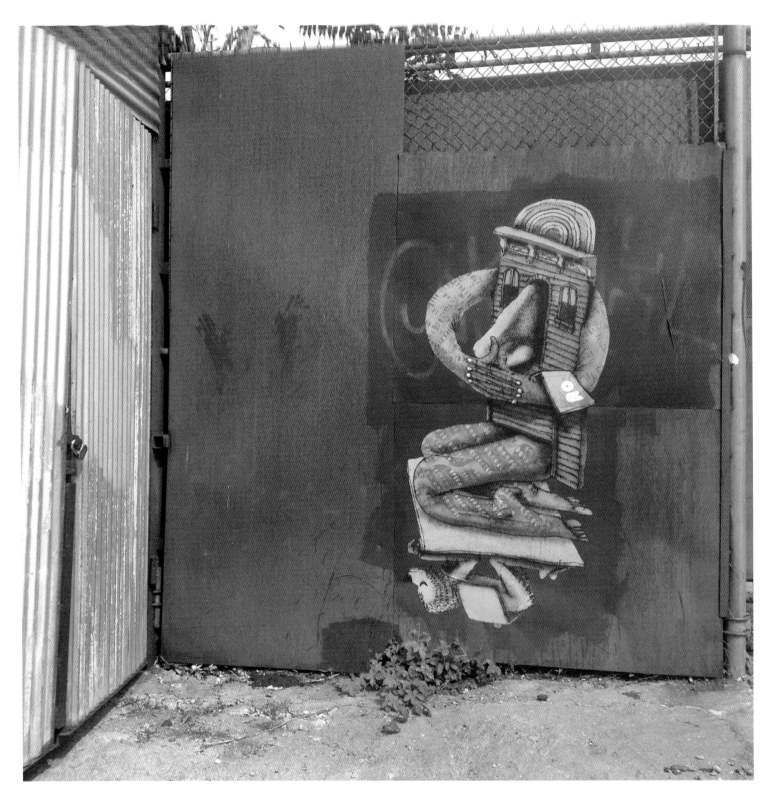

PHOTO COURTESY OF OVERUNDER

TROUTMAN ST., BUSHWICK, BROOKLYN

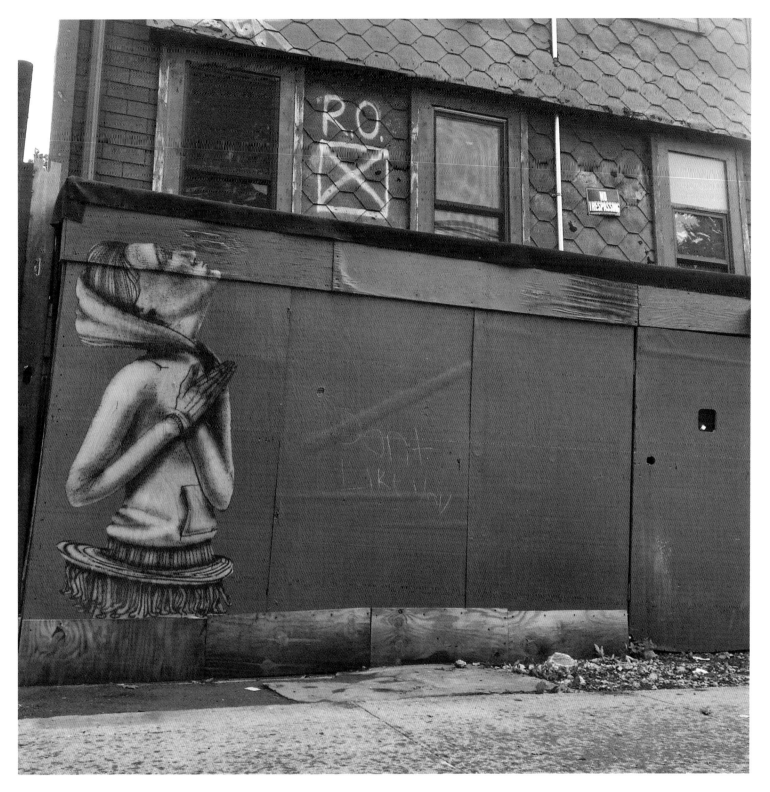

PHOTO COURTESY OF OVERUNDER

VAN BRUNT ST., RED HOOK, BROOKLYN

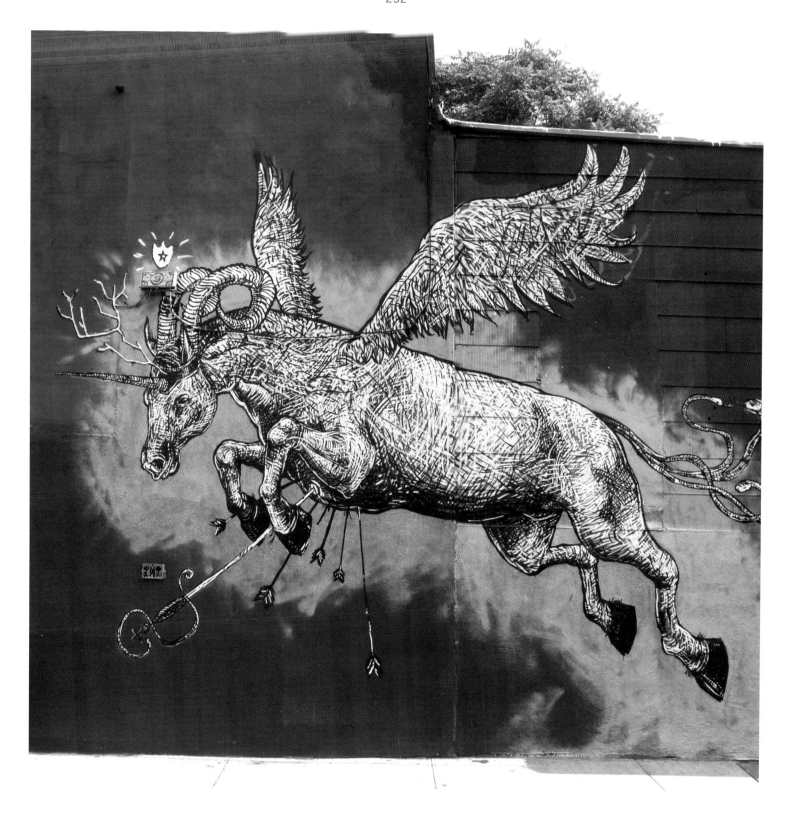

NORTH 10TH ST., WILLIAMSBURG, BROOKLYN

LUNARNEWYEAR

LUNARNEWYEAR SPEAKS…

ON STREET ART

"Art is always public by definition because it is an act of communication; it is one person's expression coming full circle when viewed by another person. Galleries, museums, markets, fame, television, blogs, entertainment are all just mediums that transmit the basic point of art, which is visual communication. Art happens in the streets now because we are returning to this basic idea of open culture, communication and sharing. It is reactionary, but then again all good things are!"

ON PERSONAL ART

"I never label myself as a street artist, I find that doing so is limiting in the same way that calling myself a gansta rapper would limit me to a certain geography and time: 1990's - 80's west coast rapping about the hardknock life. From the time I was a kid I have only called myself an 'artist' because nothing else felt right. As I got older I understood it for what it is: a creative lifestyle of rigorous practice. This life of art-making led me to bring art onto the streets organically; the work I make on paper or wood feeds the murals I paint and the books I read inform the interventions I make in public space and vice versa. There is no inside and outside division of my art."

ON NYC

"I was born in Ecuador and moved across the river from New York City, to New Jersey, when I was ten. Growing up, New York City was my playground. When I skipped school I would go to New York City because it captivated my imagination and offered everything to me. It fed and nurtured my curiosity as a youngin and it still does so today. For this reason I am very critical of what happens here and this, in turn, has made me very aware of issues such as gentrification, ethnic and wealth divisions and institutional corruption. New York City as a model city has been copied countlessly all over the world, at times for the better but sometimes for the worse. Public art in this city has played a social role in areas like Bed-Stuy, the Bronx and Brooklyn during the 70's and 80's with projects like ArtMakers Inc. and Groundswell. But of course that is overshadowed by the birth of graffiti, which is the perfect reflection of a time when the city was broke and its people struggled to survive and be heard. Nowadays New York City is a completely different beast, especially after 9/11. NYC is basically overrun by police who cater to the wealthy so much more so than to its other citizens.

Brooklyn is the new cultural capital of New York because people still take risks there. However, these ambulant communities get pushed further and further away from Manhattan in the real-estate dance that has been going on since the 80's. This dynamic is not sustainable so we'll see how far that goes. Artists play the role of canaries in a mine; if they survive long enough and prosper, then capital and people will follow. The same process is happening in so many other American megacities. As an artist who works in public spaces, I often need to deal with this reality."

ON THE FUTURE

"I really believe in art's power to affect change on both the large and small scales; art can chop like a sword or cut like a scalpel. My goal is to use my art wisely and to always keep in mind where this movement, or group of ideas, came from and whom it aims to serve. Namely, that it comes from the people and it should serve the people. It is now a global movement and there are many different takes on it, but the artists I gravitate towards and respect share the general principle of keeping it free and open. As long as we keep true to it being an open voice for the masses, then the future will be bright."

ON YOUR PROCESS

"Materials and techniques are only the letters we use to form sentences. I think of anything as a possible material or technique. String is a good material, so is water or light, a tree, traffic cones or the side of a building. The important thing is not to be restrained by the materials you use but to use materials and techniques that will open and free you and your work. Right now I'm interested in line and marks so I use paint, spray cans, charcoal, chalk and ink in most of the work I make. These materials lend themselves well to the marks I want to make and to the ideas I want to explore when painting a mural or sketching in the subway. This is very traditional stuff, you know; a brush and paint, but the language and what is being said is contemporary. It is important to always look at the past and learn from people before you. Humans have been making murals for as long as we've had walls and the older graff writers are the nicest people. Talk to them and learn to become part of this great art tradition."

"ART HAPPENS IN THE STREETS NOW BECAUSE WE ARE RETURNING TO THIS BASIC IDEA OF OPEN CULTURE, COMMUNICATION AND SHARING."

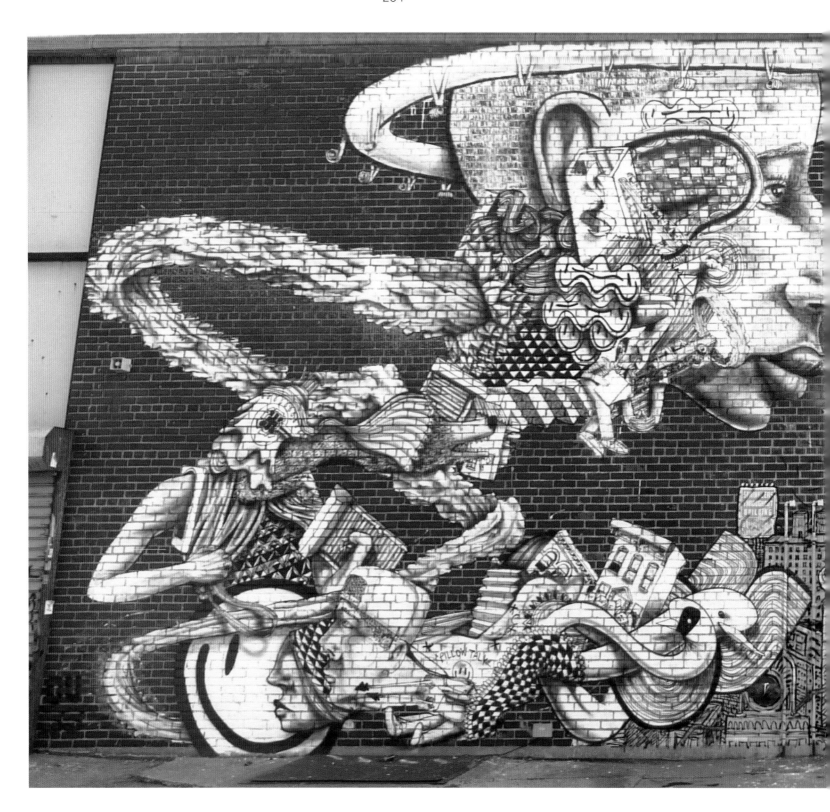

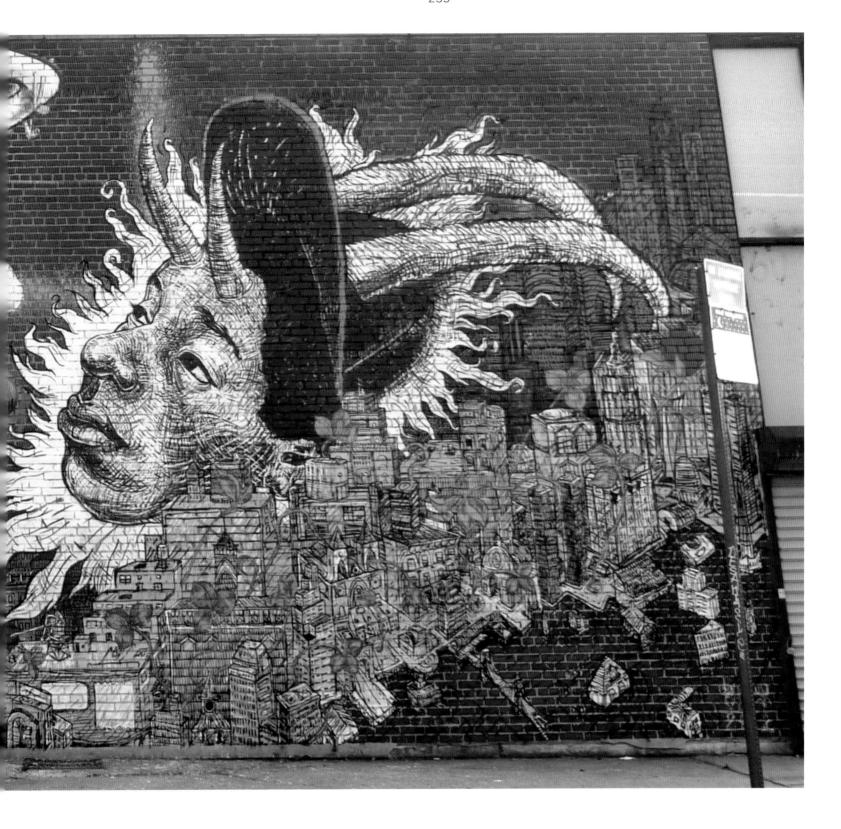

JEFFERSON ST., BUSHWICK, BROOKLYN WITH OVERUNDER

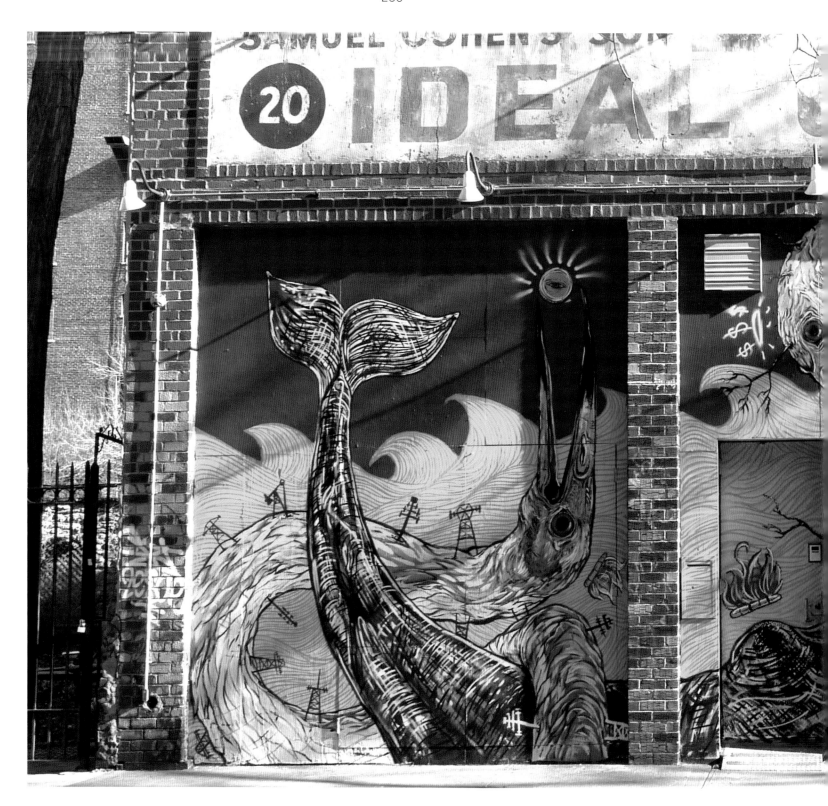

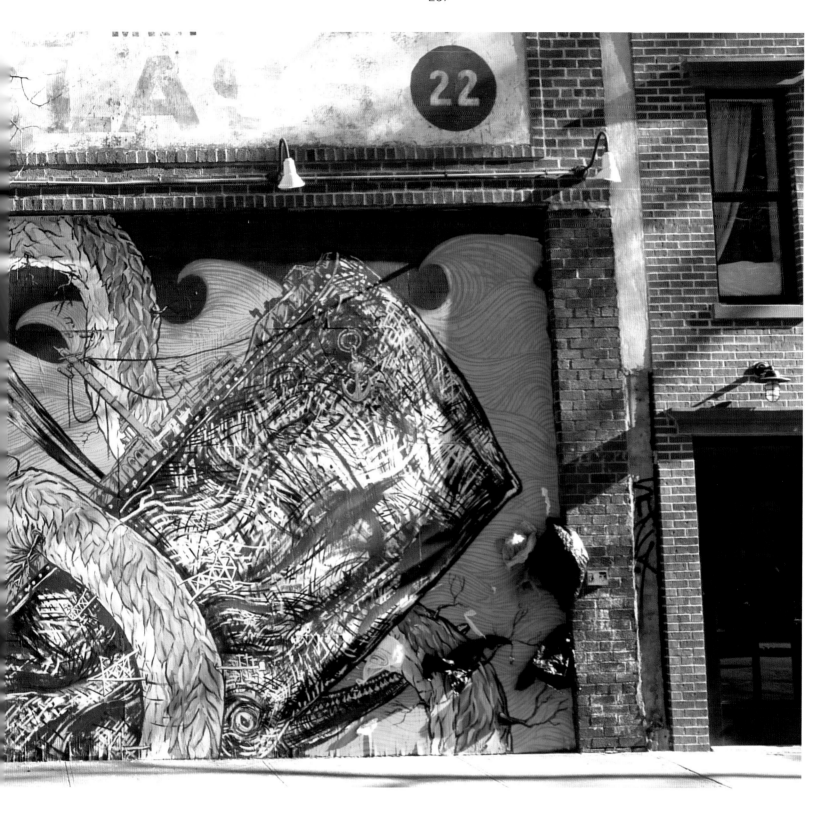

EAST 2ND ST., MANHATTAN

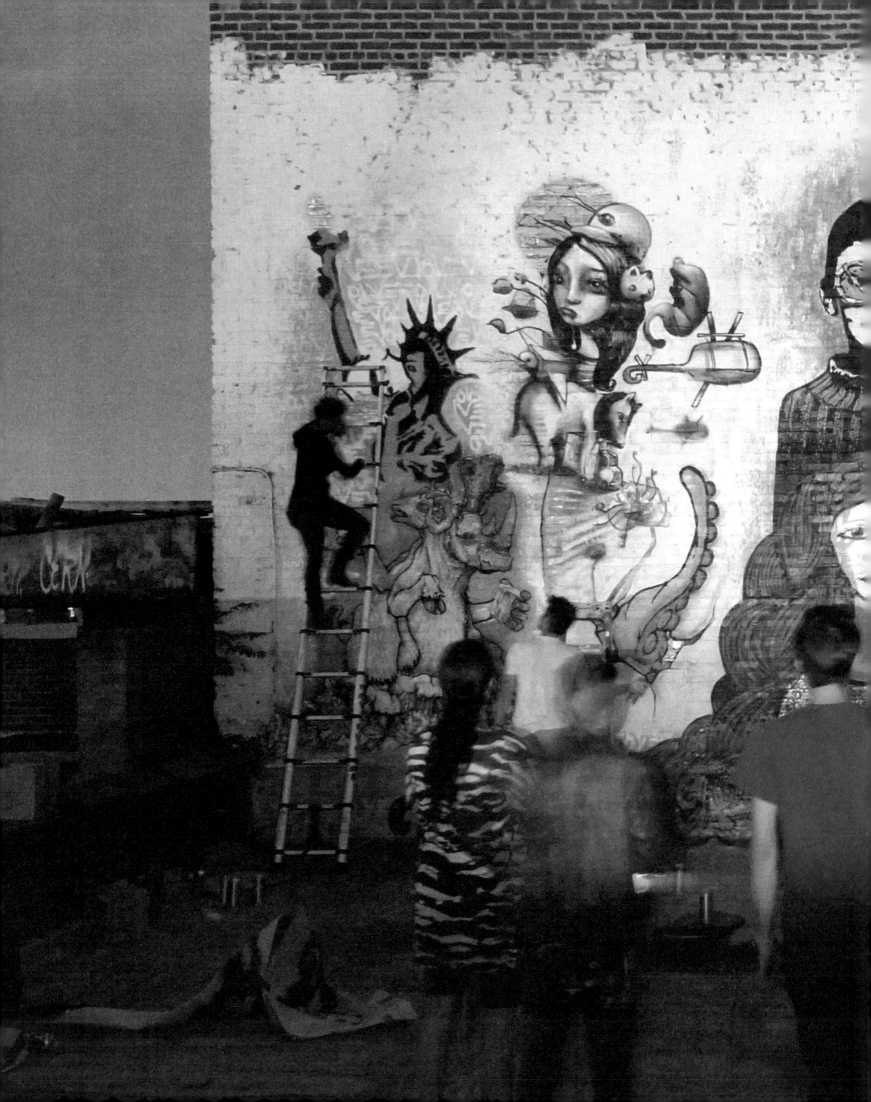